PAINTING THE CONQUEST

The Mexican Indians and the European Renaissance

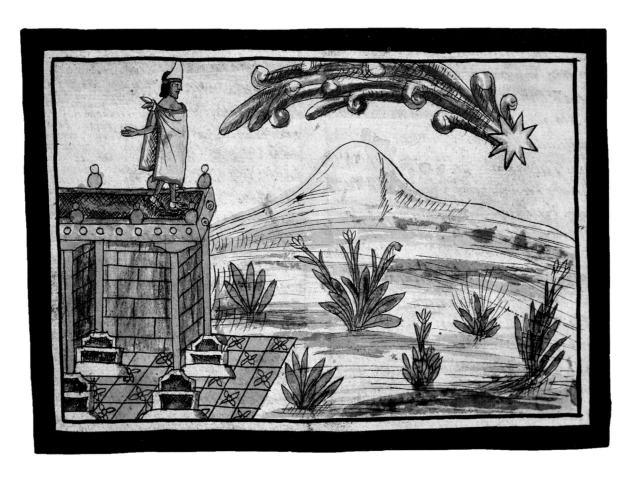

The Premonitory Comet
Codex Durán, Chap. LXIII

Moctezuma, the lord of Mexico-Tenochtit-lan, reportedly climbed to the top of an observatory one night and saw a blazing comet, an omen of death. After the Spanish conquest, the native Mexica interpreted this magnificent sighting as a premonition of the European invasion.

PAINTING THE CONQUEST

The Mexican Indians and the European Renaissance

Serge Gruzinski

Translated by Deke Dusinberre

Unesco

Flammarion

ACKNOWLEDGEMENTS

I am grateful to Jean-François Barrielle for the interest and confidence
that made this book possible.
Delphine Le Cesne, Béatrice Petit, Violaine Gérard and Jérome Faucheux
also deserve thanks for their timely and invaluable help.
Finally, my thanks go to fellow researchers at Mexico City's National Institute
of Anthropology and History—their cooperation has made this book
a finer homage to Mexican culture.

Flammarion
26 rue Racine
75006 Paris, France

ISBN 2-08013-521-X
Dépôt légal: April 1992

Designer:	Jérome Faucheux
Picture research:	Béatrice Petit
Copyeditor:	Julie Gaskill
Typesetter:	Nord Compo, Villeneuve-d'Ascq
Photoengraving:	Bussière Arts Graphiques, Paris
Printed and bound by:	Imprimerie Mame, Tours

Note: Information concerning the codices mentioned in the text and captions
can be found in the appendix on page 229.

CONTENTS

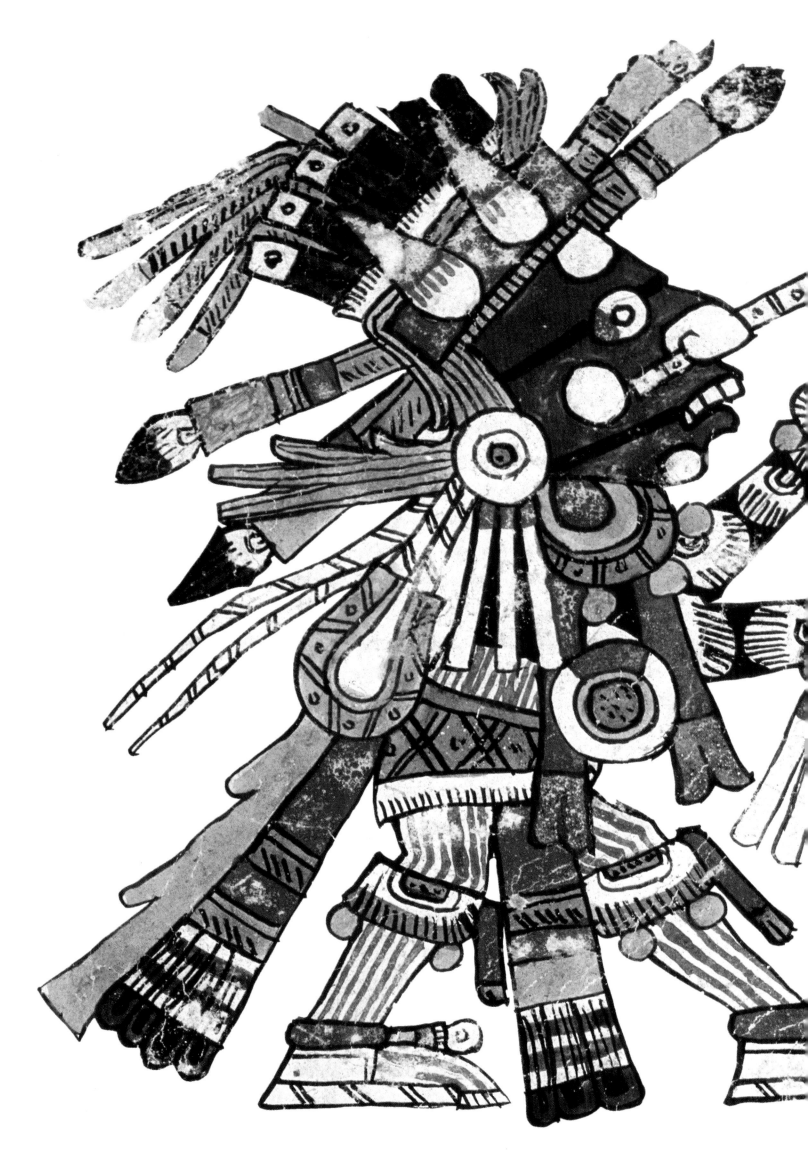

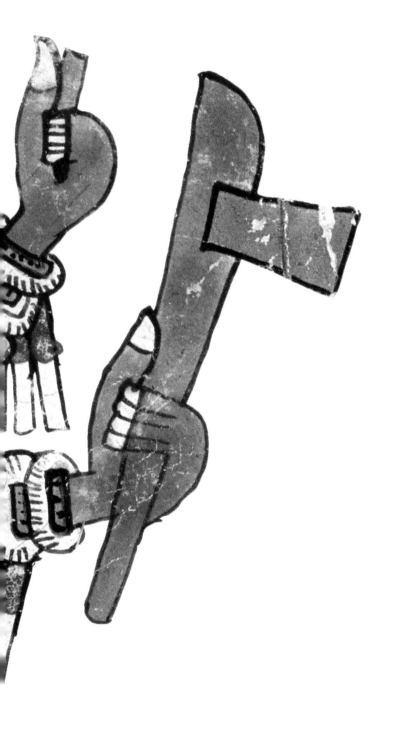

Introduction

1. A God from the Codex Borgia
Codex Borgia, p. 19

Tlahuizcalpantecutli, "Lord of the House of Dawn," was associated with the planet Venus. Identifying features include the four white disks painted on his face and the red and white stripes on his body. This god, bedecked with a multitude of ornaments and emblems, each one of which has a special meaning, is represented here as a woodcutter.

Mexican rulers and their people had been worried by troubling omens for a number of years. So when rumors of the arrival of strangers on the coast became explicit, all-powerful Moctezuma, lord of Mexico-Tenochtitlan, listened carefully to the report delivered by his coun selor. Then he ordered the finest of his painters to record the image of these unknown beings who traveled on "floating mountains." The Mexican monarch was amazed by the appearance of these bearded creatures with their white skin and colorful clothing, and in an effort to fathom this mystery, Moctezuma had the archives of every city in the Valley of Mexico and the southern regions searched for paintings that might show something similar. Thus was brought to light the very first image of Spaniards and the European invasion, produced around 1518.[1] This visual representation of the conquistadores preceded their arrival, as though underlining the extent to which images would play a complex and ambivalent role in the extraordinary conflict between indigenous America and Europe.[2]

An Unprecedented Experiment

The discovery of America represents a crucial stage in the history of Western society insofar as it pulled an entire continent into the European orbit. It forced an encounter between two worlds that had been developing independently of one another for thousands of years. This confrontation constituted a fatal shock of incredible brutality for the inhabitants of the New World; entire civilizations were devastated by the conquistadores. Worse, the epidemics that followed (or sometimes preceded) these invaders destroyed native society by decimating whole generations, silencing oral tradition and swelling graveyards everywhere, from the Caribbean to Mexico and from Panama to Chile.[3]

Such disasters tend to mask a battle of another type, perhaps less bloody yet just as crucial in the long run. The Spanish conquest led to a clash between High Renaissance culture and extremely sophisticated indigenous forms of thought and expression. Alongside explorers, merchants and conquistadores, numerous administrators and missionaries spread humanist values and attempted to transplant the religious, artistic and intellectual accomplishments of the European Renaissance onto American—and more particularly Mexican—soil. Even though such cultural projection was merely another form of colonization and domination, it nevertheless provoked a local cultural reaction of remarkable quality and diversity. This led to an experiment unique to the sixteenth century: the Renaissance arts of sculpture, architecture and painting[4] entered into a dialogue with traditions that had been cultivated by pre-Columbian civilizations for millennia. This astonishing experiment in coexistence between European and native worlds raised countless questions in addition to the basic issue of artistic creativity, for it challenged the very foundations of Mexican

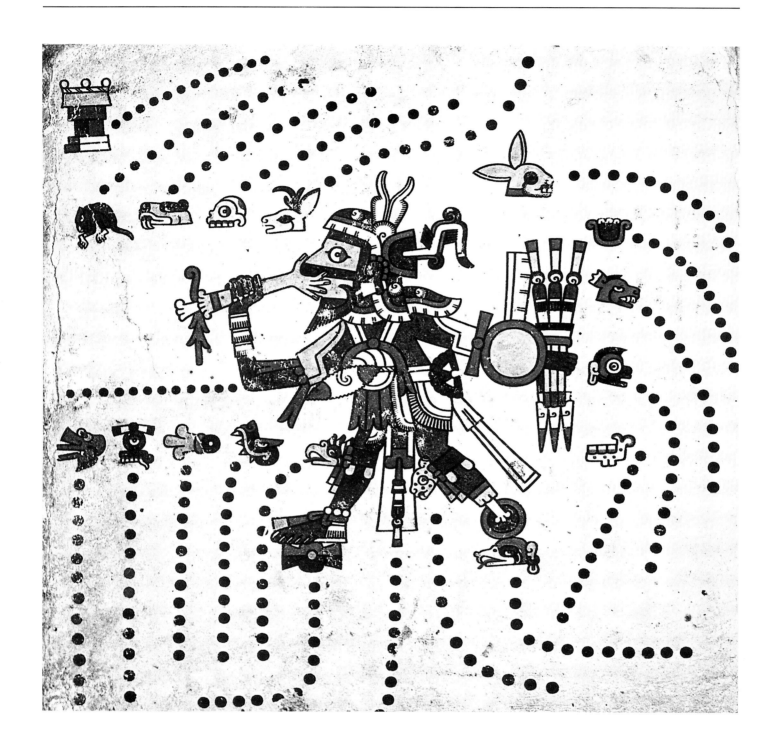

2. The God Tezcatlipoca,
Lord of the Twenty "Trecenas"
(Thirteen-Day Cycles)
Codex Fejervary-Mayer, p. 44

Produced on the high plateau of central Mexico, this codex is of uncertain date and provenance. It is painted on both sides of a twelve-foot-long strip of deerhide, and its rather spare style and clear outlines produce *an effect of elegance, rigor and economy of means. The content has ritual and divinatory significance. The omniscient, ubiquitous god Tezcatlipoca is recognizable by the obsidian mirror that replaces his maimed foot. He governed twenty trecenas, each one represented here by a glyph and twelve dots. These twenty cycles of thirteen days comprised the two hundred and sixty days of the ancient Mexican ritual calendar. Soothsayers con-* *sulted this calendar to locate the day pertaining to questions put to them, then analyzed the divine forces governing that day.*
The body of the deity is a patchwork of ornaments, apparel, colors and emblems to which several trecena glyphs have been attached, as though image and language were organically linked. Thus the dynamic concepts behind this visual analysis of the interplay of time and divine forces can literally be "seen."

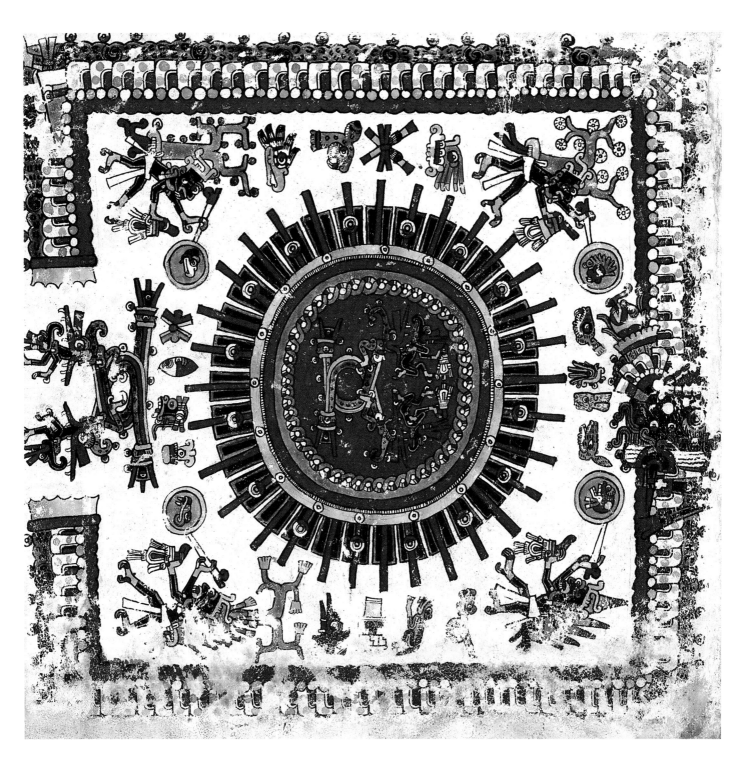

3. The Codex Borgia
Night and the Gods of Rain
Codex Borgia, p. 30

This plate is taken from a section of the codex devoted to rites. The gods of rain can be seen in the four corners, representing the four points of the world. Three of them carry trees on their back, the fourth carries *an agave. These plants probably represent the pillars holding up the sky, the columns down which cosmic forces flowed from heaven to earth. The gods of rain flank a red disk bordered with stars, representing night. Rather than presenting a realistic image of the world, the painter was seeking to convey its deeper essence, rendering esoteric systems almost palpable by combining and contrasting* *forms, colors, and symbols. This densely filled surface differs sharply from the soberness of the preceding codex. Note also the constant, significant use of color, the bold lines defining and underscoring each form, and the absence of background that yields an exclusively two-dimensional representation.*

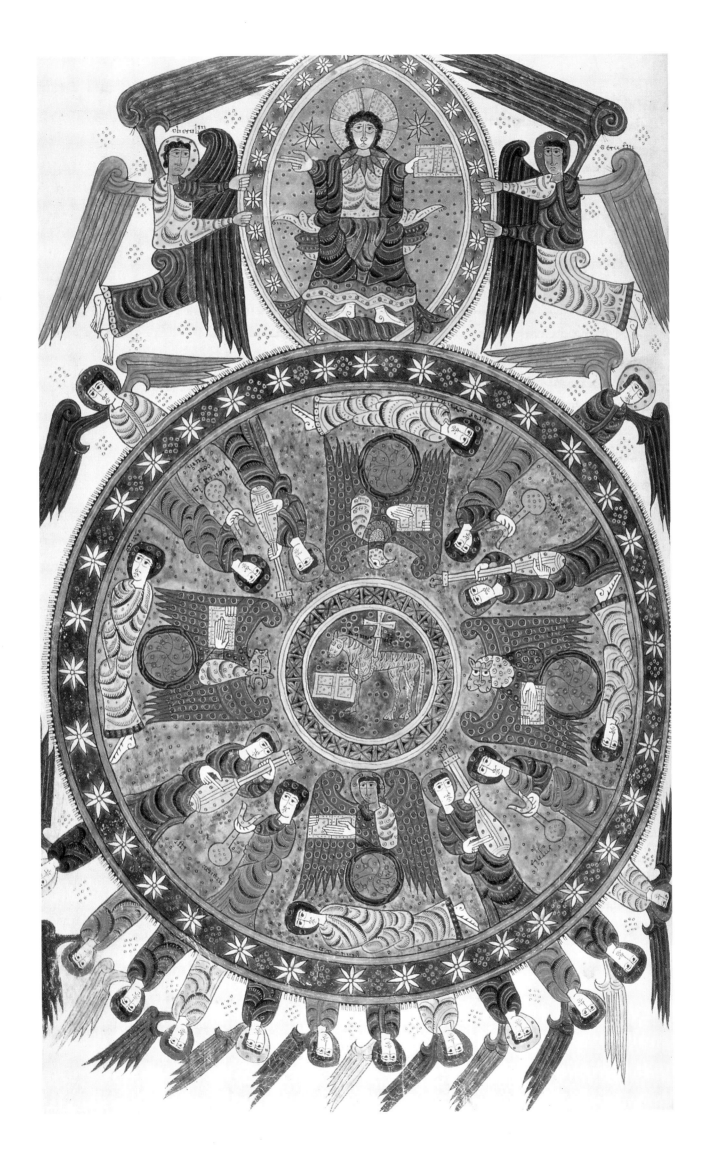

civilization. To what extent, on what levels, and at what cost could local artists manage to reconcile the irreconcilable? For how long could they juggle two ways of seeing and experiencing the world, two ways that had nothing in common at the outset? Their efforts resulted in the development of new forms during the sixteenth century, forms that will be examined here in an attempt to identify the inner strength and scope of Mexican creativity in the face of culture shock. This should demonstrate how inappropriate it is to speak of a totally "subjugated vision." Indians did not limit themselves to the role of passive spectators, they actively created images. Their wrenching testimony magnificently communicates what no text has conveyed and what no archive could record—the transformation and Europeanization of a way of seeing that remained faithful to ancient canons.[5]

The Lords of Mexico

Before examining and deciphering these images, it is worth dwelling on the nature of the universe that produced them. Central Mexico is a region particularly conducive to this approach. Like other high plateaus on the American continent, it harbored refined and complex civilizations that flourished around large urban centers.[6] The Valley of Mexico sits in the middle of this *altiplano*, shut off from the east by the snowy, volcanic peaks of Ixtaccihuatl and Popocatépetl, and shielded to the south and west by other ridge lines. At an altitude of over 7,000 feet, the valley originally held a series of shallow lakes, some of which were freshwater, others saltwater, depending on the lake and on the season. Fishing craft had plied these waters from time immemorial, gliding among bulrushes, irises and reeds, attracted by a temperate climate in which the brilliant midday sun gave way to cool nights. Gatherers of worms and parasites, salt peddlers, and peasants had seen successive invaders pass through, political powers wax and wane. Fields of corn and patiently cultivated gardens on artificial islands produced abundant crops that fed the populous cities and towns.

Ancient cities still prospered along lakeshores dotted with green ash and oak. Their history could be traced back not only to the prestigious, legendary epoch of the Toltecs (A.D. 1000), but even farther to the mysterious inhabitants of Teotihuacán in the northeast part of the valley. The gigantic pyramids at Teotihuacán, dating from the dawn of the Christian era, still cast their long shadows.[7] Then, around 1325, while France and England were locked in the Hundred Years War, an obscure tribe took refuge on a swampy island. They were the descendants of a group that had entered the Valley of Mexico roughly one hundred years earlier. These men and women slowly abandoned their nomadic lifestyle for the benefits and constraints of a sedentary society.[8] Incorrectly called Aztecs today,

◁ 4. Commentary on the Apocalypse, Liebana Beatus Manuscript London, British Library, Add. MS 11695, fol. 86 b v.

As this richly illuminated romanesque manuscript from Catalonia illustrates, Mesoamerican manuscripts were not the only ones to feature polychrome imagery in a dense weave of symbols, emblems and polysemic signs. Medieval Europe not only used images for teaching purposes, but also endowed them with a significance derived from shapes, colors and metaphysical concepts—without, however, granting such images the sacred status of Byzantine icons. In Western Europe, as in Byzantium, written script —the Holy Scriptures—constituted the prime form of learned communication, and images were linked to text. In Mexico, however, pictographs were entirely self-sufficient.

they proudly referred to themselves as Mexica, and were part of the large family of Nahua tribes. Within one hundred years, the small Mexica settlement on the lake had become the powerful city of Mexico-Tenochtitlan. Around 1428—three years before Joan of Arc was burned at the stake—it entered into an alliance with two nearby cities, Texcoco and Tlacopan. This Triple Alliance progressively extended its control over the Mexico basin and the center of the *altiplano*, its victorious armies reaching the Gulf of Mexico around 1461.[9] Thirty years later, toward 1492, they had pushed as far as the Pacific Ocean, at Acapulco. No one realized at that point that another saga was just beginning back east, for late in 1492 Christopher Columbus had reached Cuba and Haiti.

At the time of the Spanish invasion, the city of Mexico-Tenochtitlan boasted a large population, probably upward of two hundred thousand inhabitants.[10] All war booty as well as the tribute regularly paid by people subject to the Triple Alliance was sent to Mexico-Tenochtitlan. Fleets of boats transported food and wood. Caravans of merchandise brought rare goods up from Guatemala and the Maya country after a difficult trek across hostile, uncharted lands. Tlatelolco, an island separated from Mexico-Tenochtitlan by nothing but a canal, was the site of an enormous market buzzing with thousands of voices welcoming the goods that arrived from the valley and the rest of the known world. Goldsmiths, featherworkers, and weavers did business with merchants who traded precious gems, cocoa beans and cotton grown in hot countries, as well as shiny copper hatchets, wrought gold (that "divine yellow excrement"), silver, amber and slaves.[11] The scent of spices mingled with fragrant racks of flowers, the acrid smoke of braziers, and the incense wafting down from the temples. For at the center of this great city on the lake—omphalos of the universe and pillar of the heavens—a vast ceremonial precinct harbored the main temples and schools.[12] Temple priests were responsible for organizing the religious celebrations that punctuated the flow of time. Sanctuaries splattered with the blood of human sacrifice were located right next to the college grounds where the offspring of nobles studied the complexities of Mexica knowledge at the same time that they subjected their bodies to constant punishment.[13]

A Universe of Images

Since these societies had no alphabetic writing, they resorted to the image in all its forms in order to express their identity and extol their power. Huge rites deployed thousands of celebrants, frescoes stretched across temple walls, and images were inscribed on deerhide, amatl or agave bark. These are what students studied in school; historians refer to them as codices, but sixteenth-century Spaniards rightly called them "paintings."[14] Such works contained entire domains

5. The Resurrection of the Dead
Pedro de la Vega, Flos Sanctorum, Saragossa, 1521

Illustrated books began appearing in Spain in the late fifteenth century, often published by printers from Northern Europe. The conquistadores and missionaries were able to carry these books and images across the Atlantic more easily than statues and paintings. Such engravings were thus the visual source for Indians developing European-style decorative techniques. Monochrome images, plus the use of hatching to suggest shading and volume, were as exotic to the Indians then as pre-Hispanic pictographic canons appear today. This resurrection scene was copied in stone in Mexico by native sculptors.

arm

mountain

parapet

lower body

diadem

path

feathers

tooth

of Mexican knowledge, but only a few rare examples survive, such as the *Codex Borgia*. They were painted by specialists known as *tlacuilos*, a Nahuatl term that meant both painter and scribe. *Tlacuilos* were probably recruited from the priestly and noble castes, and were trained in the schools.[15] At the time of the Spanish conquest, all major cities in the center of the country had their own painters (sometimes widely known for their erudition) as well as a storehouse of "paintings."[16] *Tlacuilos* were closely linked to the ruling class, for they not only mastered a sophisticated technique but also had access to knowledge of incalculable value—what they called "red ink, black ink."[17] This included the lore of myths, the content and meaning of rites, and the genealogies of princes and rulers.[18] Apparently *tlacuilos* were organized into teams headed by a master and aided by assistants, for this division of labor continued after the Spanish conquest.

The artists would draw and paint on a surface that often folded like an accordion. Once unfolded, the resulting strip was several yards long and could be read in various ways. Objects, characters and geometric shapes were deployed across the space in a stylized representation conforming to strict and precise canons that permitted unambiguous identification of concepts, people and things—monarchs, lords, finery, weapons, furniture, buildings. Highly distilled symbols were used for frequently recurring concepts such as mountain, stone, water, and speech (represented by a volute issuing from the mouth of the speaker). These were accompanied by signs indicating the names of places, people, or days. In fact, painters employed a repertoire of glyphs that could be broadly divided into three categories. Pictographs depicted objects, beings and actions in a stylized manner (animals, plants, buildings, dance scenes, etc.). Ideographs, on the other hand, conveyed qualities or categories associated with the object represented (an eye signifying vision, a footprint signifying travel, a royal banner indicating sovereignty, and so on). Finally, phonetic symbols, though few in number, were used to transcribe syllables indicating the names of places, people or chronological data. This phonetic system was still in an embryonic stage and functioned as a sort of rebus, suggesting sounds similar to the word to be expressed. For example,

> *cuetzalli* ("red quetzal feathers") +
> *tlantli* ("tooth")
> = place name for Cuetzalan [from **Cuetza**(lli) + **tlan**(tli)]

Such symbols did not therefore transpose speech, nor did they attempt to do so. Nor, for that matter, were they arranged in linear fashion like a European alphabet.[19]

In this respect, the Mexica had no writing system, in the strict sense of the term. Instead, image systems ordered symbols according to multiple criteria and patterns. A Dominican observer who had

long studied this source material summed up the strangeness of native expression (and the perplexity of Europeans) in the following way: "Paintings . . . are used as letters for writing down their histories and ancient lore by means of paintings and effigies." [20] Such paintings are two-dimensional, devoid of background. Page layout, the scale of symbols, the position they occupy in relation to one another, and the way they are grouped together are all elements that determine both the direction in which the codex is to be read and its ultimate meaning. In addition, the colors filling the spaces delineated by the thick, regular strokes of the *tlacuilos* constituted chromatic variations that influenced meaning. [21] This explains how the authors of codices could associate and combine two activities—painting and writing—which European culture considers radically distinct. [22] This is also why such "painting" must inevitably be read and deciphered on several levels. Topographic information appears inextricably linked with religious, historical, social and even economic details. Not surprisingly it is extremely difficult for non-natives to rediscover the eye's path across these colorful surfaces, to apprehend the dialectic of overall comprehension versus fragmentary analysis. It is therefore impossible to speak of writing in the usual sense of the term. It would seem that decoding the paintings originally required a two-fold operation: while the eye scanned the images, the reader uttered words inspired by oral tradition. Sound and image apparently complemented one another, without the one being a version of the other. Paintings were thus "made" to speak and, in turn, "paintings" reinforced and refreshed oral memory. [23]

This rapid overview should suffice to demonstrate how the lack of an alphabet, far from constituting a handicap, was largely offset by the multiple resources of an expressive idiom fundamentally rooted in images. The extensive fields of knowledge contained in the codices is proof of this. Both concrete and abstract ideas could be expressed in picture writing; highly subtle concepts often unfolded before uninitiated European eyes unable to grasp their depth and extreme sophistication. [24] "Paintings" could also convey chronologies, sequences of events, calendars, ritual celebrations, lists of merchandise and goods sent in tribute. Prophecies, in particular, abounded—there were "books of years and time," "days and ceremonies," "dreams and omens." [25] The profound reasons behind this strong attraction to divination, a marked feature of Mexican civilization, will be discussed later.

Yet is it truly possible to speak of "images" per se, as though ancient Mexicans shared European vocabulary and concepts? It seems that they considered images to be more than just a representation or figuration of things existing in another place, another time. Mexican images were designed to render certain aspects of the divine world physically present and palpable; they vaulted a barrier that European senses are normally unable to cross. The thrust of the brush and the

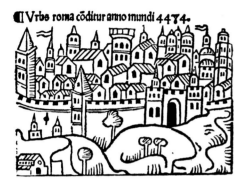

6. The City of Rome
Fasciculus temporum, Seville, 1480

This view of Rome is as stereotyped as any pre-Hispanic glyph, with snatches of landscape, ramparts, towers and houses completely unrelated to historical reality. It is an emblem of a city that enjoyed considerable influence as one of the metaphysical centers of the European universe. For a native Mexican artist confronted with such an image, the problem lay less with the cliché (whose verisimilitude mattered little) than with what it was supposed to evoke. Architecture represented another enigma, since Indians had to imagine the original buildings based on this stylized shorthand.

coupling of shapes and colors literally brought the universe of the gods to life on agave bark or deerhide. Which is why human blood was dripped onto these codices—to nourish the beings present in them. In this respect the techniques practiced by *tlacuilos* were more a path to divinity than a means of expression. Pre-Hispanic canons of selection and arrangement were designed to help grasp and extract the Essential. An image rendered "visible" the very essence of things because it was an extension of that essence.[26] This is why the religious instruction given to *tlacuilos* in the schools was an indispensable part of their artistic education. Spiritual accomplishment went hand in hand with technical mastery, as suggested by the duality of the Nahuatl term "red ink, black ink."[27]

Given their content and the mysterious force they were supposed to incarnate, it is easy to see why these "paintings" attracted the attention of Christian missionaries arriving on the heels of the Spanish conquistadores. Such images were too closely linked to pagan worship to escape the destructive energy of invaders who demolished temples and statues and masked diabolical frescoes with whitewash. In their quest to destroy everything that smacked of idolatry, conquistadores and missionaries indiscriminately burned all "paintings" beginning in 1520. By the latter half of the sixteenth century, a Dominican friar would lament such excesses, which hampered the work of historians of the day. "Ill-informed people thought they were idols . . . when in fact they were histories worthy of being saved instead of being consigned to oblivion."[28] Meanwhile, the *calmecac* schools where painters and priests studied had been closed.[29]

The Invasion of European Images

The destruction of the codices exactly coincided with the invasion of European images. In the course of their campaigns, Hernando Cortés and the conquistadores distributed countless pious images to the native Mexicans. Missionaries, administrators and colonists followed in their path, bringing to the new world illustrated books, prints, paintings and tapestries that confronted the conquered people with a new way of seeing and representing the world.[30] Unlike the Mexicans, the invaders—that is to say, the Europeans—assumed that text and image functioned on two autonomous, discrete levels. In addition to this unsettling innovation, European images possessed unfamiliar features. The natives were surprised and fascinated by the use of perspective—or even the simple suggestion of depth and the third dimension—as well as by shadings of color, the representation of landscape, and line engraving techniques.[31] The canons employed by the Indians were totally different, even if pre-Columbian civilizations were able, when they judged it appropriate, to achieve a representational realism that astonished the invaders.[32] European works also contained a host of decorative patterns—alongside illustrations and

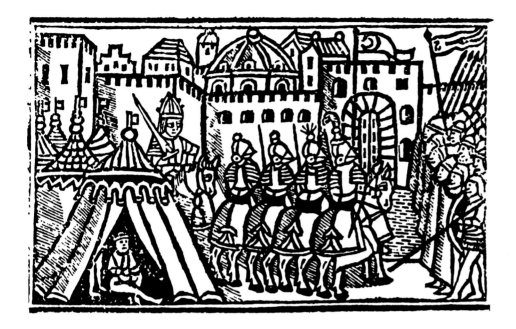

straightforward images—whose complex tracery fascinated Mexican artists. The frontispieces and margins of books, like the borders of prints, were full of grotesque ornamentation, branching forms, festoons and fantastic monsters that native Mexicans swiftly copied, even though such assimilation remained merely formal.[33] The slow process of aesthetic renewal as undertaken by Italian quattrocento art and European gothic art in returning to classical forms was obviously lost on the Mexicans. Aesthetic references to Greco-Roman antiquity[34] meant nothing to native society, which had no history of employing purely decorative forms to delight the eye; Mexican "paintings" had tirelessly developed a metaphysics of the world that was irreconcilable with virtuoso visual games designed uniquely to satisfy the senses. Thus, alongside military and religious conquest, the victors swamped Mexico with images employing a new iconographic and stylistic repertoire, constituting a store of models and techniques that competed with the art of the old *tlacuilos*. Mexican painters could hardly remain indifferent to these modes of expression linked to the power and prestige of the invaders. The question was how they would react to a revolution in communication involving the radical separation of word and image, given that Mexican tradition merged "painting" and speech into a harmonious, homogeneous whole.[35]

Their reaction was largely determined by the strategy adopted by the Catholic church. Missionaries were to teach native Mexicans to reproduce engravings, to copy illuminated manuscripts and paintings.[36] By the 1530s, itinerant teams of indigenous artists were contributing to the decoration of chapels, cloisters, and churches springing up all across Mexico (dubbed New Spain by Cortés).[37] But the missionaries did not merely promote religious imagery, display paintings and commission frescoes recounting biblical themes: they

7. Besieging a City in North Africa
Carta de la gran victoria y presa de Oran, Barcelona, 1509

This depiction of the siege of Oran was full of visual pitfalls for the native Mexica. They would have difficulty making sense of the crescent banner fluttering in the wind, the character with miter and sword (representing Cardinal Jimenez de Cisneros), and the armed knights who seem to be one with their mounts. And what meaning would Indians attach to the crusade against Islam? This modest engraving, though a long way from the complexity of the Codex Borgia and tending toward a certain realistic representation, includes many conventions, emblems and symbols that would baffle an Indian reader or copyist.

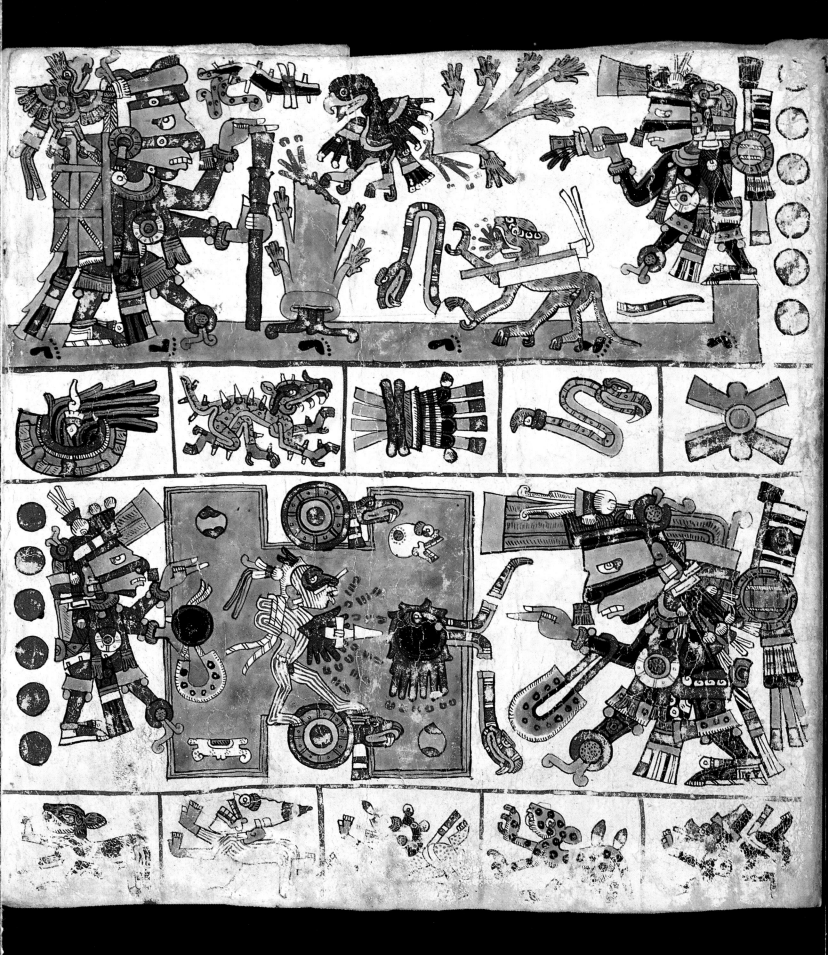

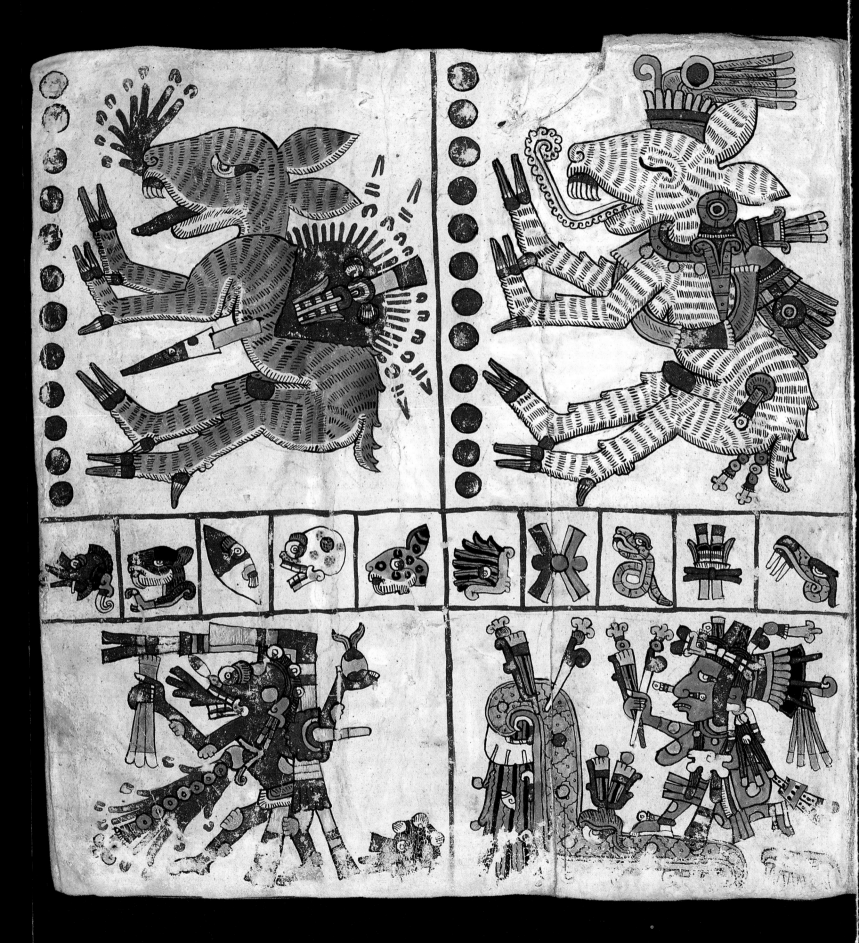

8. Ritual Calendar
from the Codex Borgia
Codex Borgia, pp. 19-22

This codex is one of the most magnificent pre-Hispanic manuscripts to have survived. It reveals the main canons governing traditional Mexican art. Its date and geographic origin are uncertain—it may originate from the Tlaxcala-Puebla area or from the northern Mixtec region. The Codex Borgia combines descriptions of major rites with the ritual calendar. The section on rites contains no less than six hundred characters (see, for example, "Night and the Gods of Rain," illus. 3).

This fragment from the ritual calendar is presented here in the form of a folding screen, like the ancient codices that were not paginated in the European manner but unfolded like an accordion before the eyes of priests and their disciples. As the gaze swept across an enormous thirty-foot screen, the eye would pick out information by following subtle paths completely independent of today's linear, left-to-right reading process.

The first three plates present an abridged version of the ritual calendar. Starting at the lower right of the two fold-out pages, the plates are to be read from right to left on the lower register, then in the opposite direction on the upper register.

Several deities appear in the lower register: Quetzalcoatl, the god of wind, is identifiable by his beak. He appears to be giving an order with a gesture of his right hand, while

The codex should be read
in the direction indicated above.

the left hand brandishes a bone pike, an agave needle and a sack of copal. Opposite Quetzalcoatl (separated by a sacrificial victim) is Tlahuizcalpantecutli, god of the planet Venus, kneeling on a platform adorned with two skulls. Flowing off this platform are a spring (at right) and a clutch of yellow, scorched grass, which together comprise the glyph for war (atl-tlachinolli). Between the two gods is a captive with arms bound and chest split open by an obsidian knife as blood spurts forth. Above the victim, a blood-red serpent, cut in sections, holds the cord of sacrifice decorated with heron feathers in his mouth.

The next scene shows Ixcuina and a naked water-maiden over a body of water; in the following scene, a black Tezcatlipoca and a red Tezcatlipoca play pelota on the H-shaped court.

On the upper register, reading from left to right, the first scene shows a red Tezcatlipoca (representing a merchant) being attacked by a black Tezcatlipoca (representing a thief). Next, Tlaloc is depicted in a field of corn, and in the last scene Tlahuizcalpantecutli, in the form of woodcutter, chops down a tree.

The last plate on the far left marks a change in direction from left to right, starting at the top. This plate also contains an abridged ritual calendar in the upper register, illustrated with two deer—one pierced by a spear and the other already dead (in white). The lower register shows two days of the twenty-day month with corresponding rites.

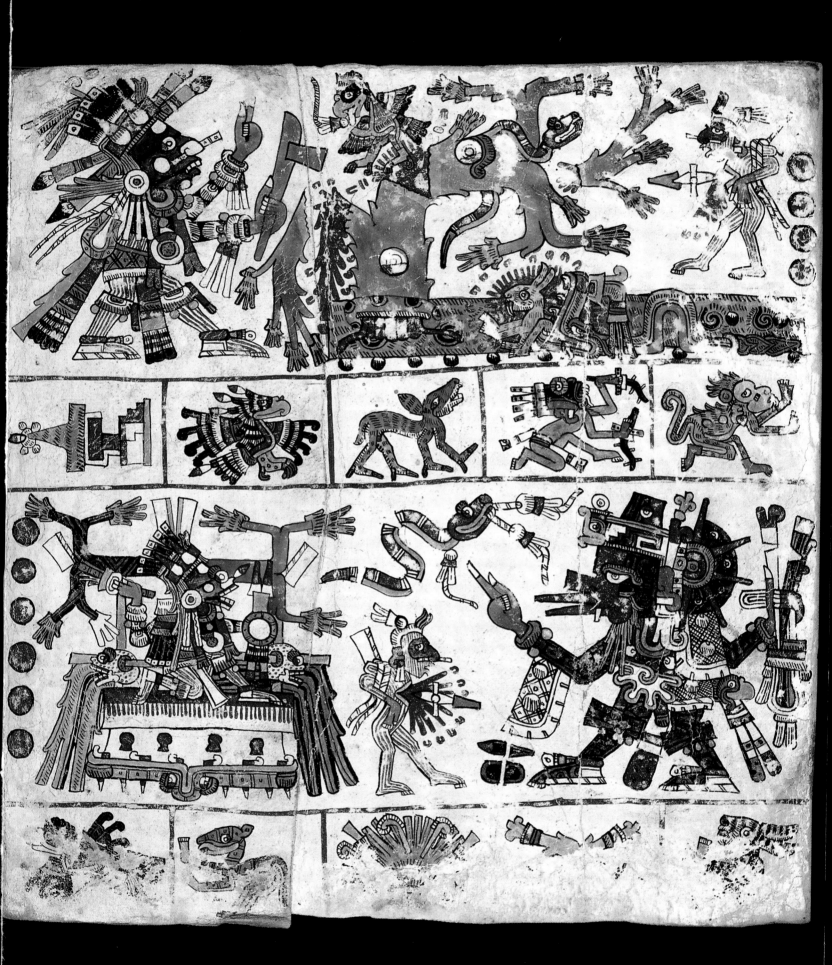

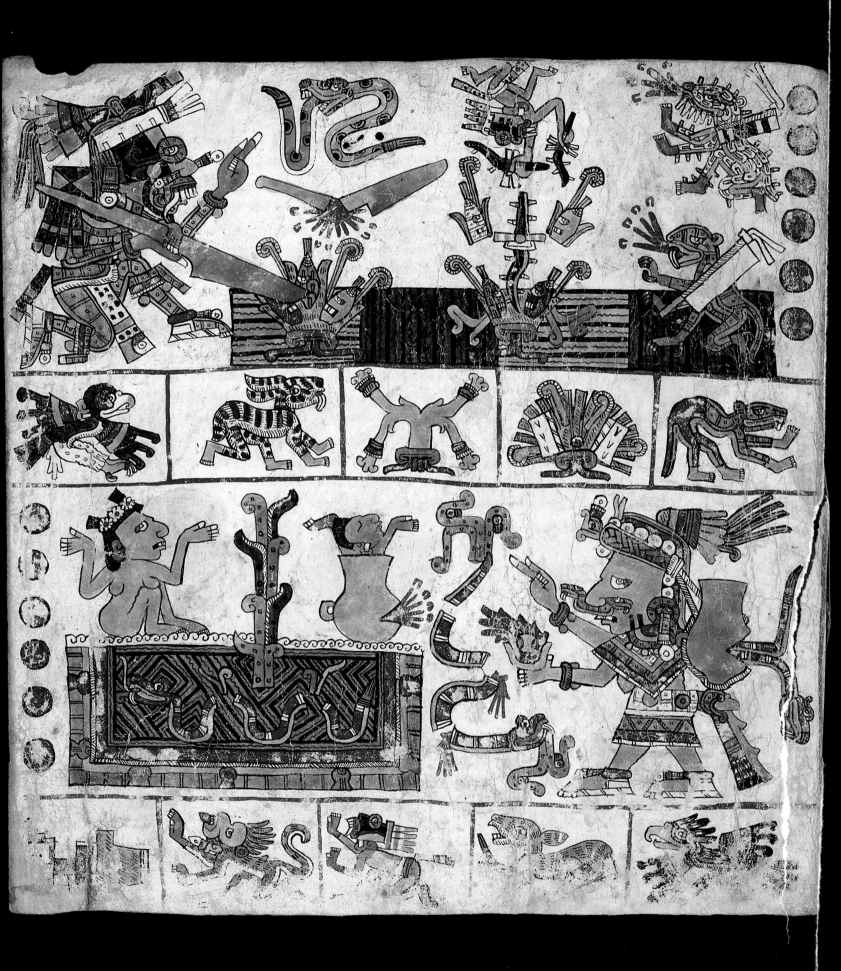

swiftly realized that they needed to fathom the indigenous world in order to master it. The thoughtless and hasty destruction of local "paintings" had worked against their own interests.[38] The evangelists began questioning pagan priests and studying pictographic codices containing information on this irrecoverable past, to acquire exact knowledge of the gods, religious customs and practices that they intended to refute and purge from memory.[39] As good humanists, however, they were also careful to save what seemed right and good to them, just as masterpieces from pagan Rome and Greece had been admired and collected by Renaissance Europeans.[40] Mexican "painting"—writing that was not really writing—simultaneously attracted and disconcerted missionaries brought up in a civilization in which writing had assumed a primordial role for centuries, reinforced in recent decades by printing. They therefore sought out the services of *tlacuilo* painters, asking them to bring their codices, comment on the images, explain shapes and symbols—in short, to reproduce everything the Indians felt was significant.[41]

The *tlacuilos* were thus obliged to adapt to the colonial situation and to the conquerors' demands. They could either pursue former pre-Hispanic traditions on their own, running the risks that went with producing and harboring idolatrous imagery, or they could collaborate—to a certain extent—with the priests' investigations. They might, for instance, censure whatever their respect for tradition (or their guilty conscience as Christian novices) prevented them from revealing to the missionaries. Whatever the case, the new styles, techniques and means of expression that they were induced to adopt broke with centuries of artistic learning and creativity.

Tragi Comedia de Calisto y me
libea Enla qual se contie·
ne de mas d su agradable
et dulçe estilo muchas sctēcias filosofa·
les z auisos muy necessarios para man·
cebos mostrando les los engaños que
estan en cerrados en seruientes z alca
buetas z nueuamente añadido el tratta
do de Centurio.

CARLE S. AMOROS

9. A Street Scene in Spain
Tragicomedia de Calisto y Melibea,
Barcelona, 1525

*Here it is less the unfamiliar urban architec-
ture and clothing—which the Indians could
see in Mexico City—than the language of
gestures that might have disconcerted native
viewers. Using specific hand gestures to
express sociability, sentiments or flirtatious-
ness was completely alien to Indian represen-
tational practice. The Spanish in Mexico,
of course, encountered the same obstacle in
the opposite direction.*

I. The clash of cultures

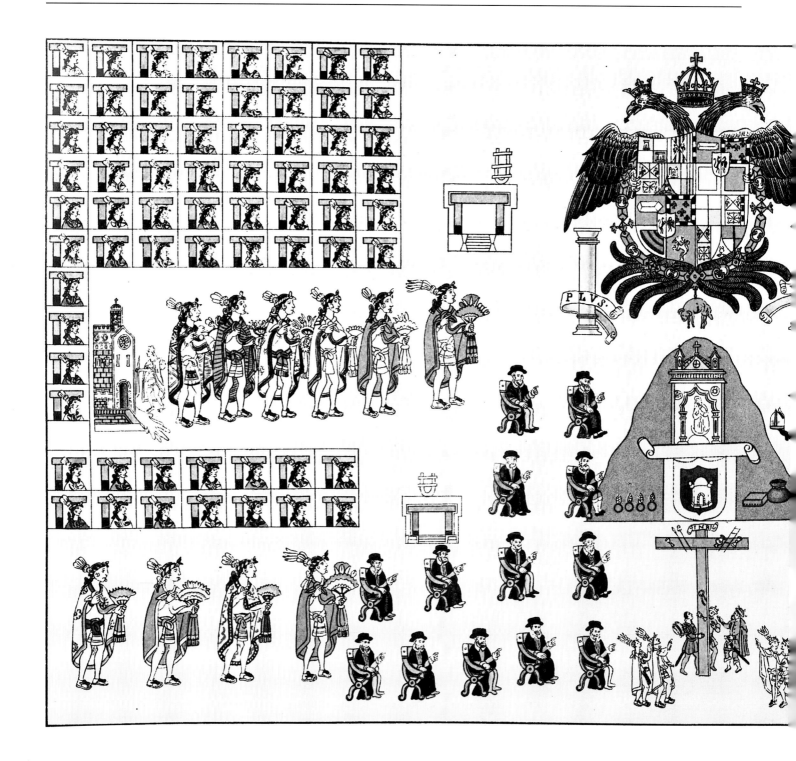

◁ 10. The Spanish Arrive at the
Outskirts of Tlaxcala
Codex Durán, Chap. LXXIII

*The Spanish are greeted by Tlaxcalan envoys.
On the far right is the glyph for Tlaxcala
(two arms above a mountain) and to the left
is a black member of the Spanish expedition.*

Sixteenth-century Indian society was absorbed into a colonial culture
based on the right of conquest. The stinging memory of the Spanish
invasion and the tragic fall of Mexico-Tenochtitlan would long remain
etched in the collective mind. Spanish and Mexican descriptions
reveal the extent of the disaster and the bitter taste of death that it
imparted. Yet the horror was perhaps most intensely transmitted
from generation to generation by Indian songs:

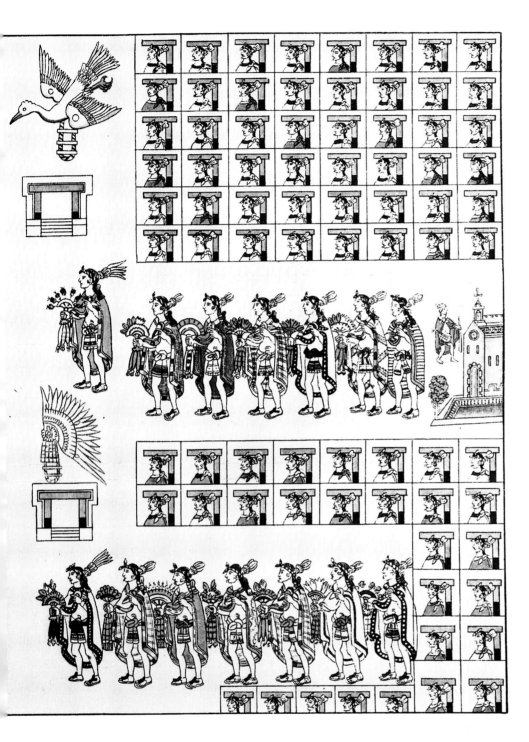

11. The Four Princely Houses of
Tlaxcala and the Spanish Crown
Lienzo de Tlaxcala, Pl. 1

This scene, which opens the Lienzo de
Tlaxcala, *recalls the big, pre-Hispanic
processions, but the society it shows is
divided into two camps: the Spanish in the
center and the Tlaxcalans to the side. The
alternation between traditional and European
styles corresponds to the subject represented.
European techniques are used for the coat of
arms, the representatives of the crown (below
the imperial columns, to either side of the
mountain, are Hernando Cortés and Bishop
Ramírez de Fuenleal, president of the second
audience and identifiable by the miter at his
feet) and the setting up of the cross. The
four princely houses ruling the city-state
of Tlaxcala, however, are shown in a two-
dimensional manner, from the front or in profile,
stemming from pre-Hispanic practice. The eagle
in flight, seen in the upper register, is the emblem
of the house of Mexicatzin. On the extreme left
and right are churches built by Franciscan friars,
which the painter has also rendered in two
dimensions.*

"Where are we headed, friends? Thus 'twas really true.
They were already abandoning the city of Mexico,
the smoke was rising, the mist was thickening . . .
Weep, my friends!
Know that by these events we have lost the Mexican nation.
Water has become brackish, brackish is our food.
This is what the Dispenser of Life at Tlatelolco has done . . .

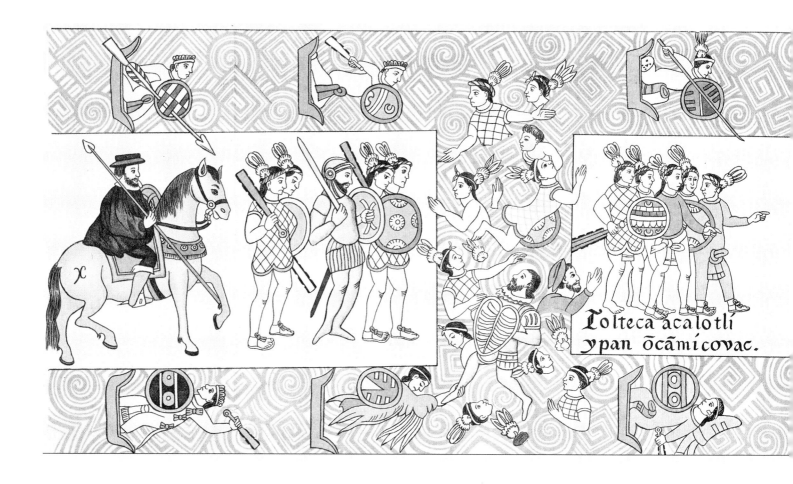

12. The Rout of La Noche Triste
(June 30, 1520)
Lienzo de Tlaxcala, Pl. 18 and 18a

When Mexico City rose up against the invaders, the Spanish were obliged to abandon the town. During this dramatic flight, the conquistadores retreated along the causeway crossing the lake, under heavy attack from the Mexica. While the lake and the boats of Mexican attackers are depicted in traditional fashion, the Spanish are shown according to European stereotypes probably copied from engravings. The juxtaposition of scenes does not give a panoramic, simultaneous view of things, but follows a succession of events. To the left, Cortés exits with his Tlaxcalan advance guard, while on the right, the Spanish troops fight a rear-guard action.

The paths are strewn with broken arrows, hair is undone,
houses have lost their roofs, their walls have reddened.
Worms wriggle over streets and squares
whose walls are splattered with brains.
Red are the waters, as if they had been dyed
so that when we drink, it tastes of saltpeter . . ." [42]

Getting Used to the Inconceivable: Conquest

The events that led to the destruction of Mexico City and the occupation of the entire country in fact unfolded over a period of slightly more than two years. Following reconnaissance missions conducted in 1517 and 1518, a fleet commanded by Cortés left Cuba in 1519. It reached the island of Cozumel, off the northeast coast of the Yucatán peninsula, then sailed along the Tabasco coast, arriving in April at the site that would become Veracruz. After spending several months on the tropical coast, the conquistadores decided to drive inland, and began marching toward the mountains ringing the *altiplano*. In November 1519, they reached Mexico-Tenochtitlan, a

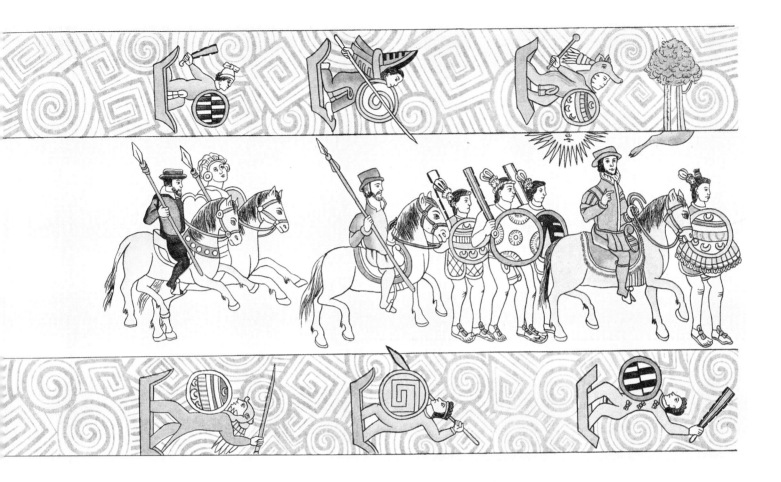

city that provoked surprise and amazement among Cortés and his men. The invaders spent several months in the capital city of the Mexica as curious and admiring guests who were nevertheless vaguely troubled by the throngs of natives all around them. To insure their own safety, Cortés had taken Moctezuma hostage. However, on learning that a rival Spanish force had landed, Cortés decided to leave the capital to meet his rivals. He left his second-in-command, Alvarado, in charge of Mexico-Tenochtitlan. As a preventive measure, Alvarado took the initiative of massacring a large number of the nobility that had gathered for a religious festival. This outrage sparked rebellion among the Mexica. Cortés, who had returned to the capital, was unable to reverse the situation and the Spanish were obliged to flee the city in a disastrous retreat now known in history books as *La Noche Triste* (Night of Sorrow). The harassed Spaniards took refuge in Tlaxcala, where they regrouped with their Tlaxcalan allies. The first outbreaks of smallpox were already weakening the Mexica. Cortés's native allies were determined to bring the Triple Alliance to an end; they were convinced that, once laden with booty, the Spanish would leave. Mexico-Tenochtitlan was therefore soon under siege. After merciless combat, the city fell to the allied troops on August

13, 1521. As described above, the city had become a charnel-house amid the dirty, stinking waters of the lake. In subsequent years, expeditions were dispatched to the northeast and southeast to conquer the countryside. Mixtec and Zapotec lands were subjugated, as were Guatemala and Honduras. The Tarasco empire to the northwest was invaded and conquered at the end of the 1520s.

Such are the broad outlines of the conquest. That, at least, is how the conquistadores viewed it, experiencing it sometimes as a chivalric romance but more often under extremely difficult conditions, gripped by the fear of winding up under the Indians' sacrificial knife and ultimately "in their bellies." The right of conquest legitimized Spanish rule; the new status quo placed the country under the suzerainty of Holy Roman Emperor Charles V, the inhabitants falling under the direct authority of those who had conquered them.[43]

The Tlaxcalan Version: A Prestigious Collaboration (1550-1556)

Native Mexicans, however, did not constitute a united block against the Spanish. Some Indian cities sided with Cortés, who took pains to present his expedition as a war of liberation. Their view of the conquest therefore entailed a victory to which they had enthusiastically contributed. These fissures in Indian society explain the swiftness of the Spanish victory, and they are reflected in the diverging written and visual accounts left by sixteenth-century natives. Tlaxcala was one of the first cities to ally itself with the Spanish. For generations, Tlaxcalan territory had been surrounded by vassals of Mexico-Tenochtitlan who barred access to the sea and prevented Tlaxcala from acquiring indispensable foodstuffs such as salt. The Tlaxcalans were swift to see the attraction of Spanish troops apparently capable of bringing the Triple Alliance to its knees. Tlaxcalan auxiliaries accompanied the Spanish in their march on Mexico-Tenochtitlan, and it was to Tlaxcala that the conquistadores retreated after the disaster of *La Noche Triste*. Finally, Tlaxcalan soldiers made up the bulk of the forces employed in the siege of Mexico-Tenochtitlan. Tlaxcalan rulers maintained close links with the conquistadores and their constant support was rewarded by Charles V, who accorded favorable treatment to Tlaxcala. Local leaders retained extensive control over the city of Tlaxcala and its territories, and the Spanish remained aloof. But this preferential treatment, so different from the subjugation suffered by other groups, was based on grateful memory of Tlaxcalan aid rather than on any formal agreements. Tlaxcalans had to bring up this glorious past to defend their privileges each time greedy Spanish colonists wanted to move into the territory to raise their flocks on land cultivated by Tlaxcalans. Starting in the 1550s, Tlaxcalan leaders redoubled their efforts to protect their rights as Spanish demands and incursions became more insistent. The

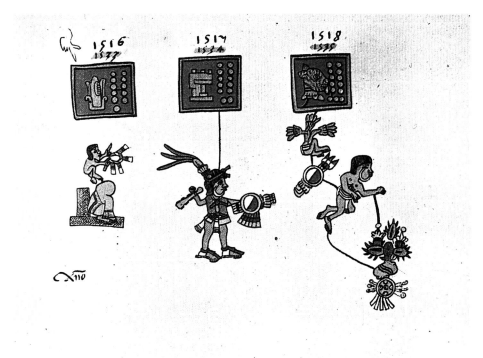

13-14. The Spanish Appear
on the Scene
Codex Tellerianus-Remensis, Part IV,
Pl. 28, and Codex Vaticanus Latinus,
3738, Pl. 134

*The three years preceding the crisis—1516,
1517, and 1518 (expressed as glyphs)—are
shown with an event marking each year: the
death of the ruler of Texcoco, the war
against Tlaxcala, and the death of a famous
Tlaxcalan warrior who was sacrificed. Usu-
ally the painter used a single line to connect
the glyph for the year to the event. In the
Codex Vaticanus Latinus, which belongs
to the same family of manuscripts, the years
1521-1522 depict the Spanish conquest.
The sword-wielding Cortés, on horseback,
confronts a Mexican warrior with three battle
standards. Above are the number of Spanish
killed (the bearded, naked European is clearly
recognizable). Behind the warrior the artist
has painted the last monarch of Mexico-
Tenochtitlan, seated and topped by a falling
eagle (the glyph for Cuauhtémoc, literally
"falling eagle"). By crowding the surface
with shapes and information, pre-Hispanic
methods and conventions manage to convey
the chaos, warfare and death sown by the
Spanish invasion. Despite their freshness,
such images were in fact painted at least
forty years after the conquest.*

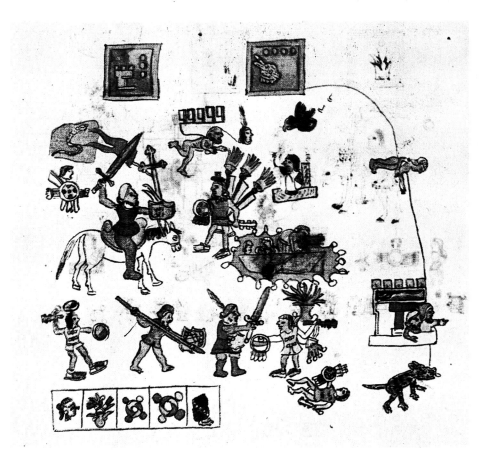

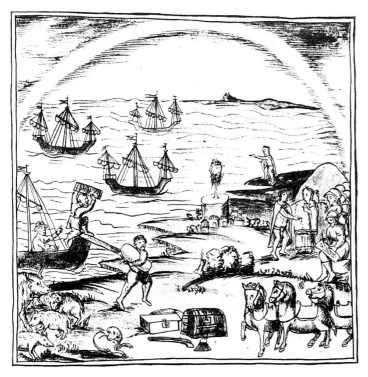

15. The Spanish Land on the Coast of Mexico
Florentine Codex, Vol. III, fol. 406 r.

This scene shows the Spanish unloading their ships near present-day Veracruz in April 1519. This was the third Spanish expedition to Mexico. Led by Cortés, its members overthrew the Mexica and subjugated the entire country.

The smoking volcano is a transposition of the glyph for Popocatépetl ("smoking mountain") into a landscape setting. The volutes issuing from the mouths of figures are a traditional sign indicating speech. A strong European influence, on the other hand, can be seen in the natural settings and the effect of depth; the sense of background and foreground lends impact to the invaders' arrival.

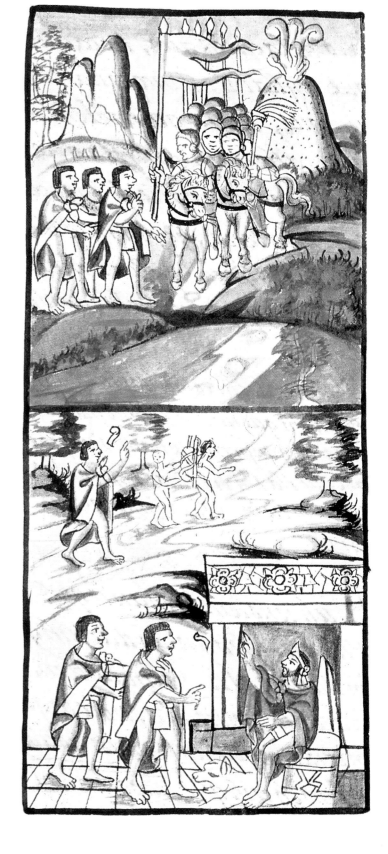

16. The Spanish Enter the Valley of Mexico (November 1519)
Florentine Codex, Vol. III, fol. 425 r.

Moctezuma's envoys met the Spanish at the foot of Popocatépetl and Ixtaccíhuatl, the two volcanoes dominating the Valley of Mexico. The envoys offered gold to the invaders, who "seized the precious metal as though they were monkeys . . . they lusted after gold like famished pigs." Below, Moctezuma's ambassadors encounter a drunkard who predicts the fall of Mexico-Tenochtitlan; they repeated the prediction to the monarch.

17. The Death of Moctezuma (June 1520)
Florentine Codex, Vol. III, fol. 447 v.

"And when four days had passed since all the chieftains had been hurled from the pyramid, the Spaniards cast forth the bodies of Moctezuma and Izcuauhtzin, who had died, at the water's edge at a place called Teoayoc. For here was a carved stone image of a tortoise. . . . When they were seen and recognized as being Moctezuma and Izcuauhtzin, then they took up Moctezuma in their arms and carried him to a place called Copulco. Thereupon they laid him on a pyre and then

kindled and set fire to it."
Two artists drew and painted these scenes. Comparison of the way the bodies and clothing are rendered show that the second painter was better at mastering European canons. An anachronism in dress (one of the Spaniards is wearing clothing from the reign of Philip II, 1555-1598) underscores the time lag separating these artists from the conquest.

18. Encircling Mexico-Tenochtitlan (December 1520)
Florentine Codex, Vol. III, fol. 461 r.

"And after this, then the Spaniards came; they marched from Texcoco. By way of Quauhtitlan they set out, and quartered themselves at Tlacopan. There then the task was divided; their routes

were there separated.... The chieftains came pursuing them... then the Spaniards turned back. The chieftains, who fought valiantly by boat, the warboatmen, shot darts at them. Their darts rained upon the Spaniards. ...[But Cortés] thereupon threw himself upon those of Tenochtitlan; he proceeded along the Acachinanco road."

This episode recounts how Mexico-Tenochtitlan was encircled and besieged. Stylizing the setting, the painters simply represented the causeways over the lake and the glyph for Mexico-Tenochtitlan against which the Spanish and their allies directed their attacks. The stone (tetl) topped by a nopal cactus (nochtli) yielded the glyph Te-nochti-tlan. This place-name is an efficient and economical way to indicate the location of the city of Mexica, and coincidentally recalls the emblems used in medieval and Renaissance theater in Europe.

19-20. Cortés's Brigs
(May-June 1521)
Florentine Codex, Vol. III, fol. 462 r. and v.

"And when their twelve boats had come from Texcoco, all of them were brought together there at Acachinanco... whereupon the Spaniards proceeded to find out where the boats could enter— where the canals were straight, or deep, or not deep.... Two boats they brought in there... and once for all they resolved and determined to do away completely with the Mexica. When they had so decided, then they placed themselves in order. They carried guns; in the lead they went bearing the large cotton banner."
From the very first encounter on the Gulf of Mexico, the conquistadores' ships had astounded the Indians. But Cortés went one better by building a fleet that gave him control of the lake surrounding Mexico-Tenochtit-

lan. This tactic, along with the cleverness of the Spanish, made a lasting impact on the Indians. The cannon-charged ships spread panic among the population, who watched as these strange engines of war sailed right up to their houses.

21. Attacking the City
(May-June 1521)
Florentine Codex, Vol. III, fol. 463 r.

"And when the Spaniards came to reach Xoloco, where there was a wall which cut across, shutting off the road, they fired at it with the big guns. As the first charge fell, it did not crumble; but at the second, it collapsed; at the third, finally it quite went to the ground; and at the fourth, at last the wall fell completely leveled. And the two boats moved in to meet those in the warboats. There was fighting in the water. And the guns occupied the entire prows of the boats. And there where the [Mexican] boats lay thick, where they lay close together, there, upon them, they fired. Many men died thereby.... But when the Mexica could behold and determine where the gun shots and bolts would strike, no longer did they follow a direct course. Only from side to side would they veer; only sideways, at a slant, they traveled. And when those on land also already saw that now the big gun was to fire, they all fell to the ground; all stretched out on the ground, and lay flat."
The painters were able to render most of these details (Indians lying on the ground, protected by their shields) as well as the desperately fleeing women and children who piled into boats as the Spanish advanced. The Mexica, who seemed able to find ways to counter European weapons, nearly turned the tide in their own favor several times.

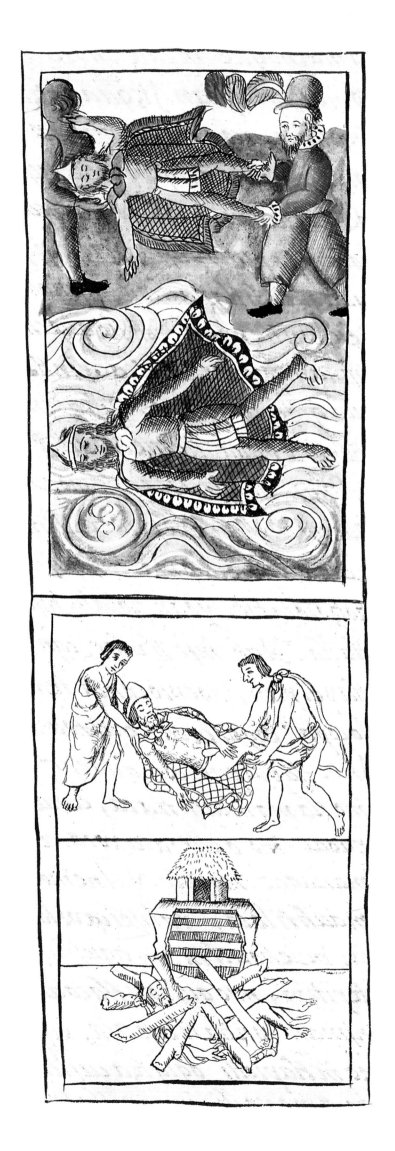

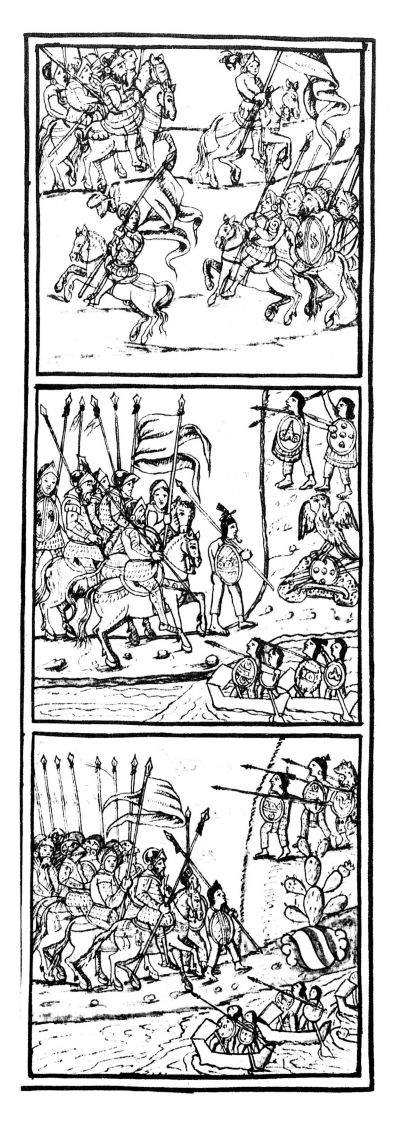

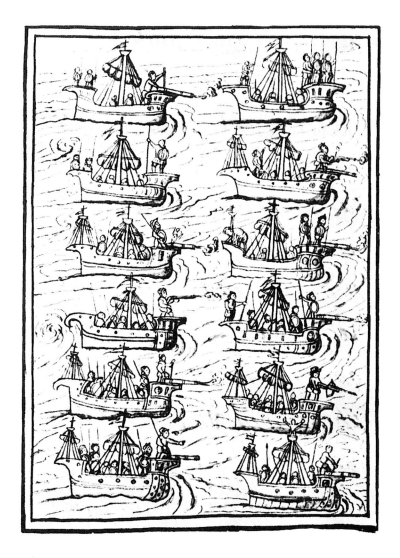

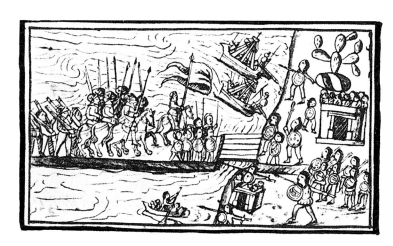

22. Fighting in Mexico-
Tenochtitlan
(July-August 1521)
Florentine Codex,
Vol. III, fol. 465 r.

"And after the canals had been filled, then came the horse[men], perhaps ten of them. They rode in a circle; they came wheeling about, twisting and circling. Once again horse[men] came, following after the others. And a number of Tlatelolcans who had quickly entered the palace which had been the home of Moctezuma then emerged in terror, and came up against the horse[men]. One of them lanced a Tlatelolcan. And though he had speared him,

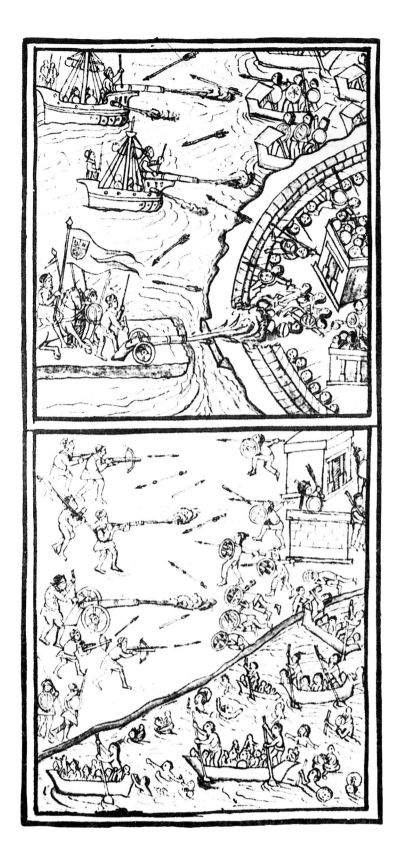

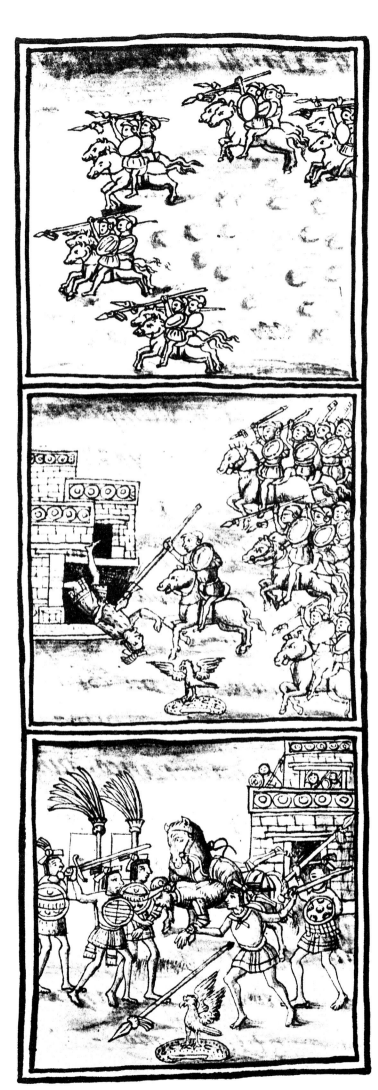

yet he took hold firmly of the iron lance. Then his companions went up to tear it from the rider's hands, threw him down upon his back, and upset him. And when he had fallen tumbled to the earth, they hit him repeatedly, they struck him on the back of the head, he died there."

These are among the most action-packed scenes in the Florentine Codex—*the thrust of the Spanish attack is conveyed with outstanding brio, particularly through the galloping cavalry and the violent sea assault. The rendering of the Tenochtitlan residence elegantly and effectively combines the glyph for house (a T-shape) with frontal representation.*

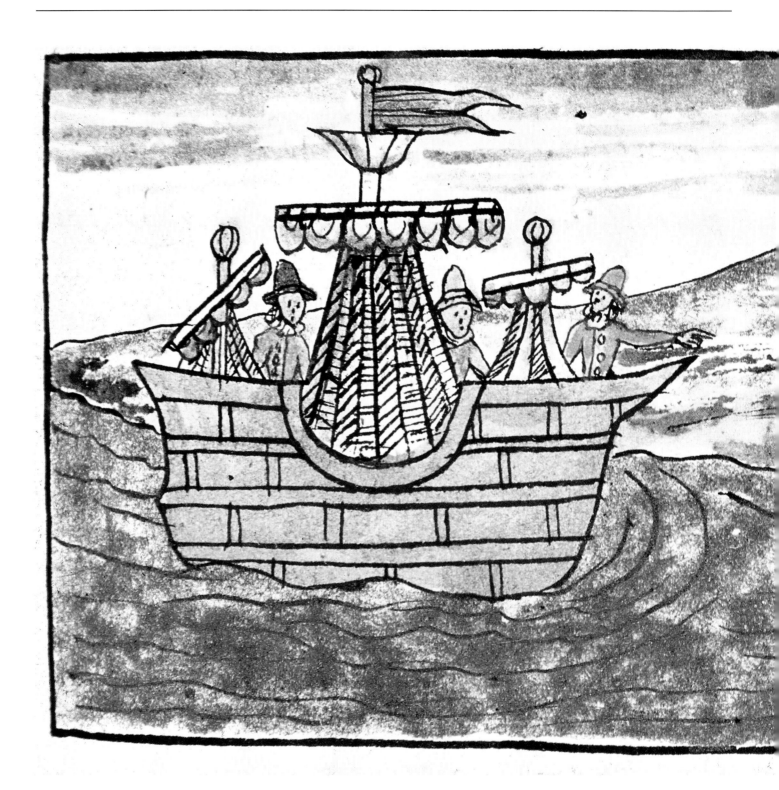

23. Spanish Ship off the Coast of
Mexico (1517)
Codex Durán, Chap. LXIX

Moctezuma's scout, perched in a tree, observes the strange vessel for the first time, while a Spaniard fishes from a small boat. "There was a terrible thing in the bay, it was big and round, in the middle of the water, and went back and forth on the waves." The picturesque details and their realistic treatment are more suggestive of Flemish painting than of the stereotyped pre-Hispanic codices, and are worth comparing to those in the Florentine Codex *(illus. 15).*

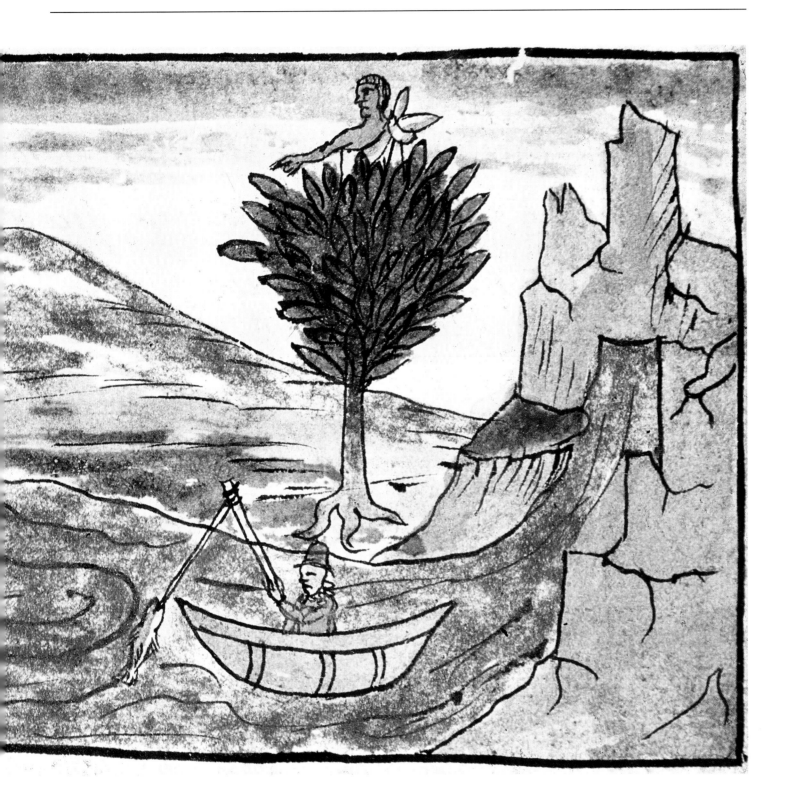

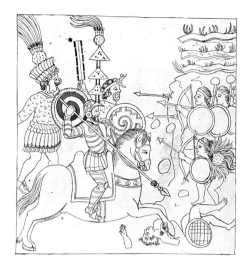

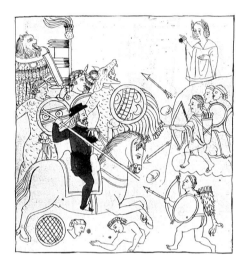

24-25. Episodes from the Conquest
of Mexico
Descripción de Tlaxcala, fol. 282
r. and v.

*These plates, which stem from the same
pictographic tradition as the* Lienzo de
Tlaxcala, *systematically show combatants
in stereotyped scenes and poses. The Spanish
conquistadores and allies are always on the
left, while their adversaries are on the right,
seen on a mountain usually combined with
an animal, vegetal or human motif (here, a
woman) to indicate a place-name glyph and
thereby identify the field of battle or region
invaded.*

Tlaxcalan nobility had become sufficiently Hispanicized to be aware of its position in a colonial universe and to apply all possible pressure on the crown in order to win its case.

As in the past, many native Mexicans felt that images constituted the best proof; they could therefore best defend their claims by painting glorious episodes of the conquest in which they had taken such an active part. This was apparently the goal behind the production by local artists, between 1550 and 1556, of the gigantic *Lienzo de Tlaxcala*. Undertaken at the request of Luis de Velasco, viceroy of Mexico, and on the initiative of the city of Tlaxcala, this work unfolds across a piece of cotton over seven meters long and two-and-a-half meters high. It recounts the Spanish conquest in eighty-seven tableaux.[44] The opening scene offers a magnificent representation of the role adopted by Tlaxcalans within colonial society: the double-headed Hapsburg eagle dominates the center of the tableau, above the city's coat of arms and its pre-Hispanic symbol. To either side can be seen the Spanish authorities who successively governed New Spain, while the four corners are occupied —practically invaded, in fact—by the four princely houses of Tlaxcala. Tlaxcalan lords claimed to answer directly to Charles V, without intermediary, as demonstrated by the deliberate absence of any reference to European colonists. The *Lienzo* then depicts scenes from the military conquest, carefully omitting anything that might suggest or evoke potential conflict with the Spanish. Throughout these campaigns, the Tlaxcalans are constantly represented as loyal allies— and soon after, good Christians—although their reactions were in fact more ambivalent than these single-minded images would suggest.

Such images produced between 1550 and 1560 (i.e., nearly forty years after the event they relate) reappear in other late sixteenth-century Tlaxcalan documents, notably the *Descripción de Tlaxcala* written by Diego Muñoz Camargo, a mestizo.[45] This manuscript contains invaluable scenes describing the conversion of Indians to Christianity, recounted through a series of episodes displaying the brutality of the early campaigns conducted by the Franciscans. Native priests were persecuted, idols burned, recalcitrants executed—the missionaries wanted to sweep everything away, creating completely "new men" whatever the cost.

Yet these images also represent the establishment of a new pictographic tradition, or at least the crystallization of a visual record to which the Tlaxcalans referred each time they wanted to reaffirm the rights stemming from their early collaboration. Images produced under colonial rule thus acted as guarantee, becoming the authentic expression of an identity to be staunchly defined and defended; at the same time, they constituted a hybrid type of representation combining both ancestral tradition and European style.

The Versions of the Vanquished

The Tlaxcalans were interested in stressing their uniqueness precisely because they enjoyed a special, minority status in sixteenth-century Mexico. Their version of events thus differed from those of the defeated peoples, that is to say the Mexica and other tribes loyal to them. These other views have been preserved in several priceless documents. The most magnificent is probably the *Florentine Codex*, written and painted at the end of the 1570s under the supervision of a Franciscan friar, Bernardino de Sahagún. One of the books of this codex is completely devoted to the story of the conquest,[46] and contains a Nahuatl text which, rather than conveying the native Mexican view of the conquest the day after the event, shows how it was recalled within educated circles three decades later.[47] This distinction is important, but the account is nevertheless remarkable because it expresses native sensibility, revealing the other side of the coin—the side of victims reeling from the catastrophe that befell their universe.[48]

The authors of this account report that even before the arrival of the Spaniards, eight omens had forewarned of dire events.[49] When it was announced that foreign vessels resembling floating mountains had arrived, Moctezuma, lord of Mexico-Tenochtitlan, sent envoys to the coast like those merchants who, under the pretext of trade, went to explore and spy on distant lands. Presents were exchanged with the Spanish, and Moctezuma's envoys believed that the god Quetzalcoatl, the "Feathered Serpent," had returned. Convinced that Cortés was the notorious deity, Moctezuma sent him the sacred regalia kept in the god's sanctuary. The news that came back from the gulf plunged Moctezuma into stupefaction, dejection and anguish, for the descriptions he received astonished him: dogs with yellow eyes, cannons that gave off stinking smoke and destroyed mountains, sweet food eaten by the strangers, horses like stags. Here the dramatic pace set by the authors of the *Florentine Codex* increases in intensity. From this point on, the monarch hesitated on the path to follow. Were the invaders really "gods from heaven" and the Blacks "foul forces?" He offered them nourishment spattered with human blood, food for the gods that the revolted Spaniards rejected in favor of corn tamales, eggs, fowl, and the colorful red and orange fruit. Wizards and sorcerers instructed to put the strangers to the test and block their advance failed in their mission. Moctezuma seemed resigned to welcoming the Spaniards. The redundant style of the Mexican text wonderfully evokes the ineluctable advance of the conquerors: "And then they left their ship; finally they were coming, henceforth they would undertake their march toward us; already they were underway, already they were on the path. . . ."

Then Moctezuma and his city were engulfed by panic, lamenting and weeping. In the midst of this terror, the monarch tried to flee to

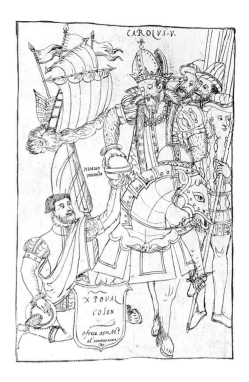

26. Christopher Columbus
and Charles V
Descripción de Tlaxcala, fol. 249 r.

History was boldly condensed in order to show the discoverer of America handing a globe (symbolizing the New World) to the emperor who reigned over the conquest of Mexico and Peru, for Columbus died in 1506 and Charles V did not mount the Spanish throne until 1516. Here the native Tlaxcalan artist purely and simply copied a European engraving, as though he had decided to adopt a completely Europeanized vision of the conquest of America.

27. The Massacre
of the Mexican Nobility
(May 23, 1520)
Codex Durán, Chap. LXXV

This episode preceded the disaster of La Noche Triste (June 1520). Pedro de Alvarado, one of Cortés's captains, massacred Indian nobles who had been dancing during a religious celebration. In the center are the suddenly silenced drums. The human figures are deployed across a two-dimensional space that shows everything that transpired on the esplanade below the temple. The use of this traditional formula provides a perfect visual rendering of the trap sprung on the Indians.

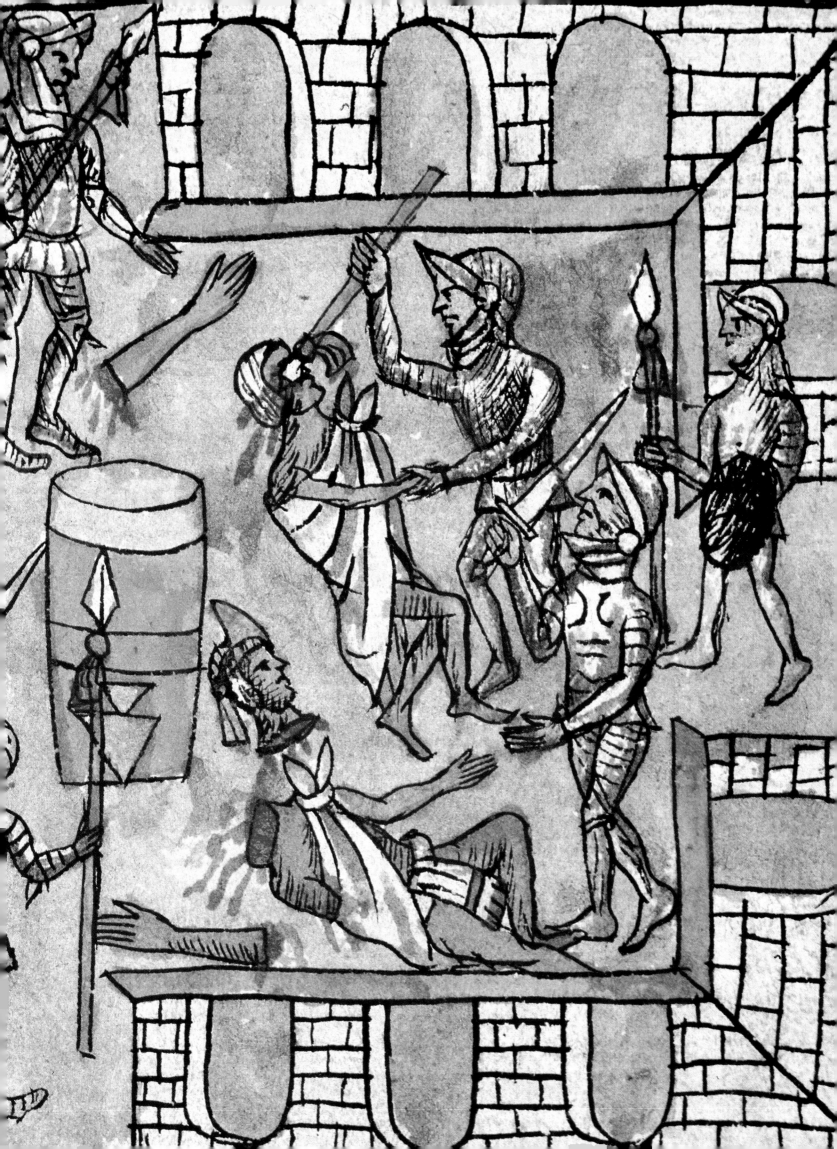

28. The Arrival of the Franciscans in 1524 and the Launching of the Religious Conquest
Descripción de Tlaxcala, fol. 239 v.

The rapid military conquest was followed by a drawn-out religious conquest that began with a handful of Franciscan monks. It was in 1524 that twelve Spanish friars (like the twelve apostles) landed and began erecting the crosses that were supposed to put demons to flight (here bedecked with the features of Mexican idols).

avoid confronting the "deities" (Spaniards) who wanted to meet him face to face, yet upon whom no human being was supposed to gaze. But Moctezuma's courtiers prevented him from fleeing. The thread of the tale unwinds as relentlessly as a Greek tragedy. Fascinated by the valiant invaders, the residents of Tlaxcala, longtime enemies of the Mexica, allied themselves with Cortés and the "deities": Moctezuma was obliged to welcome the Spaniards into his city. He greeted Cortés with these words: "Lord, you are weary, you have gone to much trouble. Now you have arrived in the country. You have arrived at your city—Mexico. Here you have come to sit on your throne. For a short while, those who have already departed, your substitutes, saved it for you, kept it for you."

Cortés replied in a "strange language, a barbaric language" (Castilian), assuring Moctezuma that he had nothing to fear. "And the Spaniards took Moctezuma by the hand [sic] and slapped him on the back to show their affection." [50] Following these unwittingly sacrilegious gestures, the invaders seized Moctezuma bodily and fired

29. Burning the Idols
Descripción de Tlaxcala, fol. 242 r.

The Spanish were determined to destroy all idols, the images of "false gods" worshipped by the native Mexica. Although in the preceding plate the Indian painter adopted a Christian interpretation (idols depicted as European demons), here a native view of the deities emerges. They have lost their devilish claws and horns and are represented as a combination of divine emblems and attributes.

cannon to sow terror among the Mexica. "Everything happened as though everyone had eaten hallucinogenic mushrooms, as if they had seen something frightful." This is followed by an image of conquistadores in search of gold, seizing sacred objects to melt them down into gold bars. The pen recording this account betrays the palpable contempt of the Indian elite toward these ruffians "in the thrall of covetousness" who destroyed works of art, finely worked shields, rare fabrics made of quetzal feathers, and golden disks. A similar disgust surfaces in the description of Alvarado's cold-blooded massacre of local nobility during the Huitzilopochtli celebrations, "while one song followed another and the hymns rolled forth like waves." The city rebelled and Moctezuma, who had vainly attempted to appease his subjects by advocating submission to the Spanish, was assassinated. This native account is powerfully evocative—the reader is overwhelmed by colors, sounds and smells. An end-of-the-world atmosphere is rendered through the cumulative touches of the terrifying impact of firearms and the gaping wounds caused by steel blades, the

30. The Mexican Counterattack
Codex Durán, Chap. LXXVI

This scene took place between the massacre perpetrated by Alvarado (illus. 27) and the retreat during La Noche Triste (illus. 12). The Spaniards took refuge in the palace, where the Mexica besieged them. The difference in weapons is striking, and the contrast is underscored chromatically—the attackers' colorful accoutrements differ sharply from the metallic gray of the Spanish defenders.
The location of these events is indicated by the glyph for Mexico-Tenochtitlan (the cactus) seen above the Mexican warriors.

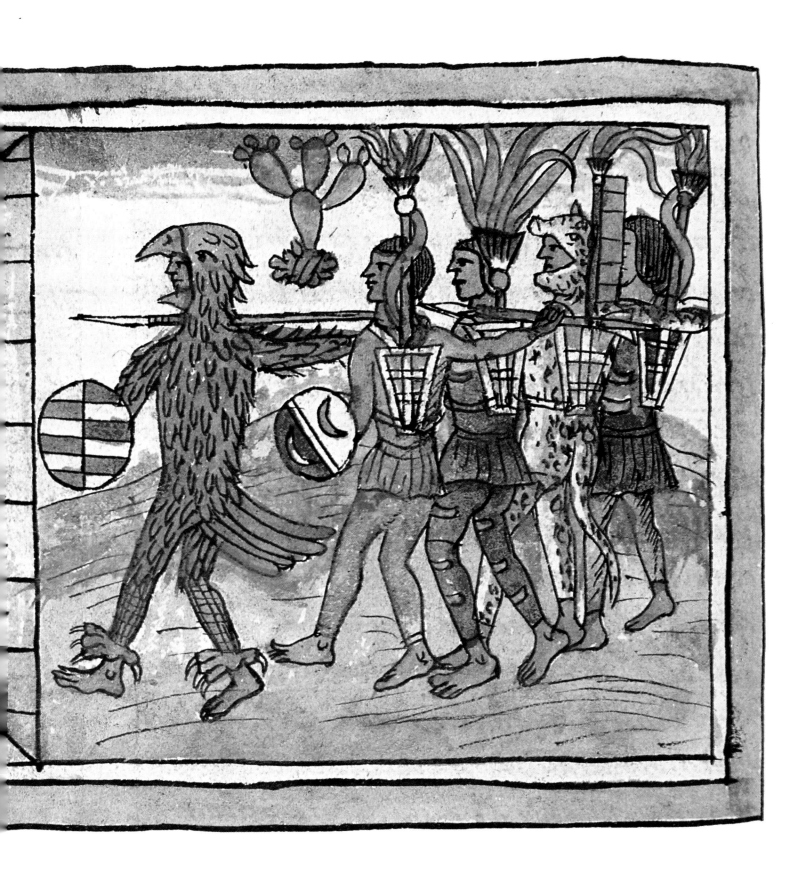

smell of burning flesh rising from Moctezuma's funeral pyre, the glow of twilight, the darkness of night, the howls of combatants, the roar of crowds and the sound of oars slicing through water.

This account, however, hardly constitutes an on-the-spot report. It transcribes the oral traditions that largely perpetuated the collective memory of Indians in the Valley of Mexico. Fray Bernardino de Sahagún, the Franciscan friar who supervised the *Florentine Codex*, was primarily involved in compiling a glossary of war vocabulary, and he could have simply included the verbal version in his book. While researching and collecting pictographic documents for his ambitious encyclopedia on the Indians, however, the Franciscan became aware of the considerable significance of images in Mexican civilization. So the account of the conquest of Mexico would be accompanied by images, as was the case in most chapters of his work. This time, however, his native illustrators were incapable of using a pre-Columbian iconography. The arrival of invaders from the east could not be represented like any old pre-Hispanic war. The painters were therefore obliged, like their Tlaxcalan counterparts, to completely invent images for this new subject that had no ancient precedent. The pages of the book were divided into two columns, one bearing the Spanish text and illustrations, the other the Nahuatl text. Most of the images were drawn in black and white as though the artists, in their haste to finish their work, did not have the time to color the drawings.[51] Native painters used glyphs for place names, but they were obviously familiar with the way war was represented in European art and engravings. They were old hands at showing troop movements, the charge of horses and lances, the flutter of flags. They could even show aerial views of battle. The images in the *Florentine Codex* admirably convey the tight ranks of infantry and the mobile clusters of cavalry squadrons.

Such mastery requires explanation. The artists probably had access to illustrated chronicles, and perhaps the large Franciscan library at Tlatelolco even supplied them with books containing engravings conducive to this sort of transposition. Editions of knightly romances, highly fashionable in Spain and the New World, often included engravings of Europeans armed and mounted in stereotyped, easily copied poses. They provided models of a horse at gallop or a charging cavalry unit. Parades of Spanish troops in the streets of Mexico City and expeditions undertaken against the Chichimecs (a nomadic tribe to the north) would also have furnished valuable visual information. Finally, native artists could study paintings showing various episodes from the conquest, in public buildings or in the homes of rich colonists. They could admire the funerary monument erected on the death of Charles V, decorated with scenes of the Spanish invasion probably executed by European artists.[52]

The artists who painted this version of the conquest, however, apparently had trouble envisaging the Indian universe, for it was not

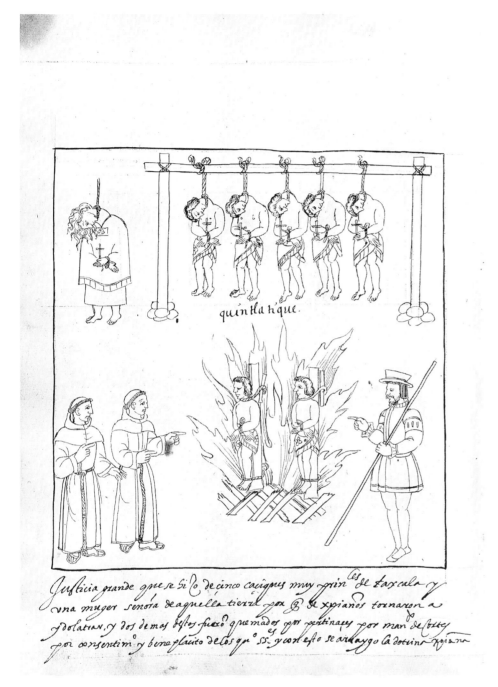

quintla tique.

Justicia grande que se hiso de cinco caciques muy prin les de taxcala y
vna muger señora de aquella tierra por q se xpianos tornaron a
ydolatrar, y dos demas destos fuero quemados por pertinaces por man de cortes
por consentim y bene placito delos q° ss. y con esto se arraygo la doctrina xpiana

31. Persecuting Idolaters
Descripción de Tlaxcala, fol. 242 r.

*Indians—particularly nobles—who openly
resisted Christianization and Spanish rule
were threatened with the scaffold and the
stake. On top, five men and a woman are
hanged, while below, Cortés demands that
two relapsed heretics be burned at the stake
as two Franciscan monks look on. The artist
opted for a mixture of European realism in
the treatment of the flames and the traditional
stylization recalling the conventions of the
codices (the hanged men).*

always displayed with the same precision and mastery used to
represent the Spanish. It is hard not to feel that their images favor,
if not the way the Spanish saw things, at least scenes in which the
invaders dominate. Nevertheless, the text of the story does not always
match the images: it brings events to life from an indigenous
perspective, complete with a wealth of details stemming from the
pre-Hispanic era of rituals and dread. The image showing the Spanish
landing provides a good example of the acuity of the Indian vision of
the conquest. It takes up half a page, below the six-line title. This

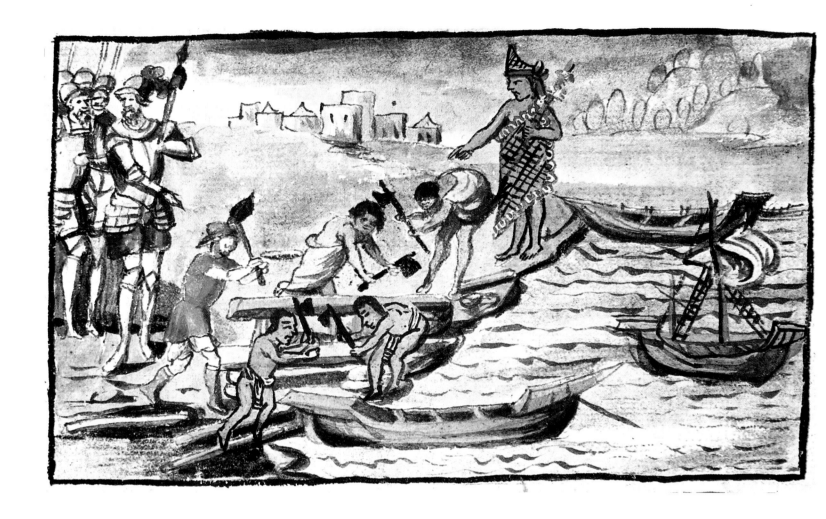

**32. Building the Spanish Fleet
(March 1521)
Codex Durán, Chap. LXXVII**

This scene shows Cortés at Texcoco on the east shore of the lake, where he went to finish construction of the fleet that would enable him to attack Mexico-Tenochtitlan from the water. In the center, a Texcoco ruler (wearing a diadem) provides assistance as Spanish and Indians work together. The natural setting and slope-roofed houses betray the European influence on a painter depicting events that had taken place sixty years earlier.

**33. The Nobles' Lament
Florentine Codex, Vol. I, fol. 44 r.**

"Our days ended in evil and the bad life. That is what these sinners in hell are saying, with great pain in their hearts, with laments of incalculable sadness, with endless tears, because they would neither recognize nor serve the true God, creator and lord of all things. When their torment began, then began their laments, their pain, their tears."

The painter who illustrated this sermon by Fray Bernardino de Sahagún supposedly showed former native lords and their wives in hell, weeping over their sins. But it is possible to picture this as a scene of native lamentation following defeat, particularly since "hell" is scarcely represented. Rather, the empty space suggests the traditional abode of the dead, which was free of Christian notions of punishment. The tears are rendered by the glyph for water, and the laments by the volute for speech.

que iamas se puede ver por donde
paso: o como vna saeta, que sale
de la vallesta, con gran jmpetu,
y llega adonde la endereça el
vallestero sin dexar rastro algu
no, de su passada: desta manera,
nos acontecio, a nosotros: nacidos en
breue tiempo, se nos acabo la vi
da: y ningun rastro dexamos,
de buena vida: fenecieron se ñros
dias, en ñra malignjdad, y en
nuestro mal viujz. B. Tales co
sas dixeron los peccadores en el in
fierno, con grandissimo dolor de
su coraçon, y con llanto de gran
tristeza, y con lagrimas no reme
diables: porque no quisieron cono
cer, nj seruir al verdadero dios,
criador, y regidor, de todas las co
sas: quando començo su tormento,
entonce començo su llanto, dolor
y lagrimas, y agora estan en el,
y para siempre iamas perseuerará
en el: los que conocen, y siruen
y obedecen, al solo y verdadero
dios, gozaron de sus riquezas, y go
zos, eternos, porque es infinjtamē
te bueno, y suaue: ansi queda di
cho en el testo de la sagrada escrip

o vntlan, vmpoliuh, intonemjliz.

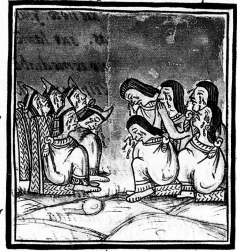

B. Ocaiuhqujhi, ynintlatol intlateu
tocanjme, iuhqui in, yninchoquiz, y
rjmixaio, ynintlaocullatol, ynjncho
quiztlatol, ynnjman aic vel moiolla
lizque. Auh inqujmiximachilia, inquj
motlacamachitia, yntotecujo dios, quje
nopilhuizque, ynjtlatocaiotzin, ynj
neaujltonolitzin: ichica cacenqujz
camocujltonoanj, yntotecujo dios, iuh
ca intcujtlatolli intlacpac omjto.

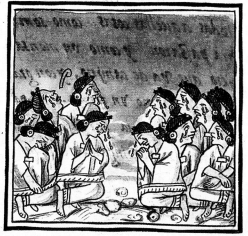

scene, in black and white, incorporates elements that wonderfully summarize the Spanish invasion in the eyes of native Mexicans: boats, horses, and livestock (cows, pigs, sheep) unknown in the Americas. The locks on the chests in the foreground and the Spaniard writing on a sheet of paper placed on his knees conveniently evoke two basic technologies introduced by the invaders—the alphabet and wrought iron, neither known to the natives.

This initial glimpse of indigenous sixteenth-century art prompts an observation that will recur throughout this study, namely that such images constitute a composite art shrewdly combining elements drawn from the iconographies and styles of both ancient Mexican and European art. Such art does not, therefore, represent the triumph of a European style; rather, it reveals the multifarious evolution of indigenous reaction to new forms. This explains why native elements (place-name glyphs, for instance) may appear right in the middle of an otherwise faithful representation of European forms. Furthermore, this codex demonstrates how the native Mexican account subtly deflects original Spanish designs. The Franciscan monk behind the project intended to acquire "war vocabulary" to enrich his Nahuatl glossary, while his informants succeeded in producing their own version of the conquest.[53]

The *Florentine Codex* is not the only document that provides a view of the invasion as painted by the conquered. Dominican friar Diego Durán collected accounts and images of the conquest from 1560 to 1580, for the Spanish missionary had decided to write a *History of the Indies of New Spain*.[54] His description of ancient Mexican rites and the history of Mexico City is a rich source that complements the work of Fray Bernardino de Sahagún on many points. Native painters apparently more Christianized and Hispanicized than those who produced the *Florentine Codex* illustrated Durán's two-volume work, notably the chapters related to the Spanish conquest. The eye is immediately struck by the profusion of mannerist and plateresque decorative motifs which, inspired by European engravings, framed historic scenes with grotesque ornamentation and foliage. A closer look at the plates, however, reveals glyphs for names and places set amidst landscapes and other scenes, demonstrating that local artists not only mastered the old repertoire but also remained convinced of its efficiency.[55]

Illustrated accounts of the Spanish conquest involved putting recent events into words and images. The story of this clash, like all history, inevitably meant rewriting the past. In Mexico, this exercise entailed a confrontation of forms that conveyed the Indian reaction to the Spanish invasion in a totally unique way. Taking the analysis a step further, the intrusion of Europeans fomented a breach that deepened with each passing day—native Mexicans lived in a present diametrically opposed to an irretrievable past. They watched as their society, dominated by the Spanish, adopted a destiny increasingly beyond

their control. Reality henceforth contradicted their cyclical and mythological view of time and history. Yet only this ancient concept could give meaning to the advent of the Spanish, by integrating it into the traditional scheme of Mexican history and eliminating the intolerable, inconceivable idea of an unforeseen and totally aberrant event.

It was in this spirit that the Mexica gradually identified Cortés's invasion with the return of their god Quetzalcoatl.[56] Just as the Mexican god would have done, the conquistador arrived from the east and demanded the previously vacated throne. Moctezuma's fall repeated the ancient disaster that had leveled the Tula empire following Quetzalcoatl's departure. A cyclical interpretation not only provided precedents and precursors, it also left room for hope—the hope of seeing Spanish domination crumble in turn and the former monarchs return to power. Someday other tribes would build a new world on the ruins of the Spanish order, just as the Mexica had built their empire on the ruins of the descendants of fabulous Tula, cradle of the arts and sciences. The elaboration of this history, the shaping of recent events according to mythological models (itself the source of secret hope), was therefore contemporaneous with the work of painters struggling to reconcile ancient visual forms with a sixteenth-century European visual idiom.[57]

While conquest and evangelization represented the beginning of a colonial universe for native Mexicans—a universe they were obliged to adopt—it did not totally erase the memory of a remote past predating the war, before the Spanish arrived. Yet the intriguing question arises as to what meaning Christianized painters under Spanish rule would give to this history, what transformations they would impose on it.

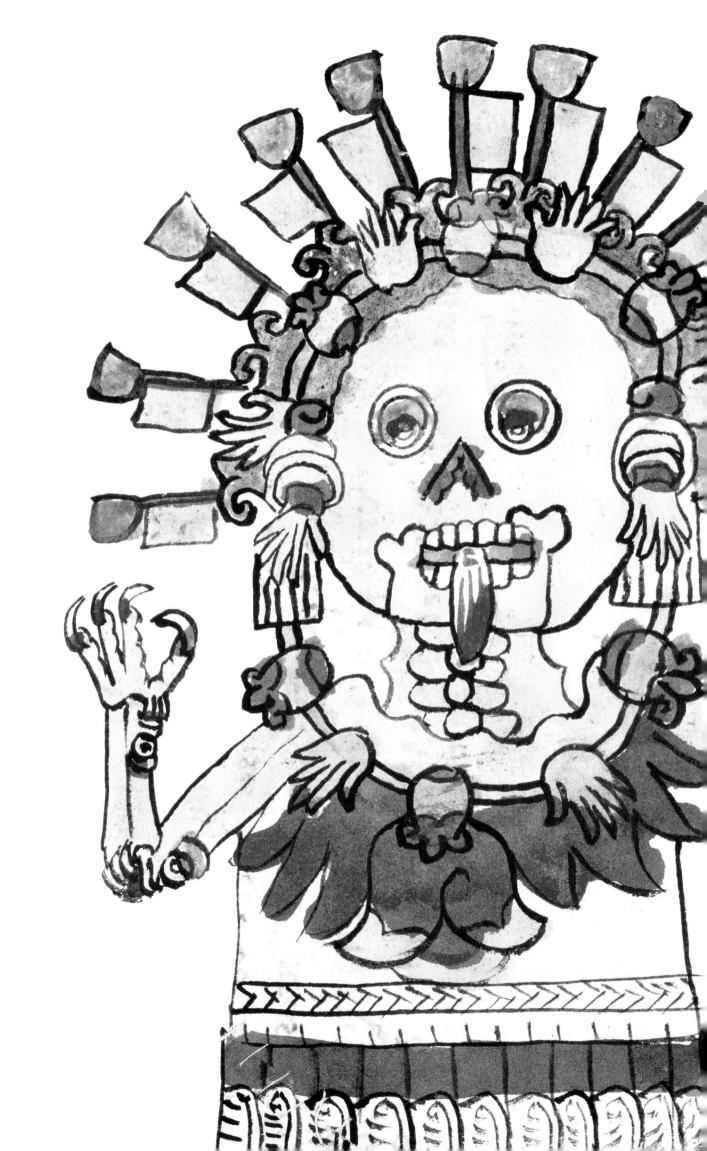

II.
Secrets of an
outlawed past

34. Tzitzimitl
Codex Magliabechiano, fol. 76 r.

This monster in the form of a skeleton descended to earth in order to devour human beings.

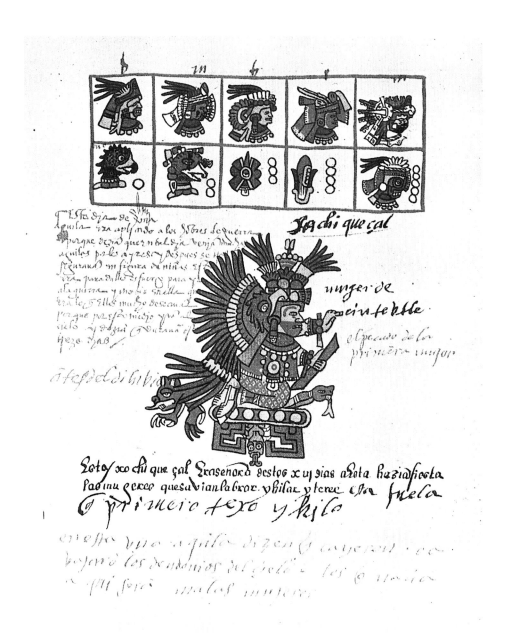

35. Xochiquetzal
Codex Tellerianus-Remensis, Pl. 30

Xochiquetzal, "Precious Flower," is shown here crowned with fruit and seated on a throne with snake, dog and centipede. This is just one of the many manifestations of the mother goddess. In her hand she holds the turquoise comb used by weavers to pull and block the threads of the weft.

She is also the mother of all fruit and animals on earth. Here Xochiquetzal is depicted as part of a ritual calendar with the days she governs.

In the morning sunshine of the last day of November 1539, twenty years after the conquest, a native prince was led—candle in hand and wearing an ignominious cap—from the Inquisition's prison to the main square in Mexico City. There, before a crowd of Indians, Spaniards, Blacks and mestizos, in the presence of the colonial authorities (Viceroy Mendoza and Basque Inquisitor and Bishop Juan de Zumarrága), native Mexican Don Carlos Ometochtzin was burned at the stake. It was an exceptional occurrence, but one that remained imprinted in memory long afterward. Of what was Don Carlos accused? This aristocrat, a member of the ruling family of Texcoco, was raised in the Catholic faith in Franciscan schools. Yet within the privacy of his palace, he had continued to worship idols, offering prayers and sacrifices to effigies of the former gods. Don Carlos had criticized the missionaries' preaching, claiming that "it was all a joke" and that there was no reason to adopt a religion that contradicted ancestral practices and the teachings of his father and grandfather, two Texcoco monarchs known to have been wise men and prophets. Don Carlos's idolatrous crime was matched by an equally scandalous resistance to the colonial order. "Come, brothers, who are these people who order us around, setting themselves above us, placing restrictions on us, destroying us? We shouldn't let anyone come between us or become our equal." By "these people," of course, he meant the Spanish. Finally, Don Carlos rejected Christian monogamy, the basis of the new society now emerging before his eyes.[58]

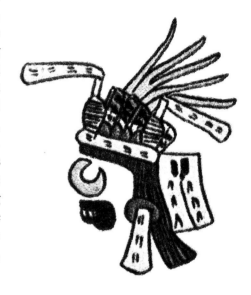

Wrenching Memories

Don Carlos's attitude was far from unusual. The missionaries became convinced that they needed to be fully aware of former beliefs in order to eradicate idolatry. They had initially devoted much energy to destroying temples and idols, persecuting and sometimes physically eliminating native priests. But the brutal approach soon proved to be of limited effect. By the early 1530s, Franciscans and Dominicans were seriously studying pagan deities and rites.[59] Their sources were "pagan priests" and the young people brought up in Catholic schools. This was a tricky and dangerous role for such Mexicans, since it obliged them to recall practices and beliefs down to the smallest detail, beliefs henceforth outlawed and condemned as false. Discussion of paganism therefore meant adopting a certain distance—informants were to consider such myths as "light words said in jest."[60] This tactic, similar to that used by the Indians during Catholic confession, was not without complications. While sincere converts might share the missionaries' goal and viewpoint, others who had secretly remained pagan might take advantage of the missionaries' inquiries to preserve ancestral practices. In helping to establish a list of what was forbidden, native Mexicans might be tempted to draw up an inventory of what remained; a decade or two after the conquest, they could record on

36. The Goddess Tlazolteotl
Codex Tellerianus-Remensis, Pl. 9

Instead of offering a figurative representation, here the painter has simply depicted the emblems—black mouth, nose ring, earrings —associated with Tlazolteotl, goddess of love and of "sins of the flesh." The statue or human who donned this apparel literally became the goddess.

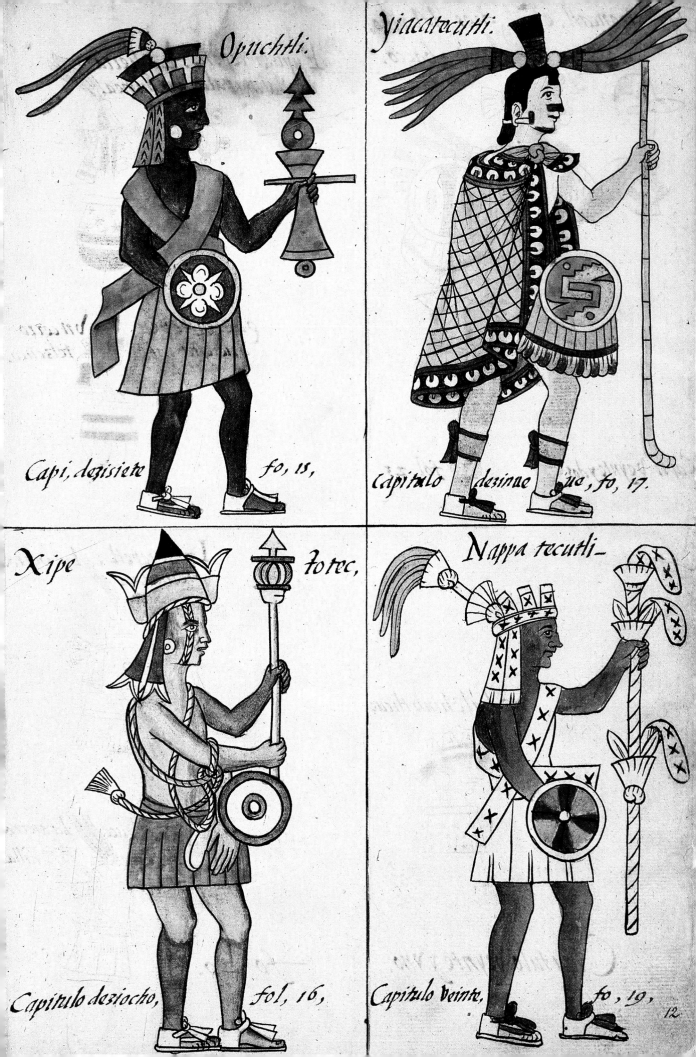

Opuchtli.

Capi, deçisiete fo, 15,

Yiacatecutli.

capitulo deziuue ue, fo, 17,

Xipe totec,

Capitulo deziocho, fol, 16,

Nappa tecutli.

Capitulo veinte, fo, 19,

12

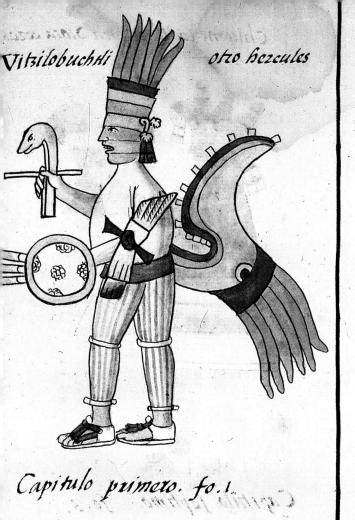

Vitzilobuchtli otro hercules

Capitulo primero. fo. 1.

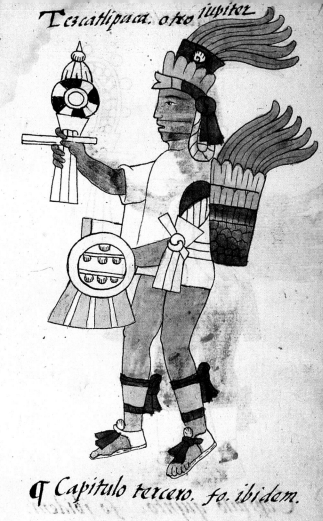

Tezcatlipuca. otro iupiter

¶ Capitulo tercero. fo. ibidem.

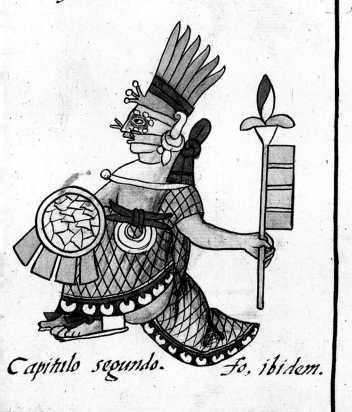

Paynal. vicario de vitzilobuchtli.

Capitulo segundo. fo, ibidem.

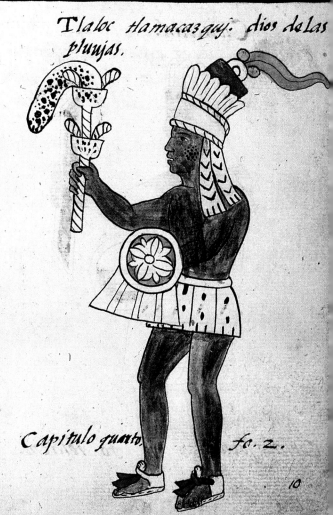

Tlaloc tlamacazqui. dios de las pluuias.

Capitulo quarto. fo. 2.

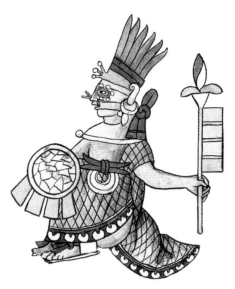

◁ 37-38. Traditional Mexican Gods
Florentine Codex, Vol. I, fol. 12 r.
and 10 r.

These plates show the gods Huitzilopochtli ("another Hercules"), Tezcatlipoca ("another Jupiter"), Paynal ("Huitzilopochtli's vicar"), Tlaloc Tlamaquazqui (the god of rain), Opuchtli, Yiacatecutli, Xipe Totec, and Nappatecutli.

*A description and explanation of these gods was given in the chapter and folio number indicated beneath each deity. Excerpts from the Nahuatl text follow.**

Opuchtli: "This Opuchtli was one of the Tlalocs. He was the god of those who lived on the water, who worshipped him. They said that he made and revealed his creations and inventions—the net, the dart-thrower, the three-pronged harpoon, the pole for propelling boats, and the bird-snare.... As his garb, he wore a paper crown; he was covered with black unguent... he wore a paper breech-clout and had a paper vestment over his shoulders with the sun emblem."

Xipe Totec, Our Lord the Flayed One: "He was the god of the sea-shore people, the proper god of the Zapotecs.... His particular creations, his attributes, with which he visited people, which he gave them, were blisters, sores, smallpox, ophthalmia, maladies causing watery eyes, infected eyelashes, lice about the eyes, withering of the eyes....

Those who were affected, we men thus sickened, would thereupon vow to him... [to don] his skin, on the celebration of the Feast of the Flaying of Men.... All hastened pursuing in a company, wrapped in skins of men... gleaming with blood so that they terrified those whom they followed.... Xipe's garb was thus: he had the quail-painting on his face... on his Yopi-crown was placed a band with forked ends. He had a wig of loose feathers, golden ear-plugs... his shield was red and had circles. His rattle stick was in his hand."

Yiacatecutli: "He was the god of the merchants.... They paid great honor to the cane, to the walking staff, of Yiacatecutli.... He had a tuft of hair on the front of his head like a pillar of stone and a headband with bunches of quetzal feathers. He wore golden ear-plugs. A blue knotted cloth was his cape.... His shield bore a coil pattern like a gourd vessel, in quetzal feathers. His traveling staff was in his hand; he had a cane staff."

Nappatecutli: "He was the special god of the mat-makers' guild, who worshipped him as a god... for it was he who first taught and showed them how to weave mats and make seats.... He was covered with a black unguent; his face had a thick coating of soot... he wore a paper crown. His hair dress, at the back of his head, was of paper, he wore a paper breech-clout... he carried a staff of long thick reeds."

Huitzilopochtli: "Hummingbird from the Left was only a common man, just a man... a sorcerer, an omen of evil, a madman, a deceiver, a creator of war, a war-lord, an instigator of war.... And when a feast was celebrated for him, captives were slain; ceremonially bathed slaves were offered up." This deity, like the following one, was described as a mortal who had become a god; the Spanish were swift to assimilate this concept to the Greco-Roman apotheosis of mythological figures.

Paynal: "Paynal was 'the delegate,' 'the substitute,' 'the deputy,' because he represented Huitzilopochtli when there was a procession. He was named Paynal [He Who Hasteneth] because he pressed on and urged them ahead.... He was garbed in the costly cape of precious feathers, with the quetzal-feather head-ornament in the manner of coastal people. Bars were painted on his face; and a star design.... He had a shield set with a mosaic of turquoise."

Tezcatlipoca: "He was considered a true god, whose abode was everywhere—in the land of the dead, on earth, and in heaven.... He brought discord among people... all evils which came to men, all these he created, afflicting men and dividing them. [But] sometimes he bestowed riches—wealth, heroism, valor, positions of dignity, rulership, nobility, honor."

Tlaloc Tlamaquazqui: "To him was attributed the rain; for he made it, he caused it to come down, he scattered the rain like seed, and also the hail.... And also by him were made floods of water and thunder-bolts. And he was thus decorated: his face was thickly painted black... he had a crown of heron feathers... he had foam sandals, and also rattles."

* *Quotes from the Nahuatl text are taken from the Charles E. Dibble and Arthur J. O. Anderson translation of the* Florentine Codex, *Salt Lake City and Santa Fe, University of Utah Press and School of American Research, 13 volumes, 1950-1982.*

European paper, right under the invaders' noses, everything that the pre-Hispanic priests and pagan schools, now closed, could no longer transmit orally or through polychrome paintings.

A surprising document, *Colloquia of the Twelve*, sheds light on the ambivalence with which the past was viewed. In the mid-sixteenth century, native Mexicans drafted an account of discussions held between the first Franciscan missionaries and Indian priests in 1525, at the start of colonization. They placed all the reasons Mexicans should convert to Christianity in the mouths of Spanish monks. But in transcribing the arguments of pagan priests in favor of traditional gods, the same authors were logically led to present anti-Christian arguments which, even though officially banished from their minds, perhaps created disturbing echoes.[61]

Divine Forces

Pre-Hispanic gods were quite different from classical Greco-Roman gods, even if Spanish soldiers and friars ignored the distinction. The Nahuas believed that the primal cosmos was dual, a systematic antithesis uniting heaven and earth, father and mother, hot and cold, light and dark. This duality was represented by a primordial deity, Ometeotl. The cosmos was divided into a number of levels comprising the various heavens and subterranean worlds.[62] Each level was inhabited by gods and by supernatural beings of lesser rank. The earth (*tlaticpac*) was in the middle. Above the earth was the heaven of the moon and rains (*tlalocan*), above which rose the heavens of the stars, the sun, and of the goddess of wholesome waters, finally attaining the empyrean sphere. Pre-Hispanic tradition often represented deities in pairs, as if to reproduce the world's primal duality. The superhuman forces driving the cosmos and regulating the world were active on the surface of the earth. They lived in rocks, plants, mountains, streams and springs; because they underwent constant metamorphosis, their name might change under each new form.

Although this system was often characterized by a spontaneous ambiguity and indefiniteness, missionaries expected the young people and former pagan priests they interrogated to provide order and clarity. Opinions were thus divided, contradictory traditions were reported, and memories strayed on a number of points. There was uncertainty over the composition and number of heavens (nine or thirteen), over the exact abode of deities, over their names and powers. Were the nine upper heavens to be distinguished from the four lower heavens? Did Ometeotl, the primordial deity, live on the twelfth and thirteenth celestial levels, or were these two levels really one?[63]

Certain gods—perhaps better described as "forces"—nevertheless stood out from the rest. This was the case, for instance, with Tezcatlipoca ("Smoking Mirror"), an omnipresent and omnipotent

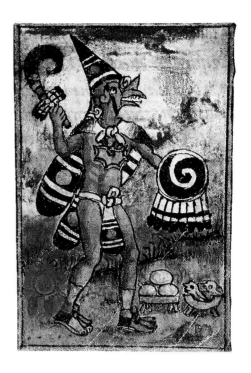

39. The God Quetzalcoatl
Codex Durán, Chap. VI

Quetzalcoatl was easily recognizable by his beak and "pointed miter of paper." Here he wears a colorful feather cape that matches his loincloth. The shield in his left hand is made of bird feathers. Quetzalcoatl was a god of creation, linked to fertility and rain in his manifestation as Ehecatl. He was also Venus, the morning star, and was often identified with Topiltzin, the legendary priest-king of Tula who was forced to abandon his city.

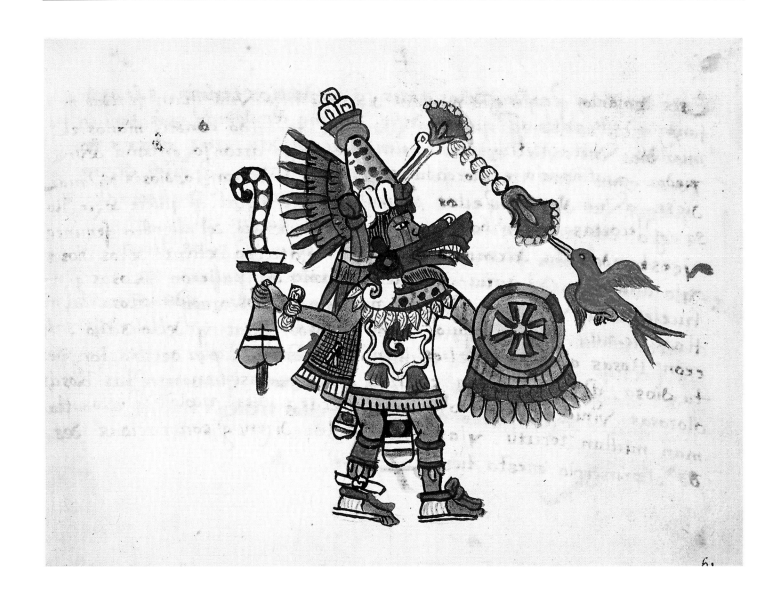

40. The God Quetzalcoatl
Codex Magliabechiano, fol. 61 r.

"Quetzalcoatl means serpent feather. They considered him to be the god of air. They painted his face from the nose down like a snout through which he sucked up the air." Here Quetzalcoatl is represented differently (see illus. 39). He stands out against an empty ground, as in the ancient codices. But the outlining is less bold and the color is not always uniform (as on the god's diadem), indicating that this image was produced during the colonial period.

41. Tlaloc, God of Rain
Codex Ixtlilxóchitl, fol. 110 v.

This is a good example of composite style. The modeling of the body and the positions of arms and legs are directly inspired by European sources, whereas the lack of background, the space occupied by the deity, his apparel and his emblems all stem from native tradition. Hence the impression of strangeness produced by this hybrid art. The crenellated surface on which Tlaloc stands is a stylized representation of the clouds over which he ruled.

tlaloc,

42. The Great Temple at Mexico-Tenochtitlan
Codex Ixtlilxóchitl, fol. 112 v.

Three stairways of one hundred and twenty steps (equalling the three hundred and sixty days of the year) led to the main temple in Mexico-Tenochtitlan, which contained two sanctuaries. The smaller sanctuary on the left was dedicated to Tlaloc, the god of rain. The wall is decorated with blue stripes representing the rain that fell on the four corners of the earth. The volutes on the roof represent clouds. On the right is the sanctuary dedicated to Huitzilopochtli, the god of war and the patron god of the Mexica. The walls are composed of stone and skulls, representing the remains of dead warriors. The butterflies on the roof also allude to soldiers fallen on the field of battle.

god who granted or withdrew his munificence at will, dispensing success as well as unleashing calamities and plagues. One of his feet was replaced by a mirror. Tezcatlipoca was known by several dozen names, was characterized by darkness (linking him to the night and to the jaguar), and had the ability to take unexpected shapes, such as the nocturnal ghosts who enjoyed frightening human beings (the boldest of whom dared to confront such ghosts in order to extract favors).[64] Other deities also had extensive powers. Tlaloc reigned over the aquatic world, over the hollow mountains filled with water, over clouds and wind. Huitzilopochtli was the patron god of the Mexica, who associated him with war; in Tlaxcala, the god Camaxtli

played a similar role. Quetzalcoatl (whom Cortés was thought to be) was connected with the ancient, archetypal city of Tula, as well as to luxury craftsmen and to magic; under other names, this same god was associated with the wind and with the planet Venus. Xipe Totec, Xochiquetzal, Tlazolteotl and a constellation of other names stood for the forces governing sexuality, vegetation, fertility, birth, impurity and purification.

A Renaissance Christian Interpretation

As far as the Spanish were concerned, these figures embodied the devil and demons sent to oppose Christ's missionaries. All were monstrous incarnations of Evil. Indigenous tradition, in contrast, held that divine ambivalence was fundamental, the world being conceived as a balance between order and chaos and not a struggle between Good and Evil. There was another filter, however, coloring the missionaries' view of the native Mexican universe. The discovery of America coincided with the European Renaissance, and monks leaving for the New World were sensitive to humanism and to the admiration in which classical antiquity was held. Greco-Roman polytheism was thus the logical model for a prolific paganism that could hardly be compared to Islam or Judaism. So this prestigious model, reinforced by a growing interest in archeology in Italy and Spain,[65] informed the way the Mexican deities were viewed. Seen through this prism, Mexican gods became anthropomorphic beings, similar to the gods of Greece and Rome (as cultivated Renaissance Europeans imagined them). The missionaries thus sought to establish parallels between Mexican and Roman gods, just as in ancient times Roman gods had been assimilated with those of Greece. Huitzilopochtli became another "Hercules," Tezcatlipoca another "Jupiter," and so on. All they needed was a pantheon so that these strange beings—which had suddenly become deceptively familiar— could be suitably organized. They were thus paired into couples, and the feats of these increasingly individualized characters were stressed so that they uncannily resembled classical demigods. This was the cost at which Huitzilopochtli and Quetzalcoatl could be viewed as cultural heroes who guided and governed their people through countless vicissitudes.[66]

The *Florentine Codex* sheds light on such Renaissance interpretations. The first book, entirely devoted to Mexican gods and written (like the rest of the work) under the supervision of Sahagún, contains a series of entries describing the jurisdiction, characteristics, apparel, attributes and feast days of each deity. These entries are accompanied by an illustrated catalogue displaying a cohort of twenty-one deities classified by sex and order of importance: five major gods, seven major goddesses, eight secondary gods, etc.[67] These plates are new versions of the illustrations in *Primeros Memoriales*, a manuscript written

43. The Cholula Pyramid
Codex Vaticanus Latinus, 3738,
Pl. 14

The pyramid was said to be so high that it reached the sky, and the Indians planned to take refuge there in the event of another flood. A precious gem that fell from the sky destroyed it. That, at least, is the way the post-conquest Indians, influenced by biblical stories and the evangelists' sermons, interpreted these impressive ruins. They can still be seen at Cholula, southeast of Mexico City.

44. The Goddess Chantico
Codex Tellerianus-Remensis, Pl. 28

Chantico was the goddess and guardian of the hearth. She was worshipped throughout the Valley of Mexico and associated with the god of fire and the lord of the dead. She also survived the flood, and invented fire in order to cook fish.

45. The God Tepoyolotli
Codex Tellerianus-Remensis, Pl. 4

Tepoyolotli, the lord of animals, was in fact one of the forms taken by all-powerful Tezcatlipoca. Here the god is represented in a tiger skin whose spots represent the star-studded night sky. As with other plates in this codex, pre-Hispanic forms and information share the page with commentaries in Spanish.

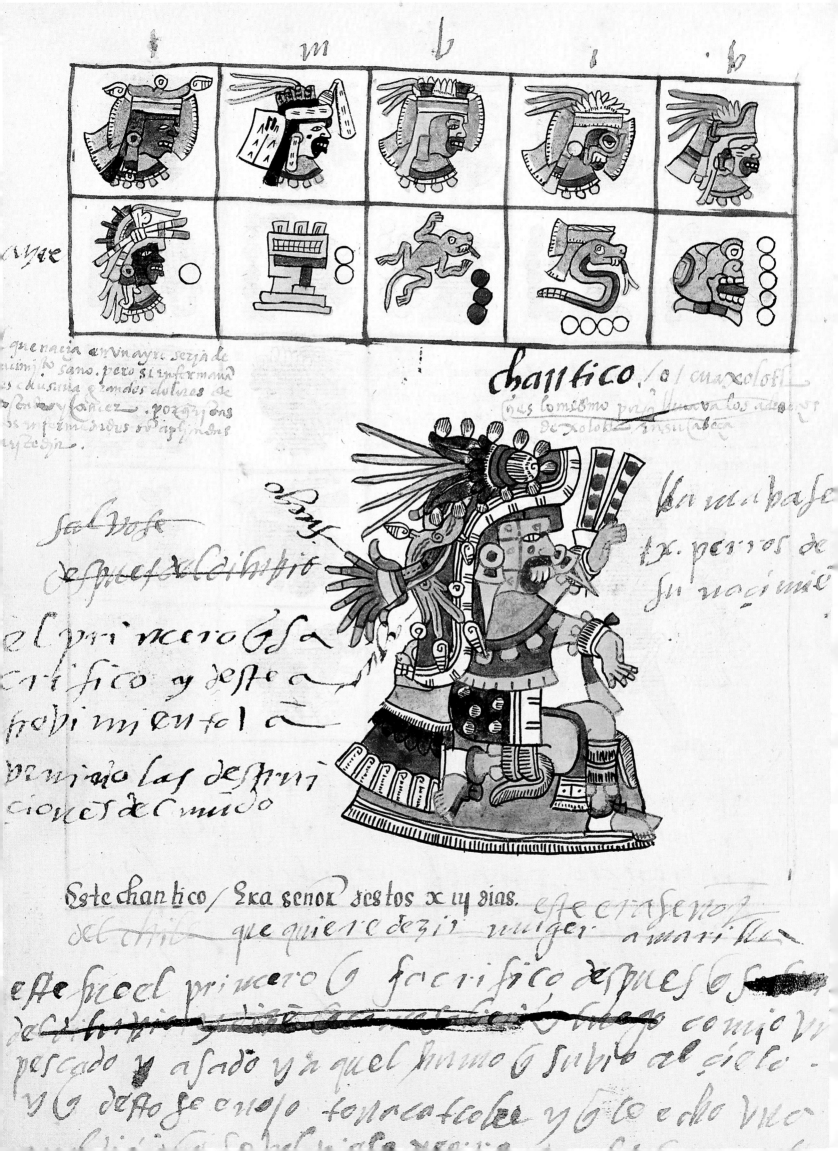

ayx̄e

que nacia en vn ayre seria de
miembro sano pero si enfermara
es chusima grandes dolores de
... y cabeça ... por q̄ dos
... y fermedades en ...
y cabeça

chantico / o / cuaxolotl
(es lo mismo por q̄ llama valos ...
de xolotl ... cabeça)

obras

saluose
despues del diluvio

el primero q̄ sa
crifico y deste a
grobi miento l a
premiado las destru
ciones del mundo

llamabase
LX. perros de
su nacimi̅e

Este chantico / Era senora destos x iy dias.
que quiere dezir muger amarilla

este fue el primero q̄ sacrifico despues los
del diluvio ...
pescado y asado y aquel humo q̄ subio al cielo
y q̄ desto se enojo tonacateotle y este e dho ...

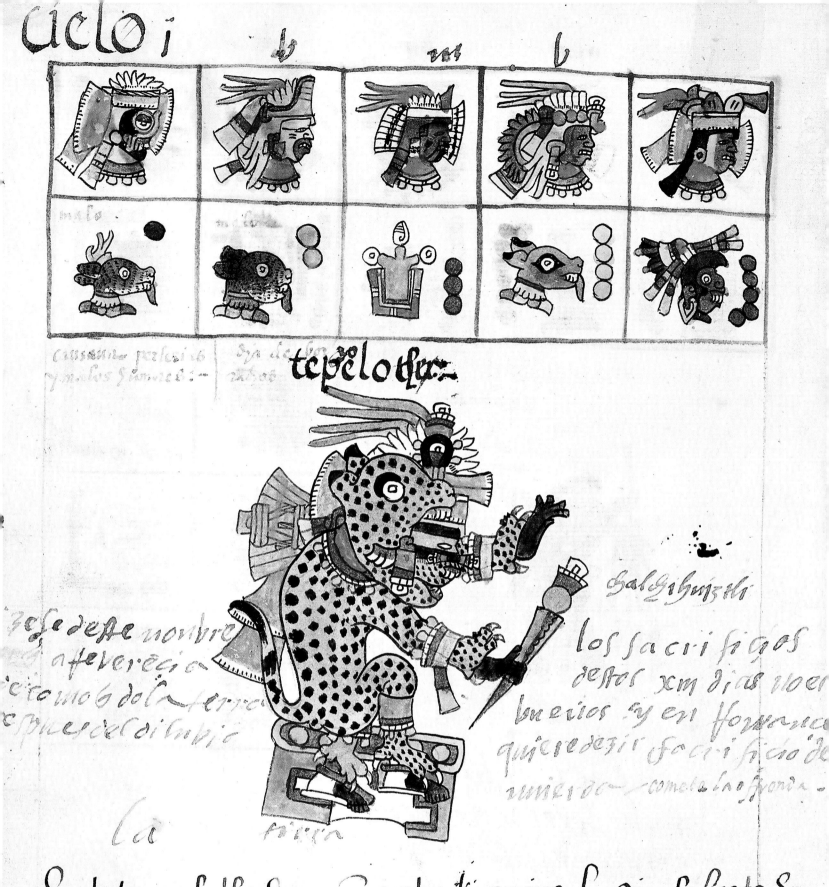

tepeolotlec

malo

chalchihuitl

la tierra

los sacrificios destos xiii dias noeran buenos sy en romance quiere dezir sacrificio de mierda como la he ofrenda

gese deste nombre afreverecia cicomos dela ferre espues del diluuio

Este tepeolotlle es señor destos treze dias hazian la fiesta en cielo tienars ya yunavan los quatro dias prosteros son es Rotan señolasac las manos tepe o lotle quiere dezir se nor selos animales los quatro dias sayuno son arreverencia desu chiquecal quees el onbre que queso enlahera queaora cusamos este es tepeolotle es lo mes no ã el tiem po dela boz cuando fetumba en vn valle de vn

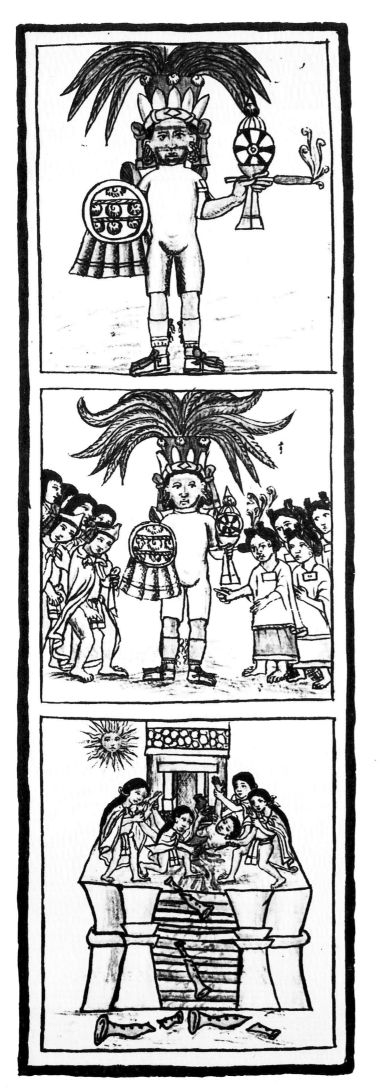

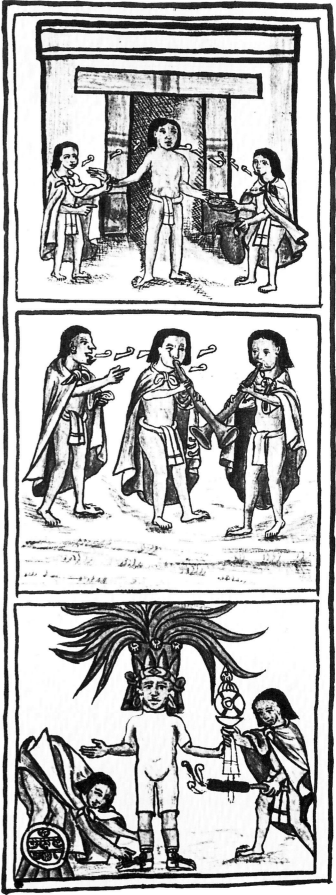

46-47. The Feast of Tezcatlipoca
and His Sacrificial Victim
Florentine Codex, Vol. I, fol. 84 v. and 85 r.

"In the month of Toxcatl, the great feast of Tezcatlipoca was held...wherefore died his impersonator, who for one year had lived as Tezcatlipoca. And at that time once more was offered to the people his new impersonator, who would again live for one year.... They then looked well that he be taught to blow the

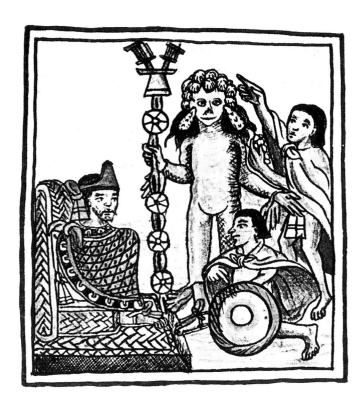

flute, that he might pipe and play his flute well.... Thus he went bearing his flute, his flowers and his smoking tube together as he walked through the streets."

48. Preparing the Sacrificial Victim
Florentine Codex, Vol. I, fol. 86 r.

"Then Moctezuma adorned the impersonator well and arrayed him in varied garb... he adorned him in great pomp with all costly articles, for verily he took him to be his beloved god.... White feathers were placed upon his head—the soft down of eagles. They placed it on his hair which fell to his loins."
Celebrants bustle around the young man, in front of the lord seated in traditional fashion. Although the Spanish commentary to this Nahuatl text does not mention it, the young man is wearing the skin of a flayed victim. His eyes gaze upon the scene through the holes of human skin, and the hands and feet of the skinned victim hang lifelessly from his wrists and ankles.

49. Human Sacrifice: Rites Performed
by the Victim's Master
Florentine Codex, Vol. I, fol. 80 v.

"While all had fasted for their captives, they had never bathed; they had remained in filth until twenty days had passed... then all bathed and washed their heads with soap.... And thereafter the owner of the captive set up in the courtyard of his house a woven twig ball on three small feet. Upon it he placed the paper adornment with which had been adorned the Totec [the captive] when he died.... Moreover, at this same time he put up, so that it hung—having removed the remaining flesh—the thigh bone of the captive, and suspended with it the sleeveless knotted cord jacket and a small spray of heron feathers. And he wrapped the thigh bone with paper, and provided it with a mask. And this was called the god-captive."
These ceremonies took place after the sacrifice of captives during the feast in honor of Xipe Totec and Huitzilopochtli. The third image appears to have been copied from a pre-Hispanic codex, as suggested by the hieratic poses, the objects floating in empty space, and the obviously late addition of the horizon line.

manta del fuego del diablo.

50. The "Fire-Devil's" Cape
Codex Magliabechiano, fol. 7 r.

This is a masterpiece of Mexican art under Spanish rule. It combines abstract forms with the representation of a sacrificial turkey lashed to bamboo. The cape was probably dedicated to the god of fire. Dazzled by the pre-Hispanic subject and the dramatic handling, the eye is slow to recognize the mannerist influence of grotesque forms and volutes in the leaping flames (?). Mannerism was spreading in New Spain when this codex was painted (circa 1563). This key link in the encounter between Europe and America combines modified pre-Hispanic traditions (colors are no longer applied uniformly) with early manifestations of the great Hispano-American baroque tradition.

51. Ritual Capes
Codex Magliabechiano, fol. 5 v. and 6 r.

Left to right, top to bottom: cape of Tezcacanecuili, cape of the water spider, cape of Nonoalcatl, cape of the coiled gourd, another cape of the coiled gourd, cape of the devil's labret (or lip plug), cape of the Ocelot or Tiger, cape of Xochipilli (A Single Lord) or of Macuilxochitl (Five-Flower).

Painted on Genoa paper, this codex includes the patterns of forty-five capes worn by priests during rites. These samples give an idea of the level of abstraction attained by Mesoamerican art through combinations of shapes and colors. The pictographic language used in the codices is here used on the cloths draping the Indians. A visual harmony was naturally established between paintings, frescoes, polychrome sculpture and the beings who moved through such settings wearing these glyphs.

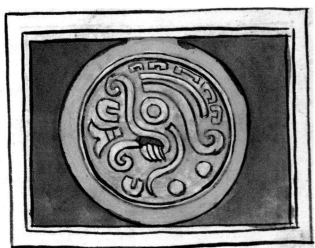

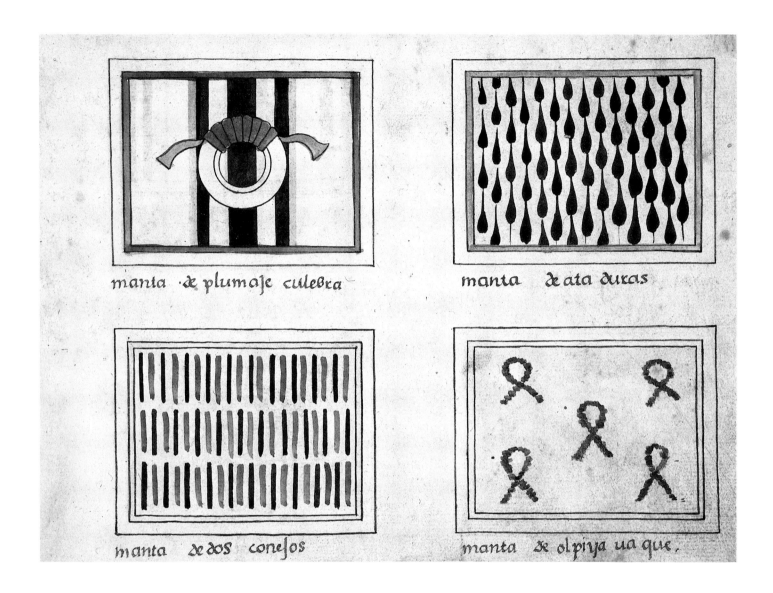

manta · de plumaje culebra

manta de ata duras

manta de dos conejos

manta de olpiya ua que.

52. Ritual Capes
Codex Magliabechiano, fol. 5 r.

Upper left, cape of Quetzalcoatl (?).
Lower left, cape of Two-Rabbit,
god of drunkenness.

by Sahagún twenty years earlier. The figures have been redrawn and repositioned, however, and the silhouettes of the Mexican deities have been systematically Europeanized. The outlines and proportions of bodies, along with the volume of garments, give the impression of anatomical realism, movement, and depth. The changes in the *Florentine Codex* version obviously reflect an evolution in the Franciscan scholar's knowledge, as well as the influence of the region and period in which he was working. Successive native sources spurred him to place the accent on some figures rather than others, or to make associations supported by local traditions. Above all, however, the images in the *Florentine Codex* demonstrate a profound transformation in indigenous pictographic tradition more than half a century after the conquest. In addition to changes in the basic information and the forms used to express it, one is struck once again by the evolution of a means of expression undergoing modulation, modification and, occasionally, destruction on contact with European art and the

invaders' point of view. The emergence of new representational canons, or rather of the European notion of illustration and representation, can be detected not only in this catalogue of gods, but also elsewhere.

Other deities appear in the first book of the *Florentine Codex*, this time in scenes further emphasizing a European vision of pre-Columbian mythology. As noted above, the text of this codex is divided into two columns; one, in Nahuatl, contains information provided by local natives, while the other, in Spanish, offers a translation, paraphrase and interpretation of the original. It should be noted that it is the indigenous text that elicits the illustrations, and not the pre-Columbian images that inspire the commentary as was the case with the ancient codices the Indians glossed for the Spanish. What is more, the Castilian text alters native reality and beliefs by skipping over the descriptions of gods and their regalia in order to stress their functions in pre-Hispanic society. They are thus transformed into mythological heroes less baffling to European readers. It is significant that the images discussed here are inserted into the column containing Spanish text as though they were part of a European interpretation—this time visual—of traditional beliefs. Contrary to expectations, this is not in fact the case. For, paradoxically, native artists often included details (in clothing, for instance) that betrayed precise knowledge of pre-Hispanic traditions, and even made alterations designed to improve the divine figures in the grand catalogue. These images by Mexican painters testify to the ambivalent attitudes and unpredictable developments that arise when groups and individuals are confronted with a multicultural, multi-ethnic situation.

One might wonder how the Indians viewed the Greco-Roman deities and paganism they discovered through the deforming lens of centuries of European history and the half-hostile, half-humanist attitude of Christian missionaries.[68] What was a distant, stereotyped past for Franciscan and Dominican monks must have seemed a very strange prehistory to educated Indians. But they could at least conclude that if their own paganism was equivalent to classical paganism, then Spaniards of long ago had also worshipped idols before receiving the boon of Christianity.[69] Native Mexicans sufficiently familiar with classical mythology—some invoked Jupiter, shining Phoebus and Minerva in letters written in Latin to the king of Spain and the Indies—probably had enough material to concoct Mexican pantheons in the image of those of Rome and Greece.[70]

Other representations, however, offered a different vision. Anthropomorphized beings were replaced by objects, finery and regalia that comprised the essence of the visual manifestation of the deity in the eyes of the Indians. This can be seen in Sahagún's first manuscript, *Primeros Memoriales*, which basically emphasized divine apparel by relying on systematic, detailed lists in Nahuatl.[71] Thus the anthropomorphic version geared to European eyes coexisted alongside a

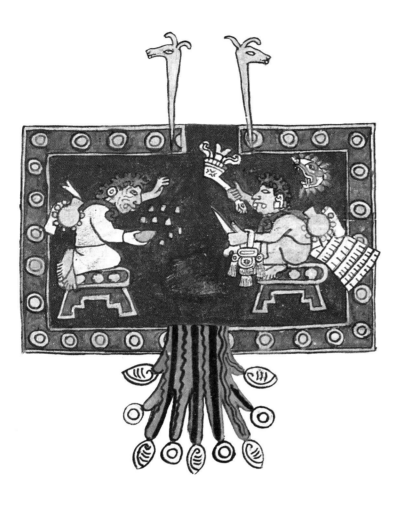

53. The Old Couple Oxomoco and Cipactonal
Codex Borbonicus, p. 21

The Codex Borbonicus is divided into two parts: the ritual calendar (or tonalamatl) and a representation of the celebrations linked to the eighteen months of the solar calendar. It was painted on a strip that initially had forty pages. The traditional visual style, combined with recurrent Spanish commentary, suggests that the codex was painted sometime after the conquest but before 1540.
On the plate shown here, Oxomoco and Cipactonal burn incense and consult the fates. The pair were believed to be the ancestors of the human race and the inventors of the art of prophecy. They presided over a twenty-six-year period (half a ritual cycle of fifty-two years).

54. Quetzalcoatl and Tezcatlipoca
Codex Borbonicus, p. 22

These deities presided over the remaining twenty-six years of a fifty-two year cycle. They are ringed by the glyphs for those years. Quetzalcoatl and Tezcatlipoca were believed to have invented the calendar.

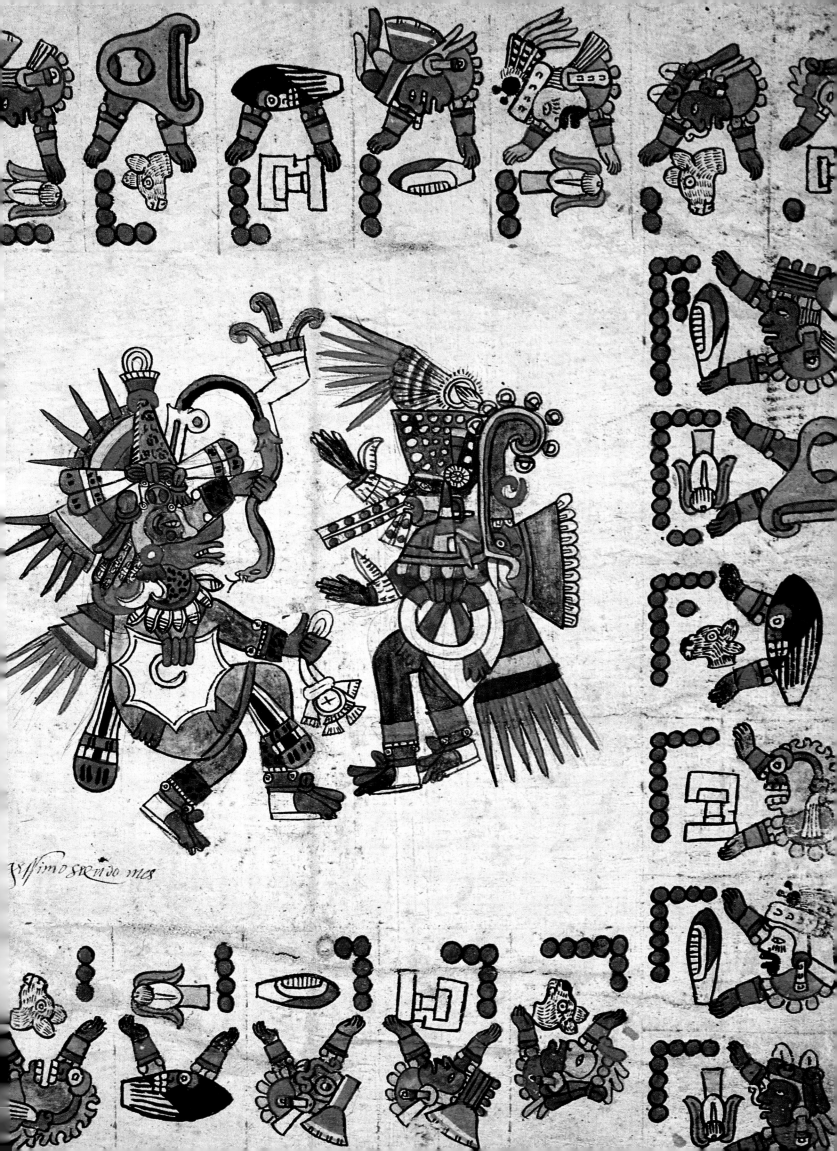

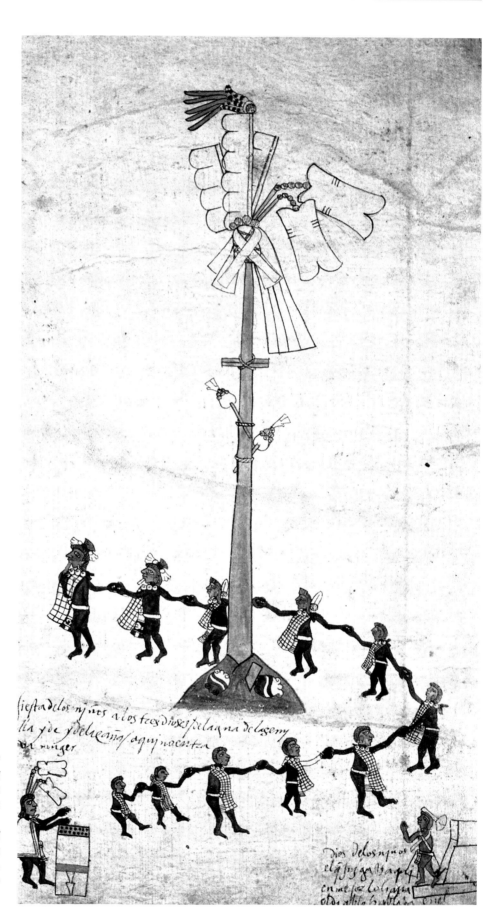

55. Tenth Month Celebrations
Codex Borbonicus, p. 28

During the tenth month of the solar year, celebrations were held in honor of Huey Miccailhuitl and Xocotl Huetzi ("Falling Fruit"). A pole was erected, on top of which was placed a funerary packet decorated with feather balls that the children tried to snatch. Young boys and girls wearing feathers and jewelry danced around the pole. The great feast of the dead was celebrated at the same time. This rite has survived into the present day through the game of Volador.

vision more faithful to pre-Columbian traditions, as represented in traditional-style paintings or copied in European-style manuscripts. Several scenes from the *Descripción de Tlaxcala* show that, within a common space, mastery of European drawing techniques was perfectly compatible with respect for ancient representational canons pertaining to pre-Hispanic deities.[72] In other words, progressive Europeanization was accompanied by a selective preservation of elements drawn from the indigenous past. This engendered astonishingly complex phenomena that cannot simply be dismissed as the inevitable, unilateral ruin of Mesoamerican tradition.

Sacrifice

The forces governing the universe, however, were only one aspect of this outlawed past. In pre-Columbian times, every human being was expected to help sustain the cosmos. Blood sacrifice was the best way to do this, for it was considered an essential element in regeneration. Parents pierced the earlobes of small children, while adults would push long, thick cactus needles through tongue, fingers, eyelids and penis. Human sacrifice, an extension of these more or less severe forms of self-sacrifice, was performed for thoroughly logical reasons.[73] The gods were not aloof from the cycle of birth, death and rebirth that characterized cosmic rhythm and rendered life indissociable from death. Divine forces needed to die in order to re-emerge stronger, more powerful; it was essential that the gods perish periodically, in order to be reborn. That is why they became flesh, why they momentarily dwelled in human beings who became the expression of divine presence on earth prior to dying on the sacrificial stone. Some humans thereby literally embodied the native Mexican conception of life that entailed a continuous alternation between states of emergence, expansion, disintegration. What appeared to Europeans as simple human sacrifice was nothing other than the death of a god that had fragmented itself prior to becoming whole once again. The blood spattering the steps of the altar, then, was literally divine.

Other men and women, however, were offered to the gods as nourishment. Here sacrifice was part of a system requiring an exchange of gifts. Hungry gods constantly needed to replenish their vital forces, and human blood served this purpose. That is why, high in the temples, the priest conscientiously dripped blood on the images of deities and sprinkled it along four cardinal points, nourishing all the forces in the cosmos.[74]

Although human sacrifice constituted mankind's concrete role in sustaining the flow of energy within the cosmos, this was not its only function. A warrior who captured a future sacrificial victim in battle was rewarded with higher rank and privileges. Regular human sacrifice also reinforced the collective conviction that the entire group

56. Eleventh Month Celebrations
Codex Borbonicus, p. 30

The Ochpaniztli celebrations honored the mother goddess Teteoinnan-Toci and the corn goddess Chicomecoatl (seen in the lower register, with a serpent), associated with rain and fertile fields. The five priestesses dressed in paper ornaments stand on the steps of a pyramid, and represent the four cardinal points plus the center (blue = east, white = north, yellow = west, red = south, multicolor = center). The same priestesses are seen in procession in the upper register, accompanied by ithyphallic priests left uncolored: according to the Spanish gloss, "these sodomite priests did not leave the temple." This plate gives a good idea of the splendor of pre-conquest rites.

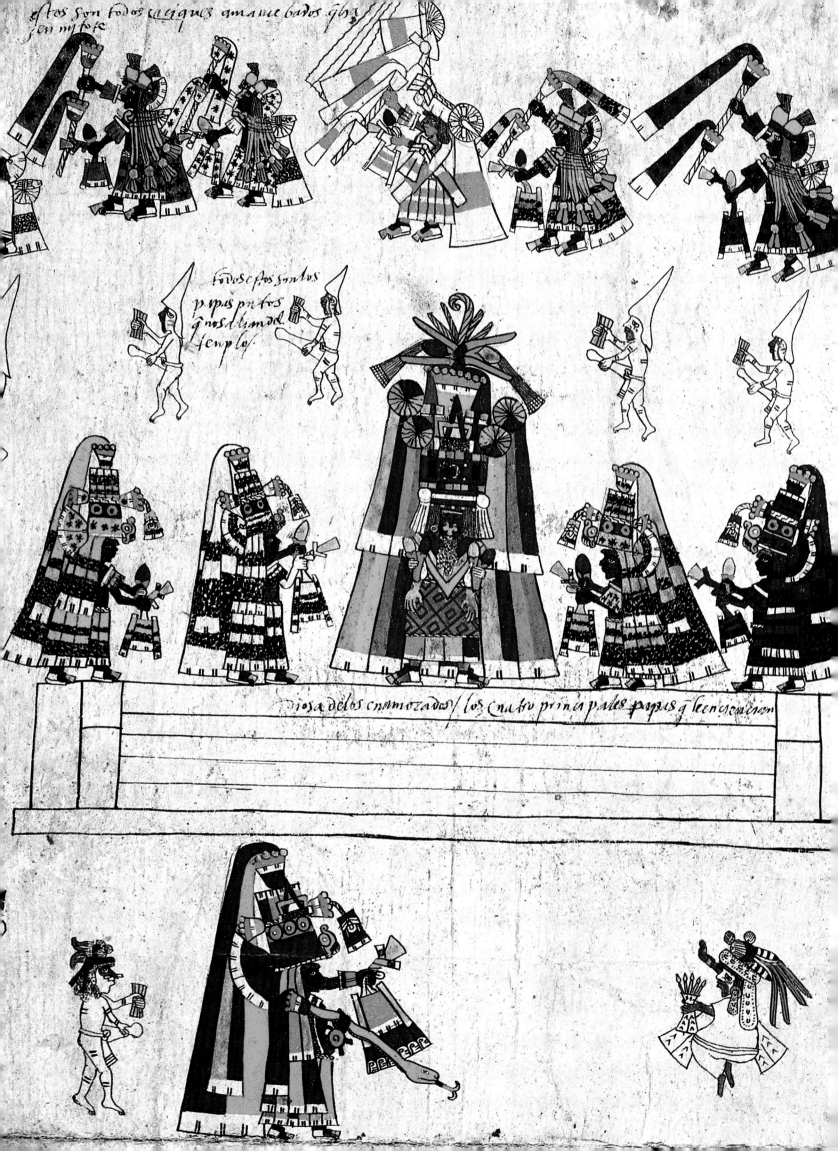

estos son todos caçiques amanecebados q̄ baz
son miɔfe

todos estos santos
papas putos
q̄ nos dl lind d
l templos

Diosa delos enamorados / los cuatro principales papas q̄ le encençiar

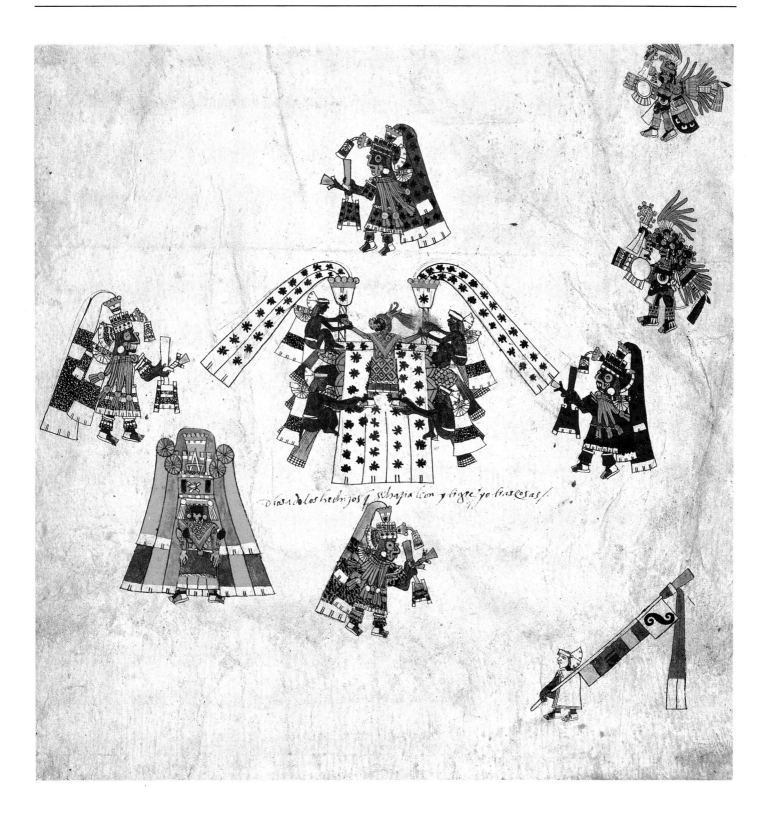

57. Eleventh and Twelfth
Month Celebrations
Codex Borbonicus, p. 31

*The Ochpaniztli celebrations continue. The
center shows four priests stretching the skin*
*of the corn goddess (that is to say, the skin
of the flayed sacrificial victim) on a platform
made of paper and ears of corn. The skin
was placed over a straw dummy and adorned
with the regalia of the corn goddess. The
deities of the four cardinal points ring the*
*scene: blue = east (top), white = north (left),
yellow = west (bottom), red = south (right).
The upper right is reserved for the gods
Huitzilopochtli and Ixteocale, whose Teot-
leco ("Arrival of the Gods") celebrations
took place during the twelfth month.*

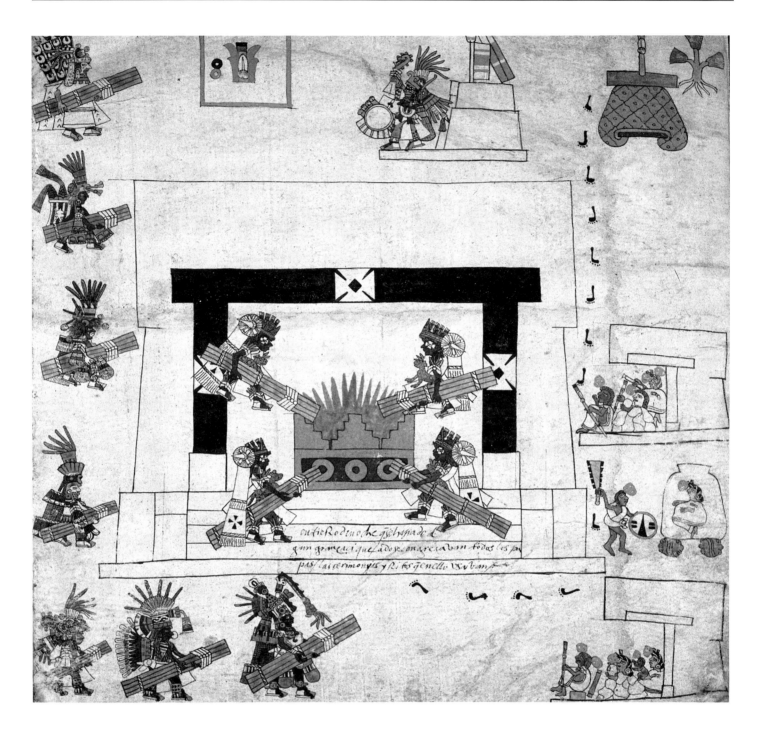

58. Fifteenth Month Celebrations
and the New Fire Ceremony
Codex Borbonicus, p. 34

The Panquetzaliztli ("Banner Raising") celebrations were dedicated to Huitzilopoch-tli. The Indians feared that the world would come to an end at the close of every fifty-two-year cycle. During Panquetzaliztli, all hearths were solemnly and symbolically extin-guished. The gods then brought wood, and

a new fire was lighted, from which all hearths were rekindled. Meanwhile, women and children (lower right) had to remain hidden to escape the dangers associated with this event. (During the total eclipse of the sun in July 1991, similar behavior was reported in Mexico.) The crosses signify the four cardinal points and center of the world. The Spanish commentator, either ignorant or hoodwinked, claims that the scene shows the nocturnal funeral of a cacique!

59. Sixteenth Month Celebrations
Codex Borbonicus, p. 35

The Atemoztli ("Falling Water") celebra-tions were associated with rain and fertility. Tlaloc and Chalchiuhtlicue, deities of the water kingdom, are seen here in their sanctuary on top of the green glyph for mountain. These gods lived in the moun-tains, which were thought to harbor the winds, clouds and waters.

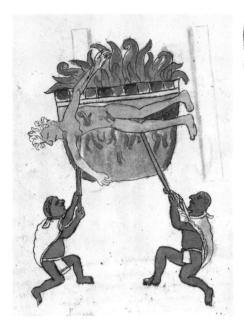

60. Cremation Rites
Codex Vaticanus Latinus, 3738,
Pl. 77

Two pole-wielding priests rotate the corpse to make sure that it is thoroughly cremated. The temple courtyard contained a masonry furnace used for cremations. "This ceremony was so sacred that the pagan priests would confess before performing it, just as Catholic priests today confess before saying mass."

owed its survival and prosperity to this constantly repeated act. Finally, human sacrifice functioned to keep enemies in a state of terror. Victors summoned allies and relatives of victims to attend the sacrifice. A refusal was more than just impolite—it constituted a *casus belli*.

The missionaries and chroniclers who gathered this information were extremely sensitive about the issue of human sacrifice. Rare indeed were those who, like Dominican friar Bartolomé de las Casas, admired a people able to offer their most precious possession—human life—to their god, even if such piety seemed excessive. Las Casas added, after recalling the practices of the Greeks and the Gauls, "Our Spanish nation does not seem to be wanting, for it has collectively sacrificed men by the hundreds." On the other hand, as soon as Cortés landed on the Mexican coast, the conquistador condemned "this horrible and abominable thing, truly worthy of punishment, that we have never seen anywhere else: every time they want to ask something of their idols, they take little girls and boys, and even adult men and women, and cut open their chests to pull out heart and entrails." [75] For most Spaniards, and particularly for the conquistadores who had seen several of their companions sacrificed, the bloody practice was sheer, diabolical madness, regardless of the explanations offered by native Mexicans. This barbaric butchery provided the ideal justification for the conquest of the country, as well as for the harsh treatment meted out to Indians.

One wonders how native Mexicans reacted when the missionaries asked them to ransack their memories and codices in order to reproduce images of sacrifice. It is hard to imagine the attitude of such painters, encouraged to depict what had been the very foundation of their society yet was now the height of abomination. Conflicting drives and motives must have guided the hands that painted these scenes of old. The frequency with which human sacrifice was pictured during the colonial period probably indicated a secret wish to safeguard testimony of this crucial act rather than merely a concern to satisfy what would seem to be Spanish voyeurism. Clergy as well as lay people were simultaneously fascinated and revolted by what seemed to be an orgy of blood and cruelty. Ritual cannibalism must have provoked similar reactions among both Spanish chroniclers and their native informants. As with images of human sacrifice, it would certainly have given Christianized Mexicans a feeling of profound malaise, since what had been one of the most glorious practices of their civilization was henceforth condemned to the most violent execration.

"Staged" Society

Sacrificial practices can only be understood in the context of a society that forthrightly stressed public staging, performance, and spectacle.

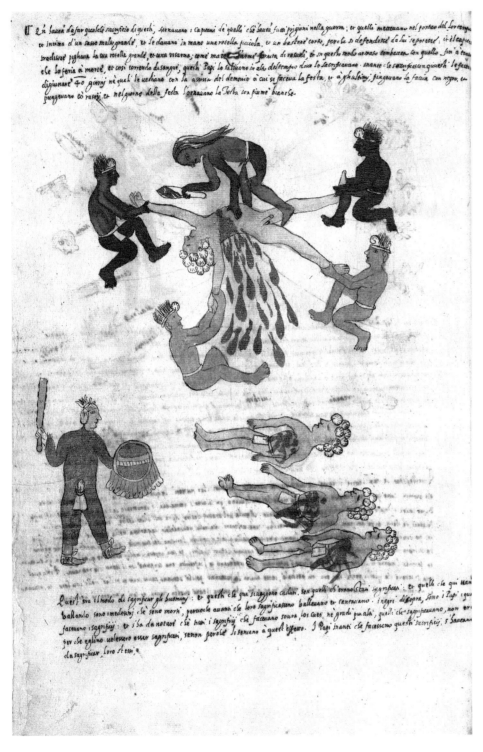

61. Human Sacrifice
Codex Vaticanus Latinus, 3738, Pl. 74

The victim is held down by four celebrants while the priest swiftly opens the chest cavity and blood gushes forth. Sahagún wrote that "two took the victim by the feet, two by the hands, another by the head, and another cut open his chest with a single stroke of an obsidian knife." The lower register shows three victims after the sacrifice. White feathers were placed in the hair of all victims.

62. The Pantitlan Whirlpool
Florentine Codex, Vol. I, fol. 35 r.

"And all their adornment—their paper garlands worn over one shoulder...and the turquoise cups and their little sauce bowls with which the celebrants ate, the little wooden bowls and the clay bowls, all these...they threw into the water, off shore, at a place called Pantitlan."

These celebrations honored the mountain and water gods. The sacred place, which was thought to be linked to the deeps of Tlaloc's water kingdom, was ringed by banners. Pantitlan means "place of banners." Birds can be seen flying above the site.

63. The Flood
Codex Vaticanus Latinus, 3738, Pl. 5

The first age in Mexican cosmogony ended with a great flood when the water deity descended to earth. Men were changed into fish, but one couple managed to escape the deluge. During this age, giants lived on earth (here, the large reclining body), and the commentary mentions the discovery of giant bones during the reign of Viceroy Luis de Velasco. These images of the distant past were recopied by a European hand, which limits their authenticity and reveals the difficulty Europeans encountered in reproducing such exotic forms.

ynjc amo mjc: iehoatl, ynjc te
piquj, ynjc moxtlaoa, ynjc quj
neltilia yn netol. Auh ynjx
qujch, ynjn ne chichioal, ynjn
tlaquen, ynjmamaneapan,
ynjmoztopil, ynjntlapetla
njlquauh, ynjmaiauh cocul:
yoan ynjnchalchiuhxical, yoa
ynjntlaquaia molcaxtotonti,
quauhcaxtotonti, coqujtecon
totonti, muchi vmpa concaoa
ia tepetzinco: atlan contepe
oaia, vmpa anepantla, ytoca
iocan pantitlan.

¶ Capitulo veynte y dos, que
habla del dios, llamado tezcatzo
catl: que es vno de los dioses del
vino.

El vino, o pulcre, desta tierra: siempre
los tiempos passados, lo tuujezon por
malo: por razon de los malos effectos,
que del se causan. Porque los borra
chos, vnos dellos, se despeñan, otros se a
horcan, otros se arronjan enel agua, do
de se ahogan: otros matan a otros, estando

¶ Jnic cempoalli vmume
capitulo, ytechpa tlatoa
in tezcatzoncatl, ynjnoan
pouj centzontotochti.

Iehoatl in vctli, ieppa tlatla
culli ipan machoia: cate te
pexiuja, tequechmecanja,
teatlauja, temjctia; tetza
vittonj, amo pinavilonj, a
mo chicoittolonj. Auh ynjn

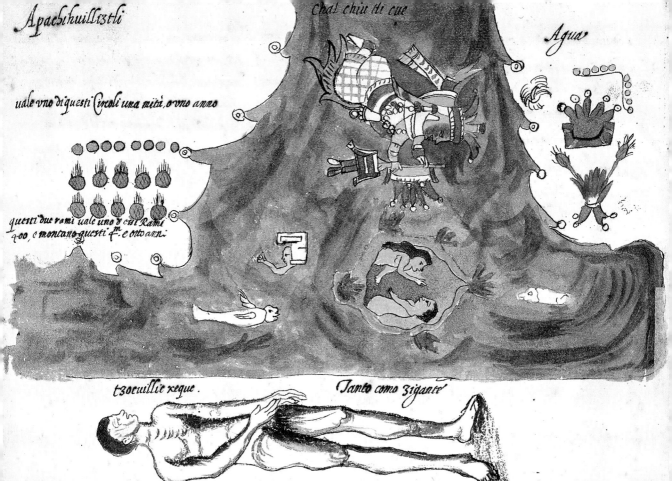

Apachihuiliztli Chalchiuhtlicue Agua

uale vno di questi Circoli una mità, o vno anno

questi due rami uale una d'essi Rami 400, e montano questi 4M. e otto anni.

tzocuilliexeque . Tanto como gigante

Questa è la prima età ch'essi dicono, in la q.le regnò l'acqua fin tanto ch venne à distrugger il mondo che hauevano moltiplicato q.lli due huomini primi, et hauevano in principio quel gran sig. erino, stato, secondo il suo conto, q.lla età quattromila otto anni, e uenendo il gran diluuio dicono ch li huomini si trasformorno in pesci, et li pesci grandi ch si mano eti, Tlacamichin, che uuol dire huomo pesce: dicono li più doll uecchi. Ch Mexico ch scappo di q.to Diluuio un solo huomo, e una donna, da li q.li fu di poi multiplicato il gener humano, l'arbore in che scapporno chiamano Ahuehuete, et dicono ch uenne questo diluuio in la letra diese, secondo la loro computatione, che significano per acqua, la quale per più chiarezza metteremo nel suo calendario, durante la prima età, dicono che no mangiauano pane, saluo certo genere di mais siluestre, che si dice, Atzitziutli: chiamano q.ta prima età conistal, che uuol dire la Testa bianca. Altri dicono che non solo scapporno di q.to Diluuio quelli due dell'Arbore, ma che altri uij. restorno ascosi in certe spece, et che passato il diluuio uscirno, e reparorno il mondo spartendosi p esso, et q.lli che di poi successero l'adorauano p Dij ogn'uno in la sua natione, et così li Tepanecha adorauano uno ch si dicea Hulhuetteotl, et li Chichimeche, à Quetzalcoual, et li culue, à Tzinacoual, perche d'essi uscirno le generationi uecch. ch q.do facevano gran conto dell lignaggio, e dove si riconovano, dicevano, co come dell'altre lignaggio, e à quel suo primo fondatore adorauano, et gli facevano li sacrificij, e dicevano ch q.llo era il cuor dell pupulo, al q.le havevan fatto uno Idolo tenuto in buon.m luogo, et uestito, e tutt'li success.ri metteuano in q.l luogo gioie ricche, come oro, e piette preciose, in anzi à q.to loro cuore ardeva sempre sagna doue metteuano il copal, o incenso. Furno in q.ta prima età giganti in q.to paese, ch sono ch sono qui, detti Tzocuilliexeque, di tanta smisurata grandezza, ch referisce un religioso dell ord.re di S. Dom.co detto frat'Petro de los Rios, ch è q.llo ch recopiò la più parte di q.ta pintura, che uiddi con li occhi suoi proprii un denti molare de la bocca d'un d'essi ch tornorno l'Indiani d'amaque neconp andando adornando le strade de mexico anno dni 1566. q.le pesò tre religioso, e pesò tre libre, manco un'oncia, l'hanno prisato al Viceré don luis de Velasco, et l'hanno ueduto altre persone dal q.le si può giudicare la grandella di q.ti giganti, e con dalcunt' ossa, che sono ritrouate in q.ti paesi, una di q.ll serue che dicono hauer scappulato dal diluuio, dicono ch multiplicandosi il mondo, se n'ando à chulalan, et li p'ncipio à edificare

64. Domestic Rituals:
The New Fire
Florentine Codex, Vol. II, fol. 247 r.

"Once the fire had been relighted, the residents of each pueblo in each house replaced all jewelry, the men and women put on new clothes and placed new mats on the ground, so that everything used in the house was new.... Using earthen spoons they offered incense to the four corners of the world."
This ritual was performed once every fifty-two years, when it was feared the world would come to an end. After a period of total darkness and anguish, all fires were relighted to great relief. The painter here is faithful to pre-Hispanic canons. In the upper image, three distinct moments—the new fire in the hearth, the couple wearing new garments, the offering of incense—are simply placed one above the other. There is no suggestion of depth, except in the woven seats, whose drawing and shading reveal that the painter knew how to represent volume. The glyph for tetl (stone) is employed to represented the new hearthstones, as well as those thrown out. In the lower image, a devil is included to indicate that this is a pagan practice, which probably means it was still performed when the codex was painted.

65. The Goddess Chalchiuhtlicue
Florentine Codex, Vol. I, fol. 18 r.

"She was painted yellow and blue, she was painted blue about the lips and on her face. She wore a green-stone necklace; she had turquoise mosaic ear-plugs. She had a blue paper cap with a spray of quetzal feathers. Her shift and her skirt were painted like water. She bore a shield ornamented with water lily leaf and flower. She carried the mist-rattleboard, which she sounded."
The lower scene shows a sacrificial victim being offered to the goddess. The celebrants in the foreground are blowing on conch shells. The sacrificial act is shown superimposed on a temple that seems to float in midair. To fit the two spaces together, the feet of the celebrants have been placed on distinct steps, although the ceremony would, in fact, have been performed in the sanctuary at the top.

The Spanish invasion had demolished the cities and towns that effectively served as stage sets. This generated palpable frustration among a populace whose raison d'être, sensibility and primary amusement were all closely bound up with the ceremonies it constantly organized. Prior to the conquest, festivities, rites, magnificent and costly banquets given by nobles and *pochteca* merchants consumed considerable time and energy, particularly if the days and nights devoted to preparing such events are taken into account (not to mention the orgy of human and material resources invested in these affairs: shimmering fabrics, turquoise jewelry, feather plumes and hundreds—indeed thousands—of human lives squandered in temples on high). The production of all the ornaments, accessories and emblems required by these celebrations employed countless craftsmen, some of whom, like featherworkers and goldsmiths, enjoyed a privileged status authorizing them to associate with nobles. A myriad of priests knew the infinite variety of divine emblems enabling celebrant, victim or statue to render the god physically present among mankind. The crowds were more than merely bit players, for it was hard to remain unmoved by the momentous frenzy of thousands of magnificently dressed *pipiltin* nobles who danced for days at a time in the enormous squares at the foot of the temples. The mass participation of the people during this "excess of public rites"[76] not only reinforced social and cultural cohesion, it also reaffirmed the existence of a society that constantly put itself on show. The grand rituals represented a thoroughly extroverted way of reproducing cosmic and temporal cycles on the surface of the earth, beneath the celestial spheres. In Mexico-Tenochtitlan, such rites also magnified the superiority of the People of the Sun (that is, the Mexica) in the eyes of others. The conviction that they effectively regulated the universe galvanized these urban spectacles. Like some gigantic codex being unfolded, they unfurled across the large ceremonial square in Mexico-Tenochtitlan that occupied the center of a precinct divided into four neighborhoods, in imitation of the cosmos. This sacred square was in turn dominated by the main temple, *ombilicus et axis mundi*, the divine mount, the vertical pillar on which cosmic forces converged.[77]

The various Mexican societies—"civilizations of show and ostentation"[78]—appeared totally dedicated to the staging of rites and liturgical pageantry that were indissociable from the polychrome paintings of the codices and temple frescoes. So much so, in fact, that one cannot help wondering whether they were already exploring the paths down which today's post-industrial societies seem to be moving. Yet when native painters were asked to put images of these ancient rites to paper, they were surely convinced that no one after them could ever witness such spectacles, such scintillation.

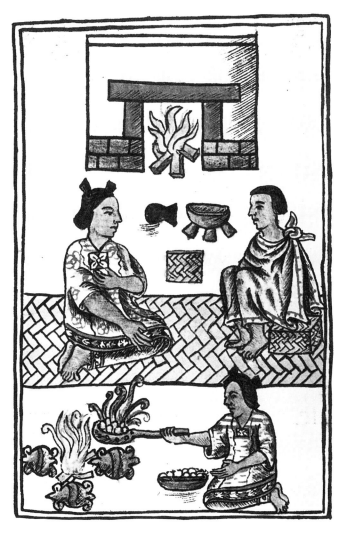

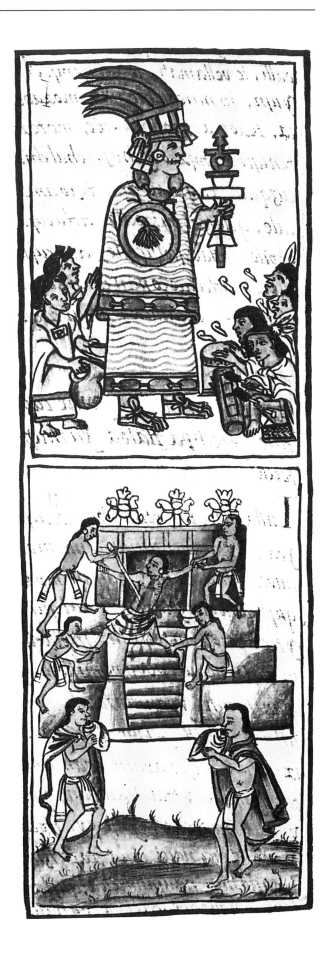

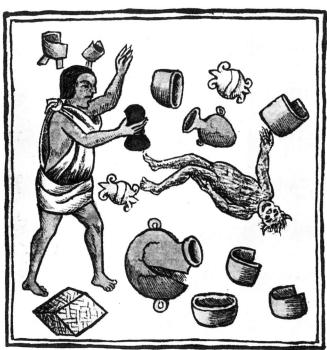

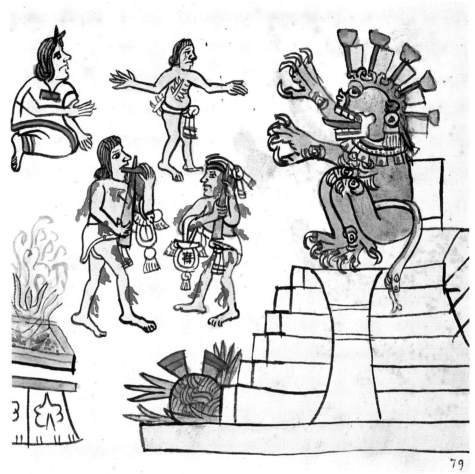

66. Cannibalism
Codex Magliabechiano,
fol. 73 r.

*This scene accurately conveys the ritual
cannibalism that followed human sacrifice.
Indian men and women are shown here
eating various parts of the body (legs and
arms). The Spanish commentary explains
that "they say that it tasted like pork, and
that is why they greatly appreciate the flesh
of pigs." (It was the Spanish who brought
pigs to America.)*
*The god of the abode of the dead, Mictlante-
cutli, can be seen here seated in his temple.*

67. Self-Mutilation
Codex Magliabechiano, fol. 79 r.

*As an offering to the god—Mictlantecutli
once again—the two Indians in the center
pierce tongue and ear lobes with cactus
needles. The claws with which the pre-
Hispanic deity have been endowed are in-
spired by the Christian devil. This gives a
satanic tenor to the image, raising doubt as
to how it should be interpreted: is it a simple
reconstruction of past practices or is it an
image of hell as imagined by Christianized
Indians? Or perhaps the painter is offering
a dual interpretation of the past.*

Time and Calendars

The painters were privy to other mysteries. The world of gods, sacrifices and celebrations was merely the earthly manifestation of a machinery churning out time and fate. Human time was shaped on the surface of the earth, where the forces descending from the heavens met those rising from the depths. This human time, however, was tributary to a prior time—the "time of creations," sparked by the violence of rape and murder marking the creation of animate and inanimate beings. The time of creations, which continued to exist,

68. The Calendar of Years
Florentine Codex, Vol. II, fol. 247 v.

"This painting represents the count of years, and it is a very ancient thing. It is said to have been invented by Quetzalcoatl."
The painter has drawn here a fifty-two-year cycle, or xiuhmopilli *("Sheaf of Years"). Each year had a name composed of a number (from one to thirteen) and one of the four signs corresponding to the cardinal points:* Tochtli *("Rabbit"),* Acatl *("Reed"),* Tecpatl *("Flint Knife"), and* Calli *("House"). In theory, the first year was called One Rabbit, followed by Two Reed, Three Flint Knife, and Four House. The fifth year would be called Five Rabbit, followed by Six Reed, et cetera, up to Thirteen Rabbit. The next, or fourteenth year, would begin at number one again, combined with the second sign, hence One Reed. The last year of the cycle was Thirteen House, when all fifty-two possible combinations had been used. For greater clarity, the missionaries had the Indians draw up charts combining glyphs for the four signs (Rabbit, Reed, Flint Knife, House) with scrolls bearing their respective names in Nahuatl and a series of concentric circles numbered one to thirteen.*

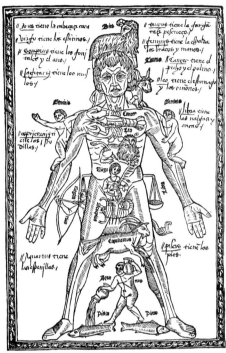

determined the nature of events around which human time was woven.[79]

Thus each instant that elapsed on earth was the product of an extremely complex set of forces that could be identified by a sign (of which there were twenty) and a number (from one to thirteen), yielding two hundred and sixty different combinations. This was the basis of the ritual calendar of two hundred and sixty days, used for divination. The ritual calendar was then combined with a solar calendar containing eighteen months of twenty days plus five additional days. The position within the thirteen-day cycle, the month, and the year created other variables that influenced the nature of the forces. To animate life on earth, each force took a specific path determined by an immutable cyclical order revealed by the calendars. There were four such paths, represented as four trees or hollow columns through which animating forces flowed in helical fashion, generating human time. The time of each day, as of each year, flowed first from the east tree, then the north tree, followed by the west tree, and finally the south tree. The days had names, and the forces behind days named Jaguar, Death, Flint Knife, Dog and Wind originated from the north tree; the forces behind Rain and Monkey days came from the east; for those called Flower and Rabbit,

69. Native Anatomy and
Divine Influences
Codex Vaticanus Latinus, 3738,
Pl. 73

Here the painter has depicted the signs representing the twenty days of the ritual calender (see illus. 71-73) and linked each one to a part of the body. The various cosmic forces therefore had a direct and intimate influence over human beings.

70. European Anatomy
and Astrological Influences
Epílogo en medicine y cirugio,
Burgos, 1495

The Spanish inscriptions indicate the relationship between the signs of the zodiac and parts of the body. Spaniards and Indians possibly noted seeming similarities between their own theories and the beliefs of the other, and that such similarities favored the eventual mingling of these two ways of conceiving of the human body.

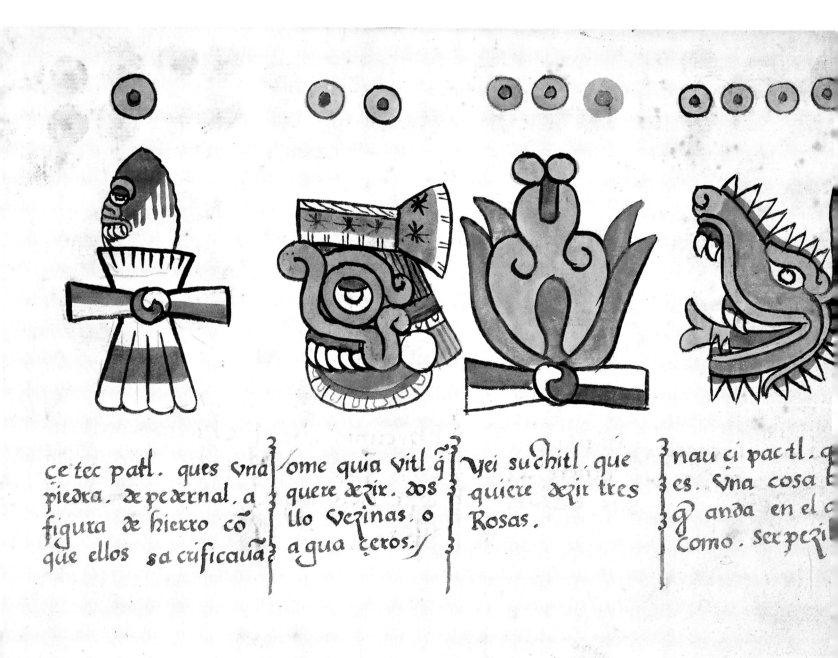

ce tec patl. ques vna
piedra, de pedernal, a
figura de hierro cõ
que ellos sa crificauã

ome quia vitl q
quere dezir. dos
llo vezinas, o
aqua ceros.

yei suchitl. que
quiere dezir tres
Rosas.

nau ci pac tl. q
es. Vna cosa
q̃ anda en el
como. serpezil

71-72. Ritual Calendar Symbols
Codex Magliabechiano,
fol. 11 r. and v.

This series shows the twenty symbols corresponding to the various days of the ritual calendar. Each sign is accompanied by a number from one to thirteen. Once the cycle of thirteen has been completed, the numbering starts over at one. The permutations progress

the forces emerged from the south; and so on. Following the same logic, the forces behind years under the Flint Knife sign came from the north, whereas those behind years under the House sign swept up from the west.

Human time was intimately bound up with divine time; all beings and things were immersed in these forces and subject to the dynamic of their influence in generating change, movement and time. Mesoamerican people struggled to master such cosmic flux, seeking to exploit and regulate beneficial energy while avoiding harmful

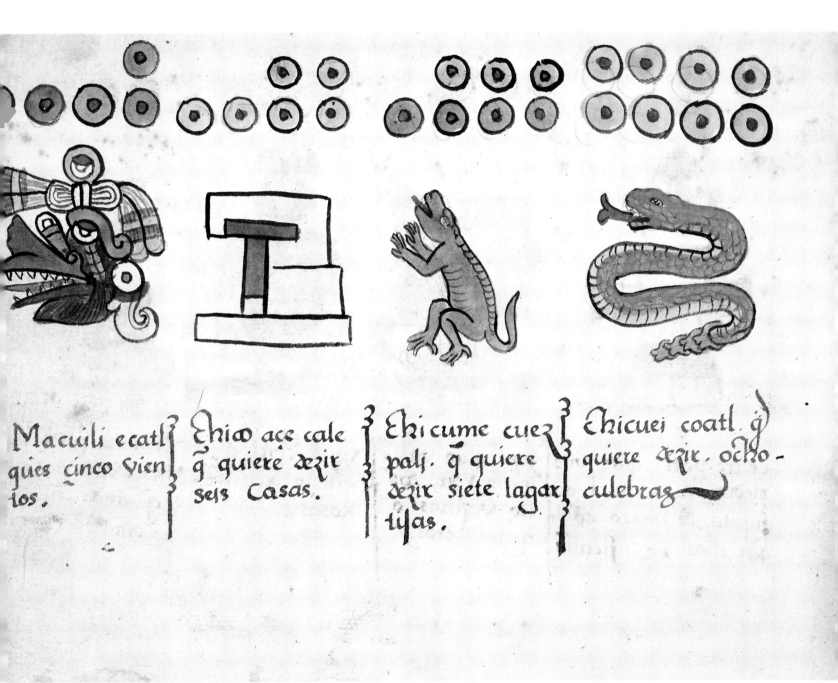

Macuili ecatl ques cinco vientos.

Chicoaçe cale q̃ quiere dezir seis Casas.

Chicume cuezpali. q̃ quiere dezir siete lagartijas.

Chicuei coatl. q̃ quiere dezir. ocho culebras

energy. This entailed developing a science of calendars that would yoke daily existence to ceremonies and rites designed to reproduce the major events of creation on a human scale.[80] A group of experts, specialized in the science of cycles and calendars, the decoding of dreams, and the reading of "paintings," had a determining impact on society. They were the ones who transmitted their expertise to the young nobles in the *calmecac* schools in the large cities.

Given all this, it is easy to understand why the missionaries became interested in native calendars, and why they were so perplexed by

systematically so that the same combination (of sign and number) does not recur for two hundred and sixty days (20 x 13), which was the length of the ritual year, or tonalpohualli. These plates show the days One Flint Knife, Two Rain, Three Flower, Four Water Monster, Five Wind, Six House, Seven Lizard, and Eight Snake.

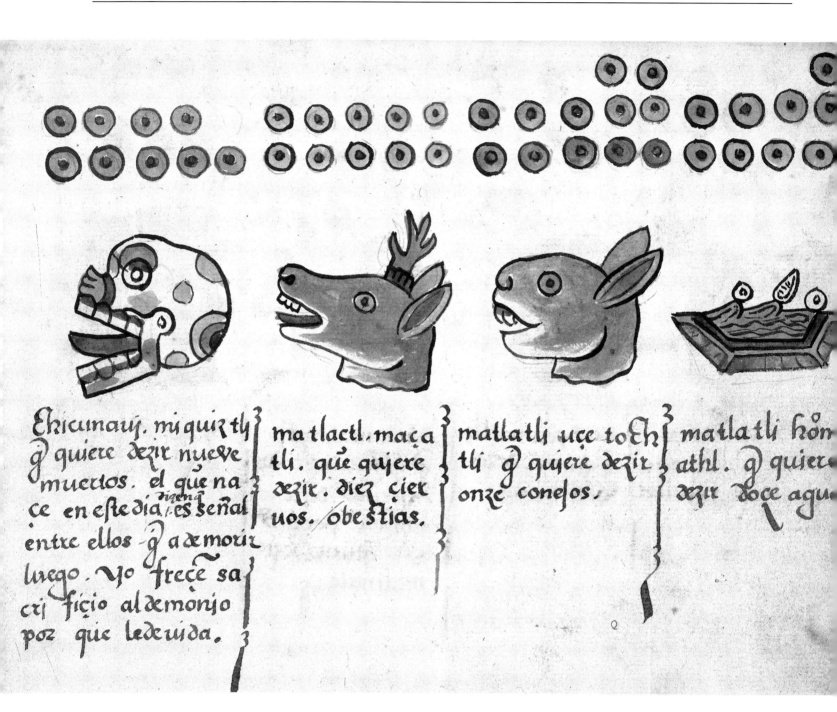

Nine Death, Ten Deer, Eleven Rabbit (the tlacuilo *mistakenly painted twelve dots),
Twelve Water.*

the incredibly dense and overlapping scope of issues covered by such calendars. The *tlacuilos* asked to paint such documents or to supply interpretations also found themselves in a difficult situation. For the colonial regime had led to the loss of a part of the esoteric knowledge behind this science, whereas the surviving part continued to govern, despite Christianization, countless activities such as crop cultivation, trade, food consumption, marriages, and even bathing.[81] The Spanish were amazed to see Indians in the fields await some mysterious

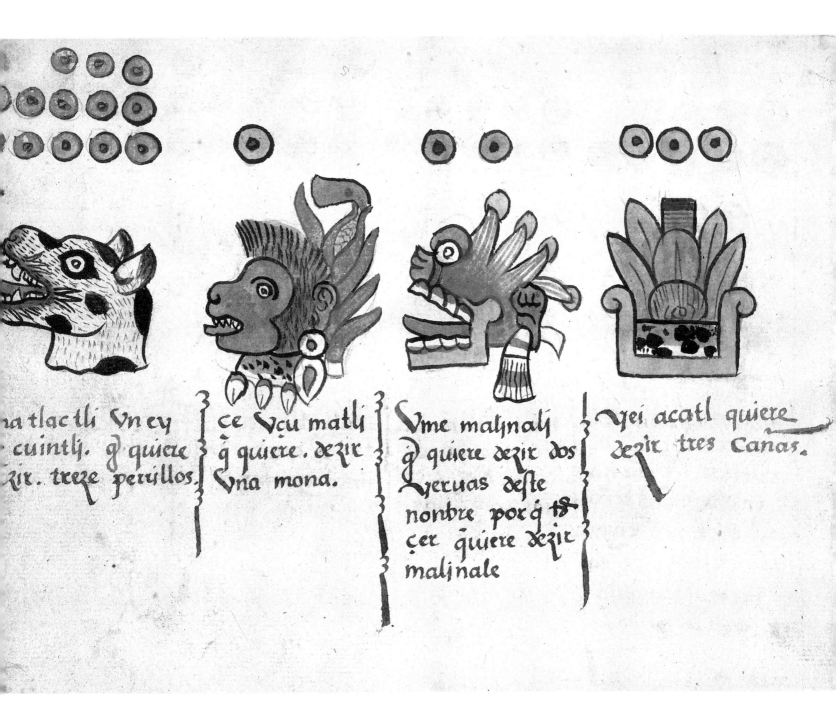

na tlactli Vn ey
cuintli. q̃ quiere
zir. treze perillos.

ce Vçu matli
q̃ quiere. dezir
Vna mona.

Vme malinali
q̃ quiere dezir dos
yeruas deste
nonbre por q̃ tʃ
çer quiere dezir
malinale

yei acatl quiere
dezir tres cañas.

authorization to harvest corn that had stood ripe for some time. Yet the elders would repeat, even in front of worried and exasperated Spanish priests, that "everything had its own reckoning, justification and appointed day." [82] Finally, under the influence of Europeans who projected their own conceptions of time (notably their taste for astrology and the zodiac[83]) onto Mexican calendars, traditional beliefs became scrambled and hybridized. Yet they never completely disappeared.

74. Ritual Calendar Symbols
Codex Magliabechiano, fol. 12 v.

Once Thirteen Dog has been reached, the numbers begin again with One Monkey, Two Grass, Three Reed, etc.

Fate

European missionaries nevertheless grasped one of the basic principles behind the Nahua conception of time and the individual: the importance of fate. A force known as *tonalli* linked the individual directly to the cosmos. It represented the warm, luminous presence of energy originating from the time of creations, and it determined an individual's earthly destiny. The Nahuas represented *tonalli* as a sort of invisible thread leaving the head.[84] Hair was therefore thought to be the receiver and receptacle for this force.[85]

Unborn infants in the womb were exposed to an initial *tonalli* that came from the upper heavens.[86] Once born, a child received its definitive *tonalli* along with its name. The nature of the *tonalli* depended on the day of birth, and determined the temperament, strength and fate of the new human being. Certain dates promised success, others protected the child from attacks by sorcerers. But woe to any child born on one of the last five days of the year and thus devoid of any influence: "He will live in anguish, will live on earth like a wretch." Parents would abandon such children to the priest, who would then sacrifice them so that they could pursue an existence among the gods that would be less dreadful than the fate awaiting them on earth.[87] The power of the *tonalli* was acquired via a ritual bath administered by the midwife, this rite being performed only if the *tonalli* corresponding to the day of birth was favorable. In order to determine this, parents consulted a priest, a "reader of fates" who consulted his "painted books." If the sign were unfavorable, it was possible to cheat fate—or rather inflect it—by postponing the ceremony to a more propitious day set by the priest. During this rite, the midwife would attach tiny arrows to the umbilical cord of a boy child, then dry it and take it to a battlefield, whereas the umbilical cord of a little girl would be buried near the hearth along with small objects representing the utensils she would use in her adult life.[88] Thus the place and social role of each sex was forever determined.

It may therefore have appeared as though life were played out in advance; this was probably not the case, but the Spanish missionaries interpreted it that way. Such determinism, which they considered to be a radical negation of free will and the true faith, scandalized them. Christianity (coupled with an Erasmus-inspired humanism for certain Franciscans) proclaimed human liberty and autonomy before God, "to whom alone the things to come are present."[89] The evangelists' objections, however, also betrayed the nagging anxiety that familial beliefs and rites were still being followed in the privacy of the home, unlike public celebrations and human sacrifice. Precise knowledge of such rites was therefore needed in order to eradicate them. Christian missionaries were not only supposed to decipher the principles behind the ritual calendar, but also be aware of the numerous situations it predicted. This required constant vigilance.[90]

75. Ritual Calendar Symbols
Codex Magliabechiano, fol. 13 r.

Six Vulture. People born under this sign were doomed to a grim fate.

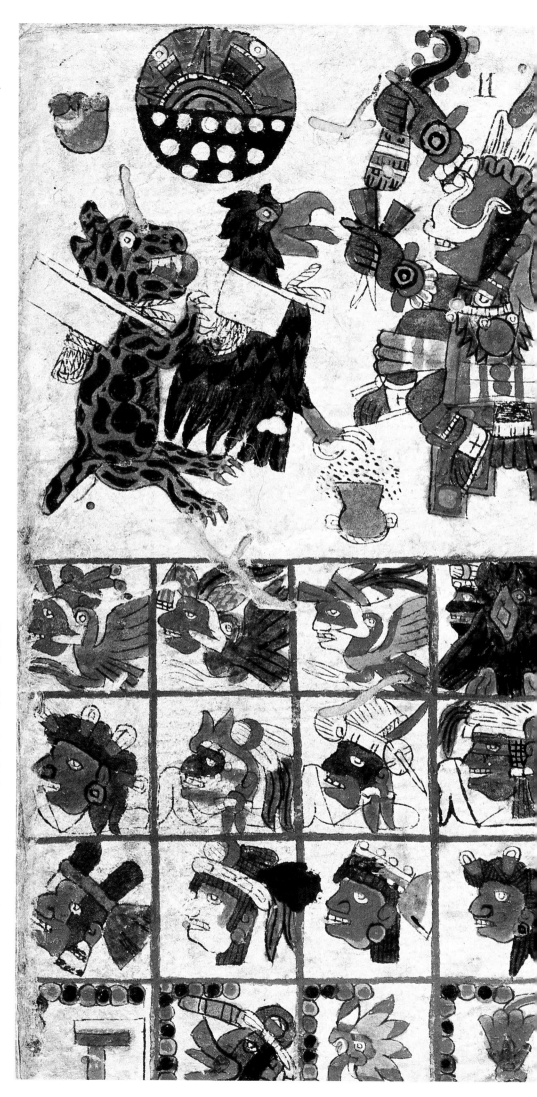

76. A Ritual Calendar
Tonalamatl Aubin, Pl. 11

The ritual calender contained two hundred and sixty days, or tonalpohualli ("Count of Days"). This codex is composed of a set of pages divided into thirteen-day periods, or "trecena." The surface is organized in four quadrants. The upper left quadrant shows the deities that govern the trecena. This eleventh "week," One Monkey, is governed by Patecatl, the god of pulque, *as well as Quauhtli the eagle and Ocelotl the jaguar. The three other quadrants are composed of squares containing the symbols for the thirteen days (nine in the bottom row and four in the upper right-hand row) along with the birds and deities corresponding to those days.*

In typical pre-Hispanic manner, the two-dimensional space is vigorously compartmentalized by lines and frames. Shapes and figures are deployed uniformly to fill the surface, as though the dread of a vacuum or the concern to use all available space constantly guided the tlacuilo's *brush.*

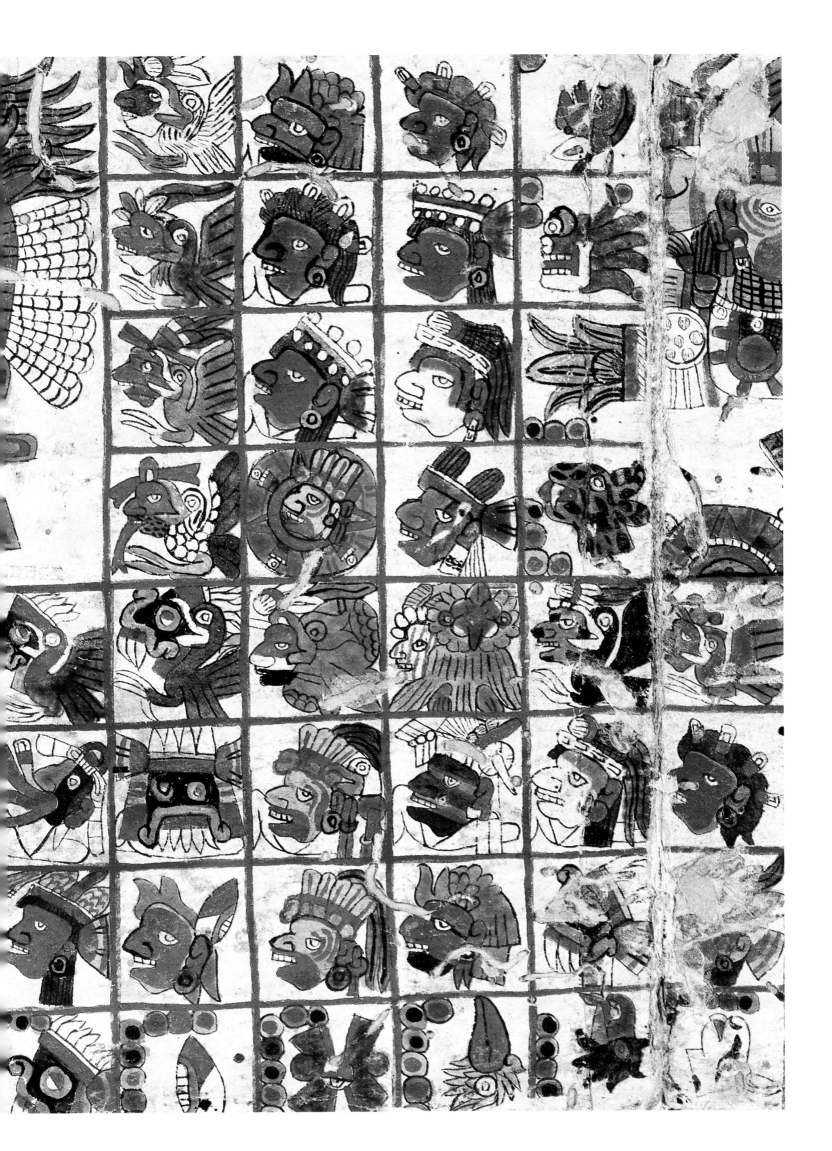

To find a path through this maze of fears, practices and rites, the missionaries had to rely on native informants and painters still familiar with former techniques and knowledge. Those who worked on the *Florentine Codex*, in particular, fully collaborated in this undertaking, even if their participation was a tricky affair in this instance. For they were perhaps helping to identify and denounce customs that, unlike the huge ceremonies and human sacrifices belonging to the past, were still an integral part of the everyday environment.

Clandestinity: Dissident Nobles, Healers, and Human-Deities

Some native Mexicans rejected this ambivalence, this betrayal. They overtly or, more often, secretly remained faithful to the tradition of their forefathers. They rejected the standardization of belief imposed by monotheistic Christianity. They defended the religious practices that had earned them the protection of the gods since the dawn of time. Indians who read the Bible pointed out, rightly, that both polygamy and human sacrifice (which Abraham intended to perform) could be found in the Old Testament, though outlawed by the church. The differences in clothing and practices that separated Franciscans, Dominicans and Augustinians (not to mention contradictions within the Holy Scripture), led the Indians to relativize the significance of the sermons they heard. The new religion proclaimed that eating human flesh and hallucinogenic mushrooms was an abomination, yet prior to the conquest such customs had provided nobles with strength and superior energy. Some Indians criticized the missionaries themselves, challenging their strange—indeed clearly absurd—conduct: "These poor people must be ill or mad; let these wretches clamor, they are overcome with madness; let them be as they are, for in the end they, like the others, will die of this malady of madness. . . ." Itinerant pagan preachers followed in the path of the missionaries, undoing what the latter had done and not hesitating to roil the population by announcing the imminent end of time. Spanish monks, they claimed, would soon be transformed into *tzitzimime* monsters, "hideous, dreadful figures who would eat men and women. . . . The human line would then come to an end, night and darkness would reign forever."[91] Finally, formerly obscure natives proclaimed themselves to be Tezcatlipoca or Tlaloc, and the people rendered them the homage due such powerful deities. The Inquisition conducted by the bishop of Mexico City extracted the following testimony from one of these human-deities in 1537: "Instead of doing what the Franciscans told me to do, for three years I preached and asserted that the Brothers' sermons were worthless, that I was god, that the Indians had to offer sacrifices to me and return to the idols and sacrifices of old. I made it rain when it rained. That is why they

offered me paper, copal, many other things, and land. I often gave my sermons openly in Tulancingo, Huayacocotla, Tututepec, Apan and in many other places. It was at Tepehualco that I became a god. Since it hadn't rained, I performed magic incantations with copal and other things. The next day it rained a great deal. That's why they took me for a god. . . . I declare that when I performed such superstitious acts and witchcraft, the devil (the pre-Hispanic god) spoke to me, saying, 'Do this, do that.' At Tepetlaoztoc I did again what I had done at Tepehualco, I performed ceremonies and offered copal. It began to rain and they took me for a god nigh on three years ago." [92]

The nobility was more prudent. Like Don Carlos (the Indian noble burned at the stake), it led a double life. To preserve and transmit the memory of divine things, clandestine studios reproduced the ancient codices. Nobles hid these images and were careful not to show them to anyone, particularly servants, who might denounce them to the Spanish. Those who took the risk of bringing such images out of hiding refused to part with them at any price, and allowed copies to be made only in their presence and under their supervision.[93] Teaching and transmitting calendars to young people was still a thriving practice at the end of the sixteenth century. This was deplored by the Spanish, who were not fooled by the apparent piety of the Indians.[94] The *Tonalamatl Aubin*, the *Codex Borbonicus* and the *Codex Selden* (1556) offer an idea of what these studios may have produced; they sometimes follow pre-Columbian canons so faithfully that they have been mistaken for pre-conquest works.[95] Certain clues point to an evolution in composition, however, and can only be attributed to the colonial environment. The traditional arrangement of information, for instance, is sometimes replaced by a European page layout. Even ancestral paganism could not remain entirely free of European influence.

77. Born under the Houses
Eight Death and Nine Deer
Florentine Codex, Vol. I, fol. 276 r.

"On Eight Death, it was evil; likewise Nine Deer was in no way a good day sign. For, as it was said, the day signs taking ninth place were in no way a time of good. For whosoever was born on it, man or woman, nothing became one's fate. . . . [So] the readers of the day signs bettered and remedied the nature of the day sign on which the useless one was born. They arranged that later, upon Ten Rabbit, he would be bathed and given a name."

The representation combines old-style counting (groups of five dots connected by a line) with a European rendering of the skull (shaded to suggest volume) and deer (in the act of grazing, set in a simple landscape). Realism here gets the better of stereotyped forms. The two lower scenes bring in the mother, midwife and divinatory specialist. The midwife greets the newborn infant with affectionate words (represented by the volutes) while the "master of fates" gives the child a bath. The child receives the name corresponding to his birth sign (once again represented by the volute).

III. Remembrance of things past

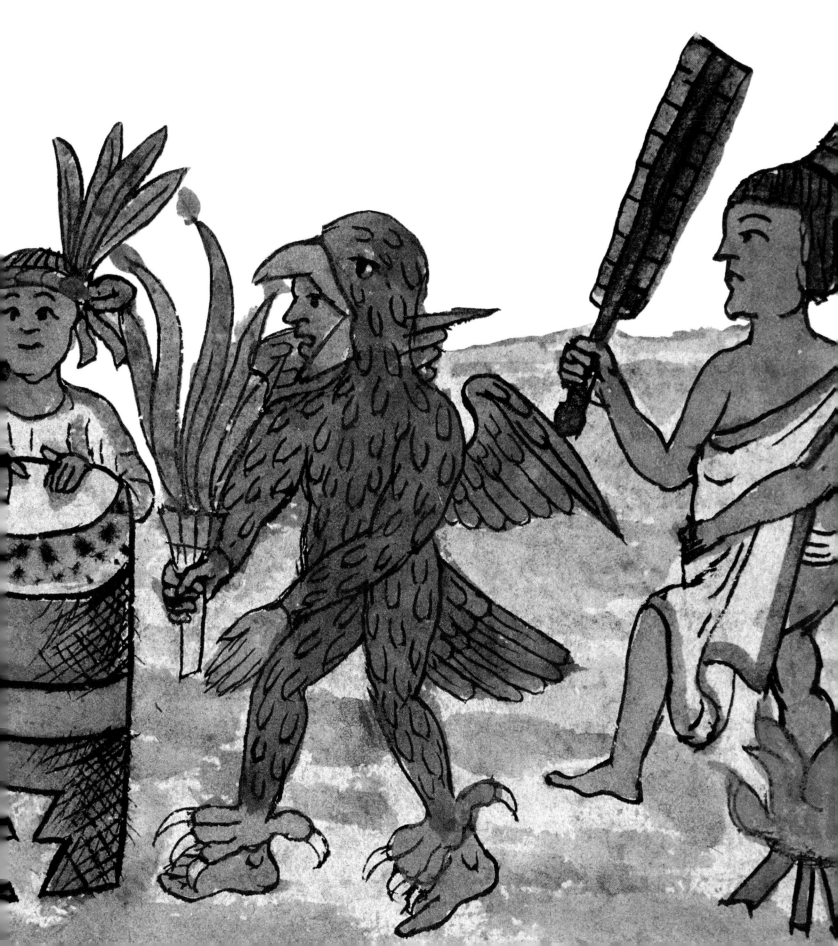

79. The Founding of
Mexico-Tenochtitlan
Codex Mendoza, Pl. 1

This plate depicts the founding of Mexico-Tenochtitlan. Canals divide the site into four triangles. In the center is the glyph for Tenochtitlan: a stone (tetl) topped by a prickly pear cactus (nochtli) plus the suffix for "place" (tlan). The city was founded on the spot where an eagle—an incarnation of Huitzilopochtli—perched on a cactus. It was divided into four neighborhoods, a system that survived the Spanish invasion. The founders of each section are represented, their names indicated by glyphs behind the head. In the lower register, the painter depicts the conquest of Colhuacan and Tenayucan. Bordering the plate are symbols for the fifty-one years of the reign of Tenochtli, lord of Mexico-Tenochtitlan from 1325 to 1375. His reign began in the year Two House (upper left) and ended in Thirteen Reed (top, center).

The plate is handled in the spirit and style of pictographic codices (use of glyphs, absence of background, two-dimensional space, posed figures). But the outlining is less bold than in pre-Hispanic images and, of course, the addition of alphabetical writing to identify places and characters dates this document from the colonial period.

◁ 78. Dancers and Musicians
Codex Durán, Chap. LIV

More than half a century after the conquest, new generations had been spawned, had lived, and had died. Yet in many households, elders still remembered. They had known the former world as children. Others had been raised by parents who had spent most of their lives under the sway of native gods and lords prior to seeing their lives transformed by the arrival of the conquerors. Rummaging through their memories or gazing at paintings that recounted the old ways, they recalled the monarchs of yore, the magnificent regalia, the wars and invasions. Long ago, they were more populous—villages everywhere teemed with people. Long ago, daily life was organized around work, war and rites. Since these reminiscences would soon fade forever, it was urgent to set them down. The Indians realized that evocation of the past could be compatible with Christianity as long as idolatrous aspects and all references to pagan beliefs were expunged. Yet this delicate surgery still had to be performed, and Spanish suspicions had to be allayed. It was not easy to separate historical material from what the Spanish called "myths." Nor was it easy to produce a secular history when, as explained above, Mexican culture inextricably mingled the human with the divine.

Recollecting Ancestry and Titles

Prominent Indian families soon began assembling archives, gathering testimony and documents proving the ancientness of their lineage, in an effort to stave off oblivion as well as to defend the rights granted by the Spanish crown. The European invaders adopted an ambivalent attitude toward such families. The Spanish deprived the Indian nobility of part of its prerogatives and land, humiliating it by forcing these "Sons of Somebody" [96] to bow down to foreigners and sometimes even to Black slaves. They also consistently backed native upstarts who offered their services at opportune moments. Caciques (chieftains) were stripped of everything. Yet the colonial authorities were too sensitive to hierarchy and the value of a noble class—whether Iberian or Mexican—to want to eliminate the former ruling class. Nobles took advantage of this to stand up and proudly proclaim their heritage.

There remained, however, the problem of establishing proof of noble blood during such troubled, uncertain times. Simmering conflicts and disputes that the Spanish conquest had momentarily buried suddenly resurfaced. People began concocting an ancestry to match their ambitions. Such attempts were particularly widespread insofar as there was no longer any indigenous central authority capable of imposing an official, unique version of the past. The collapse of the Triple Alliance and the razing of Mexico-Tenochtitlan left the path clear for provincial nobles who hoped to re-establish or invent a heritage to support their claims and flatter their egos. Such research encountered all sorts of obstacles. These included not only

Aeatitli · quapin

ōcelopa · aguexoat

aeaeimtli · tenuch · xomimitl

xocoyol · tenochtitlan · xiuhcaqz · atotoll

colhuacan. pueblo. · tenayucan. pueblo.

80-82. Episodes Recounting the History of the Mexica at the Turn of the Fifteenth Century
Codex Tellerianus-Remensis, fol. 29 r. and 30 r.

These annals record the history of the Mexica, each year indicated by the appropriate symbol. Noteworthy events are connected by a line to the year in which that event occurred. Thus in 1399 (Eleven Reed), the Mexica went to war against Culhuacan. In 1406, the monarch Acamapichtli died, shown here in his funeral shroud and identified by the glyph behind his head (a clutch of arrows or reeds). Acamapichtli's successor died in 1414 (a second shroud), to be replaced by Chimalpopoca ("Smoking Shield") whose glyph is easily recognizable above his head.

the death or silence of those who still remembered "things past," but also the destruction of archives by devil-hunting conquistadores, missionaries and even Indians who, terrified by the waves of repression, hastily destroyed any paintings that might appear compromising. This was all the more common since there was a very fine line—when there was any line at all—between historical documents and the mythological (hence idolatrous) documents that were the target of destructive campaigns. And when the "remembrance of things past" managed to overcome all these obstacles and convert divine figures into flesh and blood, it was confronted with other dilemmas. Producing a history credible to Spanish eyes meant employing European models, adopting European chronology, and renouncing once again a cyclical vision of time. It also meant developing new representational strategies. The *Historia Tolteca-Chichimeca* offers a remarkable example of this.[97] Produced in the mid-sixteenth century, this account describes the origins of the various ethnic groups that occupied Cuauhtinchan lands to the southeast of

the Valley of Mexico, recounting the expeditions undertaken by the forebears of noble houses. The book's authors contrived, between 1547 and 1560, to combine the inspiration behind traditional paintings (which occupied full and occasionally even double pages) with alphabetic writing and European illustration techniques learned from Spanish missionaries.

These historiographic undertakings were not aimed merely at defending heritage claims. Histories of ancient kingdoms were also produced, sometimes at the express request of the Spanish authorities. Viceroy Mendoza commissioned Francisco Gualpuyogualcatl, head of the Mexico City painters' guild, to produce the codex that now bears the viceroy's name. The *Codex Mendoza*, painted on European paper, was conceived and executed in 1541-1542, that is to say a full generation after the Spanish conquest. It recounts the history of Mexico-Tenochtitlan from its founding (1325) to the aftermath of defeat (1522). The narrative proceeded reign by reign, with the painters describing the victories attained by each monarch. Other

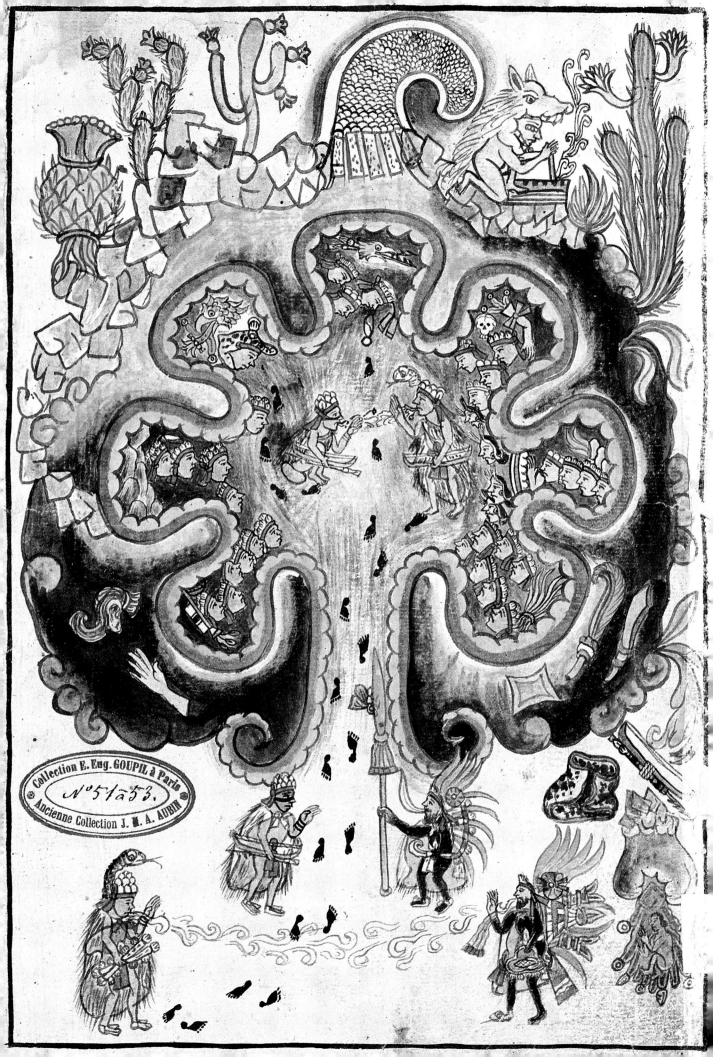

◁ ◁ 83. Journey to Chicomoztoc
Historia Tolteca-Chichimeca,
fol. 16 r.

*"On the day Thirteen Flower, Icxicouatl
and Quetzalteueyac left Xalpantzinco for
Colhuacatepec Chicomoztoc, where the
Chichimec chieftains were to be found."
The two ambassadors, with large feather
headdresses (lower right) went to seek aid
against their enemies.*
The Historia Tolteca-Chichimeca, *pro-
duced between 1547 and 1560, is remarkable
for the simultaneous importance it places on
pictographs and alphabetical writing. The
primal cavern from which the various ethnic
groups emerged is located in a mountain
topped by the glyph for snow (a white horn)
and various species of cactus. The footprints
indicate the comings and goings of the
interpreter (lower left), who attempts to
convince the inhabitants of the cavern to come
to the aid of Icxicouatl and Quetzalteueyac.*

◁ 84. Names for Chicomoztoc
Historia Tolteca-Chichimeca,
fol. 16 v.

*The text gives the esoteric names attributed
to Chicomoztoc, the cave in which the
Chichimecs dwell. The plate gives some of
these names in glyph form. Thus "white
willows" are placed on the left and right,
"mottled cotton" grows from the left side of
the central rectangle, and "mottled water
lilies" grow on the right (evoking certain
Egyptian paintings). "White rushes" grow
on top of the rectangle, itself composed of
the union of water and fire, the glyph for
sacred war, the image of cosmic flames
leaping from precious water (which also
represents blood leaping from sacrificial vic-
tims captured in battle).
In the lower register, the ball game of pelota
is depicted on the H-shaped court.
The trees and vegetation are already highly
influenced by European art. Here, however,
the shading, tonal variations, and apparent
realism are employed to convey pre-Hispanic
codes and metaphysics.*

codices also recounted the great city's past in terms of successive monarchs, notably the *Tellerianus-Remensis* and the *Codex Azcatitlán.*[98] Symbols indicating the year ran horizontally and the events associated with those years were shown via glyphs. The history of the Mexica tribe also inspired the *Mapa de Sigüenza* and the *Tira de la Peregrinación* (circa 1540). A few years later, the *Mapa Tlotzin* and *Codex Xolotl* recounted the Chichimec history of Texcoco, a city second only to Mexico-Tenochtitlan.

The Splendor of Bygone Princes

It was impossible to dissociate recollection of the past from the memory of bygone splendor. Mexican nobles proudly recalled the pomp of former monarchs and courts that had so astonished the conquistadores when they first entered the Valley of Mexico. Bernal Díaz del Castillo's descriptions of Moctezuma's residence repeatedly betray the European's amazement at such unprecedented refinement.[99] Nor were native and mestizo chroniclers to be outdone. Moctezuma's palace was described as a veritable labyrinth, the center of the cosmos. The image presented by the *Codex Mendoza* is already Europeanized insofar as it is three-dimensional, but its schematic nature indicates that the artist was more interested in conveying a symbol of supreme power than in providing a realistic description of the buildings. Until the Spanish swept him from power, Moctezuma's life was steeped in courtly ceremony. The monarch's authority was all the more absolute since his person was nearly divine, and he was constantly surrounded by the luxury of his collections of jewelry, gold, jade, fabrics and animals, not to mention his apparel, his wives, and his slaves. Other nobles kept pace, and nothing was more incongruous than the first encounter between these extraordinarily groomed dignitaries with their bouquets in hand, and the sun-scorched conquistadores, sweaty and stinking in garments frayed by harsh travel.

Prior to the Spanish invasion, the source of wealth was booty seized during wars, plus regular shipments of tribute paid by conquered peoples. The polychrome plates of the *Codex Mendoza* enumerate the contents of tribute sent by defeated city-states. These plates were inspired by pre-Hispanic registers but their internal organization had to be redesigned and rearranged to conform to a colonial codex with illustrated plates. Merchants' caravans abetted long-distance trade of luxury goods, or distributed part of the merchandise sent by tributary nations. Precious goods such as gold, jewelry, multicolored feathers, slaves, cacao, honey, weapons and finery flowed into cities in the center of the country, notably to the huge Tlatelolco market in Mexico-Tenochtitlan. The memory of the opulence of pre-Hispanic markets haunted the conquistadores and all those who survived the conquest, for they had to adapt to an economy

that was disorganized and impoverished by war and the new order.[100]

In the fifteenth century, Mexico-Tenochtitlan managed to surpass all other city-states, whether allied or enemy. Tlaxcala, which collaborated with the Spanish from the start, was one such enemy. Tlacopan and Texcoco, on the other hand, were linked to the city on the lake by an alliance that guaranteed the three partners control—though somewhat unequal—of most of the high plateau and the coastal regions. The fall of Mexico-Tenochtitlan and the Mexica defeat in 1521 gave its close allies as well as its enemies a freedom of expression they had lost prior to the conquest. Texcoco, whose territory covered the eastern shore of the lakes, conscientiously marked its distance from Mexico-Tenochtitlan, and its historical accounts suddenly became unfettered. Local chroniclers endowed Texcoco with a thousand years of existence and remarkable rulers about whom much was written during the colonial period. Nezahualcoyotl (1402-1472) and Nezahualpilli (1465-1515) were attributed with prestige superior to that of the great Moctezuma, and painters depicted them dressed in magnificent finery, delicately worked cotton and feather

85. A Page from the Historia Tolteca-Chichimeca, f. 24 r.

Text and pictographs follow one another as in some medieval illuminated manuscript. Each vignette incorporates a leader and a place name corresponding to a stage in Chichimec migration.

86. On the Warpath
Historia Tolteca-Chichimeca, fol. 23 r.

Dressed only in loincloths, the Chichimecs leave Chicomoztoc (top). After singing a hymn, two figures shoot arrows into the malinalli plant (left) and nopal cactus (right) that bleed red drops onto the page. This rite was designed to nourish the gods with their vital beverage, and also served a divinatory purpose.

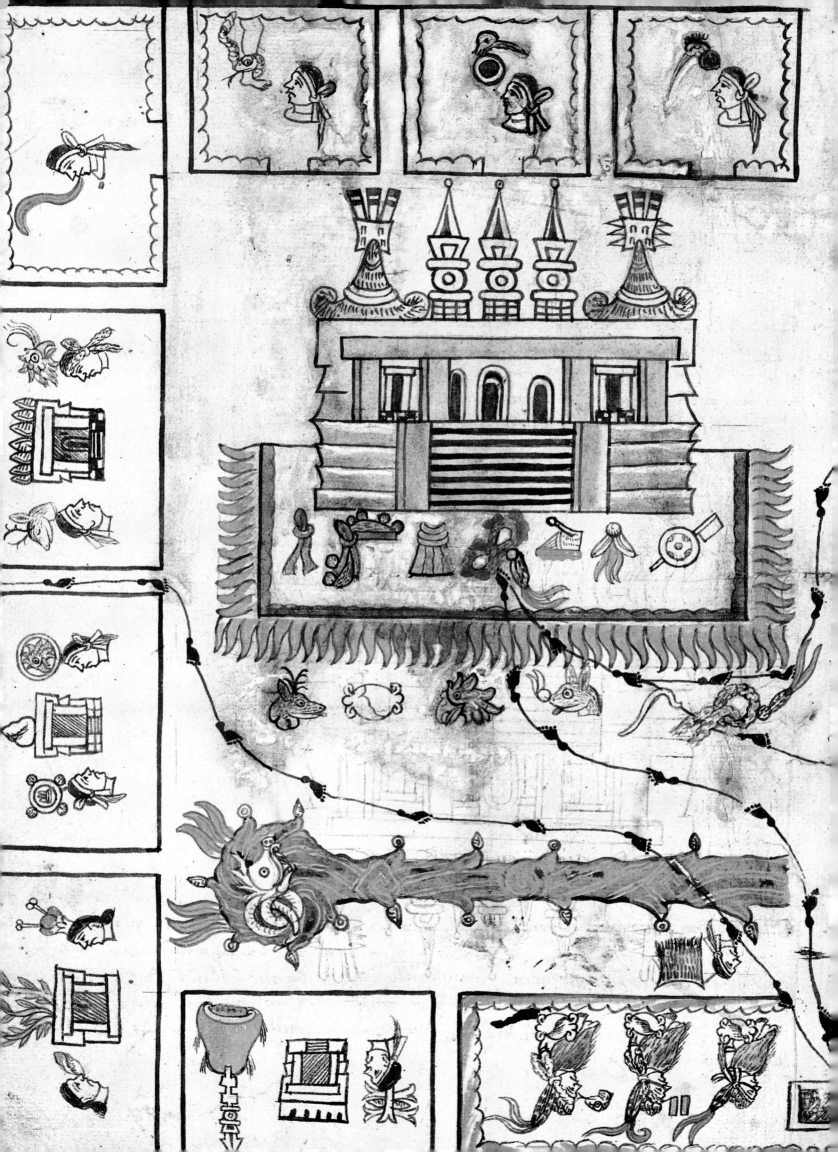

garments. For these native and mestizo historians, current adversity merely served to underscore the virtues of those "blessed days" when rulers performed true justice. It goes without saying that the tribute demanded by such monarchs was moderate when compared to the exorbitant demands of the Spanish and the conditions imposed by the Mexica.[101] And, to clear themselves of accusations of idolatry, these historians claimed that human sacrifice, idol worship and cannibalism as practiced prior to the Spanish invasion were all invented by the Mexica. The Mexica were portrayed as heinous invaders—which may have been a way of discreetly depicting them as the precursors of the conquistadores who would one day come to impose their own authority and religion.

Nobles and Commoners

Glorifying the past also carried class connotations. Defending the old order served the interests of the former ruling class threatened by Spanish domination. The Spanish conquest disrupted social and cultural differences marking the distinctions between individuals and groups. Mexican nobles were particularly sensitive to this disorder, which was so diametrically opposed to the ordered (and, apparently,

◁ 87. Arriving at Cholula
Historia Tolteca-Chichimeca,
fol. 26 v. and 27 r.

Having left Chicomoztoc, the Chichimecs arrive at Cholula. There they reassemble (center of lower register) then go to the "House of Turquoise" (Xiuhcalli) before leaving to make war against their enemies. The painter has depicted the various sectors of Cholula—the squares bordering the plate correspond to the various neighborhoods. The footprints indicate the route taken to link the House of Turquoise (center, left) to the Tlachiualtepetl pyramid (identifiable by the toad squatting on the mountain). The Quetzalac river flows below the House of Turquoise.

88. Moctezuma's Investiture
Codex Durán, Chap. LII

A prince presents the Lord of Mexico-Tenochtitlan with the royal diadem and regalia. The recollection of this event—the last coronation before the Spanish conquest—is conveyed through forms dating from the latter half of the sixteenth century. The monarch's palace is packed with Renaissance motifs that lend this part of the codex a motley, kitsch appearance.

89. Nezahualpilli, Lord of Texcoco (1472-1515)
Codex Ixtlilxóchitl, fol. 108 r.

This monarch, successor to Nezahualcoyotl, is dressed in a navy blue cape and matching loincloth. He holds a bouquet of flowers in his left hand and a feather fly-swatter in his right hand. Gold ornaments encircle his arms and calves. The European-style representation, which effectively drapes pre-Columbian finery on a Greek statue, in no way diminishes the magnificence and refinement of the princely attire that provoked wonder among the conquistadores.

90. A Lord ▷
Codex Ixtlilxóchitl, fol. 107 r.

The cape is decorated with shells and a fringe of rabbit hair. As usual, the lord is shown holding a bouquet of flowers and a stick of tobacco that gives off smoke. Scents and smoke were thought to strengthen the vital forces that empowered the ruling classes. The headdress is decorated with small quetzal feathers.

increasingly stratified and rigid) world they or their parents had known. They were nostalgic for long nights spent ingesting hallucinogenic mushrooms and journeying to divine worlds. They still longed for the incomparable taste and supreme energy associated with the flesh of sacrificial victims. Not so long ago, nobles were distinguished from ordinary mortals by privileges of war, human sacrifice, polygamy and many other customs now outlawed or forgotten. Christianity, which claimed that all Christians were equal before God, had

91. A Noble ▷▷
Codex Ixtlilxóchitl, fol. 105 r.

This noble holds flowers and a tube of tobacco in his right hand. Elegance is conveyed by the gold necklace, bracelets of turquoise strung on a red cord, a (golden?) labret, ear ornaments and a cape in a pattern seen in the Codex Magliabechiano.

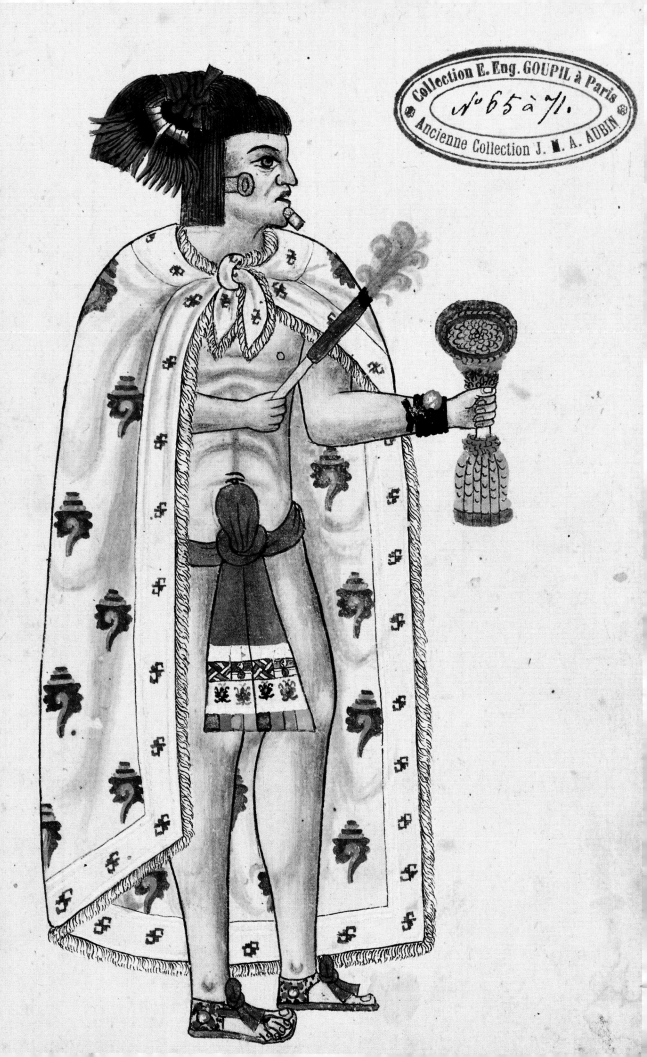

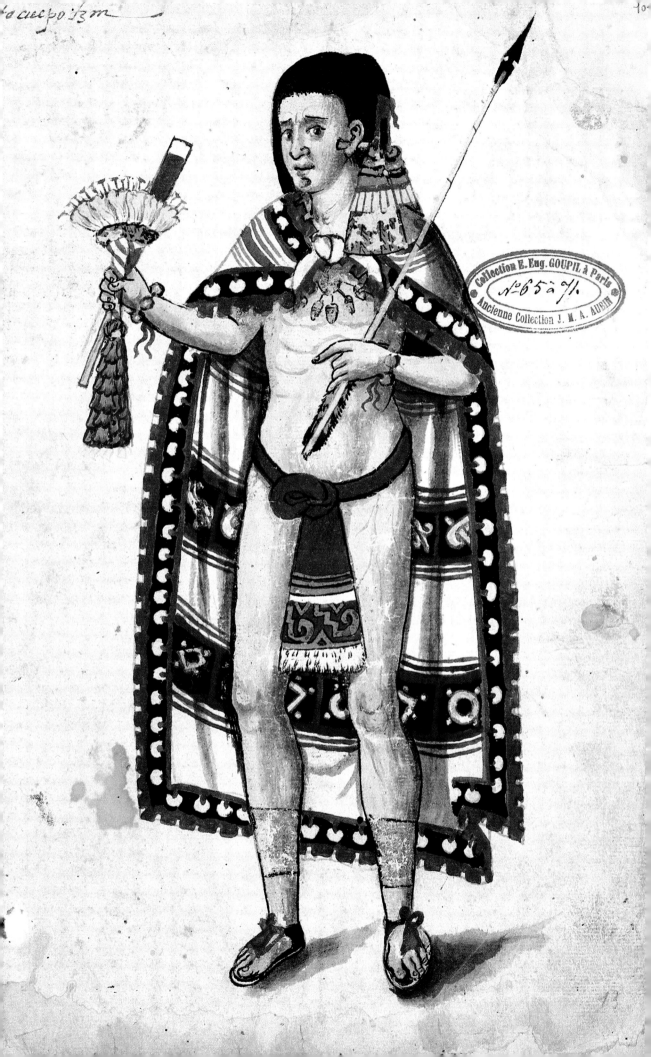

92. Moctezuma's Palace
Codex Mendoza, Pl. 70

"A drawing of the Lord of Mexico-Tenochtitlan's council chambers, his palaces, courts and steps by which one entered, as well as Moctezuma's throne." The commentary praises the order and justice that prevailed under Moctezuma: *"Thus, out of fear, all his vassals devoted themselves to useful things."* During Spanish rule, this comment often represented masked criticism of the chaos and incoherence of colonial society.

In the center of the upper register, Moctezuma sits on his royal mat. To the monarch's right and left are buildings in which his allies and friends were received. The two patios constitute royal courtyards. Below, to the left, are the chambers for the war council and, to the right, Moctezuma's personal council. In the lower right corner, plaintiffs arrive to plead their cases before Moctezuma's judges.

This picture combines several planes partly organized around an attempt at perspective drawing. The back of the rooms is darkened to underscore the impression of depth. Although the lines converge toward several different vanishing points, the European lesson has been sufficiently well learned to alter the original layout of the palace and its symbolism. Thus, instead of occupying the center of a group of four palaces arranged along the four cardinal points, the throne room is now placed at the summit (and most distant part) of a huge architectural edifice. This demonstrates how the use of new forms can modify traditional content without the painter necessarily being aware of the change.

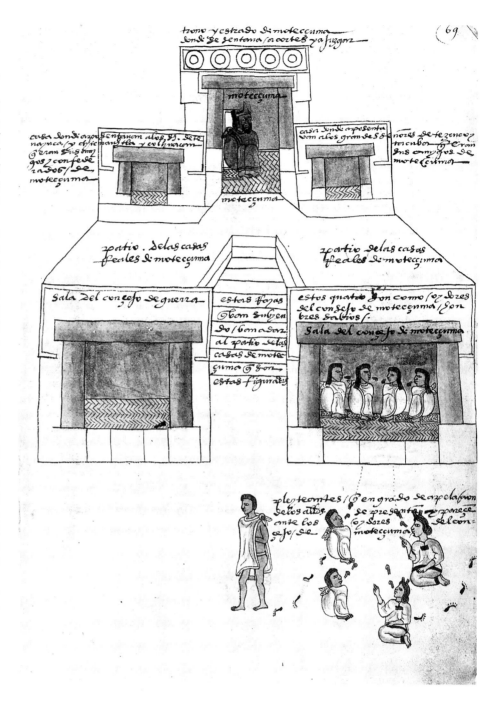

dramatically changed such habits. The Spanish conquest had sown chaos, whereas the nobles recalled—or thought they recalled—pre-Hispanic civilizations structured in the image of the cosmos, with strictly delineated hierarchies offering a pre-eminent role to priests and warriors.[102]

Painting this former world meant regaining prestige, cultivating nostalgia and secretly reaffirming ancient values destroyed by the invaders and Christianity. Traditional Nahua beliefs accounted for social differences found in native society and for the ways in which

these differences were perceived and acknowledged. Before the European invasion, the powerful upper class, or *pipiltin* ("Sons of Somebody"), skimmed off most of the tribute demanded of conquered peoples; they governed cities and led armies because they were supposed to harbor a vital energy, *tonalli*, more intense than that found in the rest of the population. In principle, nobles alone could wield power. The luxury objects they conspicuously consumed helped them maintain this vital energy—jade, quetzal feathers, colorful garments and bouquets of flowers were highly prized accessories. Heady perfumes, the effect of psychotropic plants and the flesh of wild beasts all raised the ruling class above the common people, lifting them toward delightful, divine worlds. Right from birth, nobles knew they were destined to occupy administrative, military or priestly posts. As adolescents in school, they proved their merit by subjecting their own flesh to harsh trials that strengthened their *tonalli*. The eldest nobles still recalled those days even during the period of Spanish rule.

In pre-Hispanic times, *pochteca* merchants did not enjoy the same rights and privileges as nobles. They nevertheless assumed significant economic responsibilities. They participated in the expansion of city-states and territories because they performed scouting and spying duties along with their commercial role. It would even appear that in the decades preceding the Spanish invasion, the rise of the merchant class began to worry nobles and the highest authorities. The biggest merchants controlled trade with distant lands and the supply of precious goods. They furnished the cacao, shimmering feathers and slaves that the lords and courts used so extensively. They also dominated the markets where goods produced in the Valley of Mexico were exchanged for those from distant provinces. For this reason, merchants maintained close ties to craftsmen of luxury items, such as the goldsmiths, *amanteca* featherworkers and gem-cutters who acquired privileged status through their artwork.

Pre-conquest painters ignored the common people; the universe they depicted was that of the gods, the princes and the priests who mingled with them. These painters' successors under Spanish rule likewise ignored the people, except when responding to an express request by the monks to show a world in which each person occupied the place he merited or received the punishment required by tradition. Both before and after the conquest, nobles held commoners in disdain and contempt. Don Carlos, the lord of Texcoco burned at the stake in 1539, had precisely criticized Christianized nobles for being too concerned with what their servants believed. Only the *Codex Mendoza,* perhaps, took a retrospective look at these hardworking groups of artisans, city-dwellers, farmers and fishermen. Their lives were not left to chance, either, for the children of commoners received moral and physical education in special schools that they were obliged to attend. As to individuals consigned to the lowest level of society

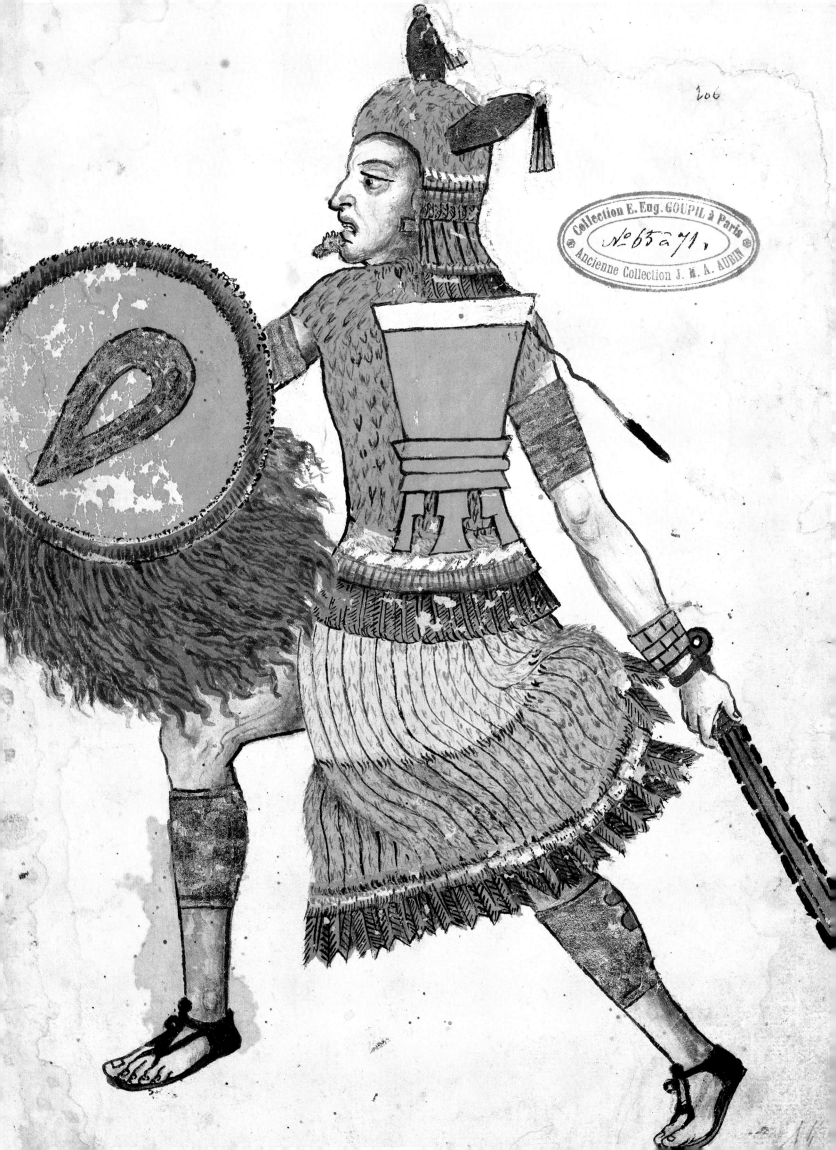

206

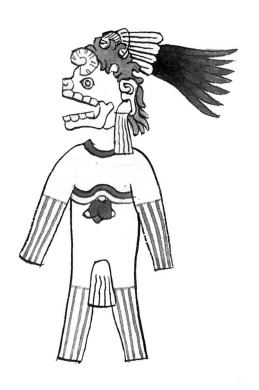

◁ 93. Nezahualcoyotl, Lord of Texcoco
(1414-1472)
Codex Ixtlilxóchitl, fol. 106 r.

This fifteenth-century monarch of the city-state of Texcoco, a powerful ally of Mexico-Tenochtitlan, is shown here dressed for battle. The tunic and feather skirt (ehautl) cover protective cotton padding (ichcahuip-illi). He also wears leggings, bracelets, sandals (cactli), helmet and gold labret (lip plug). In his left hand he holds a shield fringed with feathers (yaochimalli), and in the other he wields a sword (macuahuitl). The small drum on his back was used to give the signal to attack. The painter here conveys the dynamic movement of the warrior charging the enemy, while carefully recording the splendor of his colorful finery.

94-95. Tribute ▷
Codex Mendoza, Pl. 29, 33

This codex provides a description of the tribute that vassal cities were required to send to Mexico-Tenochtitlan at regular intervals. The Spanish were keen to record information that would enlighten them on Mexico's wealth and resources, even if they considered much of the merchandise—such as feather garments—to be of dubious value. To render these tribute lists legible, explanations in Spanish were appended to the images. The explanations are frustratingly brief; it would be interesting today to know the names and dimensions of some of these items, as well as the meaning of their patterns.

The left-hand column of illustration 94 (left-hand page) lists the cities owing tribute: Axocopan, Atenco, Tetepanco, Xochichiu-can, Temohuayan, Tezcatepec, etc. Each city is indicated by its glyph (Axocopan = "Place of the Axocopac Plant," Aten-co = "On the Shore," Tetepanco = "On the Stone Wall," and so on). Next come the objects and merchandise delivered to Mexico-Tenochtitlan's tribute collectors, beginning

with richly worked cotton fabric "worn by caciques and lords," less elaborate cloth with black and white borders, and plain white cloth. Underneath the textiles, the list continues with warriors' outfits and shields decorated with feathers. Still lower, next to piles of corn, beans and chia, there is a jar full of maguey (agave) honey. *The glyphs and numeric symbols contain information on orders of magnitude; thus the flags connected to the costumes on the right indicate the figure twenty, and the feathers above the textiles and the jar of honey mean four hundred.*

Illustration 95 (right) is organized in similar fashion. The tributary pueblo at the top of the list is Jilotepec, "On the Mountain of Tender Corn Stalks." The glyph for mountain is easily recognizable. The textiles reveal a variety of patterns and dazzling colors. Some are spotted like the ocelot, a Central American cat. Tribute also included live animals, such as the eagle shown here, to be added to Moctezuma's zoo in Mexico-Tenochtitlan. One of the battle outfits is probably the uniform of a "Jaguar Knight," worn by the bravest warriors. In the lower register there are two "granaries" filled with corn, beans and chia.

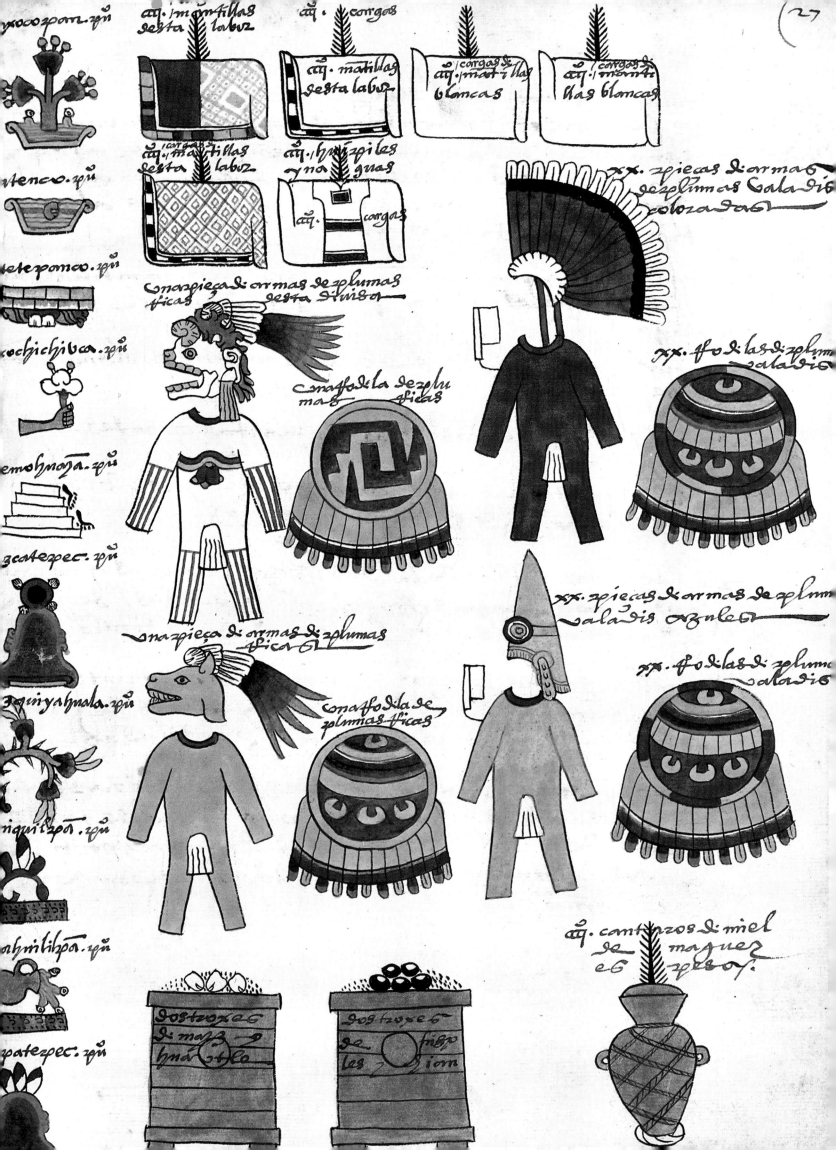

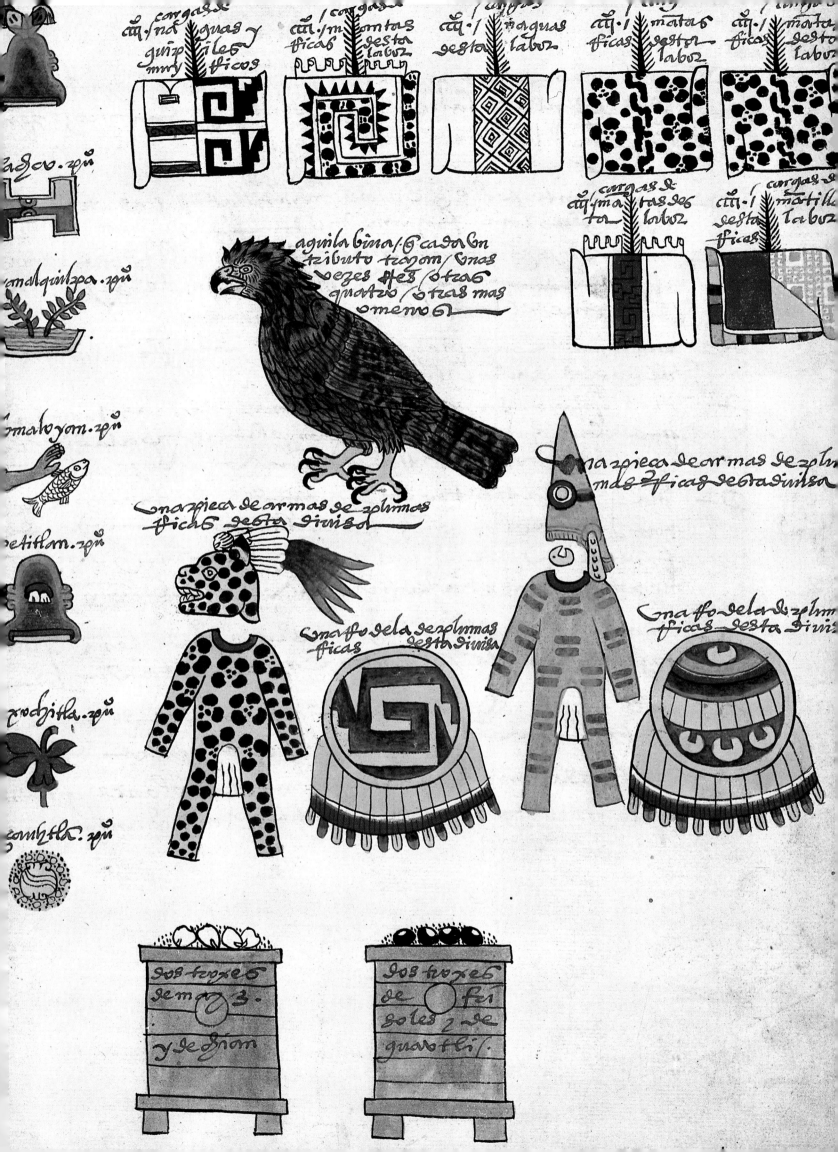

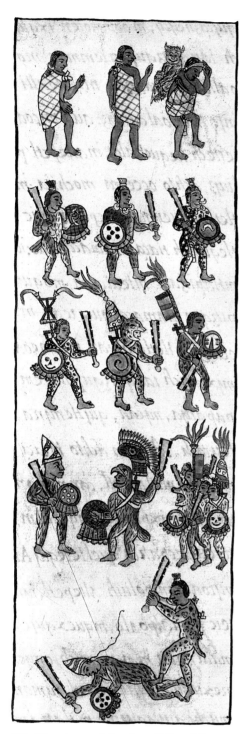

96. The Army Marches Off to War
Florentine Codex, Vol. II, fol. 284 r.

The troops are depicted from top to bottom, beginning with the priests. The third priest carries an effigy of a god (represented here as a horned devil) on his back. Then come the combatants, including an Eagle Knight and Jaguar Knights recognizable by their attire of feathers or animal skin.

either because they had been punished by judges or captured during expeditions, it goes without saying that they were considered inferior and deficient due to a defective *tonalli*.[103] The Spanish viewed them as the equivalent of Old World slaves.

Thus, prior to the Spanish conquest, differences between groups and individuals were understood in terms of degrees of cosmic force. Any changes were perceived through the same prism. Social rise or fall entailed physical transformations effected via rituals (such as baths) designed to intensify or diminish vital energy. The Spanish were not supposed to know this because they would have taken it to be an example of idolatry and condemned it. The Spanish were thus presented with the image of an exemplary society that in many respects stirred the admiration of evangelists attracted to a strict and austere society that contrasted sharply with the turmoil of colonial society.

The Harmonious Rhythm of Existence

The native world had been held together by values which, in the absence of writing and books in the European sense of these terms, were affirmed and reaffirmed by oft-repeated lectures. This continued to be the case under Spanish rule, once Christian modifications eliminated anything that might suggest abhorrent idolatry. Pre-Hispanic society had devoted considerable time to allocutions and wordy exchanges, as though this verbal intercourse with its refined laws of rhetoric conferred a sense of identity on individuals. The *Florentine Codex* contains numerous speeches that help to identify what had formerly been the major stages in life, the progressive integration of the individual into family, school, and society. The third section of the *Codex Mendoza* even provides an amazingly detailed description of these successive stages. This is an innovation since such a presentation—a kind of forerunner to sociological or ethnographic description—has no pre-Hispanic precedent, although it recounts a reality anterior to the Spanish invasion. The arrival of foreign observers and the confrontation with another universe (that of Spain and the conquistadores) was what spurred Indian society to look at its past in this way. The effects of the conquest had suddenly made Mexicans aware of their uniqueness, and the research undertaken by missionaries beginning in the 1530s induced the natives to return to the subject constantly.[104] Native informants were subjected to streams of questions on their past lifestyle.

Repeated questioning led some Indians to produce original images similar to those illustrating the *Codex Mendoza*. Painters depicted the stages of childhood, the education given in schools,[105] adolescence, marriage, and old age, and described the various classes in pre-Hispanic society. Significantly, the nature of the artists' gaze had changed. Whereas beforehand lectures and warnings accompanying

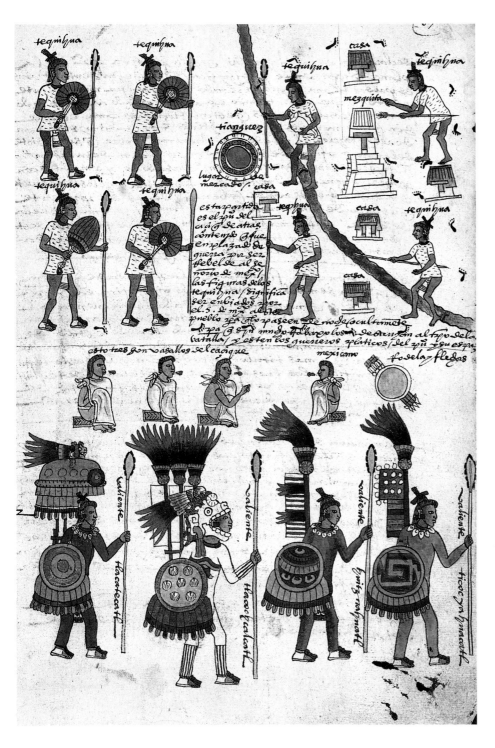

98. Preparing Military Expeditions
Florentine Codex, Vol. II, fol. 283 v.

"When he had looked at the painting
produced by his spies, the lord called together
his main captains, of whom there were
always two, and showed them the paintings
to indicate the routes... to be taken by the
soldiers and how many days it would take
and where camps should be established....
Then he gave the order that supplies of
weapons and food be gathered. For this, he
called together all his provincial stewards
...and ordered them to bring unto him all
the tribute of cloth, feathers, gold, weapons
and food."

This account suggests that the Indians
employed maps for military purposes prior
to the conquest. The top image directly
compares a map with a representation of
the coveted territory, including villages and
pathways (indicated by footprints). A moun-
tain chain drawn in the new manner (with
shading suggesting relief and volume) sepa-
rates the two spaces physically and symbol-
ically. The lower image evokes similar pages
from the Codex Mendoza.

97. Spies and Warriors
Codex Mendoza,
Pl. 68

"Tequihuas are spies sent by the lord of
Mexico-Tenochtitlan to the [enemy] cacique's
city so that they can traverse it and secretly
visit it, unknown to the adversary. In this
way the tequihuas traverse the entire city,
houses, mosque [temple] and market when
people are asleep and quiet." In the middle,
a Mexican official (behind whom are depicted
a shield and arrows) receives the representa-
tives of a people he was preparing to
crush in battle. Underneath are shown great
captains of the Mexican army. Left to right:
Tlacatécatl, Tlacochcálcatl, Huiznáhuatl,
Ticocyhuácatl.

99. The Great Temple at Mexico-Tenochtitlan
Codex Durán, Chap. XLIII

This depiction of the temple, in a landscape setting, is worth comparing to that of the Codex Ixtlilxóchitl (illus. 42). Not only is the temple once again removed from its traditional pictographic context, but the entire visual presentation is now European in conception.

100-101. Noblewomen's Dress and Hairstyles
Florentine Codex, Vol. II, fol. 280 v. and 281 r.

"Women habitually wore woven and embroidered huipil *[shifts] in a number of ways, as the Nahuatl text indicates. At home, women usually wore dark red and yellow garments, colors obtained by mixing burned incense with ink. They painted their feet with the same dark color and were in the habit of wearing their hair long, down to the waist. Some had hair down to the shoulders, while still others had the skull completely shaved with long locks on each side of the temples and ears. They could thus wear braids knotted with dark cotton thread, which they attached to the top of the head, and they still do so now, the locks forming small horns on the forehead."*

This information concerning feminine habits is somewhat surprising, coming from native informants assumed to be exclusively male. The details on braiding and hair care could only have come from questioning Indian women, however. The feminine world tended to preserve ancient customs, for women continued to wear traditional clothing whereas men adopted many aspects of Spanish dress. The subject discussed here therefore inspired a return to traditional representational conventions. But a closer look reveals an effect of relief on the huipil *and a certain animation of the female figures, thus breaking with the stereotyped solemnity of earlier canons.*

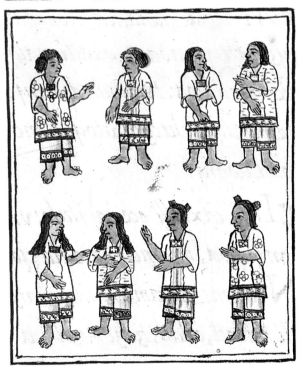

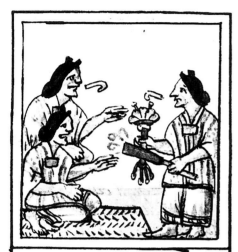

102. Noblewomen
Florentine Codex, Vol. I, fol. 312 v.

In these scenes showing preparations for the banquets regularly given by the nobility, women assemble the bouquets, smoking sticks and food that would be offered to guests during the feast.

the stages of life had a basically moral tone, the details of the codex now revealed an acute eye for everyday incidents—the brush recorded the amount of food and work corresponding to each stage of childhood, the preparation of meals or the punishment meted out according to the child's age and sex. But this taste for detail was not gratuitous, nor was it the expression of an attraction for the picturesque or a search for exoticism. The "modernity" of this approach in fact served the Indians' purpose. Behind this wealth of information, the artists' methodical—almost obsessive—insistence on work, retribution and punishment once again functioned to sustain a nostalgic vision of an ordered, meticulously organized society; in Indian eyes (and in Spanish eyes as well), this was a sign and guarantee of civilization. Yet it was also a subtle way of conveying the lost harmony of things by recording daily rhythms, of showing the cosmic order underlying the social order, of glorifying the past as distinct from a discordant colonial present.

In fact, few civilizations have devoted more attention to the intellectual, physical and moral education and guidance of its members. Pre-Hispanic society, in spite of its bloody rites and sacrifices, demonstrated striking affection for children. In greeting a newborn baby, the midwife would rock it and welcome it to "this slippery earth" with tender words—"precious necklace, precious feather, precious gem, precious bracelet, precious turquoise." [106] The tenderness shown toward infants was accompanied by constant vigilance designed to banish evil influences that might inhibit a child's growth. Parents, and later school, trained boys and girls to bear the vagaries of fate and to master them as far as possible. An Indian learned very young to be patient, to endure all, and to use good judgment. But pre-conquest schools also strove to make young people conform to society's standards, eradicating individualistic or deviant behavior. In the days when the lord of Tenochtitlan was still master of the world, obedience was highly valued in all walks of life.

The content of schooling varied according to whether the child belonged to the ruling classes or came from a modest background. Sometime between the ages of ten and fifteen, young nobles went to *calmecac* schools, prestigious institutions where they acquired ancient knowledge and learned religious duties. The *calmecac* schools trained priests, experts in calendars and rites, and future warriors. The offspring of the wealthier *pochteca* merchants were entitled to follow the strict education of the priestly schools, just like their noble counterparts. The children of commoners, however, were sent to *telpochcalli*, where they discovered what was expected of ordinary individuals subject to the gods and the powerful. These children ate their meals at home, but spent their days doing collective chores. At dusk, they returned home, bathed, dyed their skins and adorned themselves with necklaces. Once night had fallen, all went to the "House of Song" to sing and dance by the warm light of a large

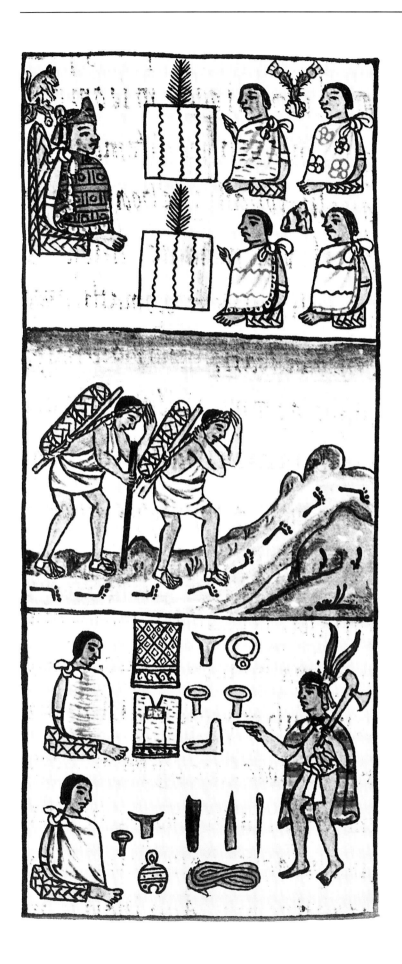

103. Merchants
Florentine Codex, Vol. II, fol. 316 r.

"*And when they went to the house of the ruler, the lord Auitzoltzin, he thereupon gave them his goods—sixteen hundred large cotton capes which he entrusted to . . . the merchants of Tenochtitlan and those of Tlatelolco assembled . . . which the merchants carried to Anauac. And behold what were the goods exclusively of the merchants, those in which they dealt as vanguard merchants: golden miters, like royal crowns; and golden forehead rosettes; and gold necklaces of radiating pendants; and golden ear-plugs; and golden covers used by women of Anauac . . . and obsidian razors with leather handles, and pointed obsidian blades, and rabbit fur, and needles for sewing, and shells.*"

This series juxtaposes a neopictographic style already noted elsewhere (no background, floating shapes, no third dimension) with a European-style outdoor scene complete with horizon, blue sky and clouds. The middle scene shows tameme *porters, who were essential to a society that had not invented the wheel and used no beasts of burden. The painter employed a European approach to depict this scene, as it was still a common sight during the colonial period. The ancient style, however, was used to reconstruct scenes from the irretrievable past—merchants from Mexico-Tenochtitlan (cactus glyph) and Tlatelolco (hillock glyph) before the monarch Ahuitzotl (glyph for the* ahuitzotl *water-animal). The lower register depicts a merchant bargaining at the market.*

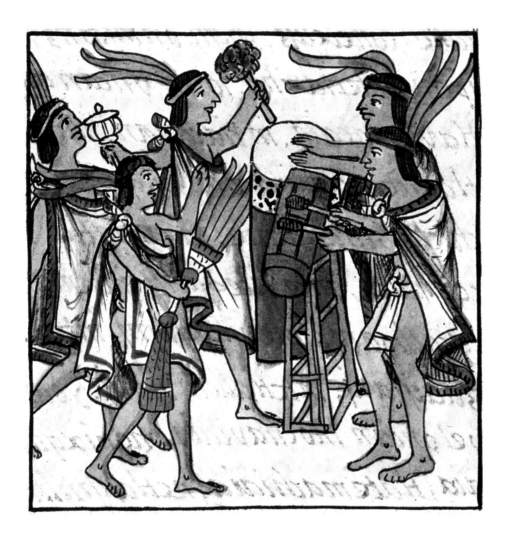

104. Musicians and Dancers
Florentine Codex, Vol. I, fol. 262 v.

*"During this sign [One Flower], the nobles
would dance out of piety.... The lord ordered
the one called Cuextecayotl...or the one
called Anaoacaiutl to recite the
chant.... They divided the emblems and
feather ornaments among the nobles, the
courageous men and the soldiers.... They
also gave capes and loincloths to the singers,
to those who played the* teponaztli *and the
drums, to those who whistled and to all the
other singers and dancers."*

*The singers and dancers present a lively scene.
Rank is indicated by garments, hairstyle and
jewelry (for example, special singers of hymns
could wear a labret, or lip plug).*

105. Games
Codex Magliabechiano, fol. 60 r.

"The game that the Indians called patolli
*was a sort of dice game played on a painted
mat."*

*By noting that playing the game involved
invoking the god Macuixochitl, the informant
was stressing the sacred, ritual aspect of
games for the native Mexica. Patolli was
played by moving beans or pebbles around
the squares.*

106. Raising Children within the
Family
Codex Mendoza, Pl. 61

*Following a plate devoted to early childhood
and the duties and punishment allotted to
little boys and girls, this plate deals with
children ages eleven, twelve, thirteen and
fourteen, as indicated by the blue dots. The
top strip describes punishment: both boys
and girls are made to breathe the smoke of
dried garlic. In the next strip, the boy whose
hands are bound has to lie for a full day on
wet, damp ground; the girl has to sweep
before the sun comes up. The glyph above
mother and daughter indicates night (the
"eyes" represent stars). At thirteen, boys had
to gather wood and carry herbs and reeds on
a boat "for the service of the household"
while their sisters learned to make tortillas
(thin cornmeal pancakes) and cook them on
the* comal *(terracotta grill). Children in this
age group received two tortillas at each meal.
Finally, at age fourteen, a boy learned to
fish from a boat and a girl was taught how
to weave.*

*The painter's representation of his own
society was more than just an ethnographic
record; in painting the stages of childhood
and education the painter was reliving his
own childhood (even if the family shown is
a modest one), a childhood that took place
prior to the Spanish conquest or at the very
least was strongly marked by pre-Hispanic
values. This produced nostalgia for a world
where everything had its place, where princi-
ples were strictly applied without the need
for a moralizing Christianity.*

brazier. At midnight, they all retired to the dormitory of their
neighborhood school. Although *calmecac* regulations were stricter than
those of the *telpochcalli*, both institutions strove to instill young bodies
with respect for tradition and tolerance of pain. Thus by age eight,
children were learning two disciplines that Nahua society viewed as
one: physical punishment and work. Right up until marriage,
adolescence was accompanied by trials such as going without food
and sleep, taking icy baths on cold nights on the high plateau, and
other physical hardships.

Marriage, in pre-Hispanic Mexican society, signalled the attainment
of adulthood and maturity. The couple would henceforth help to
carry on the line. Marriage was an affair to be settled between
families, under the supervision of the community and rulers. The
couple itself took no part in the transaction, which remained subject
to the interests of the group and the compatibility of the *tonalli* of the
two partners. Here again, class differences translated into different
behavior. Polygamy was practiced by nobles, whereas monogamy
was the rule among commoners, due to lack of financial resources.
Young commoners, however, could have passing affairs as long as
they were discreet. Old age, finally, was the source of wisdom, but
also led to physical decline that was considered somewhat unnatural.
Elders were listened to and revered, and helped govern neighborhood
and community. Their long speeches were full of advice on behavior,
setting out standards to be met and instilling healthy fear.

These features did not belong merely to the distant past. The
Indian's private lives were far less disrupted by the Spanish conquest
than were their political and religious practices. Elders retained their
authority and the community maintained social control and pressure.
And even though Christianity attempted to outlaw divorce and impose
monogamy, it was often difficult for the missionaries to distinguish
between customs to be maintained and superstition to be banished.
This meant that what they understood to be descriptions of the past
often corresponded to a reality that persisted throughout the sixteenth
century. The accounts and images contained in colonial codices are
frequently a shrewd "backward projection" of current practices. The
ethnographic "reporting" carried out by local painters was made
easier insofar as they had living examples of what was supposed to
belong to a bygone era.

Death as Commencement

Pre-Hispanic society cultivated a thoroughly original idea of death
and the afterlife. Broadly speaking, death was a preliminary and
indispensable stage of regeneration. For an individual, the moment
of death meant "disintegration," the "fragmentation" and dispersal
of the body's components as well as the definitive departure of the
tonalli, which was recovered and kept in a small chest placed in the

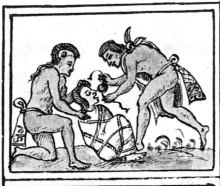

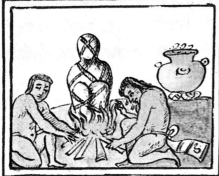

107. Funeral Rites
Florentine Codex, Vol. I, fol. 228 v.

"In the mouths of lords and nobles they placed a green stone called chalchiuitl*; in the mouths of commoners they placed a stone of lesser value... because they say that this stone represents the heart of the deceased....*
Two elders had the special task of burning the corpse, while other old men sang; as the corpse burned, the two elders would strike the body with poles. After it was burned, they gathered up the ash, coals, and bones of the deceased and, taking water, said: May the deceased be cleansed. Then they poured the water on the coals and bones of the deceased."
The key ritual of cremation has already been described (illus. 60). After cremation, the bones of the deceased were placed in a vase with a chalchiuitl *(green stone) and buried in a room of the house. Here the painter skillfully portrays the physical gestures of the elders. The simplicity of the "funerary shroud," without ornament, ritual paper or feathers, suggests that the artist has chosen to represent a commoner's funeral. As usual, older stereotyped forms (the pot of water) round out the composition and provide added information.*

house or community temple. Another force also departed from the body, this time going to one or several distinct afterworlds. Common mortals went to *mictlan* (the underworld of the dead), whereas the "Heaven of the Sun" was reserved for warriors who fell on the battlefield and mothers who died in childbirth. Those whose death was linked to water (drowning, being struck by lightning, or a victim of aquatic animals sent by the gods) went to *tlalocan*, the aquatic paradise. Still others, anointed by the gods or possessed by compelling forces, went to join their divine protectors.[107]

This multitude of afterworlds corresponded to a society that placed extreme emphasis on agriculture, on sustenance and on the realm of war and related values. It expressed a conception of human fate that combined divine will, individual behavior and the influence of the birth sign. Death, like life, bore the mark of the *tonalli*; the afterworld was therefore not designed to reward the good and punish the evil.

Unlike Europeans, Indians cremated their dead. The Nahuas felt that cremation was essential, because fire transformed the corpse and enabled it to travel from the earth's surface to other spheres.[108] Cremation was a crucible that united the remains of the deceased with the offerings, prayers and tears shed by relatives so that the voyage to *mictlan* could be undertaken in the best conditions. A poor person received clothing, food, and cooking utensils. Royalty, however, had to be accompanied in a more dignified manner, and to this end slaves were sacrificed and their hearts thrown on the pyre. The journey to *mictlan* lasted four years, whereas only eight days were needed to reach the "Heaven of the Sun." As for the bodies of those headed for *tlalocan*, they were immediately buried as an offering to the deities of rain and vegetation, who absorbed them at once.[109]

Those who died an ordinary death spent four years crossing rivers, traversing deserts swept by icy winds, and slipping through colliding mountains, only to reach *mictlan* and disappear forever in a place devoid of fire and light.[110] The deceased who went to *tlalocan*, in contrast, led a happy existence in the mountains where rivers, clouds and winds originated. Slain warriors and women who died in labor shared the "Heaven of the Sun," taking turns accompanying the sun across the sky. After four years, warriors were transformed into the birds and butterflies that flitted to earth to drink the nectar of flowers. Despite all this, the dead did not leave the living in peace. They returned to earth to hound human beings, sometimes doing good, sometimes evil, depending on circumstance and day-sign.

Such beliefs, in fact, belonged to the colonial present as well as to the pagan past. They were far less defunct than native informants led the missionaries to believe. Long after the conquest, the dead continued to receive offerings of food and to terrify the living; the Christian concept of an afterlife with a heaven and hell only became acceptable to Indian beliefs once it had been combined with pre-Hispanic rites and ideas. Nostalgia often dressed up an ever-present

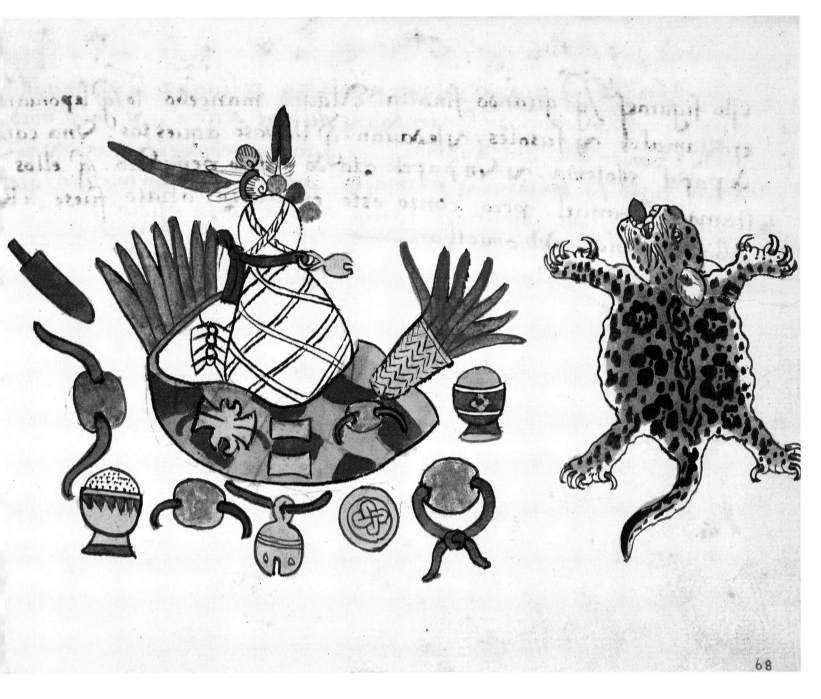

68

past, and to the consternation of the missionaries (for they were not all fools) these images of yesterday were uncomfortably close to contemporary life.

108. A Merchant's Funeral
Codex Magliabechiano, fol. 68 r.

This scene is similar to the preceding one, except that the objects and finery (a jaguar skin, gems, feathers) indicate the wealth and social status of the deceased. Such objects accompanied the deceased on his journey to mictlan.

109-111. Traditional Architecture
Florentine Codex, Vol. III, fol. 391
v., 392 v. and 394 v.

Here the painters of the Florentine Codex
*offer a brief catalogue of architectural forms.
First there is a completed palace (inhabited
by a lord), then a temple under construction
and palaces with doors facing east (?). The
painters also depict modest dwellings of
wood and straw. Other plates show the
houses of merchants and communal build-
ings. The stylized representation of noble
residences contrasts sharply with the more
realistic depiction of huts and shacks.*

IV.
Painting
New Spain

112. The Art of Featherworking
Florentine Codex, see illus. 136-143

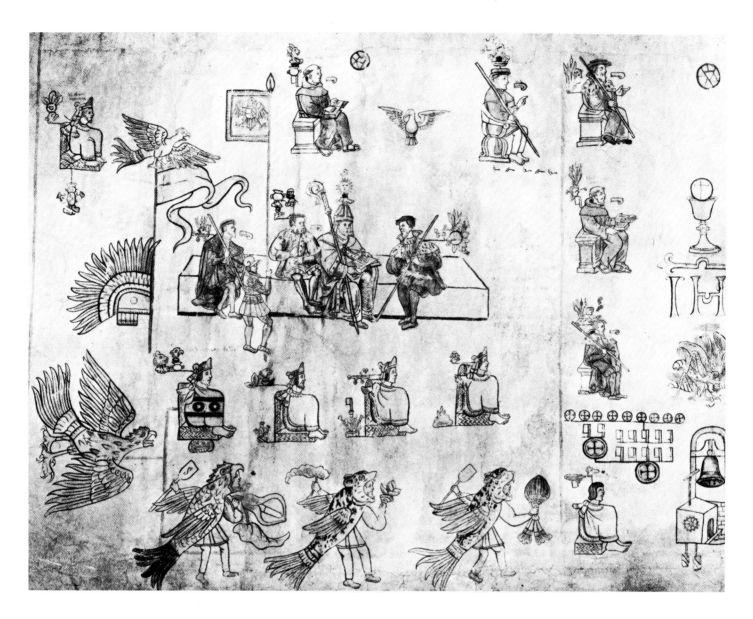

113. Beginning the Construction of
Mexico City Cathedral in 1562
Codex Tlatelolco

*The archbishop of Mexico City is seated on
a bench with Viceroy Luis de Velasco.
Opposite them are the lords of Tlatelolco,
Tenochtitlan, Tlacopan and Texcoco. The
upper register includes images of the Holy
Ghost and a Franciscan monk. All these
characters are identified by means of a glyph
near the head. In the lower register, Indians
in ceremonial dress dance in honor of the
event. The representation of a bell and
clock—acquired in the following year—in-
carnate the intrusion of the European Chris-
tian concept of time into everyday Indian
life.*

114. The Governors of Mexico-
Tenochtitlan
Florentine Codex, Vol. II, fol. 254 v.

*"The twelfth governor of Tenochtitlan was
called Don Andrés Motelchiuh and he gov-
erned for three years during the time of
the Spanish. He accompanied them in the
conquest of the provinces of Cuextlàn, Hon-
duras and Anaoac. He then left with Nuño
de Guzmán for the conquest of the Culhoacan
territory, and that is where his life came to
an end. The thirteenth governor of Tenochtit-
lan was called Don Pablo Sochiquen. He
governed the people of Mexico City for three
years. The fourteenth governor of Tenochtit-
lan was named Don Diego Vanitl. He was
governor for four years. The fifteenth governor
was called Don Diego Tehuetzquiti. He
governed three years." Following the death
of Cuauhtemoc, the last Mexican monarch,
the Indian population of Mexico-Tenochtit-
lan were subject to a native governor. Ancient
conventions were still used to represent the
governors, such as showing them seated on
the* icpalli *throne. Their names were still
indicated by glyphs—thus Pablo Sochiquen
is accompanied by a cloth with flowers on
it (*xochitlquemitl* = "flowered garment").
Were these images an attempt to reassert politi-
cal sovereignty after the line of Mexican rulers
had been broken and their powers usurped
by the Spanish conquistadores? Or were the
Indians simply displaying their penchant for
a relative formal and institutional stability
and a desire to save appearances?*

"Contemporary life," of course, referred to that hybrid universe called New Spain. This world can best be glimpsed through the festive celebrations whose lengthy preparations regularly punctuated the life of the Mexican capital. In 1562, leading dignitaries gathered for the solemn laying of the cornerstone of Mexico City's new cathedral. Archbishop Alonso de Montufar and Viceroy Luis de Velasco were accompanied by representatives of the native aristocracy. A more motley spectacle is hard to imagine. The Spanish wore their parade uniforms, seated beneath flapping banners bearing the twin-headed Hapsburg eagle. Indian nobles wore their traditional finery, and two major Mexica military orders, the Jaguar-Knights and the Eagle-Knights, danced before the dignitaries in honor of the event. A full account of the episode was recorded by the painters of the *Codex Tlatelolco*. Similarly, memorial services for Charles V in 1559 had brought together the cream of New Spain's European, Indian and mestizo society around a magnificent Renaissance bier erected by native artists under the guidance of architect Claudio de Arciniega.[111]

Collaboration: Opportunism and Compromise

As noted above, part of the Mexican nobility had joined the invaders from the beginning. Many felt that the Spanish would provide precious aid against enemies and rivals, and that they would bring down the Triple Alliance (the Mexica and their allies). This was the attitude of the Tlaxcalans, whose city-state on the high plateau struggled to hold out against the surrounding vassals of Mexico-Tenochtitlan. Part of Texcoco's ruling family also shared this attitude, for it felt that Moctezuma was usurping its power. The indigenous troops and caciques who rallied around the invaders played a decisive role in events, enabling a handful of conquistadores to defeat the Mexica. But local nobles soon discovered that the Spanish were not just passing mercenaries. The conquistadores decided to dig in, to seize both wealth and power. Above all, they were merely the avant-garde of a colossal force. Temporary cooperation turned into forced collaboration. The former ruling class realized that they would have to come to terms with the victors if they wanted to hang on to part of their authority.

This collaboration, however, did not place the native nobility entirely at the mercy of the Europeans. The Indian elite had a number of trump cards to play. Its excellent knowledge of a country largely unknown to the invaders, its familiarity with the area's human and mineral resources, and its unchallenged authority over the local population made it an indispensable intermediary between the millions of Mexican Indians and the small nucleus of conquistadores and colonists (numbering scarcely a thousand at first) who claimed to govern the land. The indigenous aristocracy clung to its role so tenaciously that the Spanish had to remain wary. In the 1520s, nobles

1529
1546

1530
1547

1531
1548

44.

Esteaño detre
cañas y de 1531
Eclipse de sol

Año deonze cañas y de 1529
se partio nuño de guzman
para jalisco yendo a su
jeptar Aquella tierra sin
jon que sale la culebra del cielo
diziendo que les venia trabajo
A los naturales y en dolos
cristianos Alla

En este Año dedozecon e
jos y de 1530 tenblo la
tierra tres vezes

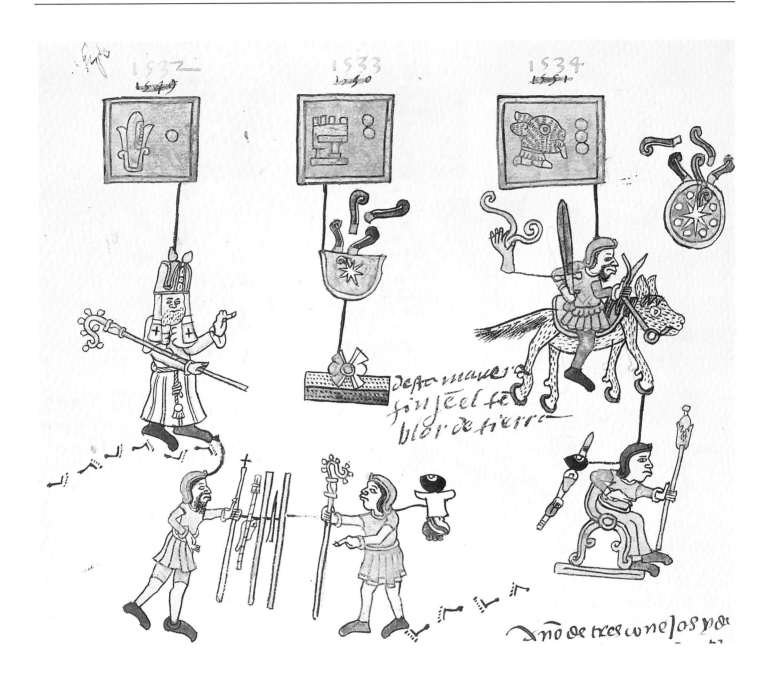

115-116. Incidents in Colonial History
Codex Tellerianus-Remensis, Pl. 29
and 30

The glyphs for the years 1529, 1530 and
1531 (left) are linked to the departure of
conquistador Nuño de Guzmán for the
conquest of Jalisco, three earthquakes, and
an eclipse of the sun. These events are
connected to the symbol for the relevant year
by a line, and accompanied by explanations
in Spanish. The ancient glyphs for earth-
quake and eclipse coexist with newer inven-
tions such as the chairs on which Spanish
authorities sit and the deer-like mount of the
conquistador (see Codex Borgia, illus. 8).
This attests to the vitality of the picto-
graphic—or neopictographic—tradition.
In 1532 (above), the first bishop of Mexico
City allegedly arrived. In 1533, smoke
issued from the morning star (Venus) and
an earthquake occurred. In 1534, Viceroy
Antonio de Mendoza arrived. Mendoza's
name is rendered by the glyph for hand,
maitl, combined with the volute-like glyph
indicating speech, notza. Together they form
a rebus pronounced mai-notza, approximat-
ing the sound of Mendoza.
The painter has depicted two important
moments in colonial history by representing
two men who would have a significant
impact on that early history—the humanist,
Eramus-inspired prelate Juan de Zumarrága,
and Don Antonio de Mendoza, viceroy from
1535 to 1550.

117. The City of Cholula in 1581
Relacion geográfica de Cholula,
Austin, Benson Latin American
Collection

*The city is laid out in rectilinear fashion,
as were all colonial towns in Mexico. The
Christian presence is indicated by chapels
and the Franciscan church in the center.
Some blocks contain views showing the city
from various angles, at the foot of the ruins
of the imposing pyramid. This colonial
vision should be compared to the much
more traditional approach of the* Historia
Tolteca-Chichimeca *(illus. 87).*

from Mexico City, Tlaxcala and Michoacán attempted to overthrow
rulers split by factionalism (partisans of Cortés, representatives of the
crown, and those loyal to the church). In the early 1540s, an exchange
of letters between the lords of Tlaxcala and Michoacán was discovered,
leading the Spanish to fear the worst once again. Just then, the
Mixtón tribes to the northwest rebelled; Viceroy Mendoza recruited
many native warriors in an attempt to crush the revolt. Banking on
their loyalty, he authorized the Indians to stockpile weapons, constitute
large arsenals and place themselves on a war footing, as of old. The
Mixtón rebels were defeated and New Spain remained at peace.[112]
Well into the 1550s, however, many colonists lived in fear of an
uprising that would have swept away the tiny Spanish strongholds
across the country.

The local nobility's wait-and-see attitude might have shifted against
the Spanish at any moment. But in the end, nobles continued to
collaborate. They profited from the military victories in the deserts
to the north, won by the Spanish crown thanks to massive support
from Indian armies. Many Nahua and Otomí warriors were able to
pursue their military careers and garner rewards distributed by
Charles V, such as the right to bear arms, own land, and display a
coat of arms. The temptation to resist was balanced by the appeal of
integrating into the victors' world via the hidalgo, or Spanish gentry.

New Society, New Economy

For the two worlds did not remain separate. Conquerors and conquered (the noble class, at least) became linked through friendships, business associations, marriage, godchildren. Mexican godsons were systematically given Spanish names, and soon there were countless Cortés and Alvarados among grand local families. Richly endowed native princesses were highly sought after by the conquerors. Conquistadores who obtained *encomiendas*, that is to say title to the revenues and labor of one or several Indian villages, did not hesitate to mix with the former ruling class since they needed its cooperation if they wanted to consolidate their wealth.

The best-known case is perhaps that of Isabel Tecuichpotzin, eldest daughter of Moctezuma and Teotlalco. Even prior to the conquest, seers had predicted that she would have several husbands. They were right. During the invasion, the eleven year-old Tecuichpotzin fell into the hands of the Spanish along with her father. When Mexico-Tenochtitlan rebelled and the Spanish were temporarily driven out, she was restored to her people. She married, in turn, her father's two successors—her uncle Cuitlahuac, who died in the smallpox epidemic unleashed by the Spanish, and her cousin Cuauhtémoc, who was captured when the city finally fell. Tecuichpotzin was baptized and became Doña Isabel (perhaps in honor of Isabella the Catholic, queen of Castile). She lost her husband several years later, when Cortés had him executed. Thus, at seventeen, Isabel was a widow for the second time. Aware of the asset she represented, Cortés granted her a large fief with several thousand vassals. But there was

118. The Franciscan Monastery at Tlaxcala in 1583
Descripción de Tlaxcala, fol. 245 v.

This is a view of the monastery erected by the Franciscans in the city that had been the Spanish crown's most faithful ally. The buildings are arrayed around a vast patio onto which open the church of the Conception, a chapel, and part of the monastery. On the lower left is a bell tower, which imposed the daily rhythm of Christian prayers on local Indians.

146

119. The Mexican Countryside under
Spanish Rule (circa 1580)
Relacion geográfica de Oaxtepec,
Austin, Benson Latin American
Collection

*To depict this fertile region with its warm
climate (today the state of Morelos, to the
south of the Valley of Mexico), the painter
has blended pre-Hispanic conventions (such
as the glyph for water, and the place-name
glyph for Oaxtepec) into a landscape of
warm colors, dotted with orchards, chapels
and churches marking the sites of native
hamlets and villages. Corn and wheat were
grown there, and monasteries cultivated most
of the herbs and vegetables found in Castile,
including cabbage, lettuce, radishes, onions,
parsley, mint and coriander.*

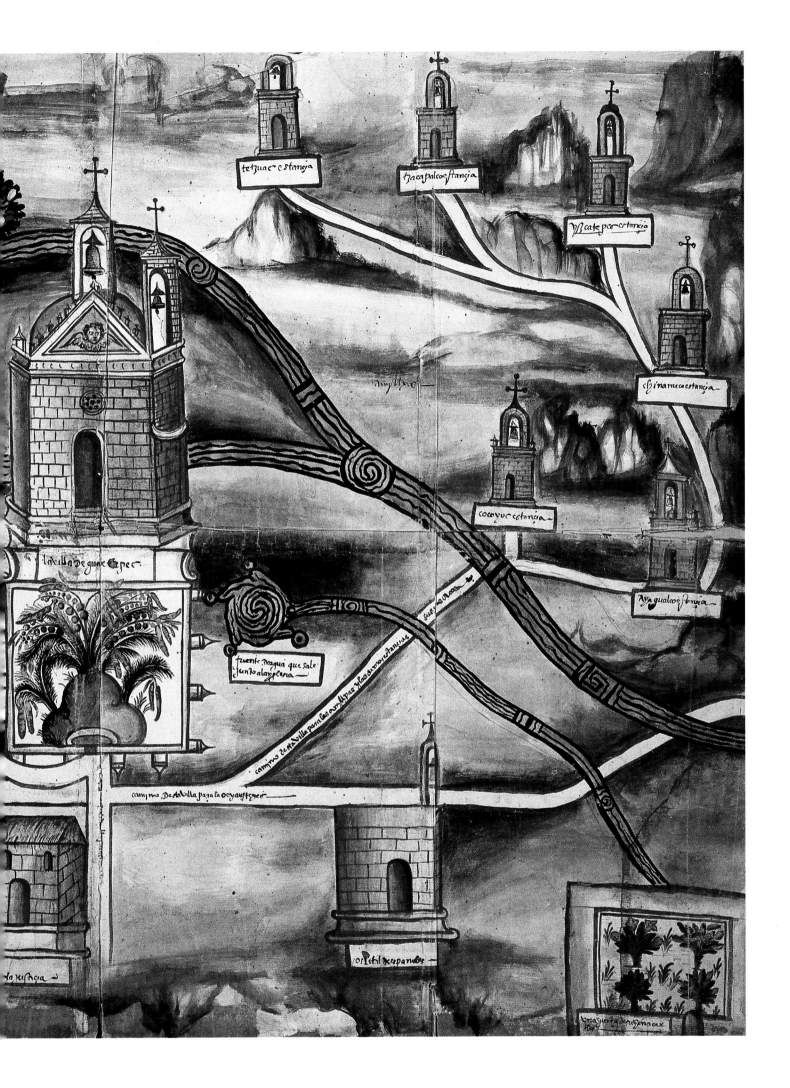

tetquac estança

tlacapalco estançia

uscate per estançia

chinamuca estançia

coçoyuc estançia

ayagualco estança

la villa de guadelupe

fuente de agua que sale
junto a la yglesia

camino de sta villa para la oxo y usças y las armas estançias

camino de sta villa para la oxy au et gue

ospital de epanudes

vna juente de agua que
sale

la estança

no question of marrying her to a Mexican noble; thus began a long series of Spanish marriages. This highly attractive woman first wed Alonso de Grado, a conquistador from Extremadura and one of Cortés's earliest companions. Thus the daughter of Moctezuma, the incarnation of aristocratic Nahua refinement, became an exemplary Christian and a model for women of the Mexican nobility, whether seen with Alonso, Cortés (her lover for a while), her last two husbands, or during her various periods of widowhood. The birth of her first son in 1530 provided the occasion for a memorable banquet attended by the elite of colonial society, including Juan de Zumarrága, bishop of Mexico City. Isabel's home was decorated in a mixture of native and European styles, as were those of many Indians and mestizos.

The collaboration took a material and economic turn very early on. Castilian husbands with aristocratic native wives took an active interest in family matters and offspring. Old and new rulers, caciques and conquistadores, worked together to exploit New Spain, that hybrid entity born of the occupation of Mexico by the Spanish. Mexican nobles were affected by the consumer goods and habits that accompanied the invaders. It had all begun one fine day in 1519 when Cortés offered Moctezuma's envoys gifts on the beach at Veracruz: an inlaid chair, a vessel in Florentine glass, and a crimson velvet cap. These Renaissance objects must have made it to Mexico-Tenochtitlan before the conquistadores. Nothing is known of what became of this first exchange, but it would seem that once the shock of invasion wore off, the Indian nobility sought out those products, substances and objects with which the conquerors surrounded themselves. Indians adored Spanish wine, to the delight of wine merchants who imported it from Europe at great cost.

Horses, firearms, and swords—all imbued with the indisputable aura, power and superiority of the invaders—became coveted items. Europe traveled on horseback, as the Indians learned at their expense during the conquest. Horses were unknown in the Americas, and all travel was done on foot, on someone else's back, in litters or on waterways. For the local upper classes, owning a horse was not simply a means of acquiring the symbol and tool of European domination, it also meant learning new techniques such as how to use saddles and reins, how to manage stables and grooming staff. It also entailed a relationship to one's mount unknown in pre-conquest Mexico. Wrapped in an old-fashioned cape, a native lord would advance on horseback, wearing armor and bearing dagger, sword, and lance, at the head of his retinue and porters. This unprecedented spectacle combined pre-Hispanic ceremony with Renaissance and late medieval pomp. Indian nobles considered the right to wear a sword a signal favor granted by the king of Spain. Legally or not, wealthy and well-connected Indians acquired crossbows and military tunics. Once again, the drive to equal the Spanish inspired the adoption of

120. Colonization and European Fashion and Hairstyles
Descripción de Tlaxcala, fol. 243 r.

One of the most immediate and spectacular effects of Christianization was the change in dress and hairstyles. Spanish monks urged the Indians to wear a tunic and trousers instead of cape and "indecent" loincloth— magnificent examples of which are shown in previous illustrations.

121. Occupying Forces, Religious and Secular
Yanhuitlan Codex

This codex, produced around 1550 in an outlying region (southeast of the Valley of Mexico, inhabited by the Mixtec tribe), displays an original style demonstrating the numerous possibilities open to painters able to assimilate and reinterpret European forms. The three pillars of colonial society are shown here side by side. The church in the center is represented by a Dominican friar (the order charged with converting the region), flanked on the left by Indian caciques and on the right by administrators for the Spanish crown.

new habits. This worried European colonists who, twenty years after the conquest, noted that the martial and equestrian arts no longer held any secrets for the conquered people.[113]

Nor did everyday life remain unaffected, even if the private and personal sphere resisted change. Both Indians and Spanish loved to hunt, and Viceroy Mendoza led his retinue into the northern plains on memorable hunts for deer, rabbit and coyote. The viceroy hunted in the "old-fashioned," Indian style with thousands of native beaters.[114] Celebrations such as marriages and banquets brought Mexican nobles and rich Spaniards together, where their different customs and forms of merriment mingled. The Europeans appreciated the exotic note provided by their Mexican guests, whereas these latter began to imitate European habits that carried the aura of the victors. Chairs with arms, plush rugs and cushions (a fashion inherited from the Mudejares) began adorning the homes of rich caciques. Walls were covered with Flemish tapestries and tooled leather. Cordoba-style morocco hung next to large mosaics of colored feathers executed in

122. Saint Gregory Saying Mass
(Valley of Mexico), 1539
Auch, Musée des Jacobins

Legend recounts that Christ and the symbols of the Passion appeared to Pope Gregory while he was saying mass. This scene inspired numerous painters and engravers (such as Dürer). Here it takes the form of a mosaic of feathers offered to Pope Paul III.

123. Spanish Woodcut of Christ
(*with inscription* "Salvador Mundi, salva nos.") Nicolaus Eymericus, Directorium Inquisitorum, Barcelona, Johann Luschner, 1503

native fashion.[115] In the 1530s, officials commissioned local artists to paint chapels with frescoes showing the lives of saints. Elements of European architecture—plateresque columns, arches, and so on—were integrated into the design of noble residences and palaces. Fray Durán's manuscript contained miniatures providing numerous examples of crossbreeding between pre-Hispanic geometric forms and Renaissance decoration. Such works were a type of spontaneous kitsch (but then, kitsch is always somewhat spontaneous) that may displease today, yet they were nevertheless a faithful expression of the culture and world in which noble Mexicans and urban Indians lived. This mingling of lifestyles—which also affected the Spanish[116]—manifested itself in a number of ways. During feasts, silver vessels and Murano glassware in red, green and gold were used alongside fine Mexican terracotta receptacles. Similar mixtures occurred in rural parish churches, whose collections of ornamental relics began to look like exotic bazaars: fabrics and chasubles from Rouen, Castile and Holland, chalices and candelabra forged in local silver, crosses, shields and blazons made of tropical bird feathers showing Christ with crucifixion wounds, Michoacán flutes, Italian trumpets, pious images painted on morocco leather, et cetera.

This adoption of certain forms of European material culture was only possible due to the emergence of native craftsmen trained in foreign techniques and able to combine them with local expertise in works that delighted an increasingly demanding indigenous and European clientele. A Franciscan monk from Ghent, Pedro de Gante, was the first to teach the Indians professional crafts. He founded workshops in Mexico City, near Saint Joseph's chapel, that attracted native Mexicans keen to discover the secrets of their conquerors. Cobblers, tailors, and blacksmiths soon assimilated basic techniques and set up their own concerns, to the exasperation of Spanish craftsmen who thought that once in Mexico they could practice their trade without fear of competition. Goldsmiths, followed by featherworkers, began imitating European designs. And with the same alacrity, *tlacuilo* painters picked up new methods for illustrating codices with a hybrid art, constantly moving back and forth between pictographic images, vignettes, illumination, and even comic strip techniques.

Native Tradition Meets European Culture: The New Intelligentsia

Native Mexicans assimilated more than just the material goods, technical skills and artistic culture of their conquerors. From the very start, European intellectual concepts had been promoted by the missionaries. By the mid-1520s, Pedro de Gante had opened schools in the Valley of Mexico. Monks spent entire days with young Indians to learn the basics of Nahuatl and compile dictionaries, then swiftly

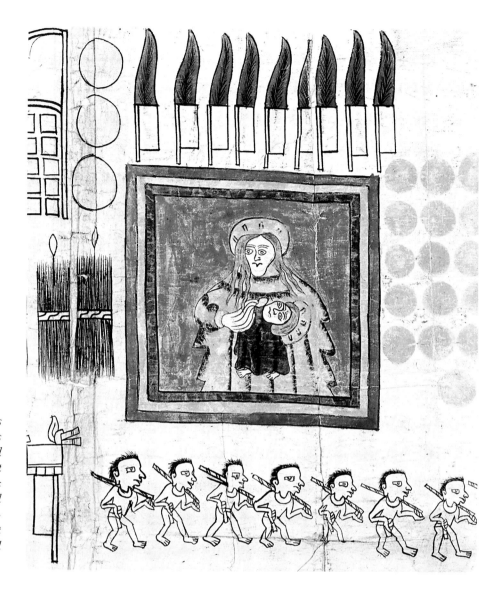

125. Virgin and Child
Codex Monteleone

The apparent clumsiness of the painter is revealing of the manner in which Indians perceived the religious imagery disseminated by the missionaries. The Virgin and infant Jesus are here reduced, like pre-Hispanic deities, to an arrangement of sharply outlined elements. The European ideal of anthropomorphic beauty appears to be of little interest to a painter perfectly capable of controlled draftsmanship in other contexts.

◁ **124. The Pantocrator**
Tepotzotlan, Museo Nacional del Virreinato

It is easy to detect the sixteenth-century Flemish inspiration behind this feather mosaic, which recreates the aura of Byzantine icons. On a more subtle level, the feathery texture lends this Christ not only a colorful brilliance, but also the immediate, tactile presence of divinity as sought by pre-Hispanic Mexican society. Whereas the Christian deity was incarnated as a man, the Mexican god manifested itself through an accumulation of ritual emblems and objects. Its aura resided in all that covered, dressed and constituted it. And it is precisely this covering of feathers that gives form, life and presence to Christ as ruler of the universe, or Pantocrator.

taught natives to read and write Latin. The teaching of European music followed, and met with great success. As of the 1530s, knowledge of Latin became more common among the upper classes, and by 1535 young Indians were haranguing Antonio de Mendoza, the first viceroy of Mexico, in Latin. Five years later, Indians could send letters "from sea to sea" (that is to say, from the Gulf of Mexico to the Pacific Ocean) and keep abreast of developments in the country with a speed and accuracy that was very likely without precedent. Young Indians who spoke elegant Latin did not hesitate to draft long letters in the language of Cicero. Spanish colonists were astounded by how quickly writing—"that knowledge as harmful as the devil"— spread among the natives.[117] In 1536, Bishop Zumarrága and Viceroy Mendoza founded Santa Cruz College in the Tlatelolco district of Mexico City. There the most learned missionaries dispensed higher education to young nobles born after the conquest and initially

schooled by monks. It was as though Renaissance humanism was suddenly, totally accessible to the younger generations. Their European governors were certainly men of remarkable culture. Bishop Zumarrága was an assiduous reader of Erasmus, Judge Vasco de Quíroga strove to put into practice the theories expounded in Thomas More's *Utopia*, and Pedro de Gante, who had studied at the University of Leuven, employed educational methods used in the Netherlands, combining spiritual fervor with the advantages of technical training.[118] As for Viceroy Mendoza, he arrived in Mexico with a library of books reflecting the tastes of his venerable family of art patrons, steeped in the spirit of quattrocento Italy.[119]

The experiment bore fruit, even though it did not lead native youth to the priesthood as the founders had initially hoped. This relative failure probably had a decisive impact insofar as it led to the development of an educated circle outside the church yet in close contact with the Spanish clergy. There thus emerged a secular native and mestizo intelligentsia that strove to reconcile traditional knowledge with European learning. Even theology became a game for these bright minds so enamored of interminable discussions. According to a Spaniard alarmed by their progress, New Spain "was becoming a Sibylline grotto, and all the Indians in the land will become clever teachers of the sciences."[120] During the 1550s, gatherings were held in the homes of brilliant Mexican aristocrats such as Don Pedro, count of Moctezuma (son of the deposed monarch) and Don Hernando Pimentel Ixtlilxóchitl (son of Coanacotzin, former lord of Texcoco). They discussed the books by Bartolomé de las Casas, who tirelessly defended the Indians for over thirty years. The cleverest among them wrote letters designed to inform the king of Spain of the fate of his Indian vassals. This correspondence with the crown enabled them to demonstrate their mastery of Latin, just as any humanist in old Europe would have done. Later, learned gatherings brought Spanish scholars and native nobles together to discuss the origins of the Indians: whether they came from Palestine or from Kurland in Poland, as argued Heinrich Martin, a German interpreter for the Inquisition.

Illustrious names and books emerged from this educated milieu in and around the capital of New Spain. Many educated Mexicans were appointed to offices by the governor, placing them at the pinnacle of native hierarchy. Most were also born in the early years of Spanish rule and attended Santa Cruz College before going on to teach. Such people included Don Fernando de Alvarado Tezozomoc, grandson of Moctezuma and author of two chronicles, one in Spanish (circa 1598) and the other in Nahuatl (1609); Latinists Antonio Valeriano (died 1605, Tezozomoc's brother-in-law), the indefatigable translator Hernando de Rivas, sometime musician Juan Berardo, typographer and printer Diego Adriano, and others. Francisco Bautista de Contreras translated *The Imitation of Christ*[121] into Nahuatl, and many

126. Young Indian in Spanish Dress
Florentine Codex, Vol. III, fol. 10 r.

This barefoot young man is wearing Spanish dress dating from the second half of the sixteenth century, over which he has thrown a traditional cape. It is as though his clothing embodies his twin cultural loyalties.

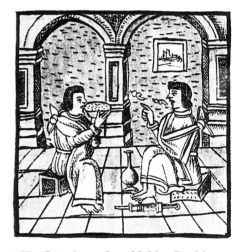

127. Interior of a Noble Residence During the Colonial Period
Florentine Codex, Vol. III, fol. 21 v.

Two Indians in conversation are depicted in an interior showing arches and a window with landscape beyond—striking testimony to the new architecture. The way the Indians are seated, however, as well as their settees and the volutes coming from the mouth of one of them (possibly a doctor) remain faithful to native Mexican tradition.

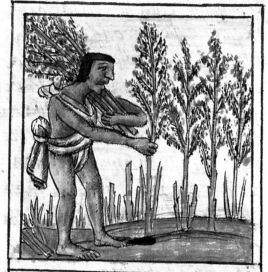

ytechcaca tlaolli. auh inpixca
que inquipixquilia, quimo
chavia, quimocholtia, quimo
cholcozcatia, mochavia, mo
choltia. mocholcozcatia, moci
cozcatia, inpixcaque, inte
pixquilique. auh cequin onne
mj motitixique, qujmotitixia,
qujmocuicuilia, qujmotete
molia incan oilcacalac cintli,
anoço molquito tonti, in
amo quicuicuicuique pixca
que, tlacencoltoca, quipa
nocvitivi, tlatlacxitamotivi
ino oaquauhtitlan, içoati
tlan, totomochtitlan, icmo
xixiquipilquentia ynjnti
tix. auh inmile çatepan
tlacuezcõtema, tlacuecuez
contema, tlacuezcomate
ma, yniiaouh, ymichie,
ymieuh achtopa quivite
qui, quirectia, quitlaiec
tilia, quitlacuicuilia, ca
rana, quecheca quetza,
quĕcatoctia, quitepeoa
inpolocatl, quitlaça yne
xotlacolli, çatepã tlacocõ
temã, quicocõtema, quip
repechoa inieixquich itla
nacaiouh. etª

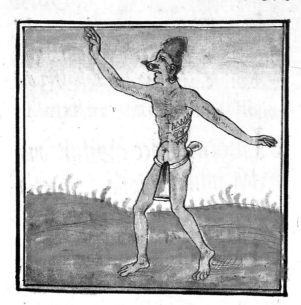

mochioaz: in aço cuestecatl, aço to
ueio, iacahuicole, iacacoionqui, is tlan
mihoa, motlaquiculo itzcohoatica:
niman iuh motlaliaia inteuthat inic
moxiximaia, inic motlatlamachia:
itech mana incatlehoatl motlaiche
calhuia inquenami iicliz itlachie
liz motlaliz; in aço aiotl; niman iuh
motlalia inteuat inic acallo, imic
molinitiez, iticpa oalitztica imitzon
tecon: molinitica imiquech, ioan ini
ma; iniuhqui icmamaçouhtica: ina
noço tototl ipan quicaz teuaui tlatl,
niman iuh mocuicui, iuhmoxima in
teuatl imic mihuiiotica matlapaltia,
mocuitlapiltia, moexitia: anoço
michin inmochioaz, niman iuh mo
xima inteuatl inic moxincaiotia,
ioan motlatlalilia inipatlania iio
mottan, ioan imiuh hicac icuitla
pul, maxaltic: anoço cuetzpalin;
mochioa, motlalia inima, inic moxi
ma teuatl: inçaço catlehoatl mo
tlaic hecalhuia ioioli: anoce teuaui
tlacozcatl iecauiz, chaiaoacaio ten
coiollo, tlatlatlamachilli tlasuchi
icuilolli. I nicoac omocencauh te
culli, ino micuilo, momo cuicuic: ni
man mopacaci in sicouitlatl, mo

◁◁ 128. Farmers
Florentine Codex, Vol. I, fol. 315 v.

"[The farmer born under the sign One Rabbit] put a lot of care into working the land, sowing all sorts of seeds, watering and tending them. That is why he has an abundant harvest of all sorts of vegetables, he fills his house with all sorts of corn and he hangs garlands and bunches of corn from all the rafters of his house."

Illustrated here, from top to bottom, are the various stages of reaping, threshing on a mat and storing in jars. These images depict the pre-Hispanic period, yet also represent colonial and modern times insofar as these same techniques are still employed in rural areas.

◁ 129. The Art of the Goldsmith
Florentine Codex, Vol. II, fol. 358 v.

Working precious metals was a craft reserved for specialists who created forms by casting and hammering gold and silver. Other Indians were responsible for selling these gold and silver objects. Like featherworkers and gem cutters, goldsmiths constituted a group of luxury craftsmen that enjoyed a privileged status.

The jewelry is set against a patch of sky and landscape, although such a background is hardly required here. The elegance of the draftsmanship and coloring suggest that the painter wanted to display his virtuosity. But the inappropriate landscape merely lends a note of strangeness.

other authors like Tadeo de Niza and Francisco Acaxitli wrote histories and annals when they were not helping the missionaries with ethnographic research. It is important to also cite several mestizo authors (some of whom descended from Indian princesses married to conquistadores) to appreciate the scope of the educated circles comprising an important part of New Spain's lay intelligentsia. Fernando de Alva Ixtlilxóchitl, Diego Muñoz Camargo, and Juan Pomar were among the mestizo writers. Spanish authors of the day all belonged, with rare exceptions, to the ranks of the church.[122]

Everyone in this little Indian and mestizo world read Aristotle, Plutarch, Flavius Josephus, the church fathers, Boetius, and so on, either in the original or in Nahuatl. Far from remaining content with access to monastic libraries, this intelligentsia wanted to build a collection of writings in the native tongue, drawn from classical authors and the Holy Scripture.[123] Texts from the Old and New Testaments, philosophers, and Aesop's fables were thus honored with translations. This interest in philology and classical languages was a feature of both the European and the Indo-Mexican Renaissances. Furthermore, the conscientious use of pre-Hispanic codices not only illustrates respect for ancestral tradition and roots, but also represents a typical Renaissance practice of referring back to ancient texts in their original language (the ancient texts here being Mexican). Such an approach had been taken by Erasmus, the Italian Lorenzo Valla, and the Castilian Antonio de Nebrija.[124] It was no coincidence that Nebrija's grammar was part of the Indians' academic syllabus. Finally, this intellectual elite was buttressed by less brilliant groups; these sprang up in distant regions and, unknown to the missionaries, copied, translated and even interpreted Christian texts at the same time that they transmitted the tradition of "paintings." The impact of these samizdat-type publications should not be overlooked or underestimated.[125]

This is the context in which the magnificent colonial manuscripts were produced. The *Florentine Codex* was one of many such examples of this development. Nor was medicine ignored, as witnessed by the *Codex Badianus*, a product of the collaboration between two Indians, one a specialist in Mexican plants and the other a Latinist who ensured that the entries accompanying the illustrations were written in Latin. The Latin dedication includes a striking detail, for the authors thank Viceroy Mendoza by calling him "Maecenas," or patron. The Mendoza family could hardly conceive of a more fitting accomplishment, for it was the viceroy's father, uncle and grandfather who became Castile's first art patrons when they strove to spread the Italian Renaissance to Spain in the closing decades of the fifteenth century. Yet another Renaissance-type attitude is echoed in this profession of faith by one of the authors of the *Codex Badianus*: *"Solis experimentis doctus"* ["Only experimentation confers experience"].[126]

Experience and experimentation were of course highly valued by

both humanists and the explorers of the New World in the first half of the sixteenth century. Finally, personal journals written in Nahuatl also appeared. These provided individual insight into everyday colonial life with its religious celebrations, bullfights, inflation, illness and death of friends and relations. The acuity of the observations (to which the painters of the *Florentine Codex* offer a perfect visual pendant in their scenes of colonial life) is an indisputable sign of the acculturation of the subject as individual; the canons of ancient art and mythological tradition are here replaced (or supplemented) by meandering personal reactions tinged with irony and a sense of distance.

Indians were also enthusiastic about European music, including plainsong and polyphony, and as early as the 1530s were composing masses that delighted the Spanish.[127] A little effort is required here to imagine this composite art combining the Nordic sophistication of a Josquin Des Prés with the popular rhythm and beat of Iberian melodies and the pre-Columbian resonance of *teponaztli* drums, conch shells and whistles.[128] Missionaries took pagan songs and replaced the words with existing or newly composed Christian texts, then used them in religious services. Soon afterward, the Indians were doing likewise. Indian musicians learned musical notation just as they had learned the European alphabet and draftsmanship. Choirs multiplied so swiftly that in the second half of the sixteenth century church authorities attempted to put a brake on this apparently irrepressible musical urge, fueled by the instruction given by itinerant minstrels arriving from Castile.[129]

Finally, painting and sculpture inspired numerous careers. By the middle of the century, conquistador Bernal Díaz del Castillo cited three Mexican painters whom he ranked alongside classical masters, Michelangelo, and the Spanish painter Berruguete: Andrés de Aquino, Juan de La Cruz, and Crespillo.[130] In addition to painting codices, artists worked on canvas and on frescoes. "When the Indians had seen our images brought from Flanders, Italy and other regions of Spain, they improved a great deal and there is no longer anything they are unable to copy and do."[131] The sculptors who decorated the façades of churches and cloisters under the supervision of missionaries were not simply skillful copiers. They added imagery from their own not-too-distant past to Christian motifs, rendering Catholic symbols in their own idiom. Thus the Franciscan emblem of a bleeding heart showed a trickle of blood in the form of the "precious water" that not long before had flowed from the opened chests of sacrificial victims to nourish the deities. Painters even dared to depict an ancient calendar on the gatehouse of a Franciscan monastery without anyone (or almost anyone) taking offense.[132] Like native writers, who tried to find Nahuatl equivalents for European concepts, painters and sculptors increasingly sought connections between European and native art. The flowering of these intellectual and artistic circles was

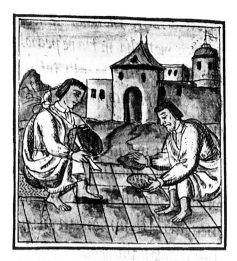

130. The Art of the Goldsmith
Florentine Codex, Vol. II, fol. 361 r.

The setting here is European. The dish and lamp prove that native craftsmen were soon able to produce copies of European objects to meet Spanish demand.

obviously directly linked to the extraordinary pace of religious construction—Mexico was soon covered with churches and monasteries that would transform the architectural landscape in less than a century.[133] The lofty naves rising toward the heavens, attracting young converts, were built by native hands. The composite architectural style, with its ever-surprising juxtapositions of romanesque, gothic, moorish and plateresque elements, was the fruit of the shared labor of monks and Indians. The former contributed basic principles and models in the form of drawings and engravings, whereas the latter copied and interpreted, freely modifying the scale, combinations and proportions of the models before their eyes. Because such work still exists, it provides a good basis for assessing the aesthetic and intellectual experiment of grafting the European Renaissance onto American soil.

Writing and painting were therefore not the only means of expression that underwent transformation. One of the distinguishing features of the native Renaissance was its composite nature, its ability to retain ancient forms instead of abandoning them for new ones. Indian songs and dance did not disappear following the conquest—only the words were changed. The hymns accompanying the celebrations of the young church simultaneously evoked the memory of ancestors, the valor of warriors, and the pre-Columbian paradise as well as the new Christian deities, the saints, the Virgin and the Holy Ghost.[134] In their own way, these songs harked back to a lost past, like the images illustrating the codices. Such hymns evoked the past with the blessings of the Spanish clergy, who did not always perceive the subtle pagan tone of these musical reminiscences interspersed with dances evoking ancient conceptions of the cosmos. It is probable that such music reacquired openly anti-Spanish and pagan content during nocturnal gatherings held far from suspicious ears. Here again, the use of Indian and Iberian instruments along with borrowed European conventions (plainsong, polyphony, *villancicos* songs, etc.) lent indigenous celebrations a hybrid, rearranged tenor not unlike contemporary rock "remixes."[135] This is simply another way of saying that once again the Indians copied, adapted and created.[136] Finally, native Mexicans also participated in writing, directing and performing the religious plays and mysteries organized by the Franciscans to convert the Indian masses mesmerized by such shows, although space does not allow for a full discussion of that phenomenon here.[137]

A New Language

Yet the effort to unite two cultures (often turning the conquerors' culture to the advantage of the conquered) is probably easiest to detect in the realm of images and pictographs. The creation of a twin system of expression—pictographic and alphabetical—was not merely a sign of compromise or collaboration. It also represented the

131. Stonecutting
Florentine Codex, Vol. III, fol. 19 v.

This is one of the most evocative landscapes in the Florentine Codex. *It shows a rock quarry set against a distant horizon, not unlike an Italian or Flemish landscape. And the artist has depicted the various stages of stonecutting on three distinct planes—extraction, roughing and final carving of capitals and bases. This visual and scenic representation of tools and techniques would be perfectly appropriate to a technical or encyclopedic text. But the goal of Franciscan Fray Bernardino de Sahagún (who supervised this codex) was to develop and illustrate the moral theme of "the good stonecutter."*

132. A Native Tailor (top and bottom)
Florentine Codex, Vol. III, fol. 25 r.

Tailors probably existed prior to the conquest, but the tools (needles, iron shears) and fashions imported by the Spanish required new skills.

133. A Spanish Tailor
Geometria y traça para el oficio de los sastres, Seville, 1588

The Florentine Codex painter perhaps made use of an engraving similar to this one in order to portray the stereotyped poses that best express the tailor's art.

discovery of new formal strategies for preserving two living traditions side by side. At the same time that they mastered Latin and massively adopted writing, painter-writers were preserving and enriching their pictographic heritage.

Examination of the *Codex Mendoza* provides several valuable points of reference concerning the first generation of painters under colonial domination. The codex was produced by artists working under Francisco Gualpuyogualcatl, "the master of Mexico City painters." These painters were perhaps between thirty and forty years old when the codex was executed (1541-1542). Born and raised during the pre-Hispanic period, they had nevertheless been in contact with European forms for at least fifteen years. The pre-Cortés world was already sufficiently distant that the memory of certain objects or rites may have faded, and it is probable that these studio artists received their *tlacuilo* training during the difficult days of the Spanish conquest, which would explain the gaps in their traditional vocabulary. A description of this early style—eloquent examples of which have already been cited—is perhaps in order. A glance at the *Codex Mendoza* and other early manuscripts clearly shows that pre-Hispanic tradition dominates, since glyphs for names and places, along with the conventional stylization of objects, occupy a preponderant place. Yet a closer examination reveals a wealth of evidence that major progress in the Europeanization of eye and hand has taken place. First of all, perspective is now used in combination with two-dimensional space, though still in a timid way. This is particularly apparent in the plate illustrating Moctezuma's palace (illus. 92). Changes in draftsmanship are equally significant. The traditional thick, regular, continuous stroke that systematically outlined shapes has given way to a brush handled lightly or heavily depending on the effect sought, as in European calligraphy. Similarly, the use of shading for certain objects represents a break with pre-Hispanic conventions; by shading the blankets included in the objects delivered to Mexico-Tenochtitlan as tribute, the painter was suggesting volume, whereas a pre-conquest *tlacuilo* would have applied color uniformly. Colors were no longer used simply to express a divine universe, they could now suggest forms and hint at modeling.[138] In the final section of the codex, the development of the representation of the human figure confirms the above observations. The body is represented as a homogeneous, unified whole, rather than as the set of distinct elements used in older codices. New poses and positions enrich the more hieratic and limited repertoire of pre-Hispanic art; arms and legs take on almost anatomical proportions, whereas indigenous canons exaggerated the size of the head. Thus the *Codex Mendoza* already indicates what the stylistic research of this Mexican Renaissance was fundamentally seeking—a union of stylized and "realistic" representation,[139] the conjunction of pictograph and illustration. Far from following a simple, uniform pattern, indigenous sixteenth-century art underwent

a complex evolution that involved grafting realistic inflections onto the ancient grammar of forms, thereby articulating an original aesthetic strategy. It would also appear that whenever traditional models were lost, poorly mastered or nonexistent, the artist would take greater creative liberty and move closer to European art without, however, slavishly copying it. At the same time that this exploration of forms was taking place, the repertoire of glyphs was being broadened. Numerous innovations were made in order to render the names of saints, Spaniards, Christian holidays and European objects in a pictographic idiom. Far from vanishing, pictographic writing was adapting and coming to terms with the alphabet.[140]

The European influence is much more marked in the *Florentine Codex,* painted by the second and third post-conquest generations. The codex was produced at a time when Mexico was sinking deeper into counter-reformation, stifling the Renaissance spirit; back in Spain, meanwhile, Philip II had become king on the death of Charles V in 1558. All evidence suggests that the nearly twenty-five hundred images in the *Florentine Codex*, painted in 1579, were executed by Indians born under Spanish rule and therefore without direct experience of pre-conquest life.[141] Due to pressure exerted by the crown, the codex had to be "illuminated" in a very short time, which explains why many artists of varying quality and sensibility were employed. Although all of them appear more comfortable with the colonial world of the 1570s than with a past already half a century distant, some artists were visibly more familiar with traditional forms, whereas others were able to make better use of European sources.

By now, however, the text (in both Spanish and Nahuatl) had become the prime vector of information. This represented the triumph of the "book"; images were relegated to the role of illustration even though, as noted above, they often recounted more—or even something different—than the text they accompanied. Renaissance inspiration can be detected in the use of the third dimension, landscape, human forms and numerous features borrowed from European engravings. Even more striking is the ability to use touches of color to suggest a background, undulating horizon or passing cloud. Equally evident is the amazing variety of influences adopted by these painters who were constantly shifting between their fidelity (or recourse) to traditional models and their acceptance of European art. The fertility of Mexican artistic vision lies precisely in this openness to forms and colors, rather than in an irreversible, unequivocal Europeanization. These startling, premature comic strip graphics are perhaps the most original product of this encounter of two worlds, and they retain an incomparable freshness even today.[142]

It is legitimate to ask what impact these *tlacuilo* images may have had on Hispano-Indian culture in the latter half of the sixteenth century. Not only did indigenous painters record images of a hybrid society, they also certainly influenced the development of Mexican

style and taste through their research into European forms, creating original settings that combined European and Indian perspectives. The painters incorporated elements from both worlds when depicting interiors, characters and apparel; they introduced new postures and gestures, such as how to sit on a chair or a stool with one leg in front and the other in back. This was all the easier for them insofar as they were conversant with both traditions and could pick and choose their influences. Painters effectively became the unconscious designers of a new lifestyle. They were encouraged in their task by nobles and authorities who were in a hurry to acquire the trappings of European luxury without, however, abandoning native tradition.[143] One of the most accomplished expressions of this Mexican Renaissance may well be the portrait of the featherworker in the *Florentine Codex* (illus. 136-143). It shows an Indian artist in a European pose and setting, gazing at sheets covered with ancient glyphs that he is about to decorate with feathers.

Once again, examination of these images provides extraordinary insight into social and cultural conditions, opening the door to a lost world. Art and images are not mere epiphenomena, they express an evolution in thought and attitudes. The use of perspective (even when sketchy) created a sense of distance between observer and object mimicking the distance adopted by Indians toward their sins during confession [144] or toward their past and a society they were obliged to rethink, reassess and defend. Missionaries employed every means to make Indians adopt a "moral perspective," a Christian view of the world that would produce a *homo novus*; this new man, renascent, would be free from the old pagan man, yet not cut off from his roots. From this standpoint, New Spain was the perfect place for early sixteenth-century Christian utopias and ideals to flourish. Humanist Franciscans were convinced of this, and the Indian nobility entrusted to them was the early beneficiary of such ideals even as it suffered a series of humiliations and oppression.[145]

These efforts to combine or order the old and the new were limited to intellectual and noble spheres. Indian society as a whole was henceforth and forever torn between divergent, indeed diametrically opposed, demands. Those Indians most aware of this inextricable situation confessed their perplexity, stating that they felt split "between the two," between two worlds and two lifestyles.[146] In fact, wherever there was a major Spanish presence, wherever evangelization had sown its churches and cloisters, highly advanced Europeanization coexisted with the most scrupulous, deep-rooted respect for native tradition. Between these two extremes, behavior varied according to social milieu, geographic location, and personal inclination; it goes without saying that the Indian mistress of a Spaniard who moved in mestizo and European circles would behave differently from a healer in a distant village in the sierra.

In many respects, the figure of Martin Ocelotl is a good example

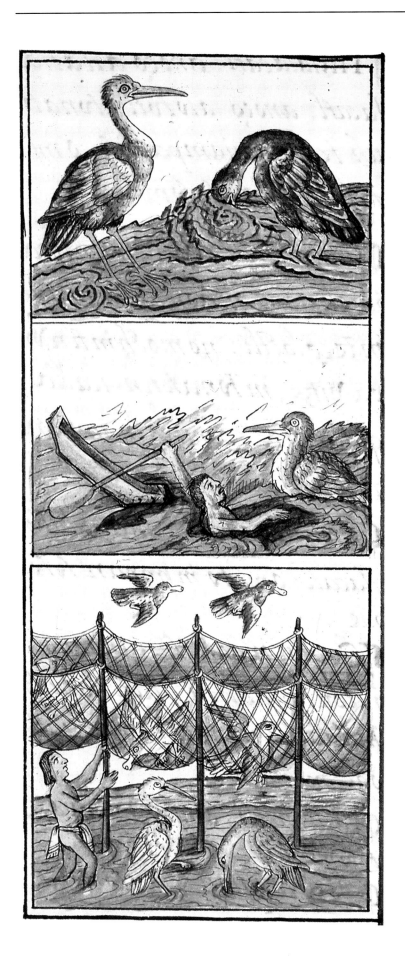

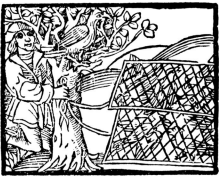

135. Birds and Fowlers in Spain
Livro llamado exemplario, Seville,
1546

*These engravings might have served as a
model for the painter of the* Florentine
Codex *(illus. 134), who nevertheless had
the important task of devising appropriate
color and shading.*

134. Hunting Birds on the Lake
Florentine Codex, Vol. III, fol. 213 v.

*Some livelihoods were little affected by the
conquest, as demonstrated by those who
continued to hunt waterfowl on lakes in the
Valley of Mexico.*

136-143. The Art of Featherworking
Florentine Codex, Vol. II, fol. 371
v.—375 r.

To illustrate a passage describing the techniques used by featherworkers, the native artist produced a series of images of amazing virtuosity, anticipating the plates in Diderot's Encyclopedia *by a century. This veritable "comic strip" is a homage to a culture that relied on images to teach science and techniques, and is one of the most successful encounters between the native and European worlds. During the pre-Hispanic period, feathers were charged with religious significance. As precious items obtained by trade with distant lands, they were used in innumerable objects and finery. Featherworkers, or* amanteca, *were among the wealthiest craftsmen. They used feathers the way a painter would use color. This art not only survived the Spanish conquest, it adapted to new conditions and new forms. As seen in these plates, the setting and dress (which varies according to age and degree of skill),* *along with the rendering of bodies and folds of clothing, identify this as a colonial document, whereas a plethora of details testifies to a pre-Hispanic approach to painting. These exceptional scenes are also moving, for the painter is, in a way, showing himself at work, confronted with a repertoire of traditional motifs (glyphs, for instance, which appear in the second and final images) and European forms (arabesques, a saint, etc.). The visual rendering is remarkable for its inclusion of a two-dimensional illustration in a three-dimensional setting, and for the use of framing and zoom effects. The painter thereby presents a series of tableaux that are both familiar and unsettling. This is the finest existing visual testimony of the adoption of Renaissance values by the native Mexica, for a period as fleeting and magnificent as the feathers themselves, the ostensible subject of these illustrations. The art of featherworking produced a range of masterpieces now dispersed in museums across Europe and America (see illus. 122 and 124).*

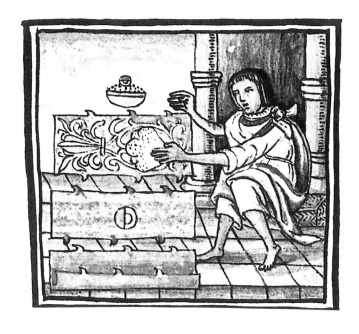

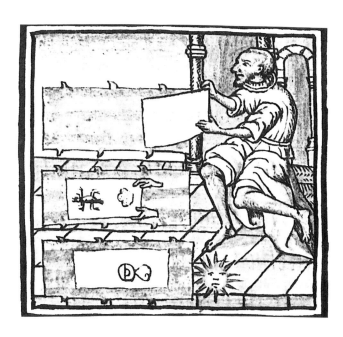

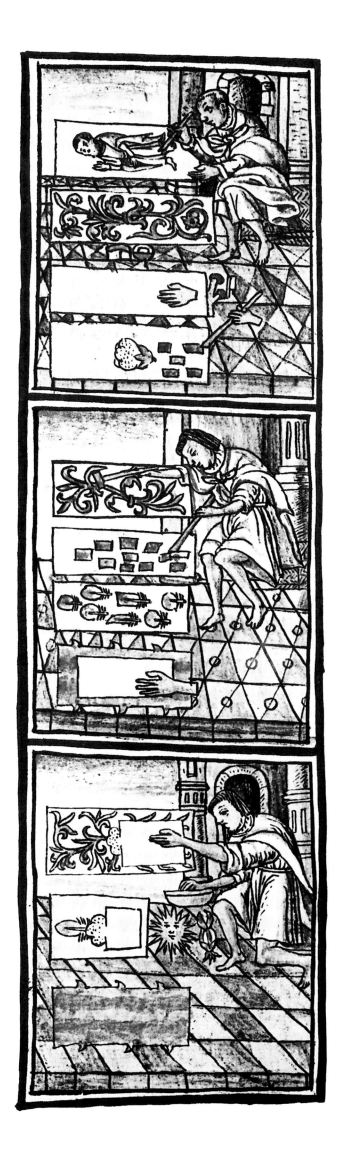

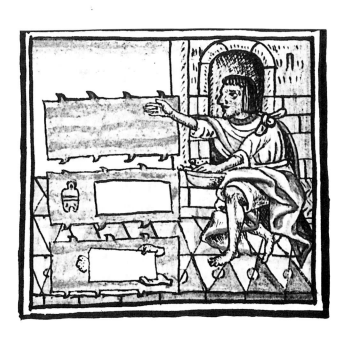

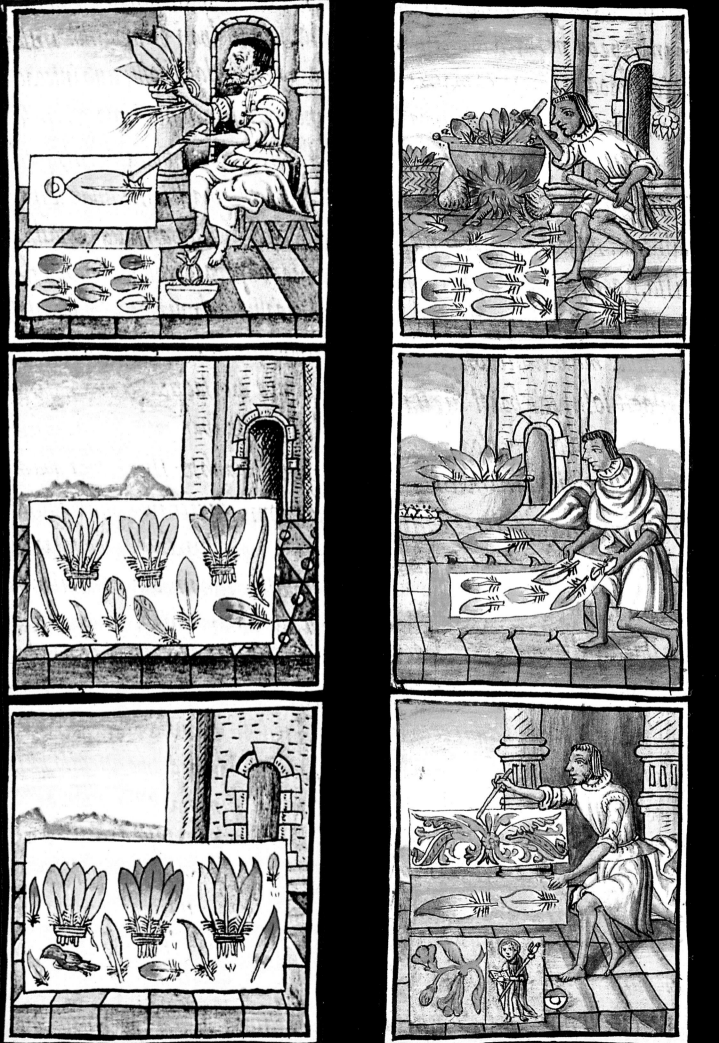

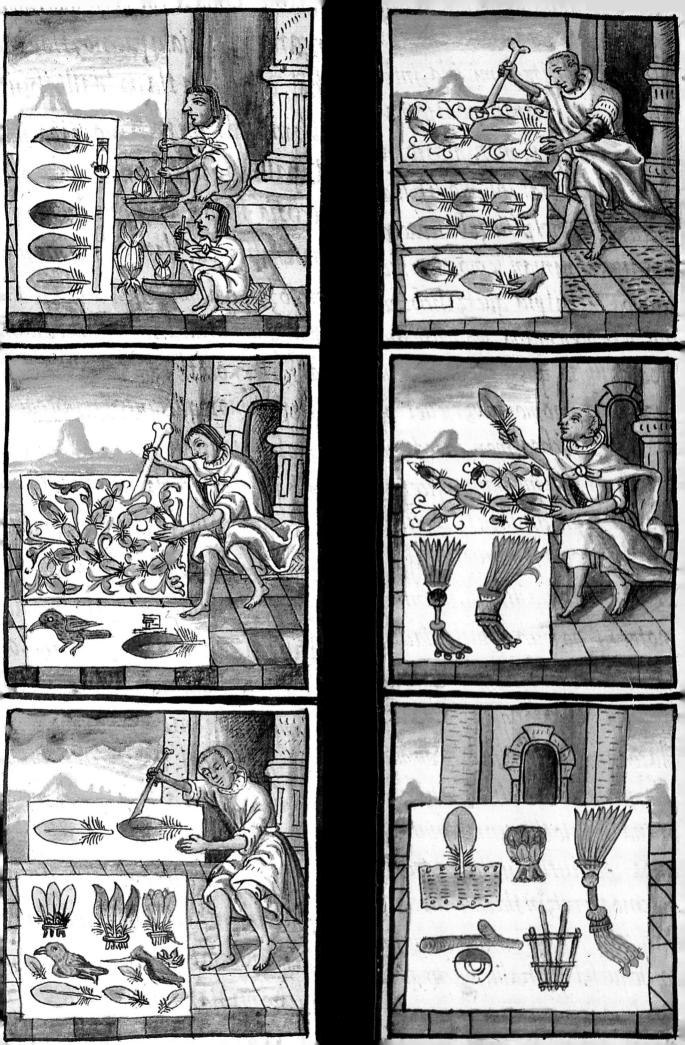

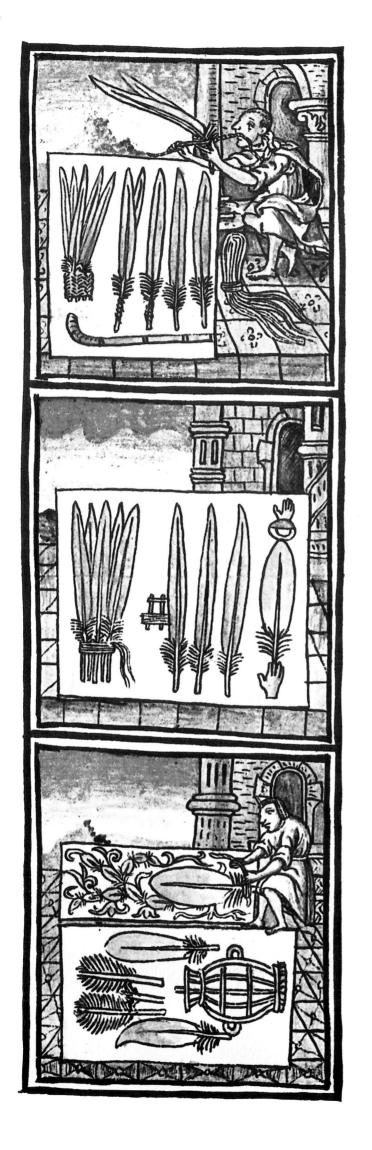
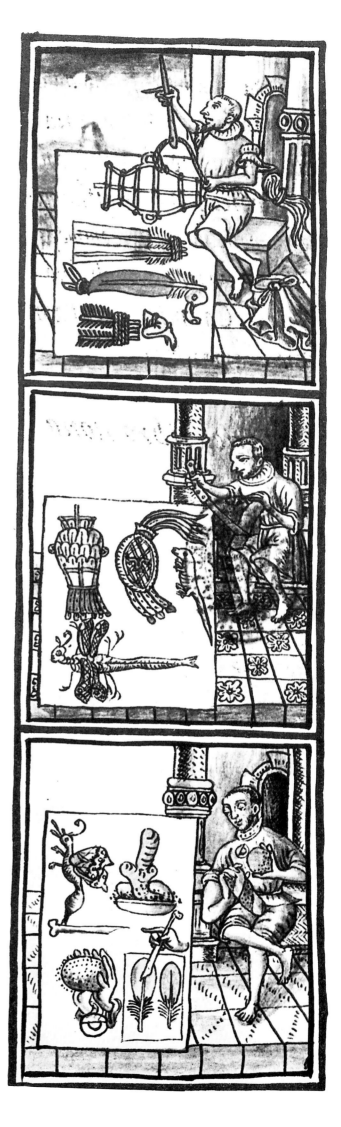

of the first generation of converts. He was born before the conquest, his father having been a merchant and his mother having apparently been a sorceress. Martin was an affluent man who worshipped the idols on his estate near Mexico City. He did business with the merchants in the Valley of Mexico who ran the lakeside trade, exchanging cypress wood for deerhide. Martin boasted an impressive assortment of possessions, from gold objects, coins and merchandise to houses and farms. He sometimes acted as healer, even treating the governor of Mexico City with jade. Yet he knew enough Christian theology to astound the missionaries with the wisdom of his responses. His country house also contained frescoes depicting the lives of Saints Hieronymus and Francis. He was nevertheless arrested in 1537 by the Inquisition on charges of criticizing Christianity and preaching the imminence of the apocalypse.[147]

Throughout central Mexico, the homogeneity of ancient cultural systems was thus shattered—or at least cracked—by such ambivalence. Even those Indians who remained fundamentally idolatrous irrevocably differed from their ancestors the day missionaries forced them to add a Christian name to their Indian names.[148]

V.
Taking stock
of the world

145. The Sun as Represented in Spanish Iconography
Francisco de Ossuna, Norte de los Estados, Burgos, Juan de Junta, 1550

◁ 144. Lunar Eclipse
Florentine Codex, Vol. II, fol. 233 r.

"During an eclipse, the moon seems almost dark, it blackens.... Then it is the earth that darkens. When this occurs, pregnant women fear they will abort, they are gripped by fear, they dread lest what they have in their body will be transformed into a mouse. In order to prevent this they carry a piece of obsidian in the mouth or on a belt and on the belly... to prevent their children from being born freakish."
The style of this illustration corresponds poorly with the beliefs described in the text. Throughout this chapter of the codex, the painter imitates European images with no attempt to transmit traditional visual values —either out of ignorance, a desire to withhold information, or simply a penchant for Renaissance models.

Strolling through the valley at an hour when the October sun was warming the spikes of corn laden with yellowing ears, a handful of Spanish Franciscans escorted by native painters and disciples made their way along the banks of the lakes reflecting the twin volcanoes Popocatépetl and Ixtaccíhuatl. Bernardino de Sahagún noted, or etched in his memory, explanations offered by the Indians. They named and described various plants, recounting ancient beliefs that, in the mouths of these recent converts, were transformed into legends and fables. Healers were visited in order to learn the use of herbs, the secrets of flowers and stones. Nothing escaped the curiosity of the missionaries and painters, from the golden butterflies chased by children in the sodden fields after the rainy season, to the tree-covered mountains and the blossoming gardens. All would be reported in the magnificent *Mapa de Santa Cruz*.[149] Native informants and disciples proudly made an inventory of this land teeming with fish and game, caressed by warm breezes humming with insects. The more the Franciscan monks interrogated, the more their informants had to say. On the least blade of grass they would spot a tiny insect, or point out the larva hanging over a puddle left from recent showers, or speak of the fantastic animals they no longer worshipped but that still sparked terror deep in the woods, in the hollows of mountains or in the whirlpools of lakes. The Franciscans delighted in the richness of the fields and luxuriance of the vegetation, indisputable signs of the effects of God's work on this land formerly in the grip of idol and devil worship. Nevertheless it was hard for them to ignore the forces that had once animated this timeless landscape, hard to make those who lived in it abandon that former lifestyle, hard to make them forget those familiar spirits.

The World of the Elders, or, Things Best Forgotten

Nature, for the elders, constituted one great continuum within which mankind, animals, stones, plants and objects were all interconnected. The idea of humanity struggling against nature and charged by a deity to tame it—as God had instructed Adam—was radically alien to both peasants and the wise men in the cities. There was no clear-cut division between human, animal and vegetable. The Nahuatl language, moreover, did not always distinguish between people and animals, for both belonged to the class of *tlatipac tlaca*, "beings who live on earth."[150] The natives told the missionaries how the gods Quetzalcoatl and Tezcatlipoca had brought Cipactli, the female Earth monster, down from the sky. They attacked, raped and dismembered her. "In recompense, the Earth monster was made the source of everything needed by mankind. The gods made trees, flowers and herbs from her hair, whereas her countless eyes became springs, caves, and wells; her mouth turned into rivers and gigantic caverns

and her nose became mountains and valleys. Sometimes, the Earth wept at night, because she wanted to eat human hearts. She only agreed to keep quiet if she was given them, and only granted her fruit if she was watered with the blood of humans." [151]

Under the starry canopy traversed by Sun and Moon, in the lower world of soil and water, there stood enormous reservoirs —the mountains—that contained the air and the waters. These mountains were the source of rivers, clouds and winds. Water ran out of the holes of springs and the winds escaped from immense caverns. The watery and windy realms were subject to Tlaloc, lord of the primeval mountain, that spring from which all waters flow to quench the thirst of men and plants. "Nature" thus abounded with divine forces, both dangerous and benign. Yet it was also a world of metamorphosis and transformation; corn could take on human form, just as men could become animals when necessary. The Indians conceived of the earth as a rectangle or disk surrounded by the ocean waters that rose to support the upper heavens and enclose the four lower heavens. The surface of the earth was divided into four sectors, like the petals of a flower whose corolla represented the center of the world, a piece of precious jade inhabited by the god of Fire. Each of the segments had a corresponding color and sign. At the edges of the earth's surface rose columns down which flowed the good or harmful influences originating in the world of the gods. Time also flowed down these columns and down a central axis into the human world.

Thus things went, at least prior to the conquest and the spread of Christianity and European knowledge. Native interpretations ultimately had to confront the European view of the earth and nature that Spanish and Portuguese explorers were just then imposing on European science. Magellan's circumnavigation of the globe, which proved once and for all that the earth was round, had begun in 1519, the very year that Cortés invaded Mexico. As the Franciscans' pupils, educated Indians could no longer ignore the fact that the world was a globe containing four continents: Europe, Asia, Africa, and the New Indies. They knew it was possible to go to Spain—land of Charles V and his son Philip II—by two routes, either by crossing the Atlantic or by the exhausting trip across the "South Seas," as the Pacific was called. Yet this new knowledge was slow to sink in and was burdened with ancient and medieval concepts. The perception of nature imported into Mexico by soldiers, farmers and craftsmen from various Iberian communities was hardly the scientific view of a naturalist. [152] And even the scientific approach was still haunted by obsessions, illusions and fantastic beliefs. Spanish colonization should not be viewed as the triumph of rational thought over a purportedly archaic indigenous system. Rather, it produced an amalgam of disparate cultures, open to all influences and all syncretistic beliefs.

146. The Moon
Florentine Codex, Vol. II, fol. 228 v.

"The myth of the rabbit in the moon goes as follows: The gods, they say, were teasing the moon and flung a rabbit in its face. And the rabbit remained marked on the moon's face. That is what darkened the face of the moon, as though it had been bruised. Upon which the moon went out to light the world."
This passage is followed by the tale of the meeting of the gods at Teotihuacan, involving the origin of the sun and the moon and generating one of the finest images in this codex. The milk-white moon, simultaneously full and crescent, stands out in all its brilliance against an intensely blue sky.

The Invasion of Plants and Animals

For flora and fauna as well as for mankind, the American continent had functioned like a gigantic trap. Alternating epochs of glaciation and warm weather opened up then sealed off the continent to species from Asia. Once cut off, these species evolved in an isolated environment. North and South America became the habitat of plants and animals not found in the Old World. Cacao grew in the hot climate of the Gulf of Mexico and Guatemala; the quetzal bird with its precious feathers perched in trees; jaguars, hunted for their furs, roamed outside the villages. Indians living in the Valley of Mexico with its temperate climate knew everything about the aquatic world because the lakes nestling in the hollows provided a large part of their sustenance. Fishermen went after *amílotl* and *xohuilin*, fish known for their tasty flesh. They also hunted ducks, cranes and pelicans, and did not turn up their noses at frogs, shrimp or *axolotl* (tadpoles). The large-beaked *chichicuilote* bird was caught and sold at the market because it killed mosquitoes. The Indians knew all there was to know about the algae in the lake, and possessed amazing knowledge about insects, which they ate heartily. They particularly liked *aneneztli* (dragonfly larva) and *axayácatl* (the larva of a black hemipterous insect). They gathered *ocuiliztac*, which resembled a white worm, and many kinds of insects in the wetlands. They crushed gray flies to make a succulent dough that they baked into a sort of bread. The small dogs and turkeys scurrying in farmyards provided appetizing meat; deer, rabbits, wild cats and other beasts were also hunted in the forests and mountains. Indians had been cultivating corn, prickly pear, agave and many varieties of pepper for thousands of years. In the hot regions, cotton and cacao were harvested in abundance. They were purchased by *pochteca* traders or requisitioned by tribute collectors, then carried by relays of porters to the major markets in the Valley of Mexico.

This universe of plants and animals was subject to the Spanish conquest as well as mankind. It is too often forgotten that the invasion of the islands and continent by European animals was an event as significant and drastic as the incursion of the conquistadores.[153] Except for llamas used in the Andes, beasts of burden were unknown in the Americas. Dogs and turkeys were practically the only domestic animals in Mexico. There were neither pigs, nor cows, nor sheep, nor goats in the New World. Such animals were an integral part of the invaders' lifestyle, from pig farms in Extremadura to enormous flocks of sheep across the Iberian peninsula. American horses had been extinct for thousands of years when Columbus unloaded the first European specimens in the Caribbean. They contributed to the conquest by sowing panic among natives who at first thought that horse and rider were one. Horses provided a mobility in battle that often compensated for numerical inferiority. At the outset of the

147. Clouds and Rain
Florentine Codex, Vol. II, fol. 238 r.

"These natives attributed clouds and rain to a god named Tlalocatecutli, who had many other gods under his authority. They were called tlaloc *and* tlamacazque....*"*
Here again, text and image diverge. The text describes gods, rituals and ceremonies linked to clouds and rain. The images, on the other hand, represent a bold invention. They evoke abstract motifs (geometric or otherwise) that decorated the pagan priests' capes. The volute of the glyph for water, repeated at least thirteen times, is woven into a visual web inspired by engraving techniques.

148. A Spanish Model
Bartholemeus Anglicus, De
Proprietatibus Rerum in Romance,
Toledo, Gaspar de Avila, 1529

conquest, after Cortés had defeated the Tabasco Indians at Cintla on the gulf, the conquistador staged a scene with cannon and horses designed to quell the Indians. He managed to make them believe that the animals had their own will and that he alone could appease them and make them obey. The Indians needed no more convincing.

The invasion of other animals was less spectacular but would have serious consequences in the long run. Wherever the conquistadores and colonists landed, they let loose pigs that reproduced in the wild and ravaged native crops, thereby devastating agricultural production and adding the scourge of famine to the plagues of epidemics and forced labor. Guinea fowl and rats also accompanied the conquistadores.[154]

The Indians had no way to fight back against this unplanned assault. They could not outfox animals the way they could men. Their only recourse was to adopt the unfamiliar beasts and learn to raise cattle, pigs and sheep, or to reject them along with the new nourishment they offered (as well as the foreign domination they represented). Prophets crisscrossed the Valley of Mexico in the mid-sixteenth century, warning baptized Indians who ate European meat: "Whosoever eats the flesh of cow will be transformed into a cow; whosoever eats the flesh of pig will be transformed into a pig and will wear his skin; whosoever eats chicken will be transformed into a chicken." All those who underwent such metamorphoses would die, then darkness would come upon the world and *tzitzimime* monsters would leap on humans and devour them. Everything, ultimately, would be transformed. Famine would reign, so the Indians were advised to hoard their eternal plants—gourds, tree mushrooms, sand tomatoes, tender ears of corn, bean pods. And they were told that they would have to crawl on their stomachs to avoid being eaten by the "Old Lady with Sharp Teeth" (probably a reference to the Earth monster). The disgust and disarray provoked by the destruction of the familiar environment once again took the form of a myth that combined cyclical fears of the end of the world with the invocation of all-powerful Earth, now more famished than ever since Christians had outlawed human sacrifice.[155]

A Renaissance Culture

These rural terrors were not shared by urban Indians, who dealt with the Spanish on a daily basis. They thereby encountered other concepts, concepts that still retained a resonance of magic. Conquistadores and colonists, for instance, were enamored of the chivalric romance literature that was so celebrated in Europe, and were the first to populate nature with fantastic animals and wonders.[156] It was the missionaries in their cloisters and monasteries who suggested a more rational approach by tirelessly studying natural

149. Stars and Wind
Florentine Codex, Vol. II, fol. 236 r.

"Those stars known as the Great Chariot in certain regions are called the Scorpion by these people because they take the form of a scorpion, and that is how they are known in many parts of the world.... The wind blows from the four parts of the word at the orders of this god [Quetzalcoatl]." The tlalocaiutl *wind blows from the east, whereas the second wind,* mictlampa ehecatl, *blows from the north; the third wind,* cioatlampa ehecatl, *blows from the west and the fourth wind,* uitzlampaehecatl, *blows from the south. Each wind comes from a divine abode. Since the native informants lived along lake shores in the Valley of Mexico, they measured the strength of these winds in terms of the effect on navigation on the lakes.*

The painter here adopts a European approach, whereas the painter of the Codex Mendoza *represented night as a gray semicircle studded with eye-like circles representing stars. In this instance, however, Indian beliefs were sufficiently similar to European conceptions to allow the painter to feel that he was remaining faithful to his ancestors' classifications by reproducing a European model.*

150. Noah's Ark: European Version
The Bible, Guillermo Romillium,
Lyon, France, 1581

A native painter from the Puebla region named Juan Gerson (like the famous fifteenth-century French theologian, Jean de Gerson), studied a series of engravings on biblical subjects such as the one shown here, of Flemish or Germanic origin.

151. Noah's Ark by Juan Gerson
Tecamachalco Church, State of Puebla

Gerson, who began painting in 1562, had to take small engraved images and extrapolate them to the scale of a fresco, adding color and tone, and calling on native conventions to explain the meaning of the scene. Thus the glyph for water appears distinctly amid the ocean waves.

Like the codices, this image was painted on amatl paper. The painter's apparently archaic style, evoking early quattrocentro art, was given free reign in a stunning series of frescoes dealing with the Apocalypse of Saint John.

152. Cuitlachtli Bear or Wolf
Florentine Codex, Vol. III,
fol. 159 v.

"It is of woolly, tangled, snarled fur, of
dark, bushy tail. When it is already old,
its tail is tangled.... It is droplet-eared;
round, broad of face as if man-faced; thick
and short of muzzle. Much does it wheeze;
a great hisser is it. When it hisses to terrify

one, it is as if a rainbow comes from its
mouth. Very clever is it—a great stalker, a
crouching spy. It stalks one; preys, hisses
at one."
This description makes it difficult to identify
the real animal. It might be a wolf or
a bear of the ursus horriacens, ursus
americanus machetes type. It is depicted
here in a relatively elaborate landscape,
although the animal's paws are not placed

in a space corresponding to the perspective
suggested by this landscape—the hind legs
are in the foreground whereas the forelegs
are in the middle ground.
Interpreted from a three-dimensional Euro-
pean perspective, the animal appears to be
rearing strangely on its hind legs. This
illustrates how dissimilar the European view
was from that of the Indians.

153. Puma
Florentine Codex, Vol. III, fol. 161 r.

"[Cuitlamiztli] is the same as a mountain lion.... When it reaches a deer, it attacks it. When it seizes it, it eats it, eats it gluttonously, eats it as it lies; indeed it consumes it all. For two days, for three days, it eats nothing else."
Cuitlamiztli is the "dung-colored puma," felis azteca azteca, felis concolor azteca.

154. Tapir
Florentine Codex, Vol. III, fol. 158 v.

"It is very large, bigger than a cow. Its head is very large, the muzzle long, its ears very wide, its molars, its teeth also very large, like the teeth of us human beings. Its neck is very thick, very fleshy.... This tapir is edible. But not of only one flavor is its flesh; all the various meats are in it: human flesh, wild beast flesh—deer, bird, dog, etc."
This animal is the tapirella bairdi, tapirella dowii or tapirus bairdii. *The reference to the taste of human flesh attests to the persistence or recollection of cannibalism, yet it also reveals how the Indians placed man and animal on the same plane. In painting this tapir, in fact, the artist has relied only on the descriptive text, which produces a fantastic animal not unlike those seen in European bestiaries at that time.*

156. "Serpent Mat"
Florentine Codex, Vol. III, fol. 236 r.

"This is not a single one; serpents are assembled, gathered, much as if they were made into a reed mat...and it goes, it travels, in this way: it runs in all directions, because the serpents' heads lie in all directions making the border of the serpent mat. Thus it runs in all directions; it goes back and forth."

According to the commentary, the wise man has no fear of this amazing thing, he sits on the living mat as though it were his own; and he has a premonition that either some disaster will occur and he will soon die, or that he will become a lord (tecuhtli), that is to say that he will attain power, the mat of snakes prefiguring the throne that shall be his.

It is possible that a collective coupling of snakes is involved here. The lower vignette evokes the ancient beliefs associated with these reptiles, an evocation heightened by the traditional dress and posture of the Indian.

◁ 155. Water Snake
Florentine Codex, Vol. III, fol. 227 v.

A fisherman, attacked by the reptile, has hidden in a hollow tree. "The snake wraps itself around the tree and squeezes so tight trying to smother the fisherman that it dies wrapped around the tree."

The whirlpools in the lake are represented by the spiralled glyph for water. The remainder of the image is a falsely realistic representation of the incident, since the man in hiding is next to the trunk rather than within it. This, however, is a product more of pre-Hispanic canons than of the painter's clumsiness.

The Florentine Codex *devotes numerous pages to reptiles and the danger they represent for human beings. They were dreaded, cunning enemies. Thus the* acoatl *was able to make a hole the size of a large book and fill it with fish that it had caught. If an Indian boldly seized this miraculous catch, the snake would fly after the victim and smother him to death.*

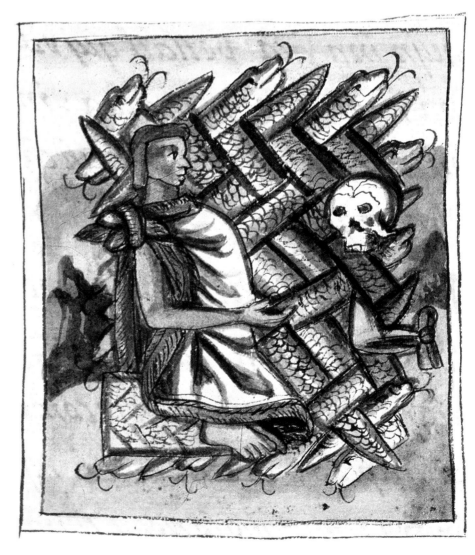

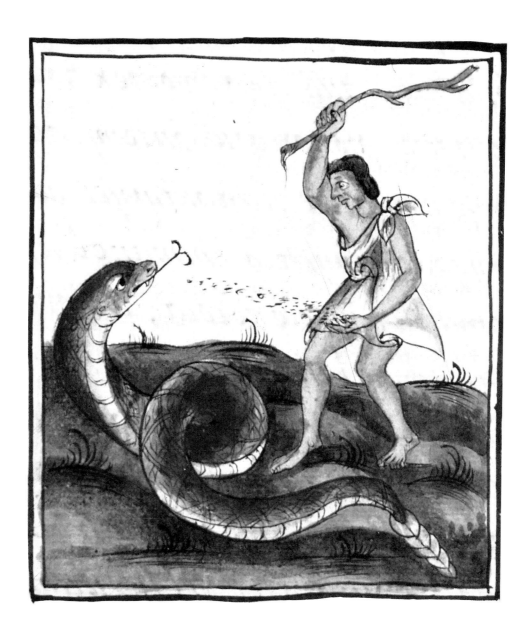

157. Hunting Rattlesnakes
Florentine Codex, Vol. III, fol. 230 v.

"Its food is rabbit, hare, bird. It pursues whatever little animal it sees, and although it has teeth, it does not chew it. When it is said that it eats it, it only swallows it whole; later it grinds it up within. . . . And if what it wishes to eat is in a difficult place, such as on top of a nopal, first it shoots its venom at it. Twice, thrice it casts it at it. Of itself it tumbles down."

The snake is called tecuhtlacozauhqui, the "yellow lord." This scene has the charm of a story-book illustration. It is explicitly based on the account of a hunter who uses picietl (tobacco) to kill his prey, "with which all poisonous snakes can be taken."

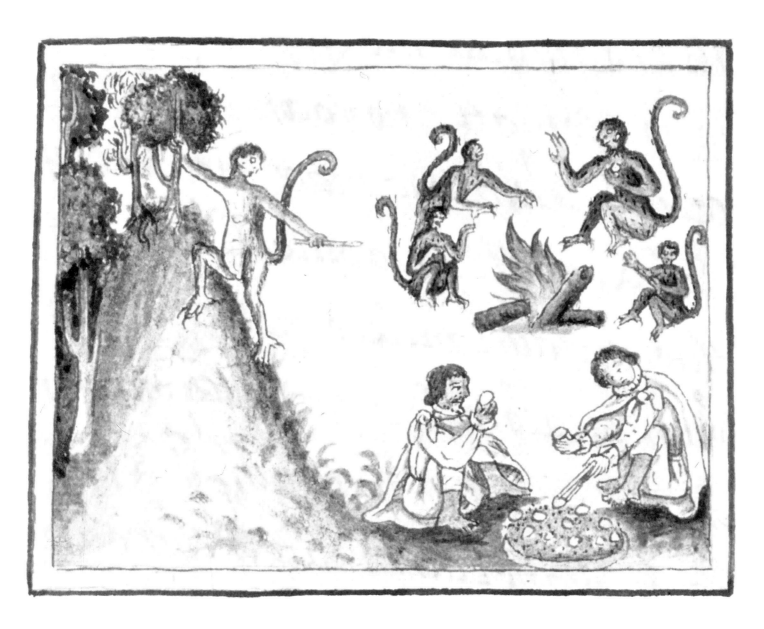

158. Hunting Monkeys
Florentine Codex, Vol. III, fol. 169 v.

"And to capture them, a large fire is built; ears or kernels of maize are put around the edge, and in the blaze is buried a very large stone called cacalotetl. *And the trappers, the hunters, take cover. And when the fire smokes, these monkeys, wherever they are, smell the fire, the smoke. Then they come;* they carry their young on their backs; they seat themselves about the fire. . . . And when the stone has been heated, it cracks, bursts open, explodes, blows up just like the firing of a gun. . . . So they run, they flee as if someone pursued them. They quickly abandon, throw aside, their young."*
The hunters then merely have to grab the young monkeys, which they tame. *"These animals are easy to domesticate; they sit like* humans and ask for food by stretching out their hands." The two stages of the hunt are shown simultaneously, and the human features of the monkeys are accentuated. They adopt the same poses as the hunters, all the more "natural" for them insofar as native mythology held that an initial human race was turned into monkeys.

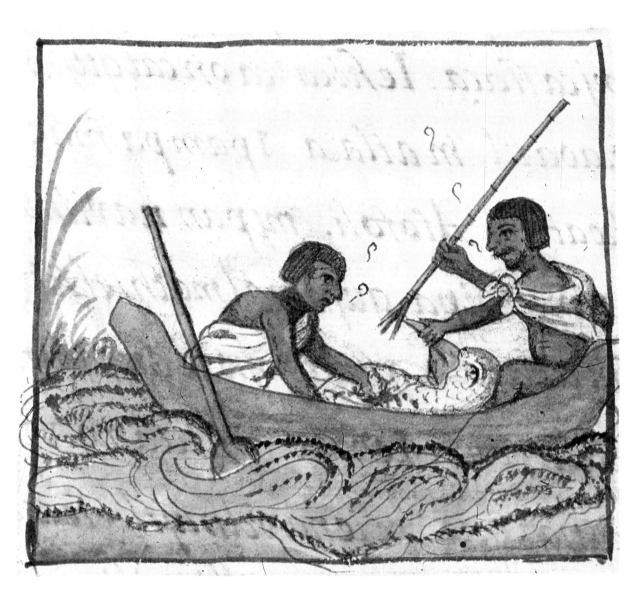

159. Hunting Pelicans
Florentine Codex, Vol. III, fol. 183 v.

"It is the ruler, the leader of all the water birds, the ducks. . . . This pelican does not nest anywhere in the reeds; it always lives there in the middle of the water, and it is said that it is the heart of the lagoon because it lives in the middle. Also it sinks people. To sink them it only summons the wind; it sings, it cries out."

The atotoli, *or "water turkey," is the white American pelican,* or pelecanus erythror-hyncus.

"To catch it, hunters stalk it for two, three or four days. But if they fail to catch it by the third day, on the fourth day the water folk . . . steel themselves to go forth and die. . . . [For] this pelican, when they have failed to shoot it by sunset of the fourth day, then calls out, cries out like a crane; it summons the wind to sink the people. Thereupon the water foams . . . and the water folk can no longer help themselves, although they try hard to pole their boats . . . there the water folk die; there the boat sinks."

Strangely, the painter here preferred to stress the ancient belief that the belly of a pelican contained a sign (in the form of a piece of jade, feather, or charcoal) foretelling the hunter's fate. "These water folk consider it as their mirror."

It is no coincidence that the painter depicts the least technical and what is probably the most questionable aspect of pelican hunting —but did he want to denounce such practices, or preserve their memory whatever the cost?

160. Toad
Historia Tolteca-Chichimeca, fol. 14 r.

The animal squatting on a mountain embla-zoned with seven flowers is not part of a rural scene. It is a glyph for one of the sacred names of the city of Cholula (or one of the names for the territory it governed). The vegetation flanking the mountain illus-trates how a realistic European style and manner could be subtly appropriated to communicate place-name glyphs rather than describe a given landscape. Indigenous paint-ers were thus able to adapt the new visual system to ancient meanings and uses.

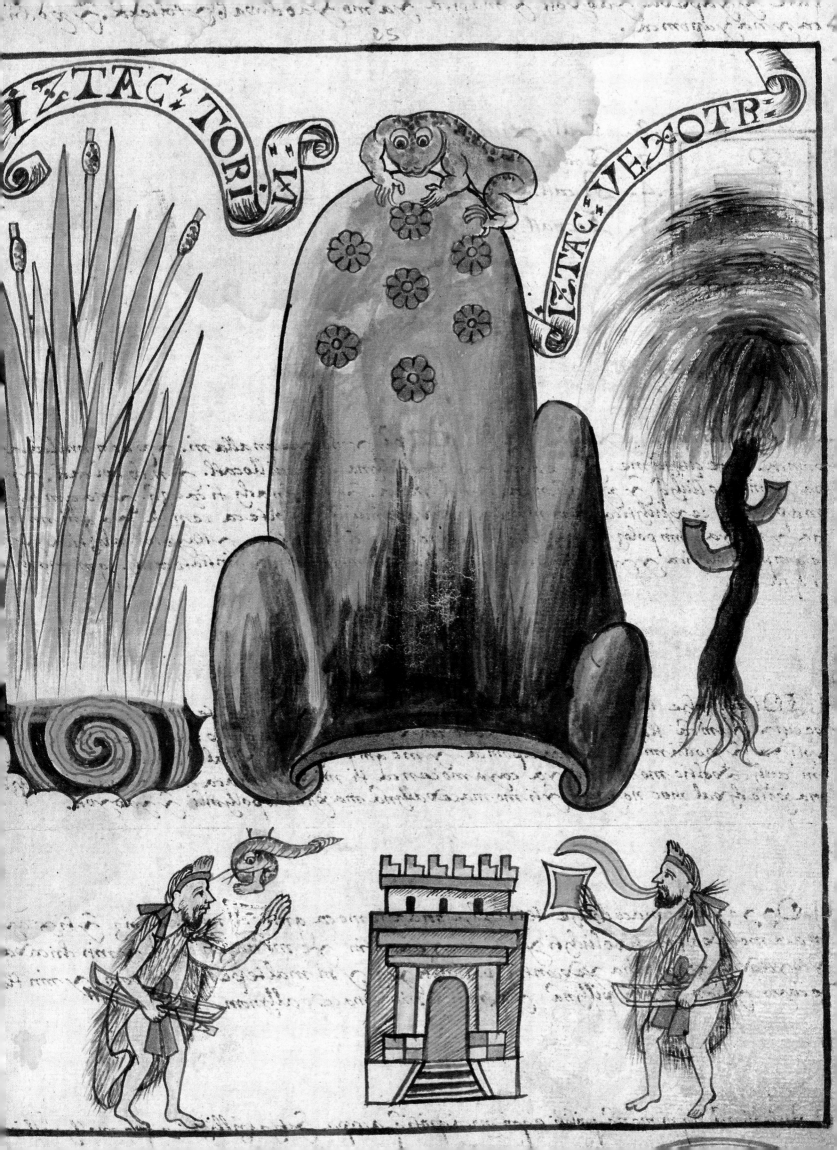

features unique to Mexico. Sahagún's teachings included Pliny, whose *Natural History* served as a primer for Renaissance Europeans attempting to describe and understand nature. The Indians, for their part, possessed detailed knowledge of the world around them, although they conceived it in terms quite different from those used by the scholarly monks. Native artists knew how to reproduce plants and animals wonderfully, producing copies whose realism astonished the conquistadores. Local royalty maintained zoos where they raised all sorts of animals. Visits to Moctezuma's aviaries and animal cages were a continuing source of amazement for the first conquerors. Under the aegis of the missionaries, the natives' sharp observation and interest in nature were exploited to twin ends. First, the Renaissance tradition of encyclopedic knowledge urged that such information be catalogued, and all unique features noted. Sixteenth-century Europe was not yet a land of museums, but it already boasted "collections of curiosities." Printed books helped to diffuse illustrated bestiaries that were a cross between scientific catalogues and exotic displays. The Indians probably leafed through a few of these, and such amalgams can be found in the collections produced by Sahagún's disciples. Secondly, the Spanish were also interested in profiting from Mexican natural resources, notably medicinal plants, in the admitted hope of augmenting European herbals. Sahagún had seven Tlatelolco doctors answer a veritable questionnaire, describing plants and their properties. As elsewhere in the *Florentine Codex*, the Nahuatl text appears in the right-hand column, while the Spanish translation and the illustrations (whose richness often contrasts with the dryness of the Spanish therapeutic information) appear on the left.

The artists who illustrated the *Florentine Codex* therefore reveal a world in which ducks and turkeys abound, birds fill the sky, and fish leap from lakes and ponds, although the most astonishing images in this work are those of insects crawling across the pages. Finally, the paintings contain several fabulous creatures that were thought to be real at the time, such as the two-headed *maquizcoatl* and the *tlilcoatl*.[157]

Another work already cited, the *Codex Badianus*, was compiled by two native scholars, the doctor Martín de La Cruz and the Latinist Juan Badiano, who translated the descriptions of plants and remedies. At first sight, the herbal appears to faithfully imitate European models. Nothing special leaps to the eye. In fact, Renaissance representation is once again superimposed on pre-Hispanic canons. The roots of the plants are systematically shown clinging to the glyph for earth and rock, thereby combining convention and realism. This syncretistic approach finds a parallel in the catalogue entries, which constantly combine objective, material data with reflections stemming from magical uses and categories of thought specific to the Nahua universe, notably conceptions concerning the body and heart.[158] Not only did indigenous medicine survive the conquest, it attracted the attention of European specialists whose therapeutic knowledge and

162. Plants as Pictured in European Engravings
Publica Laetitia, Gómez, Alcalá, 1546

One of the many models native painters might have used to present Mexican flora in a form familiar to Spaniards.

◁ 161. Herbs to be Eaten Cooked or Raw
Florentine Codex, Vol. III, fol. 286 r.

The inadequacy of Renaissance medicine made the Spanish that much more interested in enlarging their own herbals and discovering various Indian remedies. The upper left plate shows purslane (itzmiquilitl), amaranth (quiltonilli), and squash flower (ayoxochquilitl). The bottom left plate features tzitzicazquilitl, an edible nettle. These plants were used as food and as medicine.

Temahuiztiliquauitl. Tlapolcacauatl. Texcalamacoztli.

Couaxocotl. Yztacqua- Tevezqua- huitzquauitl.
uitl. uitl.

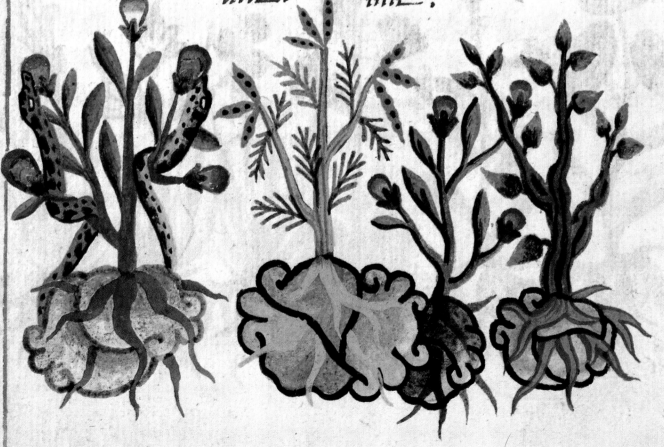

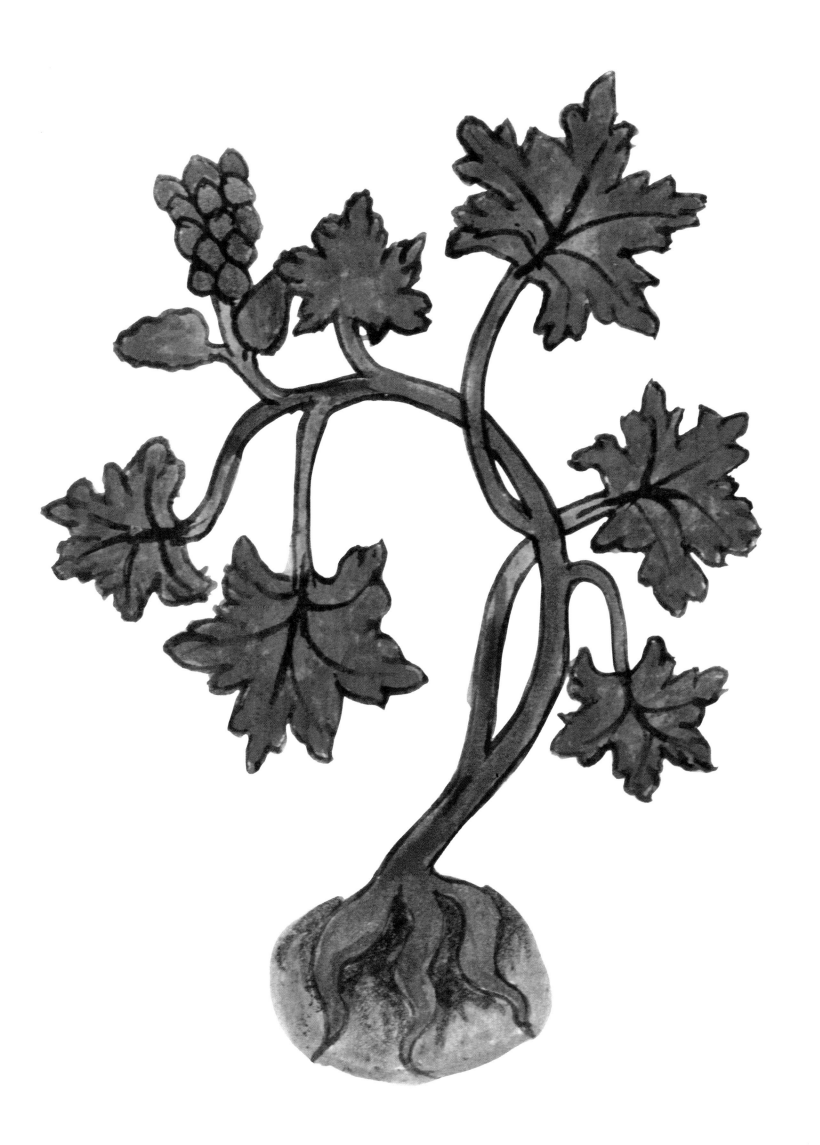

techniques were riddled with lacunae. Europeans integrated many Mexican practices into their neo-Hippocratic medicine, and the Spanish crown went so far as to dispatch royal doctor Francisco Hernández to Mexico. His lengthy research led to an abundantly illustrated *Natural History of New Spain*.[159] The inventories established by the compilers echo the encyclopedic ambitions typified by Sahagún's work.

Despite the freshness and vitality of the plates in the *Florentine Codex,* they nevertheless provoke a sensation of disturbing strangeness. Do they really present a naturalistic and realistic view of the flora and fauna, or is there an ancient native symbolism underneath the European veneer? Take, for example, *maguey* (i.e., the agave plant). Pulque, the fermented juice of the *maguey,* was the Indians' favorite drink. Like chocolate, pulque was soon adopted by the Europeans in New Spain, who were interested in its therapeutic qualities. But the painters of the codex probably still conferred a significance on the preparation of *maguey* and the production of pulque that linked such activity to a pagan, "inhabited" vision of the cosmos and nature. It was the same with cacao and corn. Although Spanish curiosity and pressures led to the de-sanctifying of things and beings in Mexico by banishing anything that appeared in any way idolatrous, landscapes and beliefs could not be destroyed as easily as buildings and human beings. Numerous late sixteenth-century accounts described extant traces of the former deities, reporting the belief that Quetzalcoatl "wandered from one sierra to another, whistling loudly," and noting the countless places "where they once climbed to perform their sacrifices."[160] It is probable that even in educated circles two ways of seeing coexisted, superimposing European materialism and utilitarianism ("what use and what role, at what cost") on an ancient, secret metaphysics that had governed things and ideas from time immemorial.

Aesop's Fables

One of the finest literary expressions of this twin way of seeing is offered by the Nahuatl translation of Aesop's fables.[161] Transposing ancient Greece onto Mesoamerica was not without problems. Although characters such as the fowler and fisherman existed in both worlds and although certain animals were similar or identical on both sides of the Atlantic, others had to be adapted. The European fox was replaced by the American coyote, the rooster by a turkey. The stables, an unknown edifice in Mexico, became the "deer house," and Mediterranean dates were translated as "palm cherries" (*çoyacapoli*).

Certain climatic differences, however, remained recalcitrant to translation. The idea that someone could be blocked by snow was incomprehensible to the Indians. Obviously, it became less difficult

◁◁ 163. Medicinal Plants
 Codex Badianus, fol. 38 v.

This "Book of Medicinal Plants of the Indians" was produced in 1552 thanks to the collaboration of two native Mexica. What is probably the oldest image of cacao can be seen in the center of the upper register; the lower register shows a plant from the acacia family in the center, and a type of wood known as brazil *(after which a country would be named) on the left. The roots are drawn around the glyph normally used for stone* (tetl); *the varied coloring and shading of the glyph perhaps indicated specific types of soil.*

◁ 164. Tlayapaloni, a Medicinal Plant
 Codex Badianus, fol. 7 v.

This species is difficult to identify today; it is perhaps cissus sicyoides, *from the grape family. The Latin text, written by Juan Badiano, indicates that this plant and those appearing on the same plate were used as remedies for boils. Crushed and mixed with egg yolk, they were to be applied to the boil morning and evening, once the pus was cleaned away.*

165. Flowering Trees
Florentine Codex, Vol. III,
fol. 340 v.

"There are also other trees in the groves, called cacauasuchitl, *that have flowers known as* cacaoasuchitl. *These flowers are small like jasmine and give off a sweet, intense odor."* A butterfly and hummingbird drink the nectar of the puyomatli *flowers on the* quararibea fenebris *tree. The delightful fragrance masks the fact that this was an intoxicating flower sacred to the Indians, only indirectly mentioned by the cautious Nahuatl text.*
Yet this allusion means that butterfly and hummingbird are no longer just exquisite, innocent details, but express the tangible presence of the dead and the ancient deity.

166. Wild Cypresses and Pines
Florentine Codex, Vol. III,
fol. 263 v.

"There exist in this land wild cypresses. The mountains are covered with them.... The wood is appreciated in all sorts of construction, to make chests, boxes and writing tables.... This land has other trees called oiametl. *There is nothing similar in Spain, as far as I know. A highly prized medicinal liquid is drawn from it, known as* abeto *(pine oil). The Indians did not use it and did not know it. It was only during our times that it has been discovered."* Innovation is being stressed here, along with a reference to another innovation—the manufacture of writing tables, linked to the spread of alphabetical writing.

167. The Art of Landscape ▷
Map of Coatlinchan, Valley of Mexico, 1578, Archivo General de la Nación, no. 1678

Indigenous cartography underwent considerable development during the colonial period. The cartographers attempted to render the landscape and natural environment of a region, as though any geographical representation should also provide a view of the area (just as maps of large cities in Europe were usually accompanied by a number of urban views). The thick foliage and the general technique inevitably evoke northern models (Germanic or Flemish) drawn from the many paintings then being brought to New Spain.

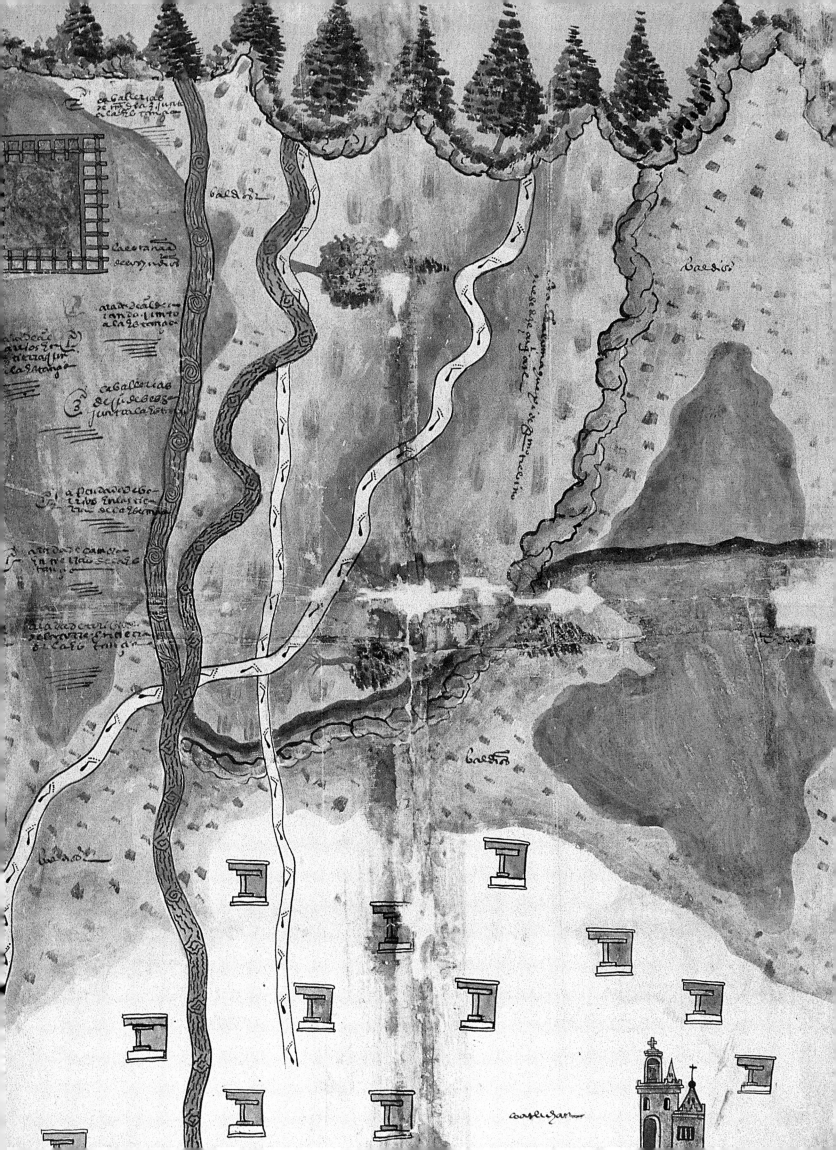

for the native Mexicans to grasp the role of domesticated animals in Aesop's fables once their own fields and towns had been invaded by these strange, dreaded yet useful beasts. The sight of large flocks with shepherds, unknown prior to the conquest, had become an everyday reality that was both familiar and alarming, as sheep and goats devoured fields of corn and trampled gardens of tomatoes and squash. Even today certain Indian communities carefully maintain a comfortable distance between their age-old agriculture and the livestock imported by European conquerors. It was nevertheless to be expected that the Greek fables involving animals endowed with speech and a will of their own would "go down" better than those describing domesticated animals and their relationships with people. This was the case, for instance, of the fable of *The Crocodile and the Coyote*. The rapport established between the animals in the ancient Greek fable found a parallel in ancient Mexico. The barrier erected by the Greek world between nature and culture (or between the wild and the civilized), however, tended to get lost in Indian interpretations, to the point of vanishing altogether. In the Indian version of *The Frog and the Hares*, the close links between human and animal worlds are particularly striking—the lament of the frogs echoes the hymns of sorrow dating from the pre-Hispanic epoch. In conformity with traditional beliefs, several fables in the Mexican translation hint at a community of living beings that included all creatures, without exception.

168. Snowy Egret, Little Blue Heron, and Wild Turkey
Florentine Codex, Vol. III, fol. 182 r.

"There are white birds called aztatl *or* teuaztlatl. *In certain areas of Spain they are called* dorales, *and here the Spanish call them white egrets. They are white as snow, have little flesh and a very long neck. . . . The* axoquen *is the same color as a crane but much smaller . . . and it smells like a fish. . . . The wild turkeys are like domesticated turkeys in terms of size, plumage and everything else."*
Aztatl *is the snowy egret or* leucophoyx thula; axoquen *is the little blue heron or* florida caerula.

169. Flight of the Hummingbirds
Florentine Codex, Vol. III,
fol. 178 r.

"This land has very small birds that resemble blue flies more than birds. Numerous species of this bird exist. They have a small, black beak as fine as a needle. The bird makes its nest in shrubs where it lays its eggs. . . . It lays no more than two eggs; it feeds on the dew of flowers, like a bee. It is very light, and flies like an arrow. Every year, in winter, it renews its colors."
The eye is attracted by the charm and finesse of this scene, which manages to convey the birds' activities in a tiny space. To evoke the dew and sap of trees (which European art would have been unable to represent), the painter simply used the glyph for water.

Despite such differences, the world of the ancient Greeks was perhaps closer to the Nahua world than was Renaissance Christian civilization, as surprising as this may seem. The Greek tales, although separated from Mexican culture by thousands of years and thousands of miles, had a number of features in common with pre-Hispanic tradition. The writings of Indian and mestizo historians such as Tezozomoc are full of fables, proverbs and myths populated by talking animals, as are accounts recorded by Sahagún.[162] Although the Greek world was easier to transpose than a medieval, Christian universe, the transposition was nevertheless done in indigenous terms, according to authentically Mexican criteria and conventions.[163]

The Mystery of Native Maps

One of the most spectacular visual examples of the Mexican Renaissance is probably the corpus of several hundred maps written and painted by Indians at the request of Spanish authorities. The Spanish repeatedly instructed the Indians: "And you will paint the site of the *pueblo*, [showing] the distribution of land and cultivated fields as well as those that lay fallow. . . ."[164] The invaders had learned early on that the Indians drew and kept maps, or at least produced a similar type of document bearing place names, territorial boundaries and indications of relief.[165] *Tlacuilo* painters had the skills, a repertoire of useful conventions (glyphs) and a familiarity with the terrain that justified recruiting them to paint the boundaries of the land granted by the crown to Spanish colonists.[166] For the same reasons, *tlacuilos* were employed in the 1580s to produce maps showing Mexican villages region by region, as required by the *Relaciones*

170. Fish of the Sea
Florentine Codex, Vol. III,
fol. 214 v.

The names and descriptions of fish tend to underscore their similarity to birds ("hummingbird fish," "bird fish," etc.). The native Mexica did not view the various species (nor the major kingdoms) as closed, distinct groups.

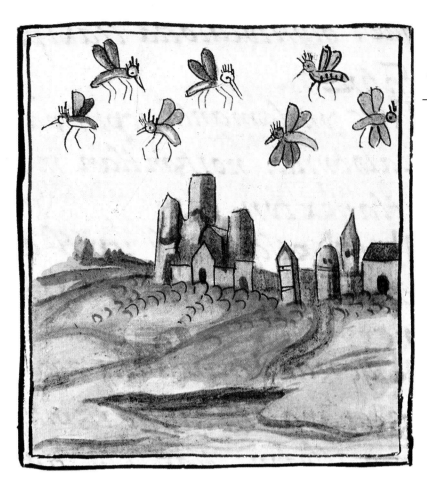

171. Green Fly
Florentine Codex, Vol. III,
fol. 259 v.

*"It is round . . . its body is somewhat green.
It is a flyer, a buzzer. It travels with great
violence when it flies; it goes buzzing,
constantly striking the walls, the ground,
ever restless. It is called* miccatzaioli
because it is said it is the lot of corpses."
The miccatzaioli, *or green fly, is the "fly
of the dead." European engravings have
obviously inspired this setting, through the
silhouette of a town with bell towers and
gateway architecture. In a striking parallel,
flies also connote death and decay in Euro-
pean iconography.*

172. Ants
Florentine Codex, Vol. III, fol. 246
v. and 247 v.

*"There are rather large red ants that bite
and are poisonous; they do not kill, but
hurt. There are other ants, called* tlatlau-
hquiazcatl, *larger than the former; their
poison rises up the groin and armpits.*
"And there other ants called cuitlazcatl;
*some are gray, others whitish, still others
dark yellow. They smell bad and live in
houses and in the roots of agaves, and they
bite. . . . Other ants are called* tlilazcatl *or*
tzicatl. *They live in cold lands. They are
tiny, black, and they bite. Their eggs are
white. In certain regions they are eaten and
for this reason are called* azcamolli *[ant
food]."*

173. Butterflies
Florentine Codex, Vol. III,
fol. 252 r.

*"There are many species of butterfly in this
country, of diverse colors, many more than
in Spain. There is a sort of butterfly called*
xicalpapalotl *or* xicalteconpapalotl— *it
is variously colored."*
*The Nahuatl text also refers to the "gourd
bowl" or "painted vessel" butterfly. So the
vessel from which the butterfly emerges is
actually a glyph, serving to identify the insect
rather than depict a particular scene. The
rest of the text expresses a sense of wonder
at the beauty of butterflies.*

geográficas then being compiled. The goal of the Spanish crown was to compile a considerable quantity of information on its American possessions, in the context of a huge survey resulting in these "geographical accounts." [167] It is not difficult to imagine the haggling that must have gone on all across Mexico every time a few European colonists, the crown's representatives and members of the native nobility gathered in some central town to draw up a cartographic image of the land in order to make room for new arrivals or simply to gratify the wishes of the Spanish administration.

The maps produced by native Mexicans are of value not only for the territorial information they provide but also for the way in which the painters rendered their natural environment. They had to develop a representational system that corresponded to their perception of space and nature and at the same time satisfied the demands of the Spanish. In addition to the conceptual difficulty created by a reversal of roles—since here it was the Indians who were keen to make themselves understood—there was the distress of having to officially acknowledge the Spanish occupation of their territory. In fact, *tlacuilos* did their best to subvert the Spanish project whenever they could. The maneuver is obvious in the maps drawn up for the *Relaciones geográficas*. The painters clung to a traditional representation of the land and the network of villages and hamlets within it, ignoring the administrative principles that the Spanish authorities sought to impose. Far from providing the simple boundaries expected of them, they took the initiative of offering a territorial synthesis of their jurisdiction that conformed to local tradition by packing their maps with pre-Hispanic features of a historical and sometimes mythological nature (these two spheres being inextricably linked in Mexican thought).

Thus native cartography would appear to have been an eminently political affair during the colonial period. It implicitly reflected and incarnated all sorts of confrontations and negotiations between victors and vanquished. Today it can be read as a series of snapshots, static polychrome images that convey the ferment of an emerging society in which everyone—whether cacique, native upstart, Spanish colonist, administrator, or missionary—strove to assert and consolidate his position. These maps, conscientiously certified by the crown's representatives, became the basis of a new legality. Thus colonial geography was born of the fusion of notions of pre-Hispanic territory and Spanish occupation. [168]

The composite visual idiom already described is expressed in these maps in a number of ways, reflecting both the struggle of local interests and iconographic strategy. A limited set of glyphs normally served to indicate features of the land such as mountains, lakes and streams. Alongside this repertoire, which seemed to be satisfactory to all, other elements began to appear on the page. These included, in part, new glyphs such as the chapels and churches that marked the

174. Rainbow
Florentine Codex, Vol. II, fol. 238 r.

*"The rainbow is like a stone arch; it is
multicolored and when it appears it is a
sign of serenity."*
*Abstract drawing—already noticeable in the
representation of clouds (illus. 147)—culmi-
nates in this rainbow where sky, rainbow
and landscape are reduced to swathes of
color. The painter seems to have liberated
himself from the convention of outlining each
shape. Pre-Hispanic pictographic tradition
and the European manner of applying color
have led the artist into new territory. The
rainbow has become the sole subject of the
picture, instead of being, more commonly,
an element of a setting or landscape in a
genre painting or ritual codex.*

175. The Monkey
Florentine Codex, Vol. III,
fol. 168 v.

*"It is a forest-dweller in Anahuac, toward
the east. It has a small back; it is round-
backed; it has a long, curled tail. It
has human hands, human feet, nails, real
nails—long nails. . . . It eats like a human
being."*
*This painting was perhaps inspired by
European engravings, but it should not be
forgotten that the image of a single monkey
was also a symbol used in the ritual calendar.*

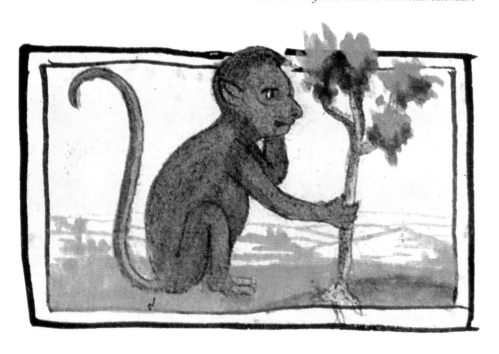

location of a *pueblo* or hamlet. Other components were added, however, in a manner that broke totally with traditional canons: landscapes, mountain crests and forests occupy the page as though the painters were attempting to merge their stylized representation with features borrowed from canvases and frescoes they had seen. This entailed raising and resolving the question of landscape-maps, as brilliantly handled by the Dutch in the seventeenth century.[169] The inclusion of these landscape elements is nevertheless puzzling on more than one occasion. Perhaps the meaning of these seemingly realistic, familiar Renaissance forms underwent modification. That is to say, the Indians may have used mountain profiles and horizon lines as glyphs, veritable place-name symbols, rather than as a picturesque rendering of surrounding landscape. Elsewhere, hybrid and composite forms offer a glimpse of the clash between two worlds, if only on the level of a polychrome image. For instance, the representation of the glyph for mountain interlaced with a serpent and topped by a cross alludes to the traditional view of peaks and the deities that resided there as much as it attests to the victory of the cross over "former idols." Yet is this cross truly victorious, or is it obliged to coexist with forces impossible to uproot? Perhaps the place-name glyph *Coatepec*, "Mountain of the Serpent," is really a reverent evocation of the force still inhabiting that region. Yet the true power of this image lies in its polysemic nature, the multiplicity of meanings it embodies. Even if the painter wanted to discreetly demonstrate that there were things he had not forgotten, a reader more attuned to Christianity would see only a place name capped by the reassuring presence of the cross that, in principle, had overcome the old demons everywhere.[170]

176. Flowering Trees
Florentine Codex, Vol. III,
fol. 342 r.

"The flowers of the uizteculsuchitl *tree are white, purple or red, and have no odor; those of the* tzompanquauitl *tree* [erythrina mexicana], *called* equimisuchitl, *are very red and odorless."*

flores dearboles.

vnas son blancas otras moradas
otras coloradas njnguin olor tiene
son pre ciosas por so buen parecer.

¶. Ay tanbien vnos arboles que
se plantan en las florestas que se llamā
tzompan quaujtl es arbol mediano tie
ne ramas acopadas tiene la copa re
donda y de buen parecer tiene vnas flo
res que se llaman equjmjsuchitl son muy
coloradas y de buen parecer no tienen
olor njnguno.

¶ Las hojas del arbol arriba dicho se
llaman Equjmjtl

-piaztli, quappitzaoac, mamae,
mamaceltic: injatlapal totomjo
avaio: injcueponca tlapalcamjl
iaialtic: injc mjtoa, vitztecul
suchitl, in cequj, camopaltic,
in cequj thichiltic, in cequj iz
tac, acan a vixquj, acan necujz
tli, acan eleviliztli, amo velic,
amo aviac, amo hiiac, tenen
co, tenenenco, tenenentlama
thti.
¶ Tzompanquavitl, çan velipā
quavitl, çan qualli injmama
ixiaiaoaltic injpapaloio inj
qujllo, inj suchio ituca equjmj
suchitl, thichiltic, thichilpa
tic, amo aviac, nentlacatl, atle
imecoca, atle imequjzço Injtzō
panquavitl necutic, tzopelic,
iece athi camaque quexqujc,
cxoio: injeio, ituca, equjmjtl,
thichiltic: iuh qujn aicoatli:
Injc moxinachoa: motvca inj
cio, yoan çan momatzaiana:
motequj in maguja iuh qujn
vexotl.
¶ Equjmjtl, çan noiehoatl intzō
pan quavitl: injtla aqujllo çā
noitvca equjmjtl: omjto mjelis

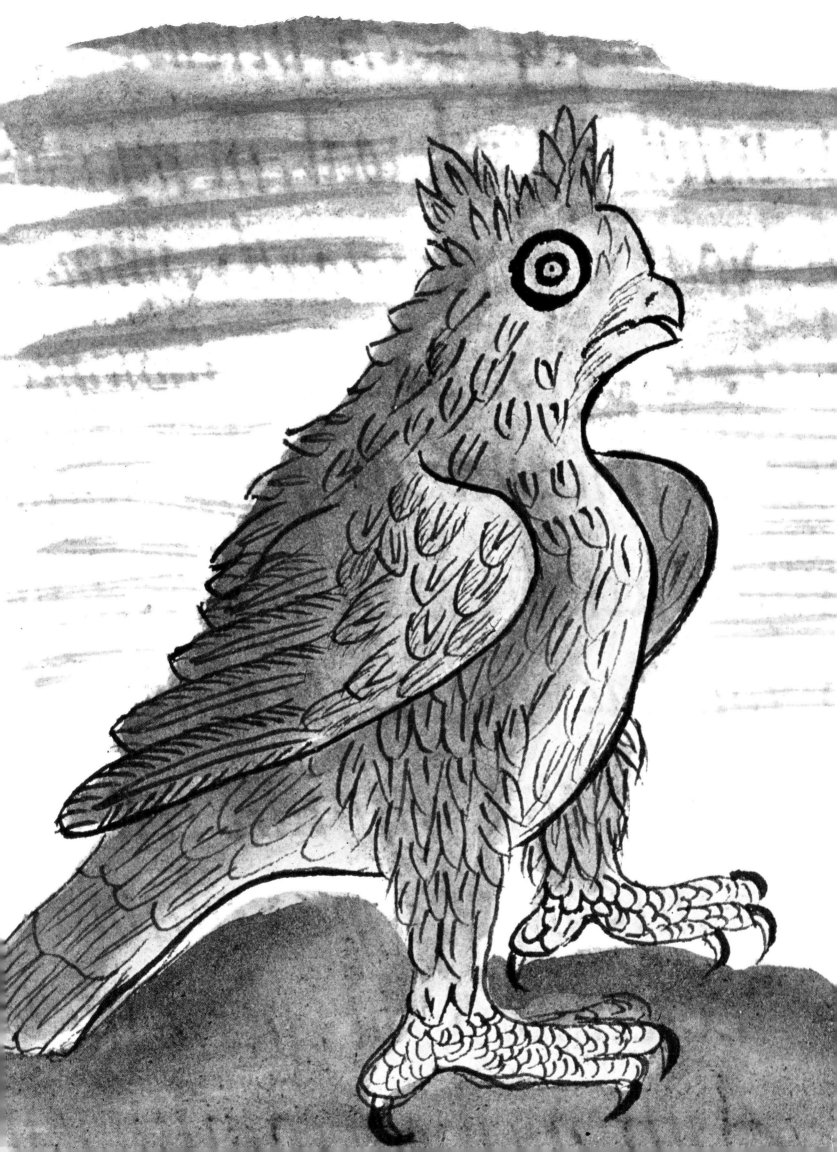

Conclusion :
The end of a world

178. Chia [A Type of Sage]
Florentine Codex, Vol. III,
fol. 323 r.-v.

"Chia seeds are ground with a little bit of the tail of the animal called tlaquatzin *[opossum]. A quantity to the equivalent of half a finger is mixed with water. A woman who cannot go into labor drinks it and then goes into labor.... It is useful to those who spit blood and have continual bouts of coughing while spitting blood.... The juice of this plant is like linseed oil in Castile with which painters give sparkle to their work...."*
This text concerns the two upper scenes, whereas the lower vignette refers to a plant used to treat typhoid.

 177. The Cry of the Owl
Florentine Codex, Vol. I, fol. 338 r.

"Likewise all took it as an omen and an augury, and it was considered a portent, when the horned owl hooted.... They said that when it was heard, it signified death or sickness; it was an omen of death. He who heard it would perhaps die, or beg, or be slothful; he would die in bondage or in war; or one of his sons would die, or his slave would flee. Perhaps now his house would be destroyed, and his land would shrink...."
Like the other birds in the codex, this bird of ill omen is presented in full and three-quarter profile. It is set against a red ground depicting sunset and the approach of night.

Indian maps lied, however, on one point. They remained silent on the gaping wounds caused by epidemics. The Mexican Renaissance could have been the start of a long experiment in cultural symbiosis between European civilization and cultures native to the New World. But it failed. Colonial rule relegated the Indians to the role of the vanquished, a position of inferiority, regardless of the efforts of certain missionaries and enlightened representatives of the Spanish crown. The epidemics that dogged the invaders' footsteps continued to decimate the native population throughout the sixteenth century. The figures speak for themselves: the roughly twenty-five million Indians living in Mexico when the conquistadores arrived in 1518 had dropped to a mere seven hundred and fifty thousand by 1635. Ninety-seven per cent of the population had disappeared in the space of a century.[171] Damning evidence of depopulation could be seen in the deserted villages, empty houses, ruined palaces, and abandoned, crumbling chapels.

As the native population ceased to constitute a huge, threatening mass (its swift decline presaging its almost total elimination), the Mexican nobility gradually lost its role as invaluable intermediary between conquerors and conquered. This role had been its primary source of strength, enabling it to retain privileges and positions within the emerging society. Meanwhile, the Spanish *encomenderos*,[172] who had established close ties to Indian caciques, were another group in retreat as many children of conquistadores slid into bankruptcy. At the same time, the Franciscan, Dominican and Augustinian missionaries who had conceived and directed the evangelization of the Mexican population and enjoyed considerable prerogatives, were divested of the control they had exercised over the Indian population and were forced to abandon the ambitious educational programs they had promoted. Finally, the Erasmus-inspired humanism that had galvanized the first waves of missionaries, making possible the spread of erudite European culture among the native elite, no longer dominated the intellectual scene in Europe.

The enthusiasm of the early decades waned even among the most steadfast defenders of the Indians. During the counter-reform in the latter half of the sixteenth century, the Catholic church hardened its position; the Spanish clergy moderated its curiosity for pre-Hispanic civilizations and began to dread the heresy that might break out among a native intelligentsia with extensive knowledge of both worlds. In a significant move, the Inquisition withdrew many of the books and manuscripts that had circulated among the Indians. Ethnographic research was halted and results were confiscated—the *Florentine Codex*, like other manuscripts, left for Europe to gather dust in archives. By 1576, the College of Santa Cruz in Tlatelolco had already begun to sink into irreversible decline. "This year's plague nearly emptied the college: dead or ill, almost everyone left."[173] In a more general fashion, European observers realized that the largely native composite

179. Worms
Florentine Codex, Vol. III, fol. 256 v.

"The worms that grow inside the body and are evacuated with the stool are called tzoncoatl."
Tzoncoatl *means the "hair-thin serpent," referring to* ascaris lumbricoides. *Like the monkey in the previous plates, the dog is here represented on the same level and in the same position as the man.*

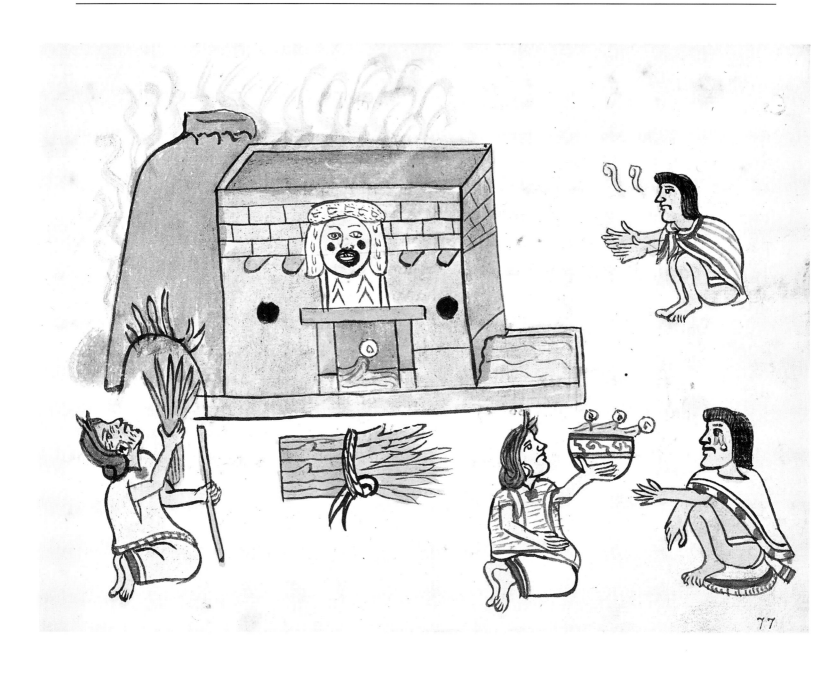

180. The Steam Bath
Codex Magliabechiano, fol. 77 r.

Prior to the Spanish conquest, steam baths functioned as both religious rite and medical remedy. Europeans adopted them for therapeutic reasons. It is not certain that Indians who continued to use them had forgotten their gods. Europeans, meanwhile, appreciated the public nature of the baths.

181. Illness and Death
Florentine Codex, Vol. III, fol. 318 r.

An ill person, reclining, is attended by someone propping up his head. The pair seem to be inspired by European pietà *imagery. The radical change in lifestyle, an absence of natural immunity, and inadequate treatment made the native population highly vulnerable to many kinds of diseases.*

182. Toothache
Florentine Codex, Vol. III, fol. 104 v.

Seated in the middle of a landscape, a young man in European dress cleans the tartar off his teeth by using a handkerchief, ground coal and salt (others even used urine and tree bark). But local remedies were useless in the face of the epidemics that decimated the population.

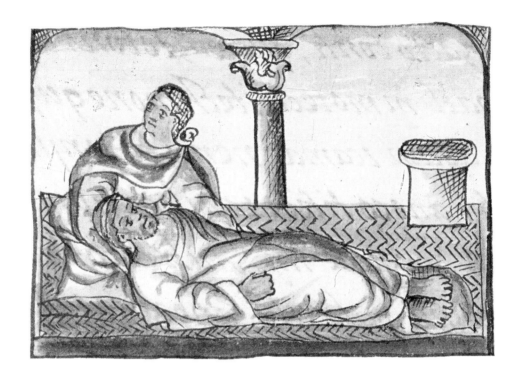

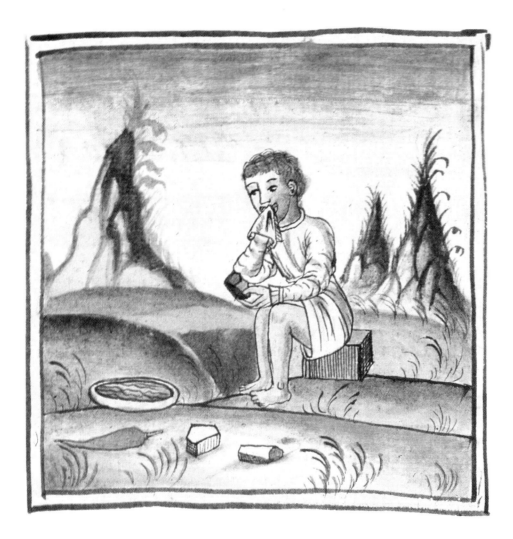

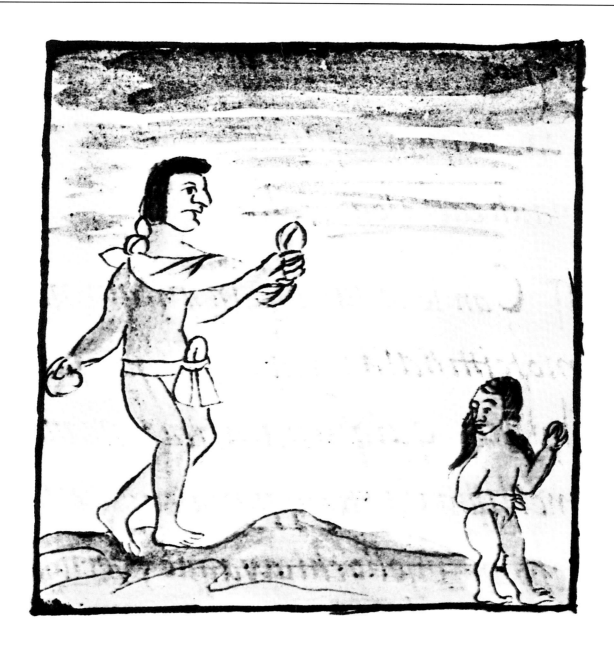

183. The Dwarf
Florentine Codex, Vol. I, fol. 344 r.

"There was another sort of ghost which appeared at night, normally where they went to relieve a call of nature at night. If a little dwarf woman appeared to them ... they felt it was an omen that they would soon die or encounter some misfortune. ... The sight of this ghost provoked strong fear. If he who saw her wanted to grab her, he could not because she instantly disappeared and appeared elsewhere, right near by...."

This scene is of particular interest because it represents a fleeting, oneiric impression of nocturnal apparitions and visions. The darkness is suggested by the black sky in the upper part of the image. The clothing indicates that the incident dates from before the conquest but, as with the owl, such beliefs continued to haunt the Indians for a long time afterward.

The Nahuatl text adds that the dwarf has "long hair, that her buttocks are fleshy, that her hair serves as garment."

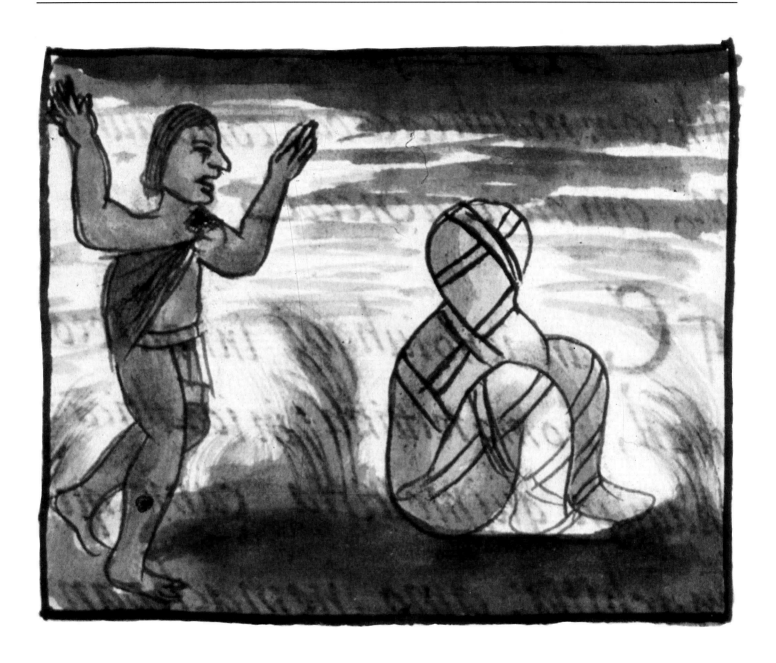

184. Death
Florentine Codex, Vol. I, fol. 344 v.

"Another sort of ghost appeared at night. It resembled a corpse wrapped in its shroud, and complained and groaned. If those who saw this ghost were courageous, they attacked it in order to seize it but they wound up with only a hunk of grass or lump of earth. They attributed these illusions to Tezcatlipoca."
The painter has used the same techniques as in the preceding image. There is the familiar figure of the seated corpse, covered with a shroud (illus. 107). Such apparitions were always interpreted as manifestations (nahuales) of the all-powerful lord of night, Tezcatlipoca.
The god might also take the form of the "nocturnal hatchet," a giant whose chest opened and closed with a din, or in the form of a skull *"that appeared to people in the night. It lurched for their calves or sometimes was heard not far behind; it began to follow those who fled, rattling as it followed. And if the person halted, it did likewise, all the while making the same noise."*

185. Drugs: Toloache
Codex Magliabechiano,
fol. 84 r.

The priests who took toloa, *or toloache
(*datura stramonium?*), the plant depicted
in the center, entered into contact with the
world of gods and esoteric knowledge. They
spoke under the sway of the drug. As with
the terrors of the night, drug-induced voyages
to the beyond continued in spite of sermons
by Spanish missionaries, who had enormous
difficulty in trying to rein in the life of the
spirit and imagination.*

186. Intoxication
Codex Magliabechiano, fol. 86 r.

*Indians, including a woman, make an
offering to* Xiuhtecutli, *god of fire. Drunk
on* pulque *(fermented agave juice), they go
into transports (the volutes for speech) on
seeing a rabbit—the god of* pulque.
*Delirium was a holy condition, a sacred
communion with the deity. It was only after
the conquest that, deprived of its religious
context and spurred by Spanish oppression,
intoxication evolved into the individual and
collective catastrophe of alcoholism.*

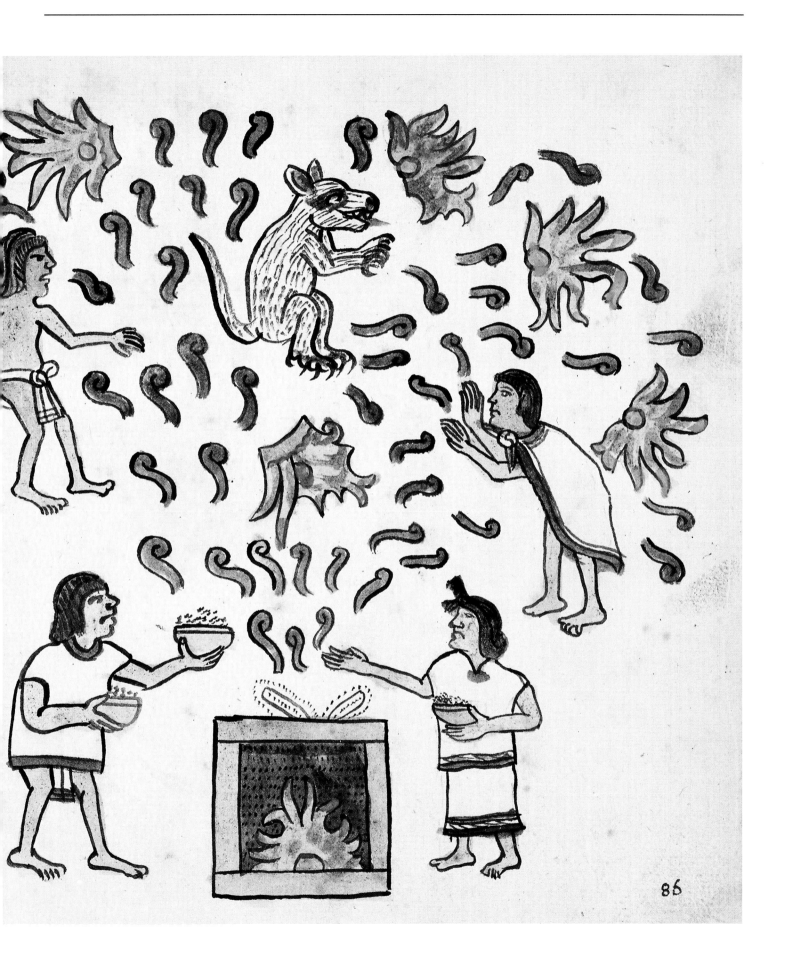

86

187. Hallucinogenic Plants
Florentine Codex, Vol. III,
fol. 294 v.

A selection of hallucinogenic plants is pre-
sented here: tlapatl *or* datura, *"sacred*
mushrooms," peyotl *cactus* [lophophora
williamsii], *and* toloa. *Pre-Hispanic*
society approved of highly controlled use
of such substances. The Catholic church,
appalled, denounced this as the work of
the devil (seen above the mushrooms) and
outlawed this straightforward path to the
realm of idols and the devil. The painter
here provides priceless testimony by showing
a Hispanicized Indian (with European hat
and cup) taking a drink made of peyotl.
Adopting certain aspects of the conqueror's
culture did not preclude observing ancestral
practices condemned by the church. In the
following plate from the Codex Maglia-
bechiano *(illus. 188) the painter attempted*
to stress (and perhaps endorse) this uncom-
promising objection to the ingestion of halluc-
inogenic drugs.

culture escaped their control. The new forms—precursors of post-
modernism's permutations of kitsch and remix—became all the more
suspect since many subjects (discussion of the past, recollection of
the conquest, rapport with nature, new visual idioms, etc.) inspired
pre-Hispanic interpretations and attitudes known to be intimately
linked to idolatry.

Death Throes of an Artistic Experiment

The juxtaposition of styles—here a snatch of landscape, there
characters represented according to European conventions, next to a
glyphic transcription of pre-Hispanic inspiration—had produced a
composite, hybrid art of prodigious variety, able to satisfy the tastes
of both Spaniards and natives. In a sense, this could be considered a
neo-Renaissance.[174] The continued use of a repertoire of glyphs within
European settings relied on traditional models handed down by
descendants of *tlacuilos*, models that remained legible to painters. The
presence of glyphs even within the most Europeanized drawings
attested to the power of this doubly expressive language. In the series
representing featherworkers in the *Florentine Codex*, for instance, the
glyph for star was still used to indicate the brilliant, shimmering surface
of cotton.[175] This language of glyphs was nevertheless influenced by
the colonial environment. New glyphs were developed to describe the
new society, to depict foreign objects, deities and ideas. European
symbolism and use of color became increasingly widespread—the
colors used for the prostitute in the *Florentine Codex*, for instance, are
inspired by biblical and medieval sources.[176] Such chromatic influence
might have enriched the local repertoire if, in the long run, all color

188. Sacred Mushrooms
Codex Magliabechiano, fol. 90 r.

A native seated before sacred mushrooms, the "flesh of the gods," is pushed into consuming them by a demonic deity. Yet the green hue of the mushroom likens it to jade, that most precious of stones. This suggests the ambivalence of a world that honored the old (by choosing the color green) while at the same time rejecting it (the demon).

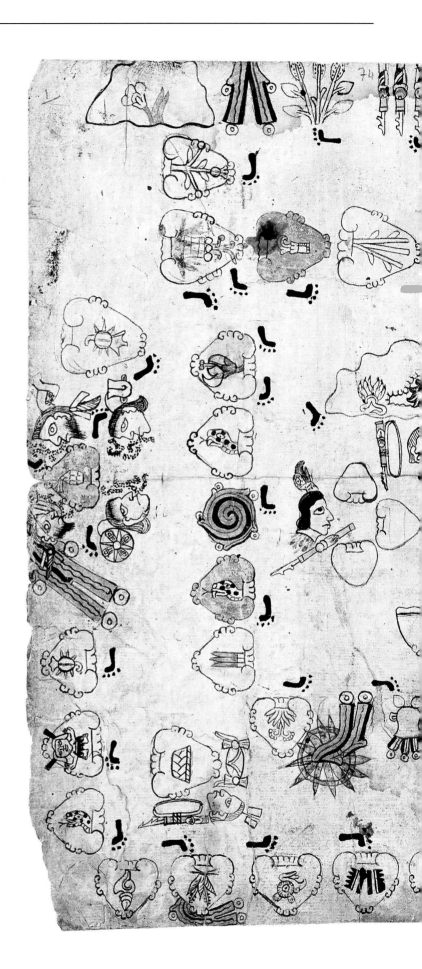

189. A Traditional Map:
The Boundaries of Cuauhtinchan
and Totomihuacan
Historia Tolteca-Chichimeca, pp. 1-2

*Although painted after the conquest, this
document appears to closely follow pre-
Hispanic tradition. Places are indicated by
glyphs painted in the order they occupy on a
given itinerary, and not as a function of
their exact geographic position. This "map"
is like a subway map or diagram whose
layout is based on the size and shape of its
backing, the sheet of paper. What is called
here a "map" is in fact the spatial weave of
an account in which glyphs also stand for
events and characters.*

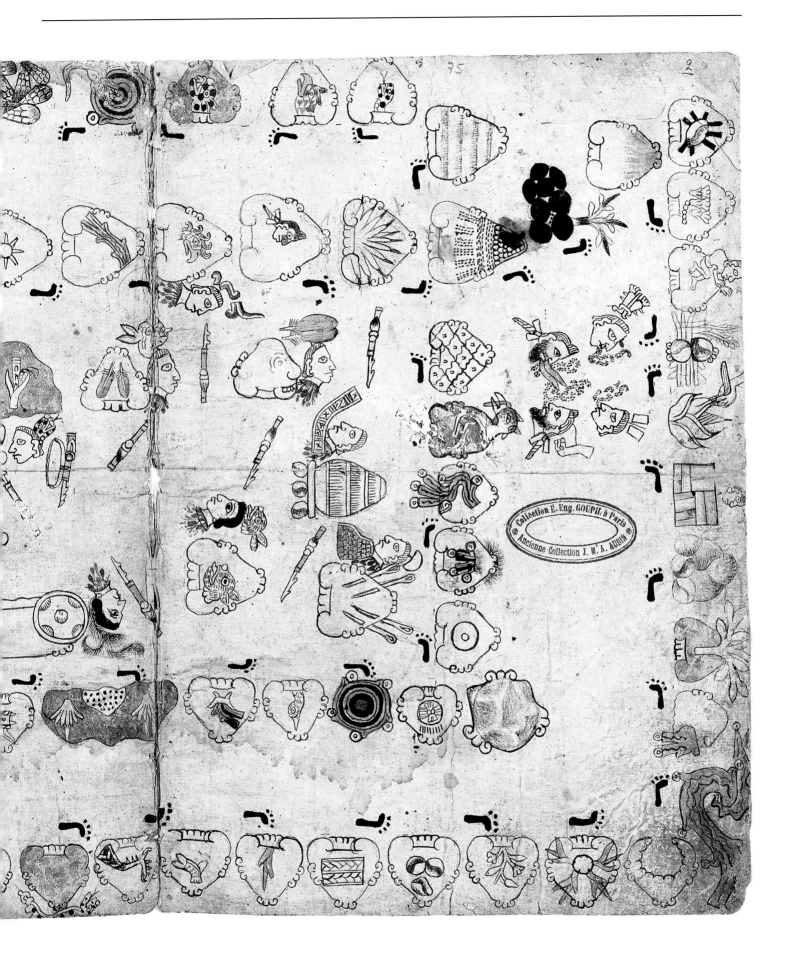

190. Map of Culhuacan (Valley of Mexico) by Pedro de San Agustín, 1580
Relacion geográfica de Culhuacan, Austin, Benson Latin American Collection

Artist Pedro de San Agustín borrowed elements from Renaissance as well as native canons. He decided to cap the local administration building with the place-name glyph for Culhuacan (in the form of a horn), but at the same time added a representational image of a mountain, using broad strokes of the brush to represent landscape in the upper left corner. Similarly, San Agustín systematically used perspective-type effects to lend volume to the various buildings. This map is an excellent example of the hybrid approach so often encountered, combining respect for tradition with newer, European techniques.

itself—traditional and European—had not been abandoned as the native world collapsed.

The final decades of the sixteenth century are the history of a slow and irreversible decline. Lines lost their vigor and control, and were replaced by rapid, often careless, draftsmanship. Sketches became a stopgap, and then the rule. Color drained away as multicolored images were replaced by the gloomy contrast of black and white. Images themselves disappeared; alphabetical script, solitary, ran across the desperately empty spaces reserved for images. The glyphs these spaces awaited—perhaps symbols indicating the year or simple vignettes indicating a figure or event—would never be painted. Finally writing itself evaporated. This aesthetic tragedy, reflecting an insurmountable crisis, is conveyed by the numerous codices that were never completed.[177] As native painters died off, ravaged by epidemics, and as families sank into ruin or oblivion, the page became more

191. Map of Tenango
(Valley of Mexico), 1587
Mexico City, Archivo General de la Nación, no. 1822

Western-style landscape has invaded this map, which is covered with trees and agave plants. A cow and fenced pen illustrate the arrival of livestock in the Indian countryside. In spite of such influences, many place-name glyphs still dot the page. In the lower register, the snake head emerging from the mountain (topped by a cross) is in fact the glyph for Cohuatepec (coatl = snake, tepetl = mountain). The painter appears to have hesitated between presenting it in traditional form or as representational landscape.

192. Map of Coatlinchan
(Valley of Mexico), 1584
Mexico City, Archivo General de la
Nación, n° 566

*Abandoning the use of color led to a decisive
break with the previous examples, even
if the draftsmanship remains fairly well
controlled and a few glyphs survive (notably
in the upper right corner where, just below
the ridge line, the glyph for mountain
produces a redundant effect). The lines of
the handwriting now tend to merge with the
lines of the map, whereas previously the
contribution of the native painter was easily
distinguishable from that of the Spanish
administrator. A European-style sun in the
upper register indicates the east.*

*In subsequent decades, lines became irregular,
shapes became increasingly diluted, and
glyphs disappeared as ancient tradition atro-
phied.*

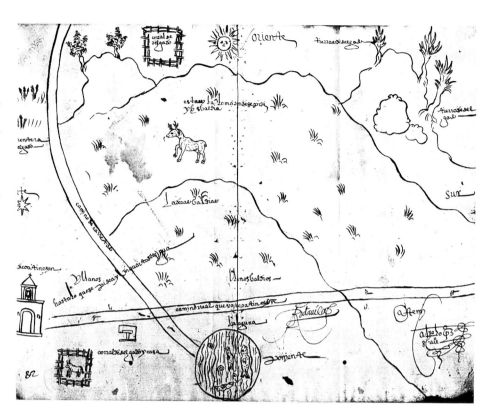

193. The Mexican Sojourn at
Chapultepec (Year Two Reed/One
Rabbit)
Codex Vaticanus Latinus, 3738,
Pl. XCVIII

*At the end of the thirteenth century, the
Mexica migrated to Chapultepec (today
within Mexico City), and this episode from
their history shows the hill with its gushing
spring (which has carried off two natives).
This sudden return to the past—or at least
to past canons—provides a good measure of
the changes that have occurred, as well as
the gulf separating late sixteenth-century
colonial maps from a traditional representa-
tion of the environment complete with glyphs,
conventions and chromatic variations.*

and more stark. Meanwhile, painters were arriving from Europe in
increasing numbers. Mannerism spread, triumphing in the cities and
winning over the native nobility (those families that survived the
debacle having become irreversibly Hispanic). The Mexican Renais-
sance withered and died.

In the countryside, however, the lessons taught by Renaissance
tlacuilos would be remembered for centuries. They would be preserved,
with local resources, by communities that strove in every way to
affirm their identity within a colonial society that excluded them.[178]
Many pueblos jealously guarded and recopied the paintings that
recorded the history and boundaries of community land. They
managed to transmit them from generation to generation, sometimes
even down to the present. As for native art, it would flow into the
ocean of mannerist and baroque forms that covered city and
countryside, placing its prodigious inventiveness and exuberance at
the service of a style that swiftly came to represent a civilization.
The image exalted by the Catholic church and native tradition—that
delight in pageantry, the appeal to the senses, the triumph of sound,
color, scent and light—contributed to the rise of baroque Mexico,
another magnificent example of cultural cross-fertilization.[179]

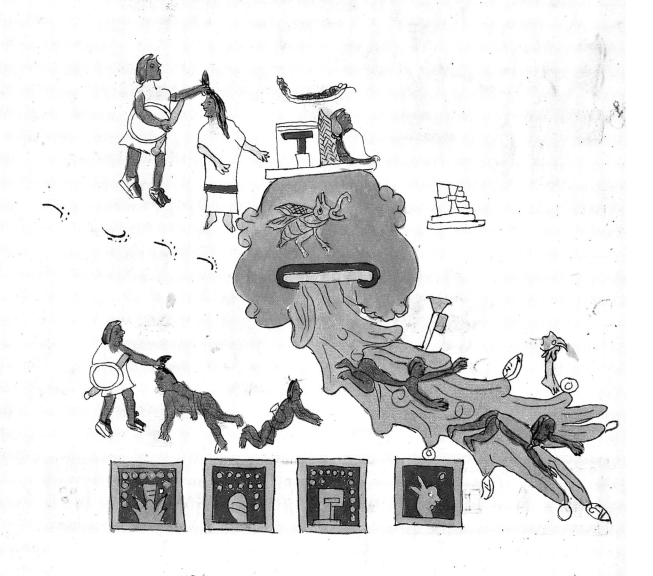

NOTES

For a brief list of works that have been consulted for the text, see the bibliography on page 235.

1. Diego Durán, *Historia de las Indias y de las Islas de Tierra Firme*, Mexico City, 1967, vol. II, pp. 513-514. Durán's suggested date of 1516 for the first recorded image seems unlikely since the first expedition to Mexico took place in 1517. It is possible, however, that this confusion stems from an earlier contact that, due to subsequent shipwreck, may have left no trace in Spanish sources.
2. See Serge Gruzinski, *La Guerre des images de Christophe Colomb à Blade Runner, 1492-2019*, Paris, 1990.
3. Carmen Bernand and Serge Gruzinski, *Histoire du Nouveau Monde. De la Découverte à la Conquête. Une expérience européene*, Paris, 1991, vol. I.
4. On art and experience in Renaissance Italy at the time of the discovery, see Michael Baxandall, *Painting and Experience in Fifteenth Century Italy*, Oxford, Oxford University Press, 1986.
5. On the richness, autonomy and uniqueness of figurative conceptualization, see Pierre Francastel, *La Figure et le Lieu. L'Ordre visuel du Quattrocento,* Paris, Gallimard, 1967. Images convey and visualize concepts not communicated by words. Such concepts may never be verbalized; hence figurative conceptualization may be the only expression of major changes in societies and civilizations.
6. On the Mesoamerican world, see Jacques Soustelle, *L'Univers des Aztèques,* Paris, Hermann, 1979, as well as the more recent work by Frances Berdan (*The Aztecs of Central Mexico: An Imperial Society*, New York, Holt, Rinehart and Winston, 1982) and Ross Hassig (*Trade, Tribute and Transportation,* 1985).
7. On Teotihuacán and Tula, see Nigel Davies, *The Toltecs until the Fall of Tula*, Norman, 1977.
8. Christian Duverger, *L'Origine des Aztèques*, Paris, Seuil, 1983.
9. Nigel Davies, *The Aztecs: A History*, London, 1973, pp. 102-103.
10. On the city of Mexico-Tenochtitlan, see José Luis de Rojas, *México-Tenochtitlan. Economía y Sociedad en el siglo XVI*, Mexico City, 1986, pp. 65-92.
11. On markets, trade and tribute, see Hassig, 1985.
12. On the ceremonial precinct, see Miguel León-Portilla, *México-Tenochtitlan: Su Espacio y Tiempo Sagrados*, Mexico City, INAH, 1978.
13. The education system is described in Alfredo López Austín, *Educación Mexica. Antología de Textos Sahaguntinos,* Mexico City, UNAM, 1985.
14. On the pictographic tradition, see Miguel León-Portilla, *Los Antiguos Mexicanos a través de sus Crónicas y Cantares*, Mexico City, FCE/SEP, 1983, pp. 52-70. It should be remembered that Maya pictographic tradition (as in, for instance, the *Dresden Codex*) is quite distinct from Central Mexican tradition.
15. Rojas, 1986, pp. 62, 109, 163; Juan de Torquemada, *Monarquía Indiana*, Mexico City, 1975-1983, vol. IV, p. 254, and vol. V, p. 313.
16. On *tlacuilo* painters, see also Durán, 1967, vol. II, pp. 513-515.
17. Miguel León-Portilla, *La Filosofía Náhuatl Estudiada en sus Fuentes,* Mexico City, 1966, p. 76.
18. Jeanette Favrot Peterson, "The Florentine Codex Imagery and the Colonial Tlacuilo," *The Work of Bernardino de Sahagún, Pioneer Ethnographer of Sixteenth Century Aztec Mexico*, Klor de Alva et al., Albany, 1988, p. 285.
19. Donald Robertson, *Mexican Manuscript Painting of the Early Colonial Period, The Metropolitan Schools,* New Haven, 1959.
20. Durán, 1967, vol. I, p. 226. "Y siempre lo sirvieron en general las pinturas de letras para escribir con pinturas y efigies sus historias y antiguallas."
21. Joaquín Galarza, *Lienzos de Chiepetlan*, Mexico City, Mission archéologique et ethnographique française, 1972.
22. Chinese ideograms provide another example of a close association between writing and painting.
23. León-Portilla, 1983, p. 64.
24. For example, the concept of movement (*ollin* in Nahuatl)
25. Motolinía, *Memoriales o Libro de las Cosas de la Nueva España*, 1971, p. 5, and Durán, 1967, vol. I, p. 226.
26. Gruzinski, 1990.
27. Edward Calnek, "The Calmecac and Telpochcalli in Pre-Conquest Tenochtitlan," in Klor de Alva et al., 1988, p. 173.
28. Durán, 1967, vol. I, p. 226. "Hubo algunos ignorantes que creyendo ser ídolos las hiceron quemar, siendo historias dignas de memoria y de no estar sepultadas en el olvido como estan."
29. Jose María Kobayashi, *La Educación como Conquista. Empresa Franciscana en México*, Mexico City, El Colegio de México, 1974, pp. 229-292.
30. Europeans brought unfamiliar iconic and iconographic codes to Mexico. Iconic codes establish an equivalence between a selective, codified perception of relevant features and the graphic signs and conventions that convey this perception; they remain closely related to perceptual schema by establishing a system of relations between graphic phenomena analogous to the system of perceptual relations established when a known object is recalled in memory. As to iconographic codes, these involve specific schools and styles that may, in fact, share the same iconic heritage.
31. On the role of engraving and the characteristics of the new visual order, see W. M. Ivins, *Imagen Impresa y Conocimiento. Análisis de la Imagen Fotográfica*, Barcelona, Gustavo Gili, 1975, and James P. R. Lyell, *Early Book Illustration in Spain,* New York, Hacker Art Books, 1976.
32. Writing generated a similar fascination—the magic of "paper that talks" is discussed in Torquemada, 1977, vol. V, p. 319.
33. See Lyell, 1976, for examples of this decorative exuberance.
34. On Italy, see Francastel, 1967, Baxandall, 1986, and Francastel, *Etudes de sociologie de l'art*, Paris, Denoël, Gonthier, 1970.
35. Miguel León-Portilla, "Cuicatl y Tlahtolli. Las Formas de Expresión en Náhuatl," *Estudios de Cultura Náhuatl*, XVI, Mexico City, 1983, pp. 13-108.
36. Motolinía, 1971, p. 236.
37. George Kubler, *Mexican Architecture of the Sixteenth Century*, New Haven, 1948.

38. Durán, 1967, vol. I, p. 226.

39. For a discussion of the major ethnographic surveys, see Georges Baudot, *Histoire et Utopie au Mexique*, Paris, 1977.

40. Andrés de Olmos, who headed one of the first ethnographic surveys, was given the following instructions: "Si algo bueno se hallase, se pudiese notar como se notan y tienen en memoria muchas cosas de otros gentiles. Y el dicho padre lo hizo así . . . habiendos visto todas las pinturas que los caciques y principales de estas provincias tenían de sus antiguallas." Gerónimo de Mendieta, *Historia Eclesiástica Indiana*, Mexico City, 1945, vol. I, p. 81.

41. On the cooperation of *tlacuilo* painters, see Klor de Alva et al., 1988, Durán, 1967, and Bernardino de Sahagún, *Historia General de las Cosas de Nueva España*, Mexico City, 1977.

42. Miguel León-Portilla, "Manuscrito anónimo de Tlatelolco," *Visión de los Vencidos*, Havana, Casa de las Américas, 1969, pp. 209-210.

43. Bernand and Gruzinski, 1991, pp. 287-325.

44. A facsimile edition, prepared by Josefina García Quintana and Carlos Martínez Marín, was published in 1983 by Cartón y Papel in Mexico City.

45. Diego Muñoz Camargo, *Descripción de la Ciudad y Provincia de Tlaxcala de las Indias y del Mar Oceano para el Buen Gobierno y Ennoblecimiento Dellas*, Mexico City, UNAM, 1981.

46. Howard F. Cline, "Notas Sobre la Historia de la Conquista de Sahagún," *Historia y Sociedad en el Mundo de Habla Española. Homenaje a José Miranda*, Bernardo García (ed.), Mexico City, El Colegio de México, 1970, pp. 121-139. See also S. L. Cline, "Revisionist Conquest History: Sahagún's Revised Book XX," in Klor de Alva et al., 1988, pp. 93-106.

47. Assuming that the basic text was written in the years 1547-1555.

48. The native viewpoint was so marked that several years later Fray Bernardino de Sahagún, a Franciscan friar, revised the text to stress the role of the Franciscans and Cortés. The viewpoint expressed was that of Indians from Tlatelolco, the market town that had been absorbed into the political and urban sphere of its powerful neighbor, Mexico-Tenochtitlan.

49. In the minds of the Mexicans, events could not be due to chance, particularly not a cataclysmic event like the Spanish invasion. To give it meaning, native Mexicans had to integrate it retrospectively into their own history, making it the outcome of a series of omens (inventing such omens or reshuffling events if necessary).

50. Sahagún, 1977, vol. IV, p. 109.

51. Peterson, in Klor de Alva et al., 1988, p. 278.

52. It should be added that, without waiting to be prompted by missionaries, native Mexicans had already recorded their own images of the catastrophe. A Dominican claimed to have seen a codex that estimated the number of nobles massacred by Alvarado at 1,800. This figure, probably rendered by a numerical glyph, must have been given as part of a "painting" of the disaster. On Claudio de Arciniega, the architect who designed the funerary monument, see Manuel Toussaint, *Claudio de Arciniega, Arquitecto de la Nueva España*, Mexico City, UNAM, 1981.

53. See S. L. Cline's article in Klor de Alva et al., 1988, p. 96.

54. Durán, 1967.

55. Once again, a composite art is involved. As in the *Florentine Codex*, landscapes are suggested by a series of touches sketching mountainous horizons under a cloud-dotted sky. Yet the lake around Mexico-Tenochtitlan is still represented by the glyph for water, as if Mexican tradition and European Renaissance coexisted naturally. See *Handbook of Middle American Indians, Guide to Ethnohistorical Sources*, Austin, 1975, vol. XIV, pp. 126-127.

56. Susan D. Gillespie, *The Aztec Kings: The Construction of Rulership in Mexica History*, Tucson, 1989.

57. The two endeavors, one intellectual and the other visual, were closely symmetrical. Inventing a Cortés-Quetzalcoatl was the literary equivalent of the anthropomorphic representation of ancient deities (discussed below), as well as the conceptual pendant to the images in Durán's history featuring indigenous scenes set in Renaissance landscapes.

58. *Proceso Inquisitorial del Cacique de Tetzcoco*, Mexico City, Gómez de la Puente, 1910.

59. Baudot, 1977.

60. "Tetzatzanilhuia, tetzatzanilli"—see the paper by Monique Legros, "La Expresión del Pasada del Náhuatl al Castellano," given at the second Simposio de Historia de las Mentalidades and published in *La Memoria y el Olvido*, Mexico City, IFAL/INAH, 1985, pp. 21-32.

61. *Coloquios y Doctrina Cristiana*, facsimile edition prepared by Miguel León-Portilla, Mexico City, UNAM, 1986.

62. Alfredo López Austín, *Cuerpo Humano e Ideología. Los Conceptos de los Antiguos Nahuas*, Mexico City, 1980, vol. I, p. 60.

63. Ibid., pp. 60-63.

64. Doris Heyden, "Tezcatlipoca en el Mundo Náhuatl," *Estudios de Cultura Náhuatl*, 1989, vol. XIX, pp. 83-93.

65. This interest in the archeology of Rome was one of the manifestations of the Italian Renaissance on the Iberian peninsula.

66. See, for example, how they are handled by Dominican friar Bartolomé de las Casas in his *Apologética Historia Sumaria*, Mexico, UNAM, 1967. See also Carmen Bernand and Serge Gruzinski, *De l'idolâtrie. Une archéologie des sciences religieuses*, Paris, Seuil, 1988, pp. 41-86.

67. Eloise Quiñones Keber, "Deity Images and Texts in the Primeros Memoriales and Florentine Codex," Klor de Alva et al., 1988, p. 261.

68. Letters exist in which educated Indians, writing in Latin, allude to the idolatrous practices of Roman emperors. Thus in 1566, Don Pablo Nazareo invoked the precedent of an *ethnicus emperador* ("pagan emperor"). See Ignacio Osorio Romero, *La Enseñanza del Latín a los Indios*, Mexico City, UNAM, 1990, pp. 34-35.

69. Such reasoning led to native criticism of the Spaniards' Christianity, which still seemed lacking despite conversion centuries earlier. See

Francisco del Paso y Troncoso, *Epistolario de Nueva España,* Mexico City, 1939, vol. IV, pp. 168-169.

70. Osorio Romero, 1990, p. 1.

71. Bernadino de Sahagún, *Primeros Memoriales, Textos en Nauatl,* Mexico City, INAH, 1974.

72. Muñoz Camargo, 1981.

73. On human sacrifice, see Christian Duverger, *La Fleur létale. Economie du sacrifice aztèque,* Paris, Seuil, 1979.

74. López Austín, 1980, vol. I, p. 434.

75. Las Casas, 1967, vol. II, p. 253. Hernando Cortés, *Cartas y documentos,* Mexico City, Porrúa, 1963, p. 24.

76. Christian Duverger, *L'Esprit du jeu chez les Aztèques,* Paris, 1978, p. 131.

77. David Carrasco, *Quetzalcoatl and the Irony of Empire,* Chicago, 1982.

78. Duverger, 1978, p. 272.

79. "The sequence of correspondences between time systems produced cycles of differing dimensions that made each instant of human existence a point of convergence for a number of divine forces, the combination of which conferred on each force its particular nature." López Austín, 1980, vol. I, p. 70.

80. Legros, 1986.

81. Durán, 1967, vol. I, p. 227.

82. Ibid. "Todo tenía su cuenta y razón y día particular."

83. The astrologer Botello accompanied Cortés in order to draw up predictions for the conquistadores. Díaz del Castillo, 1968, vol. I, pp. 392, 394, 398.

84. López Austín, 1980, vol. I, pp. 223, 236, 239.

85. This is the reason that the hair of prisoners was saved, in order to appropriate their energies, whereas the hair of delinquents was cut to diminish or destroy their *tonalli. Tonalli* regulated the organism's temperature; a chill therefore corresponded to a weakening of the *tonalli,* although fever, that is to say excessive heat, could also correspond to a malfunction, or even the loss of this energy so essential to life. Ibid., pp. 236, 242.

86. Children were thought to be placed in the mother's womb by Ometeotl, the god of duality. Ibid., p. 230.

87. Ibid., pp. 231, 401.

88. Ibid., p. 233.

89. Durán, 1967, vol. II, p. 228. "Pues sólo a Dios son las cosas futuras presentes."

90. *Tonalli,* for instance, influenced not only the growth of children, but also sexuality later in life; elders and parents discouraged precocious sexual relations because it might affect *tonalli* and therefore subsequent development. At the moment of marriage, "specialists in destinies," who could identify *tonalli* and minimize negative tendencies if necessary, were called upon to examine the future spouses. Incompatibility could prevent the wedding ceremony.

91. Quoted in Miguel León-Portilla, *Culturas en Peligro,* Mexico City, Alianza Editorial Mexicana, 1976, pp. 83-89.

92. Serge Gruzinski, *Man-Gods and the Mexican Highlands: Indian Power and Colonial Society 1520 to 1800,* Stanford 1989, pp. 32-33.

93. Durán, 1967, vol. I, p. 30.

94. Durán, 1967, vol. I. pp. 227-228. "Yo sospecho que en este caso siguen todavía su ley antigua y que aguardan se cumplan las letras de sus calendarios porque en pocas partes hay que no los tenguan guardados y mui leídos y enseñados a los que agora nacen para que *in aeternum* no se olvide."

95. The first part of the *Codex Borbonicus* contains a ritual calendar that was long attributed to the pre-Hispanic era; see Robertson, 1959, pp. 87-88. Mary Elisabeth Smith considers the *Codex Selden* an example of Mixtec art. See her *Picture Writing from Ancient Southern Mexico,* Norman, 1973.

96. Nobles were called *pipiltin,* which means "Sons of Somebody."

97. Paul Kirchhoff, Lina Odena Güemes, and Luis Reyes García (eds.), *Historia Tolteca-Chichimeca,* Mexico City, 1976.

98. Robertson, 1959, p. 99.

99. Díaz del Castillo, 1968, vol. I, pp. 270-276.

100. Hassig, 1985.

101. Juan Bautista Pomar, *Relación de Tezcoco,* Mexico City, Biblioteca del Estado de México, 1975, p. 7.

102. Pedro Carrasco and Johanna Broda, *Economía Política e Ideología en el Mundo Prehispanico,* Mexico City, Nueva Imagen, 1978.

103. López Austín, 1980, vol. I, p. 464.

104. Baudot, 1977.

105. In Klor de Alva et al., 1988, p. 170, Calnek counts eighty-two scenes or tableaux, forty-one of which (one-half) are devoted to the education of youth in *calmecac* and *telpochcalli* schools.

106. ". . . You have arrived on earth, land of torment and pain, here where it is hot, where it is cold, where the wind blows." Sahagún, 1977, vol. II, pp. 183-185.

107. For example, a person who died in a state of drunkenness belonged to the god Ometochtli, lord of *pulque* (fermented agave juice). López Austín, 1980, vol. I, pp. 246, 253, 363, 368, 380.

108. "Elemento transformador de todo lo existente, [el fuego] puede romper la barrera entre el mundo habitado y los sitios en los que moran los dioses." Ibid., p. 370.

109. López Austín, 1980, vol. I, p. 366.

110. Ibid., p. 381.

111. Toussaint, 1981, pp. 10-11.

112. Joaquín García Icazbalceta, "Carta de Gerónimo López," *Colección de Documentos para la Historia de México,* Mexico City, Porrúa, 1971, vol. II, p. 142.

113. Paso y Troncoso, 1939, vol. IV, p. 166. "Todo lo que dellos [los españoles] se había de alcanzar estaba alcanzado e probado."

114. Motolinía, 1971, pp. 483-485.

115. Federico Gómez de Orozco, *El Mobiliario y la Decoración en la Nueva España del siglo XVI,* Mexico City, UNAM, 1983.

116. See Solange Alberro's fine book on this subject. *L'Acculturation des Espagnols,* Paris, EHESS, forthcoming.

117. García Icazbalceta, 1971, vol. II, p. 148; Osorio Romero, 1990. On the spread of writing and testamentary practices, see Arthur J. O. Anderson, Frances Berdan and James Lockhart, *Beyond the Codices, The Nahua View of Colonial Mexico,* Berkeley, University of California Press, 1976, as well as S. L. Cline and M. León-Portilla (eds.), *The Testaments of Culhuacan,* Los Angeles, UCLA Latin American Center Publications, Special Studies Vol. II, *Nahuatl Series,* no. 1, 1984.

118. On Archbishop Zumarrága, see Joaquín García Icazbalceta, *Don Fray Juan de Zumarrága primer obispo y arzobispo de México*, Mexico City, Porrúa, 1947, 4 vols. On Vasco de Quíroga, see J. Benedict Warren, *Vasco de Quíroga y sus Hospitales-Pueblos de Santa Fe*, Morelia, Universidad Michoacana, 1977. On Pedro de Gante, see Ernesto de la Torre Villar, "Fray Pedro de Gante, Maestro y Civilizador de América," *Estudios de Historia Novohispana*, Mexico City, UNAM, 1974, vol. V, pp. 9-77.

119. On libraries, see Román Zuláica Gárate, *Los Franciscanos y la Imprenta en México en el siglo XVI*, Mexico City, Robredo, 1939, and Miguel Mathes, *Santa Cruz de Tlatelolco, la Primera Biblioteca Académica de las Américas*, Mexico City, Secretaría de Relaciones Exteriores, 1982. It has been estimated that 232 books were printed in Mexico during the sixteenth century. Mendoza, the viceroy, descended from a great aristocratic family and was raised in the exotic atmosphere of a recently reconquered Grenada; he was inspired by Alberti when he reorganized Mexico City. See Bernard and Gruzinski, 1991, pp. 376-382.

120. García Icazbalceta, 1971, vol. II, p. 150.

121. The famous religious treatise and masterpiece of Dutch spiritual mysticism, written by Thomas à Kempis, canon of Zwolle, around 1427.

122. On educated Indians, see the prologue to Juan Bautista's *Sermonario en Lengua Mexicana*, Mexico City, Diego López Dávalos, 1606-1607.

123. Spanish missionaries Molina, Basaccio and Sahagún translated the gospel into Nahuatl. Friar Luis Rodríguez perhaps translated Ecclesiastes and almost certainly the Proverbs prior to 1572. Franciscans also translated the books of Job and Tobias in whole or in part. As early as 1536, Indians from Michoacán could read the life of Saint Francis in Tarascan, their local language. See Motolinía, 1971, p. 162.

124. On this question, see Margarita Zamora, *Language, Authority and Indigenous History in the Comentarios Reales de los Incas*, Cambridge, Cambridge Iberian and Latin American Studies, Cambridge University Press, 1988.

125. The first Mexican Council (1555) was more worried about the manuscripts being circulated than the idolatrous "paintings." *Concilios Provinciales Primero y Segundo...*, Mexico City, Imprenta del Superior Gobierno, 1769, pp. 143-144.

126. Osorio Romero, 1990, p. 30.

127. Las Casas, 1967, vol. I, p. 335. Motolinía, 1971, is more reserved in judgment.

128. On pre-Columbian music, see Robert Stevenson, *Music in Aztec and Inca Territory,* Berkeley, 1976.

129. Motolinía, 1971, p. 238.

130. It is not clear whether "Berruguete" refers to Pedro Berruguete (1450-1504) or Alonso Berruguete (1488-1561). See Díaz del Castillo, 1968, vol. II, p. 362. On indigenous painters, most of whom remained anonymous, see Kubler, 1948.

131. Torquemada, 1977, vol. IV, p. 254.

132. Mendieta, 1945, vol. I, p. 107. "Y en particular en la portería del convento de Cuatinchan tienen pintada la memoria de cuenta que ellos tenían antigua con estos carácteres o signos de abusión."

133. Kubler, 1948; John MacAndrew, *The Open Air Churches of Sixteenth Century Mexico. Atrios, Posas, Open Chapels and Other Studies,* Cambridge, Harvard University Press, 1965; Manuel Toussaint, *Arte Colonial en México,* Mexico City, UNAM, 1948.

134. John Bierhorst, *Cantares Mexicanos. Songs of the Aztecs,* Stanford, 1985.

135. On musical composition, see Motolinía, 1971, pp. 236-237; Sahagún, 1977, vol. III, p. 158; Torquemada, 1977, vol. V, p. 320 (Book XVII, Chap. II). In the absence of organs, the Indians ingeniously used flutes "playing in concert" to produce a similar effect.

136. Most native Mexican musicians remained anonymous, but Francisco Plácido (1553) and Cristóbal del Rosario Xiuhtlamin (1550), both probably from Azcapotzalco, northwest of Mexico City, are known to have composed and performed the new songs.

137. Fernando Horcasitas, *El Teatro Náhuatl. Epocas Novohispana y Moderna. Primera Parte,* Mexico City, UNAM, 1974. Two such plays— *The Conquest of Jerusalem* and *The Fall of Rhodes*—are described in Bernand and Gruzinski, 1991, pp. 363-369.

138. Robertson, 1959, p. 103.

139. "Realistic" refers here to the way in which European Renaissance art attempted to reproduce perceptible reality by using, it should be stressed, a series of methods and techniques as artificial as those used by *tlacuilo* painters, even if these conventions have become so ubiquitous that they appear to be a direct transcription of the external world.

140. See Joaquín Galarza, *Estudios de Escriture Indígena Tradicional Azteca-Náhuatl,* Mexico City, Archivo General de la Nación, 1979, and Gruzinski, *La Colonisation de l'Imaginaire,* Paris, 1988a.

141. José Luis Martínez, *El Códice Florentino y la Historia General de Sahagún,* Mexico City, Archivo General de la Nación, 1982. This codex contains 1,855 illustrations excluding ornamental designs.

142. See plates 136-143.

143. The term "tradition" is misleading insofar as it does not refer here to a return to the past but rather to an ongoing re-interpretation of that past by an elite determined to defend its identity and role.

144. On confession, see Serge Gruzinski, "Individualization and Acculturation: Confession Among the Nahuas of Mexico from the Sixteenth to the Eighteenth Century," *Sexuality and Marriage in Colonial Latin America,* A. Lavrín (ed.), Lincoln, University of Nebraska Press, 1989, pp. 96-115.

145. For the influence of Erasmus on the American continent, see Marcel Bataillon, *Erasme et l'Espagne,* Paris, Droz, 1937. Translated into Spanish as *Erasmo y España,* Mexico City, FCE, 1982, pp. 807-831.

146. Durán, 1967, vol. I, p. 237.

147. Gruzinski, 1985, pp. 36-43.

148. Such as the many Pedro Coatls or Juan Cuetzpals. The Christian first name was added to the sign corre-

sponding to the day of birth (*coatl* = serpent, *cuetzpal* = lizard). See Durán, 1967, vol. I, p. 236.

149. Carmen Aguilera and Miguel León-Portilla, *Mapa de México-Tenochtitlan y sus Contornos hacia 1550,* Mexico City, 1986.

150. Gordon Brotherson (with Günter Vollmar), *Aesop in Mexico,* Berlin, 1987, p. 25.

151. *Teogonía e Historia de los Mexicanos, Tres Opúsculos del Siglo XVI,* Mexico City, Porrúa, 1973, p. 128.

152. Jean-Michel Sallmann et al., *Visions indiennes, visions baroques. Les Métissages de l'inconscient,* Paris, PUF, 1991.

153. Alfred W. Crosby, *Ecological Imperialism: The Biological Expansion of Europe, 900-1900,* Cambridge, Cambridge University Press, 1986.

154. Ibid., p. 191.

155. León-Portilla, 1976, pp. 88-89.

156. Irving Leonard, *Books of the Brave,* New York, Gordion Press, 1964.

157. Maquizcoatl ("ring serpent") was a two-headed snake. Tlilcoatl ("black serpent") was some unidentified reptile.

158. Carlos Viesca Treviño and Ignacio de la Peña Páez, "La Magia en el *Códice Badiano,*" *Estudios de Cultura Náhuatl,* vol. XI, pp. 267-301.

159. Francisco Hernandez, *Historia de las Plantas de Nueva España,* reprinted in *Obras Completas,* vols. II and III, Mexico City, UNAM, 1960.

160. Gruzinski, 1988a, pp. 130-131.

161. Brotherson, 1987.

162. Angel María Garibay K., *Historia de la Literatura Náhuatl,* Mexico City, 1971, vol. II, pp. 304-306.

163. The underlying presence of the ritual and solar calendars can be detected in certain fables. See Brotherson, 1987, p. 47.

164. These instructions figure in the mandates accompanying the maps. Most of these maps are held by the Archivo General de la Nación (Mexico City).

165. See Galarza, 1972 and 1979, as well as Aguilera and León-Portilla, 1986, pp. 13-15.

166. Some maps, such as the *Mapa de Santa Cruz,* also seem to have been produced primarily to satisfy Spanish curiosity and please the emperor. See Aguilera and León-Portilla, 1986.

167. Concerning the maps produced by these "geographical accounts," see *Handbook of Middle American Indians, Guide to Ethnohistorical Sources,* vol. XII, Part One, Austin, Texas University Press, 1975.

168. Duccio Sacchi, *La Représentation du territoire dans la Nouvelle Espagne. Analyse des sources (XVI-XVII siècle),* DEA diss., Paris, 1990.

169. Svetlana Alpers, *The Art of Describing,* The University of Chicago Press, 1983. For the second half of the sixteenth century, see Georg Braun and Remigius Hohenberg, *Civitates Orbis, Terrarum,* Cologne, 1573.

170. Serge Gruzinski, "Colonial Indian Maps in Sixteenth Century Mexico: An Essay in Mixed Cartography," *Res,* no. 13, Spring 1987, pp. 46-61.

171. Sherburne F. Cook and Woodrow Borah, *Essays in Population History: Mexico and California,* Berkeley, University of California Press, 1979, vol. III.

172. Spaniards granted an *encomienda* were entitled to part of the revenues produced by the native villages attributed to the estate.

173. Garibay, 1971, vol. II, p. 217.

174. Peterson, in Klor de Alva et al., 1988, p. 289.

175. Ibid., pp. 291, 287.

176. Ibid., p. 285.

177. Similar trends can be detected in the *Codex Tellerianus-Remensis* and the *Historia Tolteca-Chichimeca.*

178. Gruzinski, 1988a, pp. 139-188.

179. See Gruzinski, 1990, pp. 149-242.

Saint John the Evangelist Opening the Book of the Apocalypse, by Juan Gerson. Tecamachalco Church, State of Puebla.

The Mexican codices have had an eventful past. Yet the greater part of their history remains shrouded in mystery, and everything suggests that other priceless documents are still buried in collections outside of Mexico, waiting to be uncovered and brought to light. Reconstructing the exact paths taken by these key witnesses to Mexican history, which often led them to Europe or the United States, would require much patient work. A brief account is offered here, other scholars having already drawn up full lists and annotated inventories (see, for example, volume fourteen of the *Handbook of Middle American Indians,* listed in the bibliography).

Nearly five hundred indigenous "paintings" are still extant. This legacy is simultaneously modest and substantial. It seems modest when compared to the vast pictographic output of pre-Hispanic societies, yet is substantial when compared to other Amerindian civilizations (such as the Incas) that left no such records. Rare indeed are documents painted prior to the arrival of the Spanish. The best known include the Maya codices (*Dresden Codex, Codex Peresianus*), the Borgia group (*Codex Borgia, Codex Laud, Codex Fejervary-Mayer*) and material from the Oaxaca region (*Codex Nuttall, Codex Vindobonensis*). The documents from the Valley of Mexico essentially date from the colonial period, although the dating of a few of them remains uncertain.

Some codices were destroyed or ravaged by time. Others crossed the Atlantic on Spanish ships and galleons in the sixteenth century and found their way into the collections of Spanish monarchs or other European popes, emperors and kings. The path followed by the *Codex Vindobonensis,* a pre-Hispanic document from Oaxaca, is exemplary in this respect. It is thought to have been among the gifts (along with the *Codex Nuttall*) that Cortés sent to Charles V in 1519, at the outset of the conquest of Mexico. The *Codex Vindobonensis* belonged successively to Manuel I, king of Portugal (died 1521), Pope Clement VII, Cardinal Ippolito de' Medici and Cardinal Capuanaus (died 1537). A century later it turned up in Weimar, in the possession of the duke of Saxe-Eisenach, only to return to the Hapsburgs and end up in the Imperial Library in Vienna where it can be found today.

From the seventeenth to the nineteenth century, various items sent to Europe came into the possession of scholars and collectors. Those that have escaped destruction or loss are now dispersed in libraries throughout Europe.

The codices that remained in Mexico were preserved by missionaries interested in the Indian past or rescued by native and mestizo historians of the sixteenth and seventeenth centuries, such as Tezozomoc, Muñoz Camargo, and Chimalpahin. They were subsequently housed in monastic libraries or held by scholars like the brilliant Carlos de Sigüenza y Góngora (1645-1700). Sigüenza inherited the collection of Don Fernando de Alva Ixtlilxóchitl, a mestizo descendant of the lords of Texcoco and a passionate historian of the native Mexican past. In the eighteenth century, Milanese scholar Lorenzo Boturini (1701-1755) assembled numerous

items, maps, manuscripts and codices that Sigüenza had bequeathed to the Jesuit school of San Pedro y San Pablo. Boturini had entered New Spain illegally and was about to return to Europe when his collection was seized. He nevertheless managed to convince Spain of his worthiness and was subsequently appointed Chronicler of the Indies. He compiled the first catalogue of codices in 1746. In the nineteenth century, the codices became objects of growing interest in Europe and newly independent Mexico. The Frenchman Joseph Aubin, who lived in Mexico, collected a significant number of "paintings" that made their way to France and are now among the prized holdings of the manuscript department at the Bibliothèque Nationale in Paris. In England, Lord Kingsborough began publishing the first series of facsimile editions in 1830 under the title *Antiquities of Mexico.* Neither the advent of the twentieth century nor the zeal of librarians has brought this eventful history to a close, however, for just a few years ago a daring Mexican stole the *Tonalamatl Aubin* from the Bibliothèque Nationale in Paris and "restored" this priceless calendar to Mexico.

Codex Azcatitlán

Painted on European paper, this codex was produced at the end of the sixteenth century in the Valley of Mexico. It is currently held by the Bibliothèque Nationale (Paris), after having been part of the collections of Lorenzo Boturini (eighteenth century) and Joseph Aubin (nineteenth century). It contains the historical annals of the Mexica, from the moment they left legendary Aztlan up to the Spanish conquest.

Codex Badianus
or *Libellus de Medicinalibus Indorum Herbis*
by Martín de la Cruz

This codex, painted on European paper in Mexico City in 1552, was sent to Charles V and later found its way into the collections of Cardinal Francesco Barberini and Diego de Cortavila. A copy of it was made in the seventeenth century. It then belonged to the Biblioteca Apostolica Vaticana (Rome), where it was rediscovered in 1929 by scholars Charles Upson Clark and Lynd Thorndike. It has recently been transferred to the Museo Nacional de Antropología e Historia in Mexico City.

Codex Borbonicus

Now held by the library of the Assemblée Nationale at the Palais Bourbon in Paris, this codex probably originated in the colonial period, although its date is the subject of debate. It was discovered at the end of the eighteenth century at El Escorial in Spain, and purchased by the Palais Bourbon librarian in 1826.

Codex Borgia

This pre-Columbian codex describing rites, gods and the

ritual calendar belonged to Cardinal Borgia in the eighteenth century. The prelate had it examined by the Jesuit scholar Fabrega, who produced the first modern analysis of a manuscript of this type (1792-1797). It is currently held by the Biblioteca Apostolica Vaticana (Rome).

Dresden Codex (or Dresdensis)
This pre-Hispanic Maya codex was painted on amatl paper. A librarian from Dresden purchased it in Vienna in 1739, bequeathing it the next year to what would become the Sächsische Landesbibliothek (Dresden). It contains information concerning calendars, astronomy and divination. According to J.E.S. Thompson, it may be a copy of a twelfth-century manuscript displaying Mexica influence.

Codex Durán
This is the name given to the paintings done on European paper circa 1579-1581 to illustrate the *Historia de las Indias de Nueva España* by the Dominican friar Diego Durán. The codex is held by the Biblioteca Nacional (Madrid).

Codex Fejervary-Mayer
Considered part of the "Borgia group," this pre-Hispanic codex was painted on animal skin (deerhide?) and describes various aspects of the 260-day ritual calendar. It is currently held by the National Museums and Galleries on Merseyside (Liverpool), and has numerous points in common with the *Codex Laud* in the Bodleian Library (Oxford). The history of this manuscript prior to 1829 remains a mystery.

Florentine Codex
(also known as the *Historia General de las Cosas de Nueva España*)
This three-volume work was produced on European paper around 1579, under the supervision of Fray Bernardino de Sahagún. It constitutes the outcome of a long ethnographic study that also produced the *Primeros Memoriales* (1559-1561) and the *Códices Matritenses*. The so-called *Florentine Codex* was sent to Spain shortly after it was written, and perhaps offered to the pope. Its seventeenth-century binding bears the Medici coat of arms. At the end of the eighteenth century, the Bandini catalogue mentioned its existence in Florence but the codex went unnoticed until the 1880s. It is currently held by the Biblioteca Medicea Laurenziana (Florence).

Codex Ixtlilxóchitl
This codex contains drawings relating to native gods and ancient rites, along with texts in Spanish. Produced late in the sixteenth century, it was based on texts and drawings found in the *Codex Magliabechiano,* and had been attributed to mestizo historian Don Fernando de Alva Ixtlilxóchitl. Prior to ending up at the Bibliothèque Nationale (Paris), it passed through the hands of collectors Sigüenza y Góngora, Boturini, Aubin, and Goupil.

Codex Magliabechiano (or Magliabecchiano)
Painted on European paper prior to 1566 in the Valley of Mexico, this work belongs to a set known as the "Magliabecchiano group" that also includes the *Codex del Museo de América* (Madrid), the *Codex Veytia* (Madrid) and the *Codex Ixtlilxóchitl* (Paris). It is thought that various copies were made of a now-lost manuscript, at the request of missionaries. The history of this codex remains an enigma. It has been held by the Biblioteca Nazionale Centrale (Florence) since 1862, and prior to that was owned by Florentine collector Antonio da Marco Magliabecchi (who gave the codex its name), though how it came into his hands remains unclear.

Codex Mendoza (or Mendocino)
Produced in 1541-1542, this codex comprises seventy-two pages of drawings accompanied by commentaries in Spanish. It was commissioned by Viceroy Antonio de Mendoza, who sent it to Charles V. But the work fell into the hands of French pirates and then into those of cosmographer André Thévet, "the first true French Americanist and the first collector of Aztec curiosities" (1553). Thévet drew ample inspiration from the work before selling it in 1587 to English historian Richard Hakluyt for twenty ecus. The codex is now part of the Bodleian Library collection (Oxford).

Codex Monteleone
Currently held by the Library of Congress (Washington), this codex was painted circa 1531-1532 in the Puebla region. It was formerly in the archives of descendants of conquistador Cortés, the dukes of Monteleone (hence its name). The plates illustrate a case brought by Cortés against Nuño de Guzman and the members of the first *audiencia* (administrative court). The document contains information of an economic nature.

Codex Selden
This codex was painted circa 1556-1560 in Mixtec country (Oaxaca), and contains dynastic and genealogical information. Once owned by John Selden, it is now in the Bodleian Library (Oxford).

Codex Tellerianus-Remensis
(sometimes *Telleriano-Remensis* or *Le Tellier Codex*)
Painted circa 1562-1563 in the Valley of Mexico, this codex was partly copied from an original document that probably also served as inspiration for the *Codex Vaticanus 3738*. It appears to be a synthesis of various colonial and pre-Hispanic sources. The codex contains the *tonalpohualli,* or ritual calendar, plus the eighteen-month calendar and historical annals. Nothing is known of the history of this document prior to 1700, when it belonged to the archbishop of Reims, Charles-Marie Le Tellier (hence its name). It subsequently entered the collections of the king of France and the Bibliothèque Nationale (Paris).

Codex Tlatelolco

Painted circa 1565 on amatl paper, this codex was perhaps once part of Boturini's collection. It is now housed in the Museo Nacional de Antropología e Historia (Mexico City).

Codex Vaticanus Latinus 3738 (or Vaticanus A or Ríos Codex)

This codex is probably a copy executed in Italy between 1566 and 1589 by a European artist. It is accompanied by an Italian commentary based on the writings of Dominican friar Pedro de los Ríos. It is not known whether de los Ríos was present in Rome when the original codex was copied and annotated, nor even if he was alive at this date. Nor is it known whether the original document still exists, nor what it looked like. But both the Codex Tellerianus-Remensis and the Codex Vaticanus Latinus 3738 are thought to have been copied from the same original, now called the Codex Huitzilopochtli, probably executed between 1549 and 1562. The hypothetical reconstruction of the Codex Huitzilopochtli is very difficult for scholars, and reveals the eminently composite nature of "paintings" done during the colonial period. The codex purportedly juxtaposed pre-Hispanic originals with colonial copies and inventions, combining elements originating in the Valley of Mexico with documents from other areas of central Mexico. The Codex Vaticanus Latinus 3738 is held by the Biblioteca Apostolica Vaticana (Rome).

Codex Yanhuitlan

This codex was painted on European paper around 1545-1550 in the Oaxaca area, and is housed at the Academia de Bellas Artes (Puebla). It is a product of Mixtec culture and concerns the Yanhuitlan and Teposcolula regions where major city-states existed.

Descripción de la Ciudad y Provincia de Tlaxcala

This "geographical account" was drafted circa 1583-1585 and reportedly handed to Philip II by the author himself, mestizo historian Diego Muñoz Camargo. The description includes one hundred and fifty-six pen and ink drawings, eighty of which are taken from the Lienzo de Tlaxcala (see below). It remained part of the Spanish royal collection until the latter half of the eighteenth century, when it was somehow acquired by Scottish doctor William Hunter, who bequeathed it to the University of Glasgow Library. Camargo also authored a Historia de Tlaxcala that enhanced the collections of Boturini (circa 1740) and Aubin before joining that of the Bibliothèque Nationale (Paris).

Historia Tolteca-Chichimeca

This codex was owned by Boturini (eighteenth century) and by Aubin (nineteenth century) before arriving at the Bibliothèque Nationale (Paris). Painted on European paper, probably between 1547 and 1560, it recounts the migration of the Chichimecs from the legendary site of Chicomoztoc to the Puebla region, the founding of Cuauhtinchan and the wars conducted by the city-state. It covers more than four centuries of Indian history, from the twelfth century to 1547.

Lienzo de Tlaxcala

This work, undertaken around 1550 in Tlaxcala, is known only through copies, the most famous being the copy made in 1772. One of the originals (several were created simultaneously) was initially kept in Tlaxcala's city hall, but was later taken to Mexico City to be copied by the French scientific committee charged by Emperor Maximilian to make an inventory of Mexican antiquities. All trace of it was then lost. A second original was sent to Charles V in Spain in the sixteenth century, but is now lost or destroyed. A third original once belonged to Boturini, but its whereabouts have been a mystery since 1804. The library of the Museo Nacional de Antropología e Historia (Mexico City) holds the eighteenth-century copy executed by Juan Manuel Yllañez.

Mapa Quinatzin

This largely historical codex was painted circa 1542-1548 at Texcoco in the Valley of Mexico, and is currently held by the Bibliothèque Nationale (Paris) after having belonged successively to Alva Ixtlilxóchitl, Boturini and Aubin.

Mapa de Sigüenza

Painted on amatl paper in the Valley of Mexico, this "map" describes the wanderings of the Mexica from the time they left Aztlan to the founding of Tenochtitlan. After having belonged to Sigüenza y Góngora and then to Boturini, it is now housed in the library of the Museo Nacional de Antropología e Historia (Mexico City).

Mapa Tlotzin

Like the Mapa Quinatzin, this codex was painted on deerhide in the first half of the sixteenth century. It describes the arrival of the Xolotl Chichimecs in the Valley of Mexico during the era of Nopaltzin and Tlotzin. The codex once belonged to Alva Ixtlilxóchitl, Boturini and Aubin, and is now at the Bibliothèque Nationale (Paris).

Tira de la Peregrinación (or Codex Boturini)

Drawn in ink around 1530-1540 in the Valley of Mexico, this document recounts the migration of the Mexica from Aztlan to Colhuacan, noting the time spent at each stage on their route. It is in the form of a folding screen of amatl paper nearly seventeen feet long. It is housed at the library of the Museo Nacional de Antropología e Historia (Mexico City).

Tonalamatl Aubin

Probably produced early in the colonial period, somewhere in the Valley of Mexico or the Tlaxcala region, this ritual calendar was painted in a traditional pre-Hispanic style. As its name indicates, it once belonged to the French collector Aubin (after having belonged to Boturini). It was then purloined from the Bibliothèque Nationale in Paris, and is now in Mexico City.

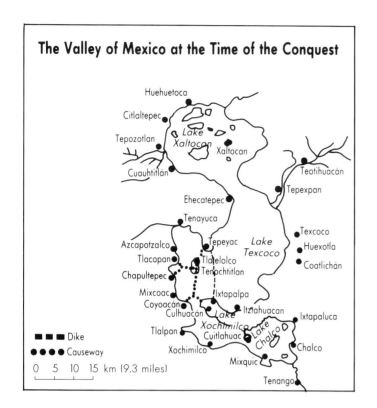

The Valley of Mexico at the Time of the Conquest

Huehuetoca
Citlaltepec
Tepozotlan
Lake Xaltocan
Xaltocan
Cuauhtitlán
Teotihuacán
Tepexpan
Ehecatepec
Tenayuca
Texcoco
Azcapotzalco
Tepeyac
Lake Texcoco
Huexotla
Tlacopan
Tlatelolco
Coatlichán
Chapultepec
Tenochtitlan
Mixcoac
Ixtapalpa
Coyoacán
Itztahuacan
Ixtapaluca
Culhuacán
Lake Xochimilco
Tlalpan
Cuitlahuac
Lake Chalco
Chalco
Xochimilco
Mixquic
Tenango

■■■ Dike
●●●● Causeway

0 5 10 15 km (9.3 miles)

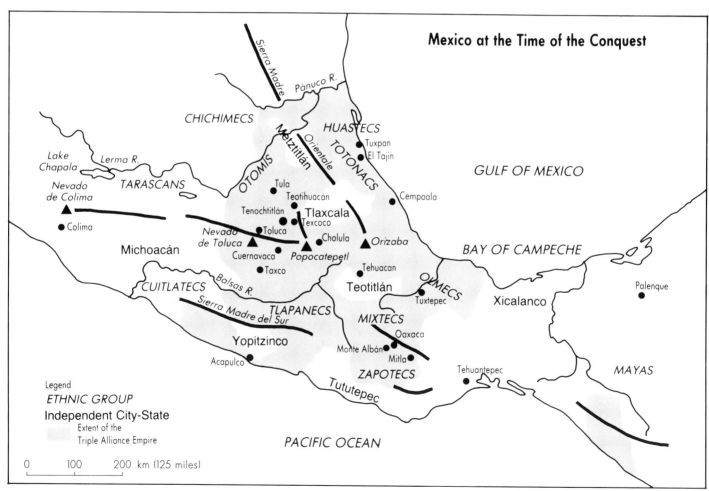

Mexico at the Time of the Conquest

Sierra Madre
Pánuco R.
CHICHIMECS
HUASTECS
Lake Chapala
Lerma R.
Metztitlán
Orientale
TOTONACS
Tuxpan
El Tajín
GULF OF MEXICO
Nevado de Colima
TARASCANS
OTOMIS
Tula
Teotihuacán
Cempoala
Colima
Tenochtitlán
Tlaxcala
Texcoco
Nevado de Toluca
Toluca
Cholula
Orizaba
BAY OF CAMPECHE
Michoacán
Cuernavaca
Popocatepetl
Taxco
Tehuacan
CUITLATECS
Balsas R.
Teotitlán
OLMECS
Palenque
TLAPANECS
MIXTECS
Tuxtepec
Xicalanco
Sierra Madre del Sur
Yopitzinco
Oaxaca
Monte Albán
Mitla
MAYAS
Acapulco
ZAPOTECS
Tehuantepec
Tututepec
PACIFIC OCEAN

Legend
ETHNIC GROUP
Independent City-State
Extent of the Triple Alliance Empire

0 100 200 km (125 miles)

	CODICES	MEXICAN HISTORY	EUROPEAN HISTORY
PRE-COLUMBIAN PERIOD	*Dresden Codex* *Codex Fejervary-Meyer* *Codex Borgia*		
1492		Columbus discovers the New World	Fall of Grenada
1516			Charles becomes king of Spain Machiavelli, *The Prince* (1513)
1517-1518		Mexico discovered by the Spanish	
1519		Mexico invaded by Cortés	Charles V elected Holy Roman Emperor
1520-1521		Smallpox epidemic	
1521		Fall of Mexico-Tenochtitlan	Martin Luther excommunicated
1519-1540	*Codex Borbonicus* and *Tonalamatl Aubin*		
1523-1524		Arrival of Pedro de Gante and the first Franciscans	Ignatius Loyola, *Spiritual Exercises* (1526) Sack of Rome (1527)
1530		Epidemics	*Augsburg Confession*
1535		Antonio de Mendoza named viceroy of New Spain	Henry VIII breaks with Rome (1534) Thomas More beheaded (1535)
1536		College of Santa Cruz de Tlatelolco founded	Calvin, *Institution of Christian Religion* Death of Erasmus
1539		Don Carlos, cacique of Texcoco, burned at the stake	Society of Jesus founded
1541-1542	*Codex Mendoza*	Mixtón Indians rebel	
1545-1548		*Cocoliztli* epidemic	Council of Trent begins (1545)
1548		Death of Archbishop Zumarrága of Mexico City	Rabelais, *The Fourth Book*
1550		Luis de Velasco named viceroy	Ronsard, *Odes*
1550-1556	*Lienzo de Tlaxcala*		Jean Goujon sculpts Louvre caryatids (1550)
1552	*Codex Badianus*		Mary Tudor, queen of England (1553), marries Philip II (1554) Charles V abdicates (1556)
1559		Epidemic	Elizabeth crowned queen of England (1558) Death of Henri II of France (1559)
1559-1561	Sahagún: *Primeros Memoriales*		Saint Teresa, *Life of Mother Teresa of Jesus* (1561)
1562-1563	*Codex Tellerianus-Remensis*		Council of Trent ends (1563) Edict of Amboise (1563)
1563-1564		Epidemics	
1565	*Codex Tlatelolco*		
Before 1566	*Codex Magliabechiano*		
1566-1589	*Codex Vaticanus 3738*		Duke of Alba named governor of the Low Countries (1567)
1571		Mexican Inquisition	Battle of Lepanto Kepler born
1576-1581		Epidemics (typhus) Tlatelolco college ravaged	Montaigne, *Essays* (1580) Tasso, *Jerusalem Delivered* (1580)
1579	Sahagún: *Florentine Codex*		Founding of the United Provinces (Low Countries)
1579-1581	*Codex Durán*		
1579-1585	*Relaciones geográficas:* Maps		
1582	*Codex Ixtlilxóchitl*		Philip II backs the Catholic League in France (1582)
1579-1583	*Descripción de Tlaxcala*		
1587-1588		Epidemics	Mary Stuart beheaded (1587) Spanish Armada defeated (1588) Marlowe, *Tamerlaine* (1587)
1590-1593		Epidemics	Henri IV besieges Paris (1590)
1595-1597		Epidemics	Mercator's *Atlas* (1595) Shakespeare, *Richard II* (1595)
1598	*Crónica Mexicayótl* by Tezozomoc		

GLOSSARY

amanteca (Nahuatl): the elite craftsmen who worked with feathers (= "those who come from Amatlan").

amatl (Nahuatl): a type of tree belonging to the genus *Ficus;* the term also refers to the paper made from this tree.

cacique (Carib): a native chieftain.

cactli (Nahuatl): sandal.

calmecac (Nahuatl): school attended by children of nobles and rich merchants (= "in the row of houses").

chalchiuitl (Nahuatl): a precious, emerald-green stone.

chia (Nahuatl): a plant whose seeds were valued for their oil and, when steeped, yielded a refreshing beverage; sage.

codex: the name given in the nineteenth century to Mesoamerican manuscripts painted according to native canons.

comal (from the Nahuatl *comalli*): a terracotta plate on which tortillas (thin cornmeal cakes) were cooked.

copal (from the Nahuatl *copalli*): the resin produced by the tree of the same name, used to make incense.

encomendero (Spanish): a person who was granted an encomienda.

encomienda (Spanish): a grant of one or several villages awarded by the Spanish crown to a Spaniard. The encomendero was entitled to tribute from these villages, in the form of personal services as well as income in cash or in kind.

hidalgo (Spanish): a member of the Castilian gentry.

house of song: a sort of music school for the children of commoners.

ichcahuipilli (from the Nahuatl *ichcatl*, cotton, and *huipilli,* shirt or jacket): jacket or breastplate stuffed with cotton.

icpalli (Nahuatl): a seat with a high back, symbol of power.

macuahuitl (Nahuatl): a wooden sword studded with obsidian points.

maguey (Carib): a plant of the agave family.

mictlan (Nahuatl): the underworld inhabited by people who died under normal circumstances (= "abode of the dead").

Nahua: an ethnic group that lived in central Mexico and spoke Nahuatl. The Mexica, Texcocans and Tlaxcalans all belonged to this linguistic and cultural group.

nahual (from the Nahuatl *nahualli*): the transformation of a god or living being into another being.

Nahuatl: the language spoken by the Nahua peoples.

New Spain: the name given to Mexico by its Spanish rulers.

petate (from the Nahuatl *petatl*): a straw mat.

pipiltin (Nahuatl): the nobles (= "Sons of Somebody").

pochteca (Nahuatl): Nahua merchants (= "those who come from the place of the silk-cotton tree").

pueblo: a village and its surrounding land.

pulque (from the Nahuatl *poliuhqui*?): the fermented juice of the maguey plant.

quetzal: a bird native to Chiapas and Guatemala (*Pharomachrus mocinno*) whose feathers were highly valued.

Quetzalcoatl (Nahuatl): the Nahua god of the wind, procreation and the morning, called the "Richly Feathered Serpent" and the "Precious Twin."

telpochcalli (Nahuatl): a school attended by the children of commoners (= "the house of young people").

tlacuilo (Nahuatl): painter, and—during the colonial period —writer, a person who wrote with the alphabet.

tlalocan (Nahuatl): the abode of Tlaloc, god of rain and fertility, as well as one of the abodes of the dead.

tonalli (Nahuatl): vital energy, located in the head. Loss of *tonalli* was thought to cause various diseases.

tonalpohualli (Nahuatl): the ritual year of two hundred and sixty days, as well as the ritual calendar associated with this year (= "*tonalli* count").

tortillas: thin pancakes made of cornflour.

trecena: a week of thirteen days, as ordained by the ritual calendar.

tzitzimime (Nahuatl): monstrous creatures ready to fall upon humans and devour them. It was thought that the sky would collapse and these monsters would then descend to earth.

villancicos (Spanish): popular Spanish Christmas carols.

yaochimalli (Nahuatl): shield.

BIBLIOGRAPHY

PRIMARY SOURCES

BERLIN, H., and and BARLOW, R. H., *Annales de Tlatelol-co...y Códice de Tlatelolco*, Mexico City, Rafael Porrúa, 1980.

BIERHORST, John, *Cantares Mexicanos. Songs of the Aztecs*, translated from the Nahuatl with an Introduction and Commentary by John Bierhorst, Stanford, Stanford University Press, 1985.

BROTHERSON, Gordon, and VOLLMER, Günter, *Aesop in Mexico. Die Fabeln des Aesop in Astekischer Sprache. A 16th Century Aztec Version of Aesop's Fables*, Berlin, Gebr. Mann Verlag, 1987.

Codex Badianus, see Cruz, Martín de la.

Codex Borbonicus, Paris, Bibliothèque de l'Assemblée Nationale, Y 120, Graz, Codices Selecti 44, 1974.

Codex Borgia, Rome, Biblioteca Apostolica Vaticana (Messicano Riserva 28), Graz, Codices Selecti 58, 1976.

Codex Dresdensis, Dresden, Sächsische Landesbibliothek (Mscr. Dres. R 310), Graz, Codices Selecti, 1975.

Codex Fejervary-Mayer, Liverpool, City of Liverpool Museums (12104 M), Graz, Codices Selecti, 1971.

Codex Ixtlilxóchitl, Paris, Bibliothèque Nationale (Ms. Mex. 65-71), Graz, Fontes Rerum Mexicanarum, 1976.

Codex Magliabechiano, Florence, Biblioteca Nazionale Centrale CL.XIII.3 (B. R. 232), Graz, Codices Selecti 23, 1970.

Codex Mendoza, The Mexican Manuscript Known As the Collection of Mendoza, London, Waterlow and Sons, 3 vols., 1938.

Codex Tellerianus-Remensis, reprinted in *Antigüedades de México Basadas en la Recopilación de Lord Kingsborough*, Mexico City, Secretaría de Hacienda y Crédito Público, 1964.

Codex Vaticanus 3738 (Codex Vat. A, Codex Ríos), Rome, Biblioteca Apostolica Vaticana, Graz, Codices Selecti 36, 1979.

CRUZ, Martín de la, *Libellus de Medicinalibus Indorum Herbis, Manuscrito Azteca de 1552*, Mexico City, Instituto Mexicano del Seguro Social, 1964.

DÍAZ DEL CASTILLO, Bernal, *La Historia Verdura de la Conquista de la Nueva España*, Mexico City, Porrúa, 2 vols., 1968. [Díaz del Castillo, *The Discovery and Conquest of Mexico*, translated by A. P. Maudslay, New York, Noonday, 1956.]

DIBBLE, Charles. E. (ed.), *Codex Xolotl*, Mexico City, UNAM, 2 vols., 1981.

DURÁN, Diego, *Historia de las Indias y de las Islas de Tierra Firme*, Mexico City, Porrúa, 2 vols., 1967. [Durán, Diego, *The Aztecs: The History of the Indies of New Spain*, translated by Doris Heyden and Fernando Horcasitas, New York, Orion, 1964.]

Florentine Codex, facsimile edition (Nahuatl-Spanish), Mexico City, Giunti Barbéra, 3 vols., 1979. Translated into English by Charles E. Dibble and Arthur J. O. Anderson, Salt Lake City and Sante Fe, University of Utah Press and School of American Research, 13 vols., 1950-1982.

GARCÍA QUINTANA, Josefina and MARTÍNEZ MARTÍN, Carlos (eds.), *Lienzo de Tlaxcala*, Mexico City, Cartón y Papel, 1983.

Handbook of Middle American Indians, Guide to Ethnohistorical Sources, Austin, University of Texas Press, Part 3, Vol. 14, 1975.

KIRCHHOFF, Paul, OODENA GÜEMES, Lina, and REYES GARCÍA, Luis (eds.), *Historia Tolteca-Chichimeca*, Mexico City, CIS-INAH, INAH-SEP, 1976.

MENDIETA, Gerónimo de, *Historia Eclesiástica Indiana*, Mexico City, Salvador Chávez Hayhoe, 4 vols., 1945.

MOTOLINÍA (also known as BENEVENTE, Toribio de), *Memoriales o Libro de las Cosas de la Nueva-España y de los Naturales de Ella*, Mexico City, UNAM, 1971.

MUÑOZ CAMARGO, Diego, *Descripción de la Ciudad y Provincia de Tlaxcala de las Indias y del Mar Oceano para el Buen Gobierno y Ennoblecimiento Dellas*, Mexico City, UNAM, 1981.

———, *Historia de Tlaxcala*, Mexico City, Ateneo Nacional, 1947.

PASO Y TRONCOSO, Francisco del, *Epistolario de Nueva España*, (Volume IV, 1540-1546), Mexico City, Robredo, 1939.

SAHAGÚN, Bernardino de, *Historia General de las Cosas de Nueva España*, Mexico City, Porrúa, 4 vols., 1977.

———, *Primeros Memoriales, Textos en Nauatl*, translated and with an Introduction by Wigberto Jímenez Moreno, Mexico City, INAH, 1974.

TEZOZOMOC, Fernando Alvarado, *Crónica Mexicayótl*, Mexico City, UNAM, 1975.

TORQUEMADA, Juan de, *Monarquía Indiana*, Mexico City, UNAM, 7 vols., 1975-1983.

SECONDARY LITERATURE

AGUILERA, Carmen, and LÉON-PORTILLA, Miguel, *Mapa de México-Tenochtitlán y sus Contornos hacia 1550*, Mexico City, Celanese, 1986.

BAUDOT, Georges, *Histoire et Utopie au Mexique, Les premiers chroniqueurs de la civilisation mexicaine (1520-1569)*, Toulouse, 1977.

BERDAN, Frances F., *The Aztecs of Central Mexico: An Imperial Society*, New York, Holt, Rinehart and Winston, 1982.

BERNAND, Carmen, and GRUZINSKI, Serge, *De l'idolâtrie. Une archéologie des sciences religieuses*, Paris, Seuil, 1988.

———, *Histoire du Nouveau Monde. De la Découverte à la Conquête. Une expérience européene*, (Volume 1), Paris, Fayard, 1991.

CARRASCO, David, *Quetzalcóatl and the Irony of Empire*, Chicago, The University of Chicago Press, 1982.

DAVIES, Nigel, *The Aztecs: A History,* London, Macmillan, 1973.

DUVERGER, Christian, *L'Esprit du jeu chez les Aztèques,* Paris, Mouton, 1978.

GARIBAY K., Angel María, *Historia de la Literatura Náhuatl,* Mexico City, Porrúa, 2 vols., 1971.

GIBSON, Charles, *The Aztecs under Spanish Rule,* Stanford, Stanford University Press, 1964.

_____, *Tlaxcala in the Sixteenth Century,* Stanford, Stanford University Press, 1952.

GILLESPIE, Susan D., *The Aztec Kings: The Construction of Rulership in Mexica History,* Tucson, Arizona University Press, 1989.

GRUZINSKI, Serge, *La Colonisation de l'imaginaire. Sociétés indigènes et occidentalisation dans le Mexique espagnol, XVI-XVIIIᵉ siècle,* Paris, Gallimard, 1988.

_____, *Conquering the Mind of the Native,* Cambridge, Polity Press, 1992.

_____, *Le Destin brisé de l'empire aztèque,* Paris, T. Hudson, 1992.

_____, *La Guerre des images de Christophe Colomb à Blade Runner, 1492-2019,* Paris, Fayard, 1990.

_____, *Man-Gods and the Mexican Highlands: Indian Power and Colonial Society 1520 to 1800,* Stanford, Stanford University Press, 1989.

Archives contemporaines, 1989.

HASSIG, Ross, *Trade, Tribute and Transportation,* Norman, University of Oklahoma Press, 1985.

KLOR DE ALVA, J. Jorge, NICHOLSON, H. B., and QUIÑONES KEBER, Eloise, *The Work of Bernardino de Sahagún, Pioneer Ethnographer of Sixteenth Century Aztec Mexico,* Albany, Institute for Mesoamerican Studies, 1988.

KUBLER, George, *Mexican Architecture of the Sixteenth Century,* New Haven, Yale University Press, 2 vols., 1948.

LEGROS, Monique, "La Conception mexica du temps," a series of conferences given at l'Ecole des Hautes Etudes en Sciences Sociales, Paris, 1986.

LEÓN-PORTILLA, Miguel, *La Filosofía Náhuatl Estudiada en sus Fuentes,* Mexico City, UNAM, 1966.

LÓPEZ AUSTÍN, Alfredo, *Cuerpo Humano e Ideología. Los Conceptos de los Antiguos Nahuas,* Mexico City, UNAM, 2 vols., 1980.

LÓPEZ SARRELANGUE, Delfina, *La Nobleza Indígena de Pátzcuaro,* Mexico City, UNAM, 1965.

REYES VALERIO, Constantino, *Arte Indocristiano. Escultura del Siglo XVI en México,* Mexico City, INAH, 1978.

RIEFF ANAWALT, Patricia, *Indian Clothing Before Cortés: Mesoamerican Costumes from the Codices,* Norman, University of Oklahoma Press, 1959.

ROBERTSON, Donald, *Mexican Manuscript Painting of the Early Colonial Period, The Metropolitan Schools,* New Haven, Yale University Press, 1959.

ROJAS, José Luis de, *México-Tenochtitlán. Economía y Sociedad en el Siglo XVI,* Mexico City, Fondo de Cultura Económica, El Colegio de Michoacán, 1986.

SACCHI, Duccio, *La Représentation du territoire dans la Nouvelle Espagne. Analyse des sources (XVIᵉ-XVIIᵉ siècle),* DEA diss., Ecole des Hautes Etudes en Sciences Sociales, Paris, 1990.

SMITH, Mary Elisabeth, *Picture Writing from Ancient Southern Mexico,* Norman, University of Oklahoma Press, 1973.

SOUSTELLE, Jacques, *L'Univers des Aztèques,* Paris, Hermann, 1979.

STEVENSON, Robert, *Music in Aztec and Inca Territory,* Berkeley, University of California Press, 1976.

TOUSSAINT, Manuel, *Pintura Colonial en México,* Mexico City, UNAM, 1965.

The Moon (see caption page 173)
Florentine Codex, Vol. II, fol. 228 v.

PHOTOGRAPHIC ACKNOWLEDGEMENTS

The numbers refer to illustration captions.

AUCH: Musée des Jacobins 122 — AUSTIN: University of Texas, Benson Latin American Collection 117, 119, 190, 191 — BARCELONA: Arxiu Mas 23, 30, 32, 88 — FLORENCE: Biblioteca Medicea Laurenziana/Donato Pineider 16, 17, 33, 34, 37, 38, 62, 96, 100-101, 104, 112, 128, 129, 132, 134, 138-141, 144, 146, 147, 152, 153, 154, 155, 156, 158, 159, 161, 166, 169, 170, 171, 172, 173, 174, 175, 177, 178, 181, 182, 184, 187; Biblioteca Nazionale Centrale/Donato Pineider 40, 50, 51, 52, 66, 67, 71-72, 73, 74, 75, 105, 108, 180, 185, 186, 188 — GLASCOW: Library of University 24, 25, 26, 28, 29, 31, 118, 120 — LIVERPOOL: National Museums and Galleries on Merseyside 2 — LONDON: British Library 4 — MEXICO: Archivo General de la Nacíon 167, 192, 193; Biblioteca del Museo Nacional de Antropología e Historia 113 — OXFORD: Bodleian Library 79, 92, 94-95, 97, 106 — PARIS: Bibliothèque de l'Assemblée Nationale 53, 54, 55, 56, 57, 58, 59; Bibliothèque Nationale 13, 35, 36, 41, 42, 44, 45, 76, 80-82, 83, 84, 85, 86, 87, 89, 90, 91, 93, 115-116, 189; G. Dagli Orti 10, 27, 39, 78, 99, p. 2 — TECAMACHALCO (State of Puebla): Rebeca Monroy 151 — TEPOZOTLAN (State of Mexico): Museo nacional del Virreinato/Palle Pallesen 124 — VATICAN: Biblioteca Apostolica Vaticana 1, 3, 8, 14, 43, 60, 61, 63, 69, 163, 164, 194 — WASHINGTON: Library of Congress 125 — ALL RIGHTS RESERVED: 5, 6, 7, 9, 11, 12, 15, 18, 19-20, 21, 22, 46-47, 48, 49, 64, 65, 68, 70, 77, 98, 102, 103, 107, 109-111, 114, 121, 123, 126, 127, 130, 131, 133, 135, 136, 137, 142, 143, 145, 148, 149, 150, 151, 157, 162, 165, 168, 176, 179, 183.
The maps on p. 232 were executed by Carto-Plan, Boulogne.